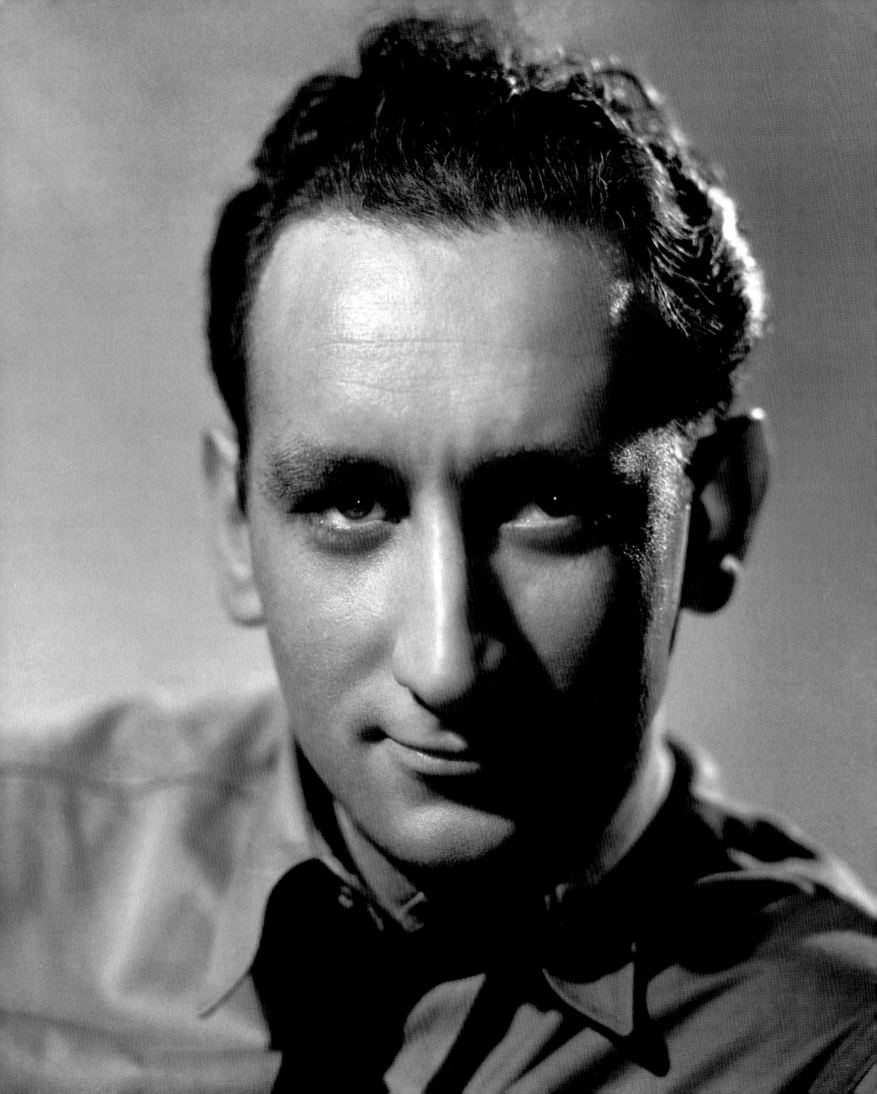

SID AVERY

the art of the hollywood snapshot

RON AVERY AND TONY NOURMAND

REEL ART PRESS

First published 2012 by Reel Art Press, an imprint of Rare Art Press Ltd., London, UK.
www.reelartpress.com

ISBN: 978-0-9572610-0-6

Printed by Hampton Printing (Bristol), England.

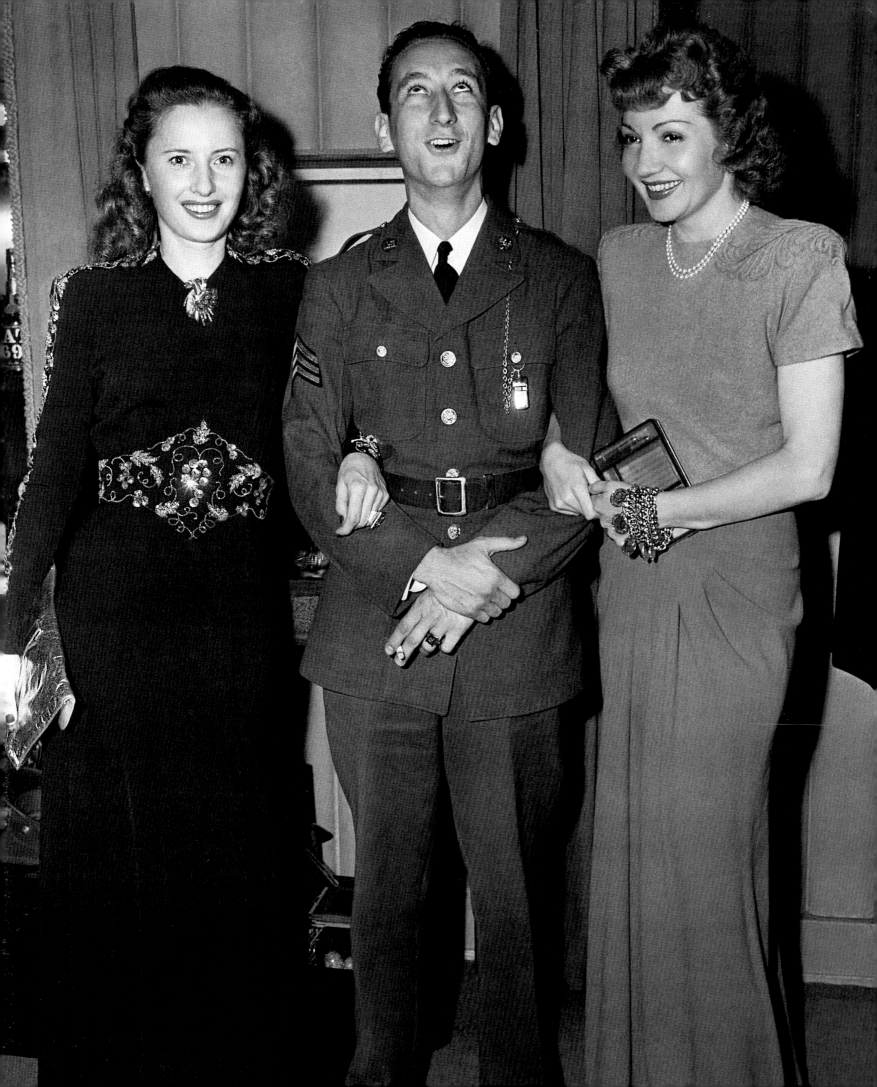

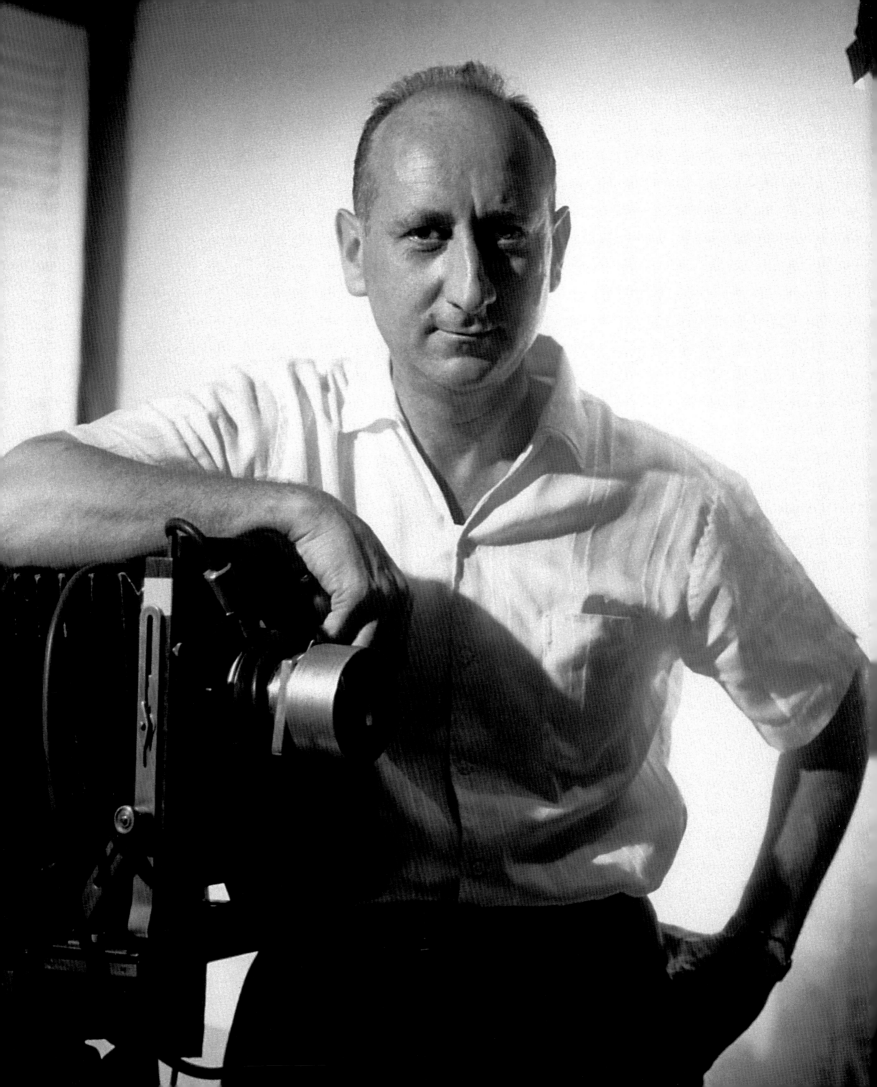

Text
SID AVERY
RON AVERY

Additional Text
ALISON ELANGASINGHE
BRUCE McBROOM

Editor
TONY NOURMAND

Art Director
GRAHAM MARSH

Page Layouts
JACK CUNNINGHAM

Research and Consultation
ANDY HOWICK

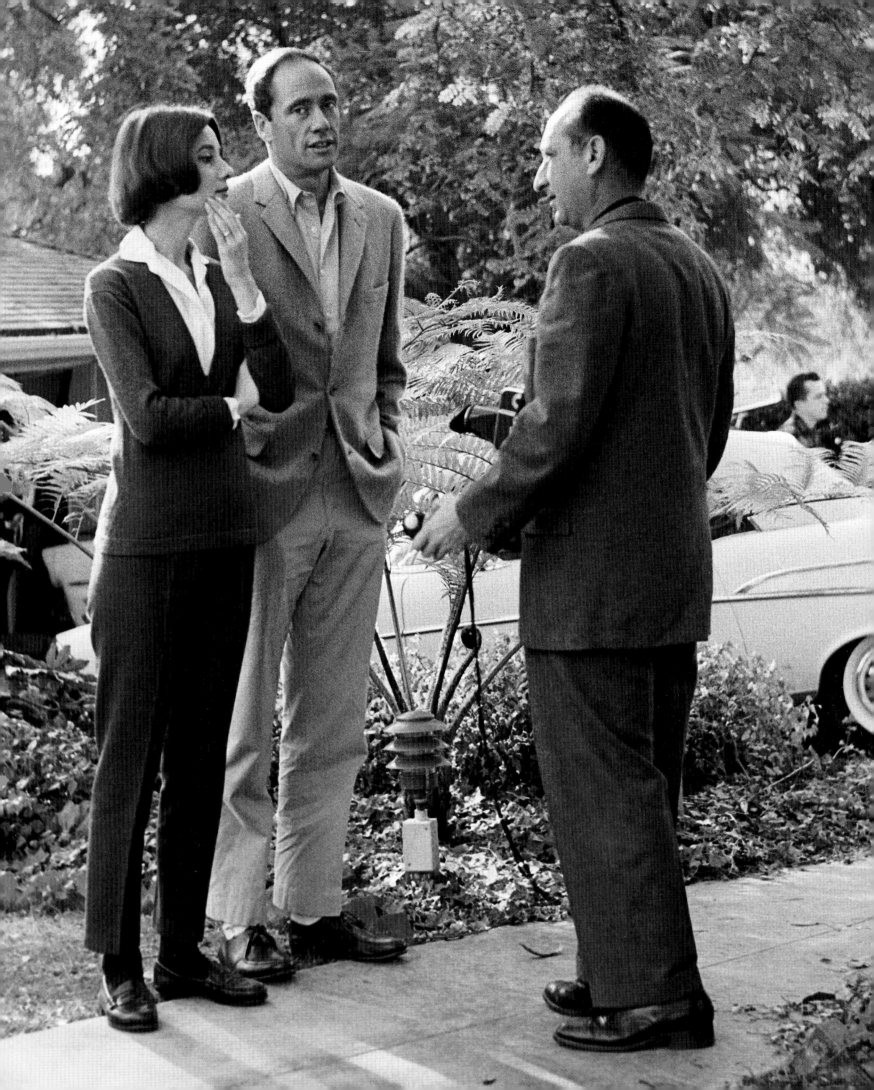

CONTENTS

FOREWORD

My name is Ron Avery and my father was Sid Avery. When people ask if I'm Sid's son, I joke, 'That's right, I'm S.O.S.' Not the appeal for help, mind you, but rather, 'Son of Sid'. For the 45 years I knew my dad, I always considered myself very lucky to hold that title. I tried to model my career after his and admired him not only as a person but for his work. To honor the memory of my dad, I thought it was high time to let others share in some of the magic he captured through his lens during his extraordinary career. More than that, though, I wanted the reader to hear, for the first time, my dad's stories about the assignments he shot and the interactions he had with some of the twentieth century's most celebrated icons. These stories are sometimes as interesting as the images themselves.

I was always in awe of my dad's work ethic. Whether I was helping him in his studio as a child during my summer break or when I began working with him full-time as an adult, he always treated everyone with respect and kindness, from the first assistant down to the lab technician.

My dad was also known for his accomplishments as an innovator in his field. He came up with the technique of solarization used in motion picture film and he invented the first motion picture strobe that synced up with a film camera. Beyond that, though, he was the go-to photographer when it came to subjects who had a reputation for being difficult. What's interesting is that, in most cases, when he would shoot these subjects he encountered no difficulty at all, and that's a testament to my dad. He treated these stars like people and, as a result, they treated him in kind.

A funny story to illustrate this is when my dad was shooting an ad with Bob Hope for Cal-Fed, a California based bank. There was a full day of shooting to do, many different set-ups and props, so as the day wore on, Mr. Hope's expression became static. My dad was trying to coax a slightly different smile or pose out of him, but to no avail. At that point, with a flash, my dad shouted, 'Come on Bob, Goddamnit! Get that shit-eating grin off your face and let's go!' Everybody froze, the art director gasped and Bob cracked a smile. After that, Mr. Hope loosened up and my dad got some nice shots. The client was pleased, and my dad's instinct for people won the day again.

While the majority of the photos in this book were shot before I was born, or while I was a very small child, in 2001 I had a great opportunity to get a glimpse of dad working as he would have been in his heyday. To set the scene: my dad famously photographed the 1960 cast of *Ocean's Eleven* around the pool table; an iconic shot of Frank Sinatra, Sammy Davis Jr., and Dean Martin with the rest of the movie's cast. Now, let's cut to 41 years later, in 2001, when we get a call from Warner Bros. They told me that Julia Roberts had seen my dad's original photo in a New York gallery, and after sharing it with the director, Steven Soderbergh, and George Clooney, thought it would be a great idea to recreate this classic image with the current cast of the remake; one that included George Clooney, Brad Pitt and Matt Damon, to name a few.

At this point, my dad was retired some 30-plus years from the still photography business and was reluctant to take the job. He didn't even own a professional still camera anymore. I explained to him that back in the day, he was able to work with the biggest stars of the 1950s and 1960s, and now he could do the same with today's stars. I added that Bruce McBroom would assist and I would produce. He realized I was right and he picked up the phone to take Warner Bros off hold and tell them he would take the assignment. I'm so glad he did, too, because it turned out to be a real treat for the both of us. For me, having not been around when my dad shot James Dean on the set of *Giant* in 1955 or Steve McQueen driving through Nichols Canyon in 1960, I got a chance to see him really enjoy himself on this set amongst the current era's A-list celebrities. The respect they gave him and the level of interest they showed in him was gratifying. From the producers, actors and director, they all showered him with affection. It was extremely rewarding to see him in that environment, and for my dad, it turned out to be a nice capper to his action-packed career.

This book of my dad's photos and accompanying stories shows an insight into the man, as much as it does into the subjects he shot. As I went through my own family snapshots recently, I realized how few there were of just me and my dad together. He was always the one behind the camera, capturing me enjoying time with my family and friends. Likewise, while dad's not in most of the shots on these pages, his warmth, his talent and his skill shine through in the faces of those in the pictures. I trust that will be the lasting impression: not so much with the fame of the people in the photos, but with the artistry of the man who created them.

A common expression my dad used to say after I'd drive him somewhere was, 'Thanks for the buggyride!' Well, this time, thank you dad, it was a great ride.

RON AVERY

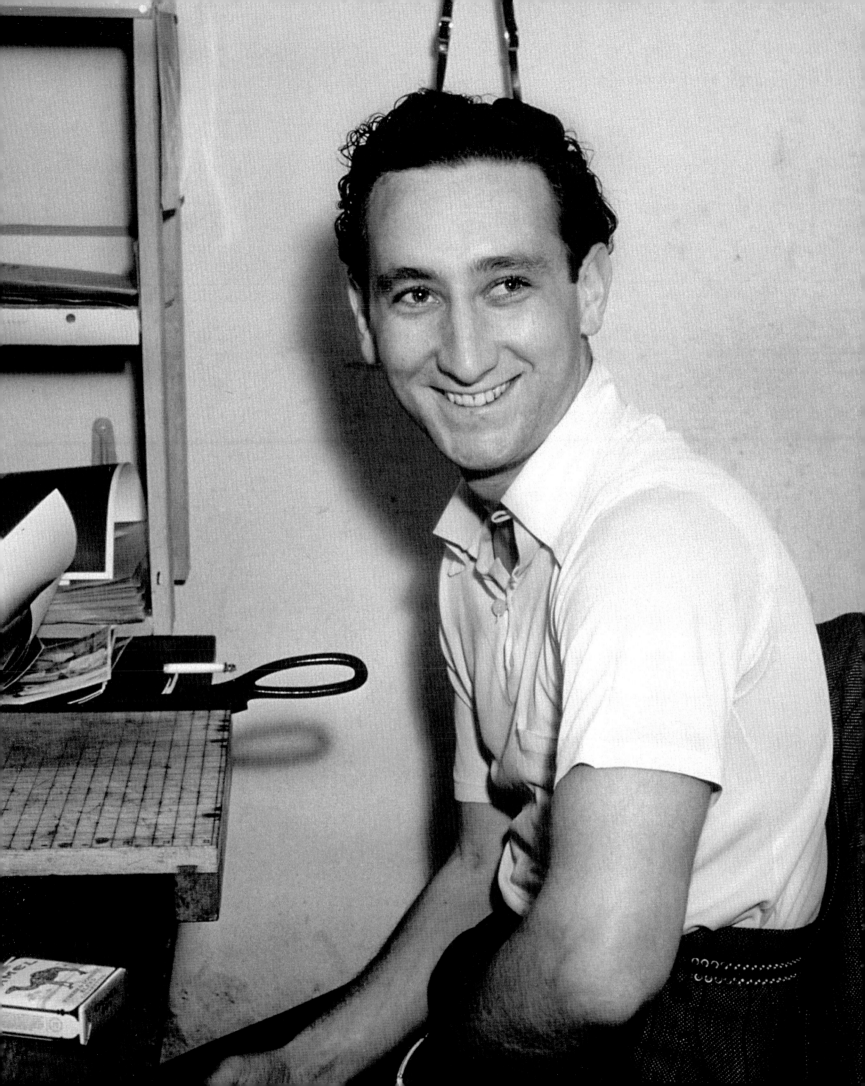

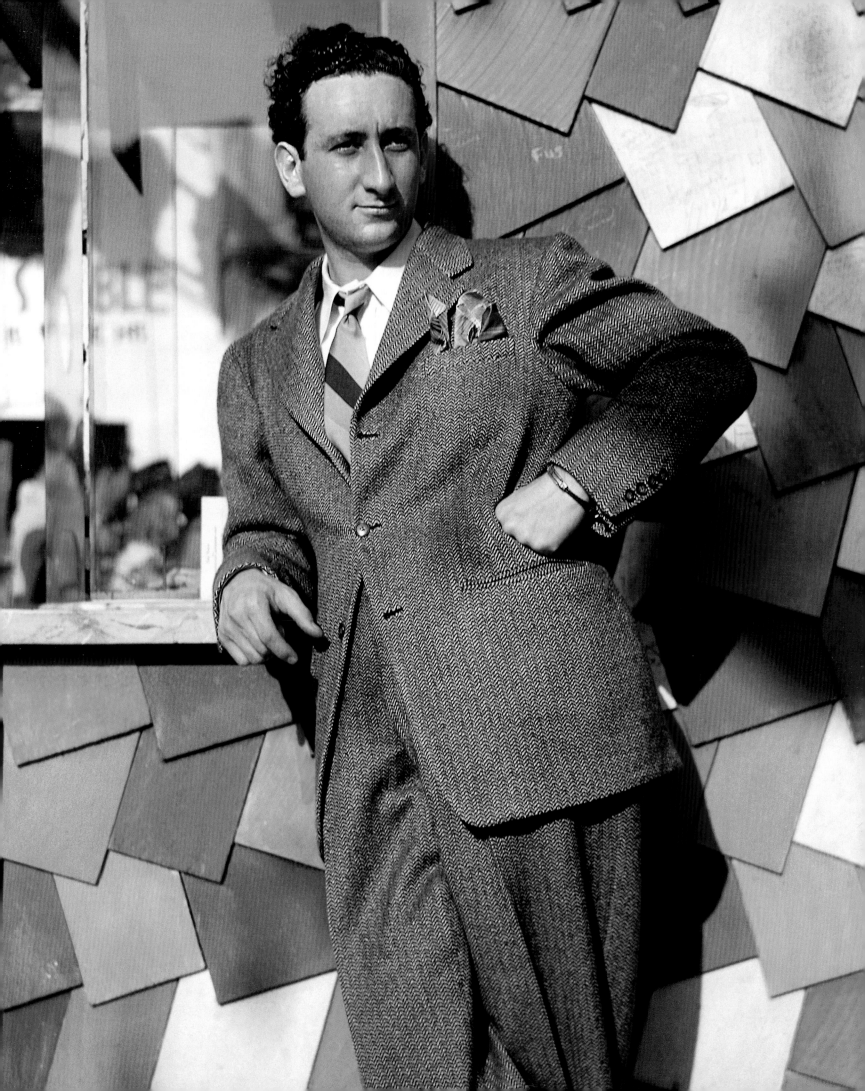

INTRODUCTION

Sid Avery's photographs are iconic. Audrey Hepburn on a bike with pet dog in tow, James Dean on the set of *Rebel Without a Cause*, Marlon Brando taking out the garbage, Rock Hudson emerging from the shower, Elizabeth Taylor soaking up the sun, Frank Sinatra chatting between takes in the studio… the list continues to include every Hollywood idol of the post-war era. Avery was the master chronicler of the sunset years of the Golden Age of Hollywood. From 1946 to 1961, he shot over 350,000 images of Tinseltown's greatest stars for the most popular magazines of the day, including *Look*, *Saturday Evening Post*, *Silver Screen* and *Collier's*. A pioneer of a candid new style of Hollywood portraiture, his 'snapshots' offered a behind-the-scenes peak at the world's most beautiful people; a glimpse into the ordinary lives of the private, A-list elite.

Born in Akron, Ohio, in 1918, Avery moved to Los Angeles with his family at nine months old. One of six siblings, he had a modest upbringing and his father worked in the restaurant supply business. Photography captured Avery's imagination as a child, with two early events playing a key role in the development of a lifelong passion. At the age of seven, Avery was introduced to photography by his uncle, Max Tatch – a professional photographer specializing in landscapes and architecture. Tatch would take his nephew along on assignments and invite him to watch him at work in the darkroom. As Avery later recalled, 'I saw him put a piece of paper in what I thought was water, and all of a sudden this magic thing happened – a beautiful image appeared. The appearance stuck with me for a long time.' Then, as a young teen, Avery found an abandoned box brownie camera, which he fixed up and began to experiment with. A pupil at Roosevelt High School, he won several camera club prizes and took all the pictures for the yearbook.

On graduating high school in 1937, Avery secured work as a darkroom technician at Morgan's Camera Shop on Sunset Boulevard. He also attended evening classes in photography at Los Angeles Art Center, studying under the renowned Fred Archer. Morgan's was near the old NBC studio and was a hub for several of the *Life* photographers. Avery's job involved processing their celebrity portraits and he made several invaluable contacts. He was hired as an assistant by Gene Lester, the pioneering Hollywood photographer.

Under Lester's guidance, Avery was soon photographing celebrities at nightclubs and his images began to appear in the *Saturday Evening Post*, *Silver Screen* and *Photoplay*. In 1939, at the age of just 21, Avery opened his own studio on Hollywood Boulevard with his then partner, Eero 'Cookie' Cook, focusing on publicity photos, portraits and photojournalism. One of his first assignments was taking glamour shots of chorus girls at Florentine Gardens and at Earl Carroll Theater.

Avery's flourishing career was interrupted in 1941 when he was called up to war service. Far from being an impediment, however, Avery was fortunate to be selected to receive six months photojournalism training at *Life* in New York, before being sent overseas with the photography unit of the Army Signal Corps. Based in London, Avery helped establish the Army Pictorial Service laboratory, which processed all film footage coming out of the European theater. He also worked on the highly secret plans for the Normandy Invasion. While stationed in London, Avery met a young English girl, Diana Berliner, who became his wife and future mother to his three children. After the war ended, Avery came back to Los Angeles with Diana and opened a new studio in 1946, Sid Avery Photography, on Selma in Hollywood.

The post-war landscape Avery returned to was a very different place to the industry he had first encountered in his teens. The 'Glamour of the Gods' portrait style of the 1930s and 1940s, pioneered by photographers like George Hurrell and Laszlo Willinger and which emphasized the chasm between the ordinary citizen and the Hollywood deity, fell out of favour. The public was hungry for more candid portraits that emphasized the human side of the screen's biggest stars. Furthermore, the homogenous culture of the 1950s fuelled a singular vision of 'the acceptable norm' across all strata of society, which had family life, surrounded by the rewards of the new consumer culture, at its heart. In the introduction to Avery's 1990 book, *Hollywood at Home: A Family Album 1950-1965*, the *Time* critic Richard Schickel writes, 'There was something abnormal about fifties normalcy. … As with all fictions, one was free not to buy it. But the mass media did buy it and sell it. And we, the great audience, bought it from the movies and the magazines and the broadcasters. We also did our best to resell it, to our sometimes

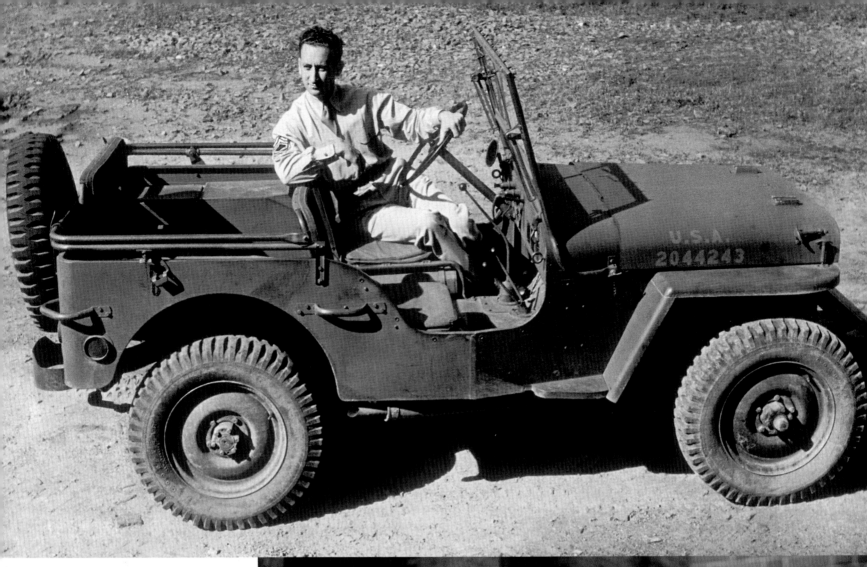

Clockwise from top left:
*Sid Avery in May of 1942 at Camp Robinson in Arkansas; Sid with editor Daniel Longwell and Elton Lord at the **Life** magazine office in New York, 1941; Sid (Master Sergeant, Army Pictorial Service), circa 1942; Sid and Lana Turner at Ciro's Nightclub in Hollywood, California, 1941; Sid and wife Diana on their wedding day, 19 July 1943.*

16

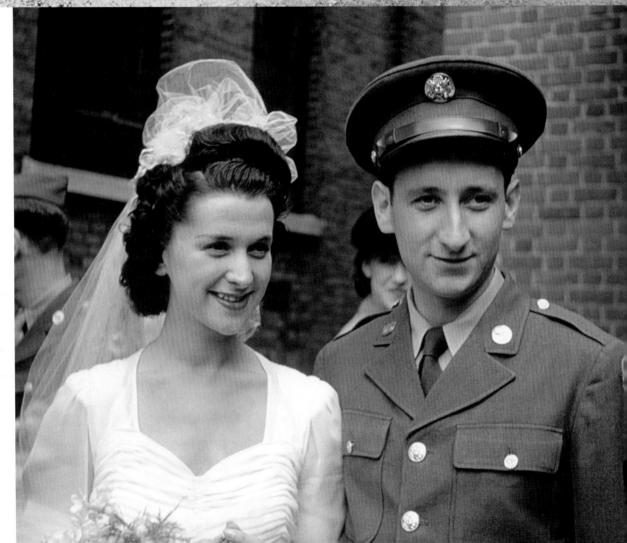

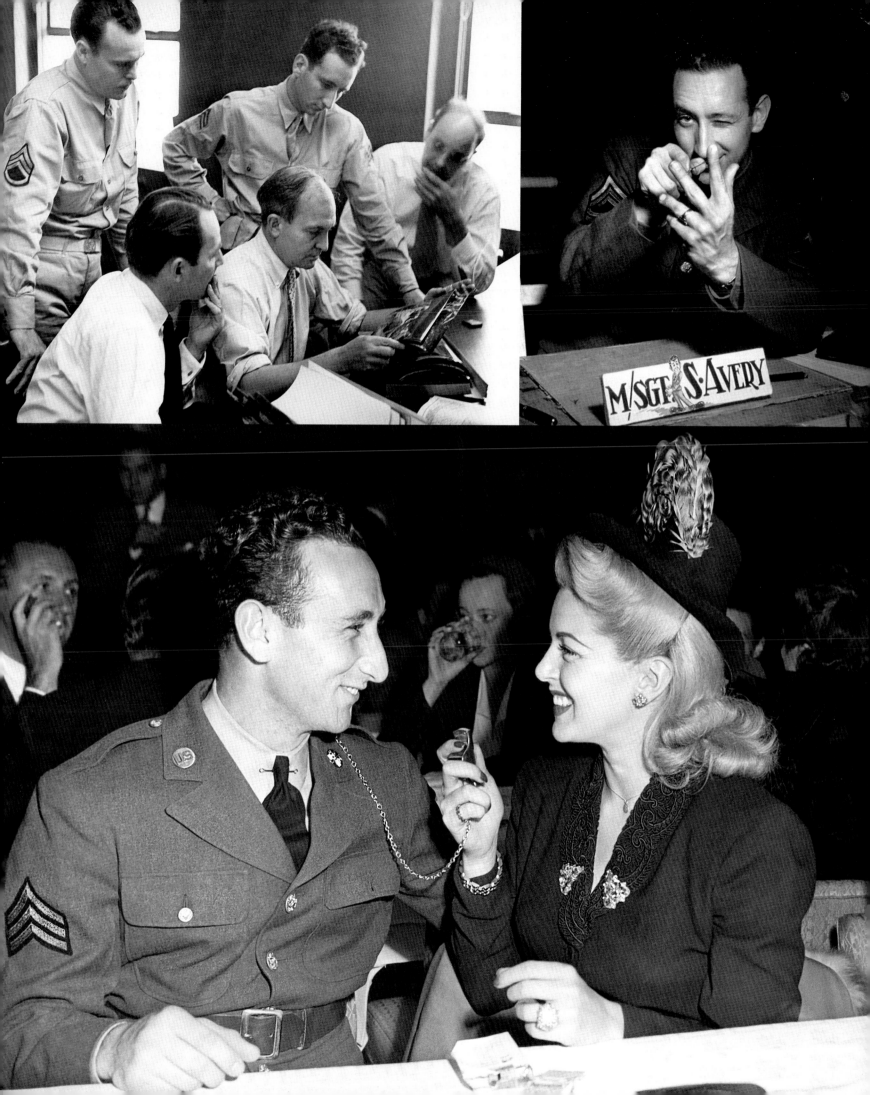

M/SGT S·AVERY

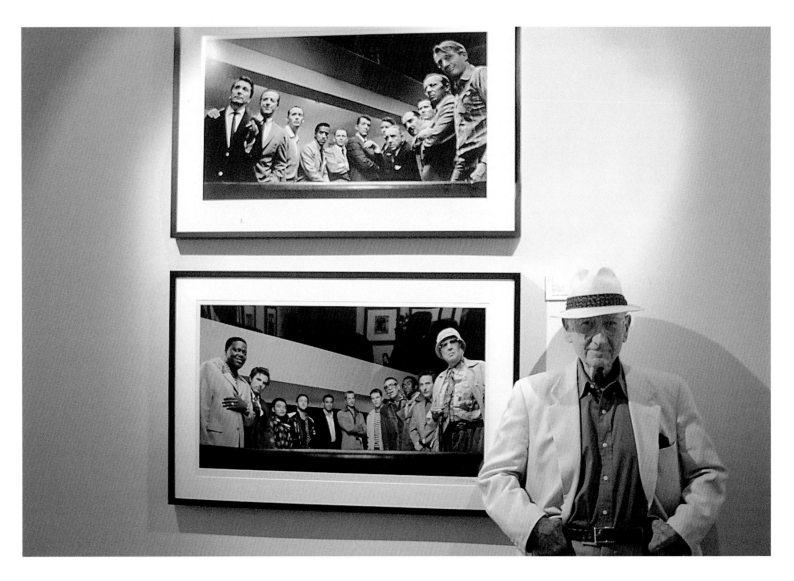

Sid Avery made history when he recreated his iconic photograph of the original cast of **Ocean's Eleven** *around the pool table with a new generation of actors for the 2001 remake. Photo taken at* **Tinsel: Stars That Shine** *opening at Apex Fine Art in Los Angeles, California, 19 October 2001.*

dubious selves, and then to each other.' … And Avery sold it better than anyone. His candid portraits of Hollywood's finest, posing in their beautiful homes surrounded by happy family, new cars, sparkling swimming pools and expensive art presented 'normality' in its most idealized, romanticized form. Avery's photographs held up a mirror to the everyday public and reflected back at them a more beautiful, perfect version of their own lives. The *LA Times* wrote, '[Avery's] photo shoots … did their part to create a Hollywood star mythology suitable for the family-friendly Eisenhower era.'

Avery's ability to capture an intimacy in his candid portraits was helped by the extraordinary access he had into the private world of the Hollywood elite. Avery had a reputation for managing to get the pictures no one else could. On some occasions, this was down to determination, as with his persistent calls to Humphrey Bogart to be allowed five minutes of his time or to Marlon Brando to squeeze in a ten minute visit before a trip to New York. Once in the door, however, Avery had an ability to put his subjects at ease. His five minutes with Bogart turned into an

intimate 72 hours with the star and his family; his ten minutes with Brando into one of his most famous and iconic shoots.

Avery became friends with many of the biggest stars that he worked with. They trusted him and had faith in his talents. His working style was to remain at a slight distance and subtly direct a scene, which gave his subject room to let their personality emerge. Bruce McBroom (the famous photographer and former Avery apprentice) remarked that Avery's talent was in 'coaxing a performance out of his subjects'. Avery himself mused on his success in a rather self-deprecating interview with Dean Brierly in *Camera & Darkroom* magazine in 1994, 'Many celebrities liked to work with me, because they recognized that I reflected their image instead of trying to create a work of art. I never considered myself an artist. I considered myself someone who brought forth people's character for reproduction.' Even in sessions that were notoriously difficult – such as his assignments with Bing Crosby and Shelley Winters – Avery managed to walk away with an essential element of his subject's character captured on film.

The speed and proficiency with which Avery worked was another significant factor in his ability to capture the perfect moment as it happened. His technical expertise in gauging the exact composition and lighting required in any given situation within minutes was second-to-none. After shooting 4x5 inch and 120mm for years, he was one of the first to begin shooting on 35mm film for the magazines. He rarely used a light meter. As he told Brierly, 'I once tried a Weston meter, but I could never figure out the Zone System. For Christ's sake, who's got time to sit there and figure out a Zone System? You've got to shoot a celebrity in five minutes. I mean, come on.'

Avery worked exhaustively in Hollywood from the 1940s to the early 1960s. This corresponded with a period of immense difficulty for the industry as it struggled with the rise of television. As the Golden Age died, so too did the magazines that fed on it and so, too, did Avery's commissions. In 1962, with the help of his wife and manager, Diana, Avery made the move into advertising photography and television commercials. After an initial tough period of readjustment, Avery found his feet in his new environment and was soon in high demand as one of the top names in the business. He formed Avery-Kuhn Associates with title designer Dick Kuhn, developing innovative special effects such as solarization, synchronized strobe and soft lens effects, which were used in the title sequences for movies like *The Collector*, *Our Man Flint* and *Fantastic Voyage*. Avery also brought such innovation to his commercial work, developing lighting techniques that were adopted across the industry as standard. Avery had a successful career in advertising for over twenty years. Some of his most iconic campaigns included the legendary Chrysler Cordoba advert starring Ricardo Montalban and campaigns for Levis, Gillette, Baskin Robbins, US Steel, Max Factor, Chevrolet and Coca-Cola.

By the early-1980s, Avery was becoming increasingly frustrated with the industry for its focus on profit at the expense of creativity. In 1982 he started the Hollywood Photographers' Archive: a non-profit organization dedicated to preserving the work of the great Hollywood photographers. Avery understood the value and importance of preservation for the historical record. He explained to Brierly that, 'I wanted to accumulate, record, exhibit and publish these photographers' work. A lot of them had fallen through the cracks, great photographers who just disappeared.' He also had first-hand experience of the pain and frustration of losing archives of his own work and hoped he could prevent other photographers from having to endure a similar experience: when the magazines that Avery worked for went bust in the early-1960s, they had lost hundreds of his negatives in the process, including whole sessions that he shot with James Dean and Marilyn Monroe.

In 1987, Avery donated the Hollywood Photographers' Archive to the Los Angeles County Museum of Art and The Academy of Motion Picture Arts and Sciences. He then began the task of rebuilding the collection under the name, the Motion Picture and Television Photo Archive, now known as mptvimages. It was at this time that Avery retired from advertising and began to focus on the archive full-time. Until his death in 2002, Avery worked tirelessly to develop the collection. Ron Avery, Sid's son, has continued this legacy. Under Ron's ownership, mptvimages is today recognized as one of the greatest archives of Hollywood imagery, with a collection that represents over 60 photographers from around the world and includes over one million celebrity and entertainment-related images. In keeping with Sid's original vision, mptvimages is dedicated to preserving the memory of some of the greatest legends of our time through the art of still photography.

Avery's portraits hang in the permanent collections of leading museums, including the Metropolitan Museum of Art, the Smithsonian, MoMA and the International Center of Photography. This publication is a long overdue tribute to Avery's prolific talent and is the first time the complete archive of his work has been exhaustively re-examined. The photographs on these pages include Avery's most iconic work and many unused and never-before-seen images. The portraits are accompanied by personal recollections of Avery's: these anecdotes are mostly taken from a Palm Springs Museum Lecture in 1994, from an interview with Bruce McBroom, and from stories told to his son, Ron. These personal tales of days spent with the twentieth century's most legendary stars offer their own snapshot in time, adding another fascinating dimension to the pictures and bringing them alive for a new audience. These are some of Avery's greatest ever photographs, reproduced to the finest quality yet seen in print. They are a master-class in the art of the Hollywood snapshot.

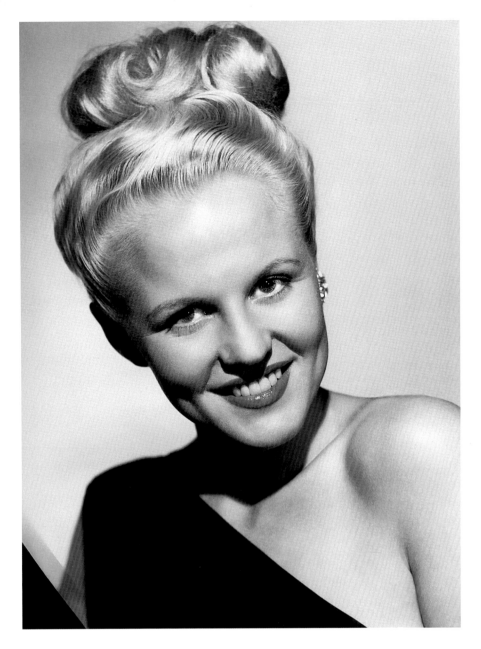

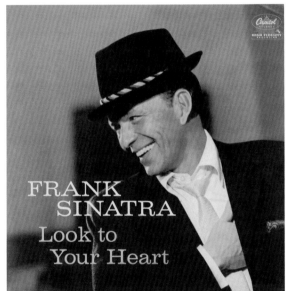

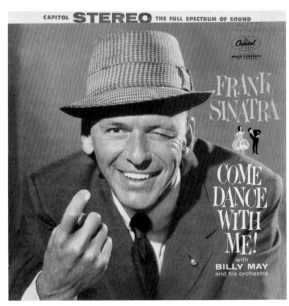

CAPITOL RECORDS

I had worked with Nat on many album covers and portrait sessions for Capitol Records. If only we had known of the damage done by cigarettes, it could have saved his life for many years. He was a true gentleman, cooperative, laid back and down to earth, with musical talent unsurpassed by any other ballad singer or jazz pianist.

Peggy Lee photographed for Capitol Records, 1955.
Nat King Cole photographed for Capitol Records, 1954.
Avery also photographed several of Sinatra's Capitol Records releases.

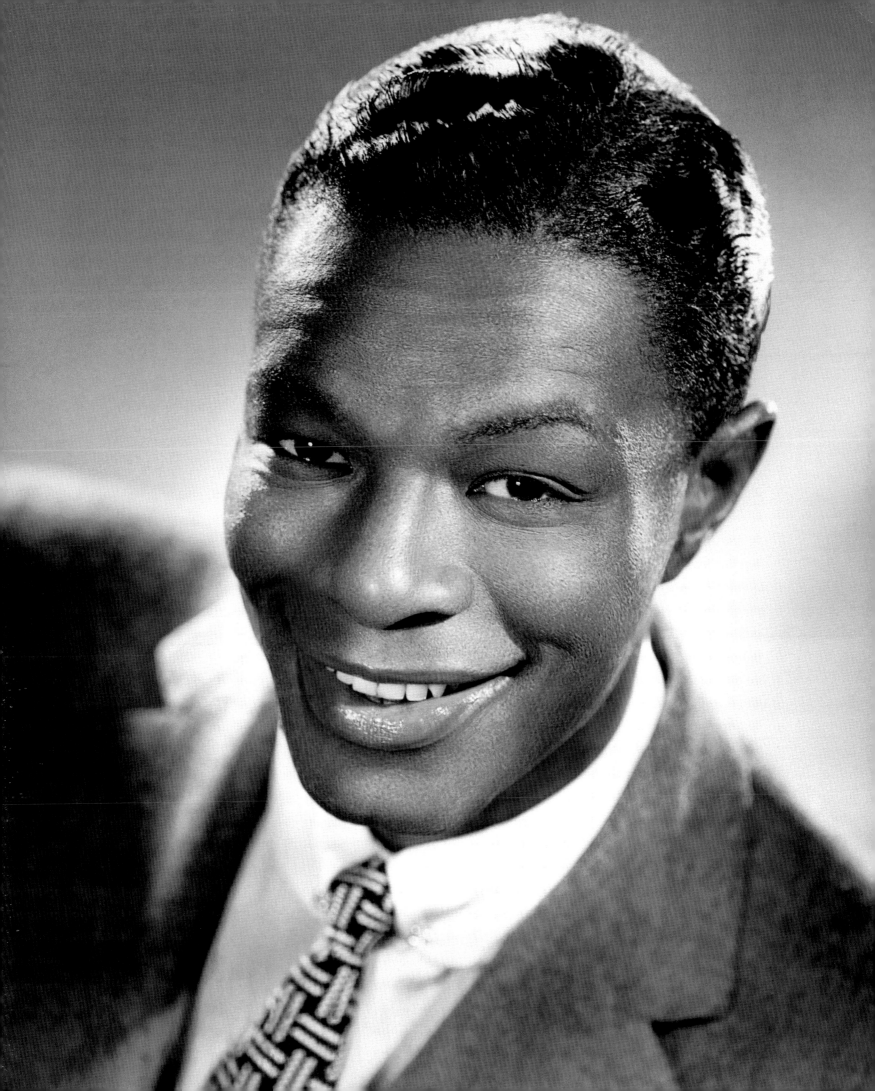

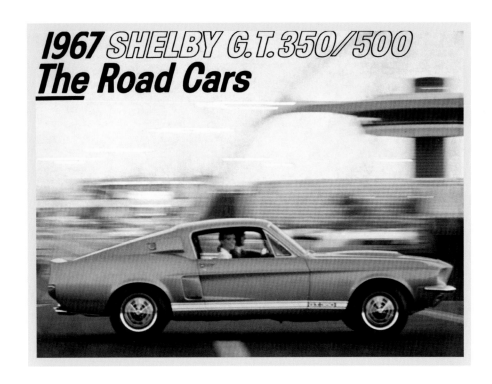

1967 SHELBY G.T. 350/500
The Road Cars

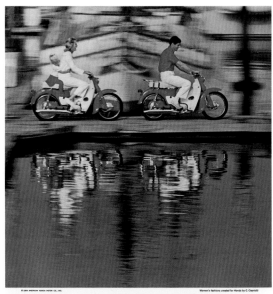

You Meet the Nicest People on a Honda

Hondas take quite readily to family life. They're easy on the budget. (Price: $245 plus a modest set-up charge). The up-keep is negligible. They never gulp gas, just sip it — 200 miles to the gallon. The 4-stroke 50cc engine makes few demands. Holds a brisk 45 mph without raising a ruckus. Among the other ingratiating qualities: 3-speed transmission, automatic clutch, cam-type brakes on both wheels. Even an optional pushbutton starter. Hondas are fun to have around. But a word of warning: for peace in the family, you should have more than one. Think it over. For address of your nearest dealer or other information, write: American Honda Motor Co., Inc., Dept. BX, 100 West Alondra, Gardena, California.

HONDA world's biggest seller!

How to save up for a Porsche.

ADVERTISING

Avery worked in advertising and television commercials for over twenty years. Some of his many landmark campaigns include Shelby cars, 1967; Honda Motor Co., Inc., 1964; Volkswagen Beetle, 1971; Smokey the Bear public service announcement, 1972 (pictured: Sid Caesar, Gail Fisher, Jonathan Winters, Rosie Grier, Arte Johnson, Louis Nye, Ruth Buzzi, Ernest Borgnine, Jill St. John, Merlin Olsen, Phyllis Diller); Telly Savalas in a Gillette razors advertisement, 1975; Cheryl Tiegs in a Pendleton clothing advertisement, 1974.

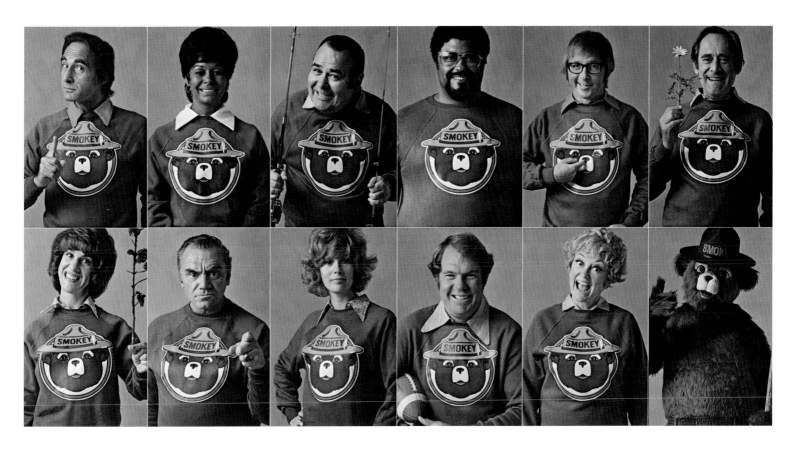

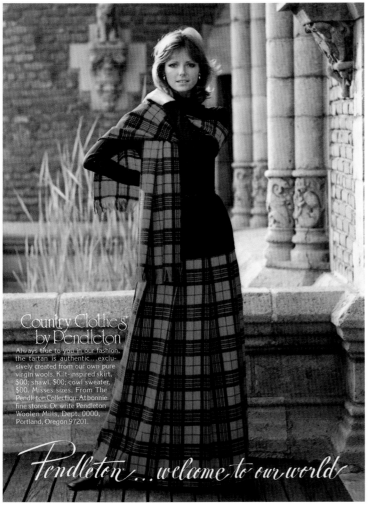

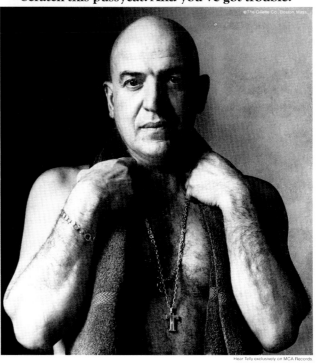

ERNEST BORGNINE

Sid was always easy to work with; and, after all the years I have worked in the movie business I am aware of the need for still photography, especially for promotion and publicity. Like every other actor I've ever known, I have come to hate photo sessions but Sid made it easy. You never knew he was shooting and he was so comfortable, you forgot you were working.

Sid was a great companion with or without his camera. He and I established a friendship away from the business and spent many happy moments together. I remember the time in the mid 1950s when Sid had just purchased a new home on Tyrone Avenue in the San Fernando Valley in California. One of my friends and I went over on a weekend and helped pour a cement patio in the backyard of his new home. We had a blast!

Another memorable time, was during the filming of "Go Naked in the World". We were on location in Acapulco Mexico and Sid was on an assignment for the Saturday Evening Post, completing a photo layout of Gina Lollobrigida. During a break in filming, the President of Mexico offered the use of his luxury yacht to me and Sid, providing all the food and drinks we could want. We took the yacht to go out deep sea fishing and needless to say, it was a fun time!

In 1980 when my wife's cosmetic company TOVA, needed to make a cable television commercial for the cosmetic line, I naturally thought to call Sid. He had already been directing television commercials for about 15 years. After the TOVA commercial was completed there was a gala premiere held at the Century Mann Theater in Century City. It sure was nice to have Sid as our director!

Sid was a talent--more than that--he was a friend! He was always there when I asked for help on anything! I will never forget how many times people stopped to say they had seen my picture in front of Sid's studio on Cahuenga Boulevard, when he had first started.

Sid left an impression wherever he went and he most certainly brightened my life and I am sure, the lives of many others.

I miss you, dear friend, but your pictures will live on forever! God Bless you, Sid!

With love - Ernie Borgnine

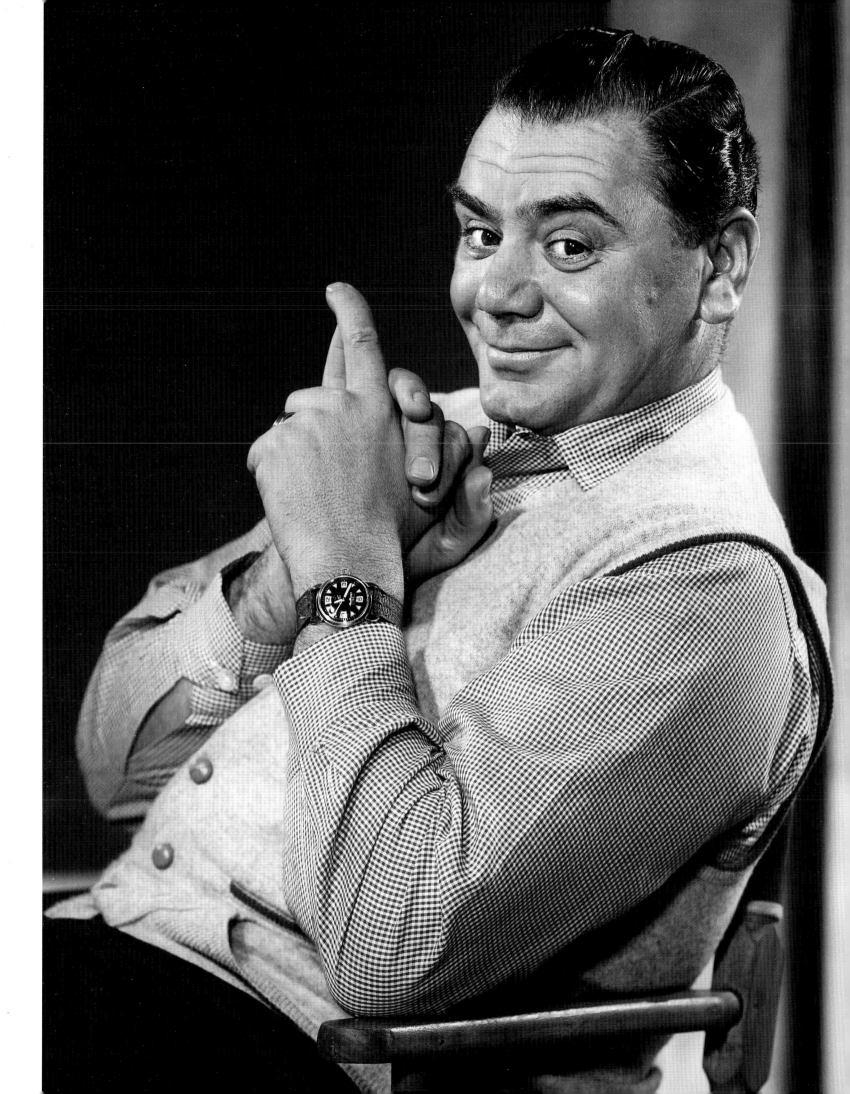

BRUCE McBROOM MEETS SID AVERY

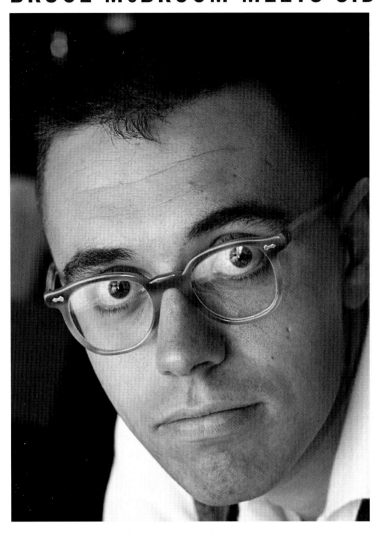

Renowned photographer Bruce McBroom began his career as an apprentice to Sid Avery. He remembers their first encounter:

I got an appointment to meet him, wore some clean clothes and I went down and was introduced to Mr. Avery. In those days, he always wore a suit and expensive Italian shoes, really a sharp dresser. He was very nice, he sat me down and looked at some photographs, out of my very small portfolio, and he asked what my background was, what I wanted to do. I said, 'My goal is to become a great photographer like you, Mr. Avery,' and he said, 'Well here's the deal, I need an assistant, part-time. I understand you're going to school. What I do is I give people a two week tryout and if after two weeks I like what you're doing and after two weeks you're happy working here then we can talk about further employment.' I said that sounds very fair, I stood up to shake his hand goodbye and he said, 'Well, do you want the job or not?' I said yes and he said, 'Good, then you start right now.' I just said, 'OK…'

So after introducing me to the man who managed the studio, whose nickname was Cookie, Sid asked Cookie to, 'Give Bruce something to do.' So within half an hour of my interview, I was in the darkroom developing film. Without even asking if I had developed film before he just said, 'Here's some film that needs developing.'

I was there only a couple of days and Sid said, 'So I've got your first assignment,' and I was pretty nervous because I had never been paid to take photographs. The assignment was Helms Bakery. Sid said, 'They want us to take some pictures of their new ovens or something, but everyone's busy and I'm busy so why don't you go out there?'

He gave me no direction or advice for the shoot, and when I got there, the place was dark, so I had to figure it out myself. But I remembered something from school that an instructor had taught me and that was to paint light, it was a basic idea and we still do it today, you just open the shutter on your camera and walk around with a photo flood as a paintbrush and just kind of paint the whole place with light. And eventually I was all sweaty, and dirty, and by the time I got back Sid had gone home and Cookie was there, asking how I did. I told him and he said, 'Well, who knows, maybe you got something, maybe you didn't.' We made a couple of prints and I showed Sid what I had done and he said, 'How did you do this?' I told him and he said that was pretty impressive. That was all within two weeks.

One day he sat me down and said, 'So you're going to school and that's great, but what's the main reason for you going to school?' My response was to be a great photographer. Sid's suggestion to me was to, 'Quit school, come to work for me full-time, and I promise that you will learn so much more from working here so much quicker.' My parents and my instructor were supportive, and my instructor even said, 'That's why we have the school we do, to get people like you jobs. If you work for him for a year that will count as your schooling and we will graduate you.' And that's what I did.

Sid had this image in Hollywood that, even to this day, you say his name and people say, 'Sid, yeah I loved Sid.' He just exuded so much confidence in what he was doing. He said to me once, 'Even if you aren't sure of what you are doing, you should never let on.' And another thing I learned from Sid was to be on equal footing with the people you are photographing. If I got an assignment with these people, I would have to think, 'What would Sid do?'

Above: Photograph of Bruce McBroom by Sid Avery, c.1960.
Opposite: Sid Avery at work shooting model Cami Sebring, c.1965.

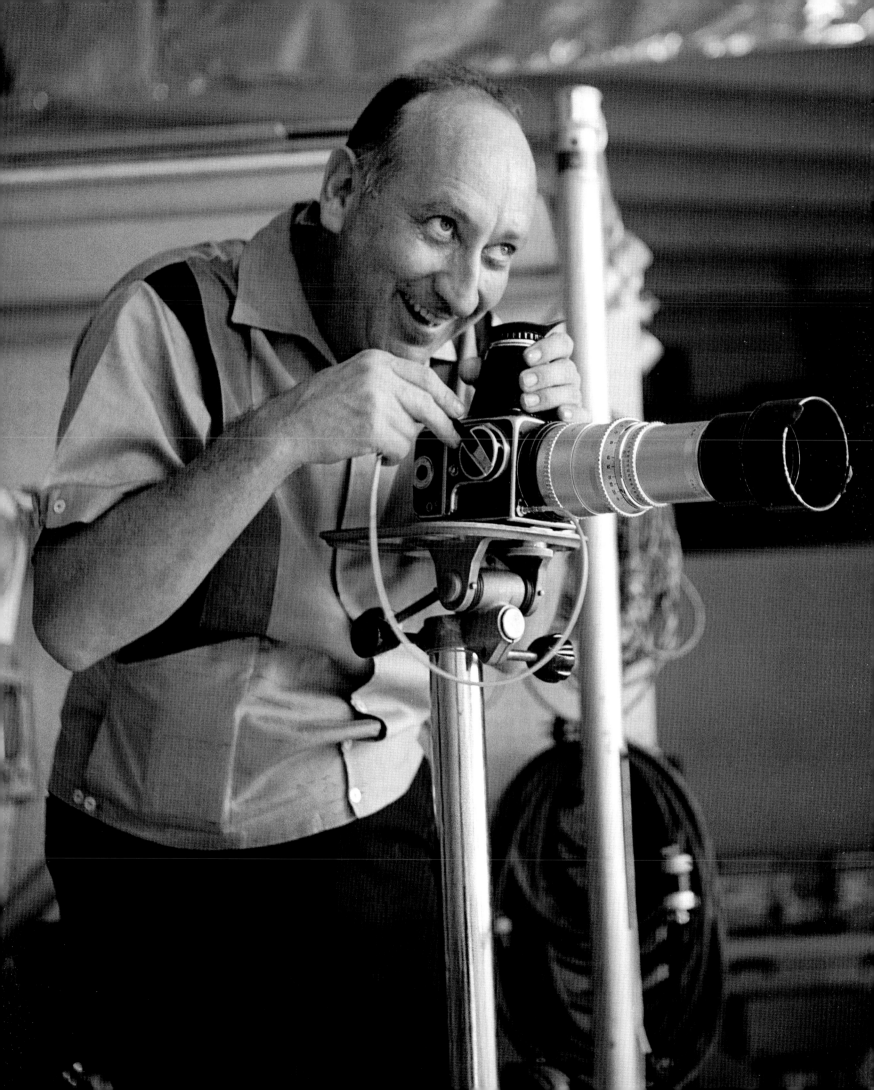

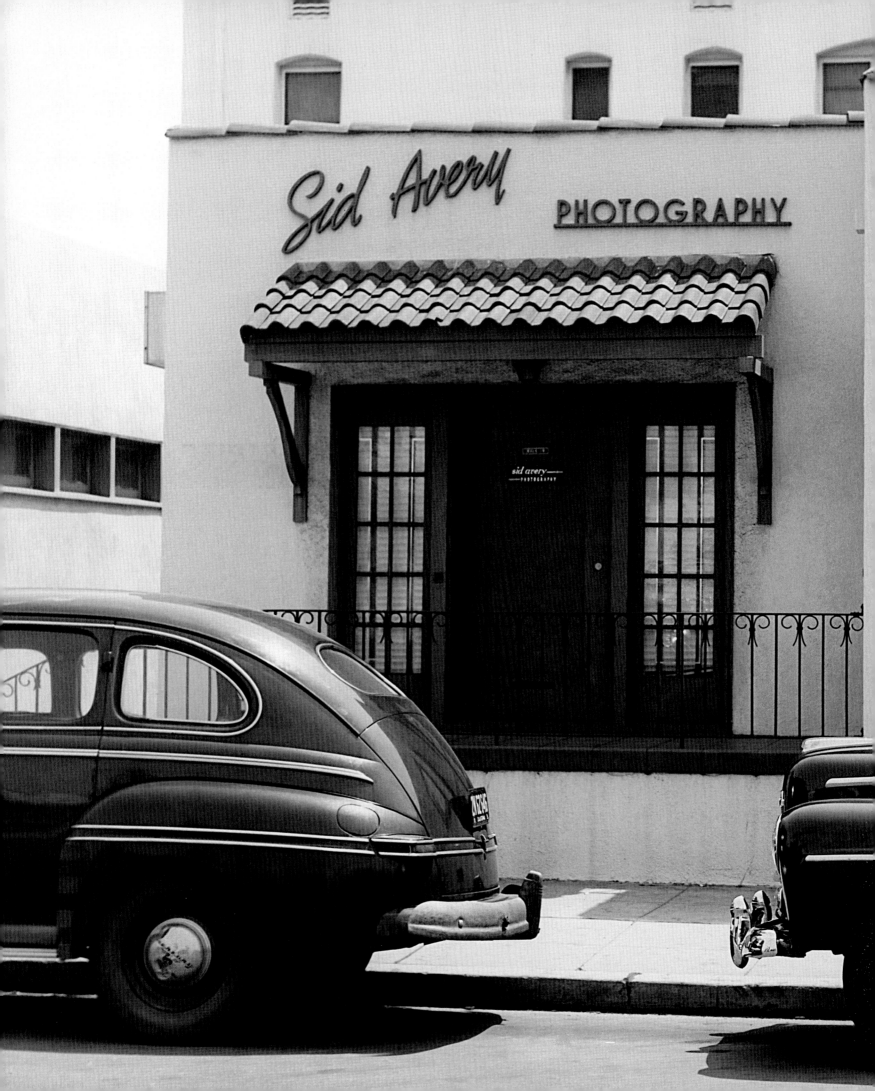

FRANK SINATRA

I worked with a lot of people at Capitol Records, but Frank Sinatra was one of the people I worked with most often. I was always impressed with his natural sense of tempo.

I was already a fan of Frank's music before I started photographing him at Capitol, but once I started seeing him at work in the recording studio I was very impressed with his professionalism. You also had to know exactly when to approach Frank. I prided myself on not invading his space when I felt he wouldn't be receptive to being photographed.

Bruce McBroom remembers working with Sid during this time: 'Sid presented this image of confidence and never got his hands dirty. His talent was coaxing a performance out of his subjects. Lets face it, Frank Sinatra was famously difficult, he wasn't a relaxed kind of guy like Dean Martin was. But over the years, Sid photographed Sinatra so many times, and I would go to recording sessions where he would photograph Sinatra. One time I was introduced to Mr. Sinatra and he was such a cool guy, and you called him Mr. Sinatra. There were a couple of beefy guys in suits standing in the background. Sid was on a first name basis with Frank. He would say, 'Hey, how are you Sid?' and Sid would say, 'How are you Frank?' No one called him Frank, seriously.'

Frank Sinatra photographed at Capitol Records on several occasions between 1954 and 1958.

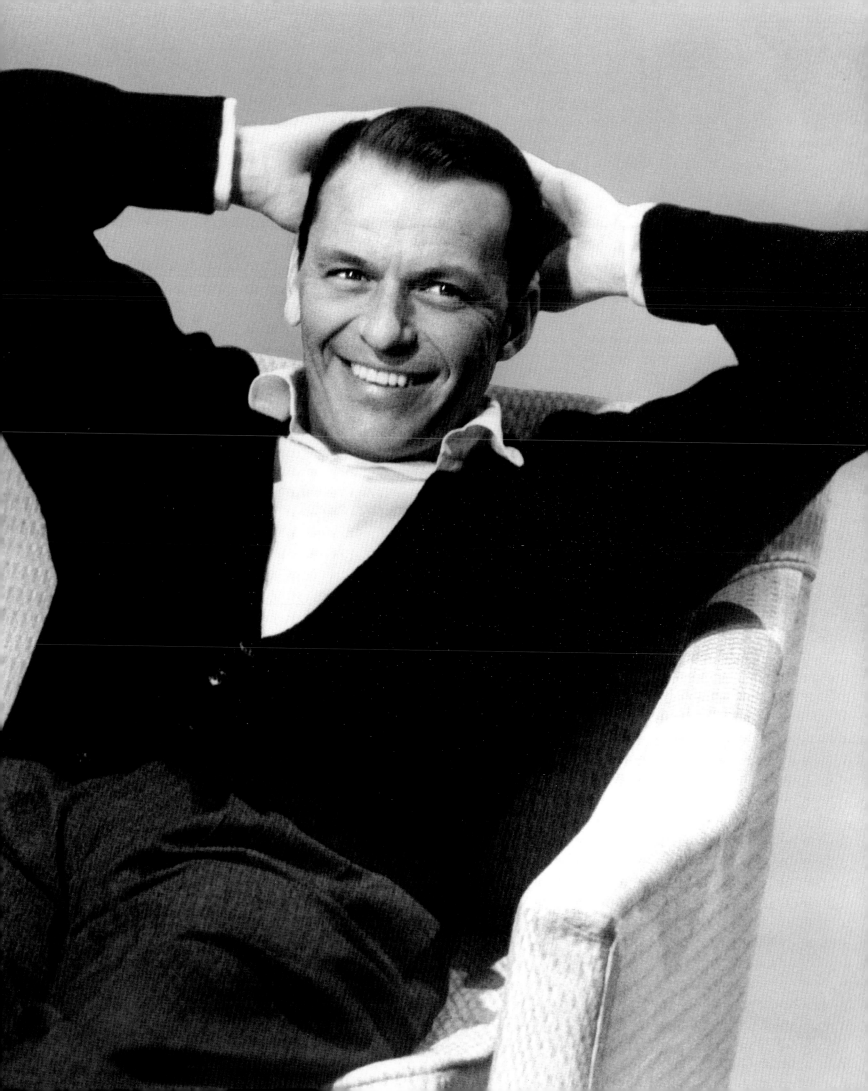

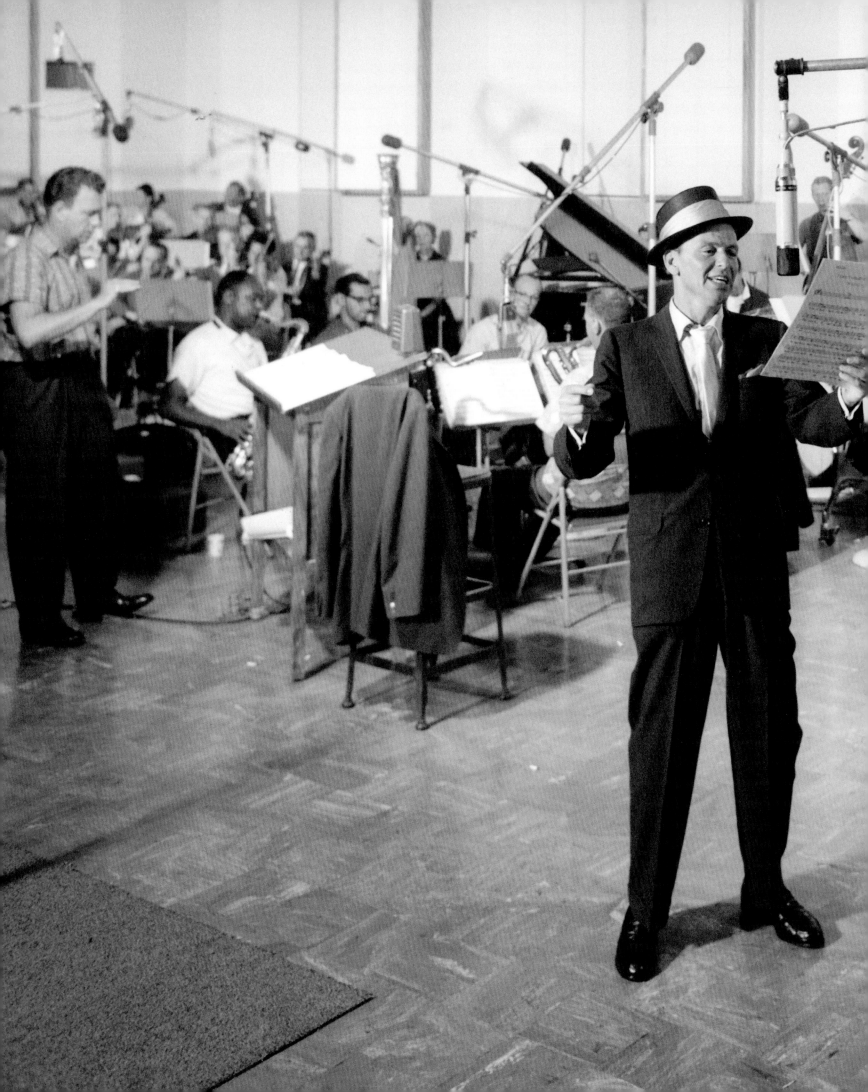

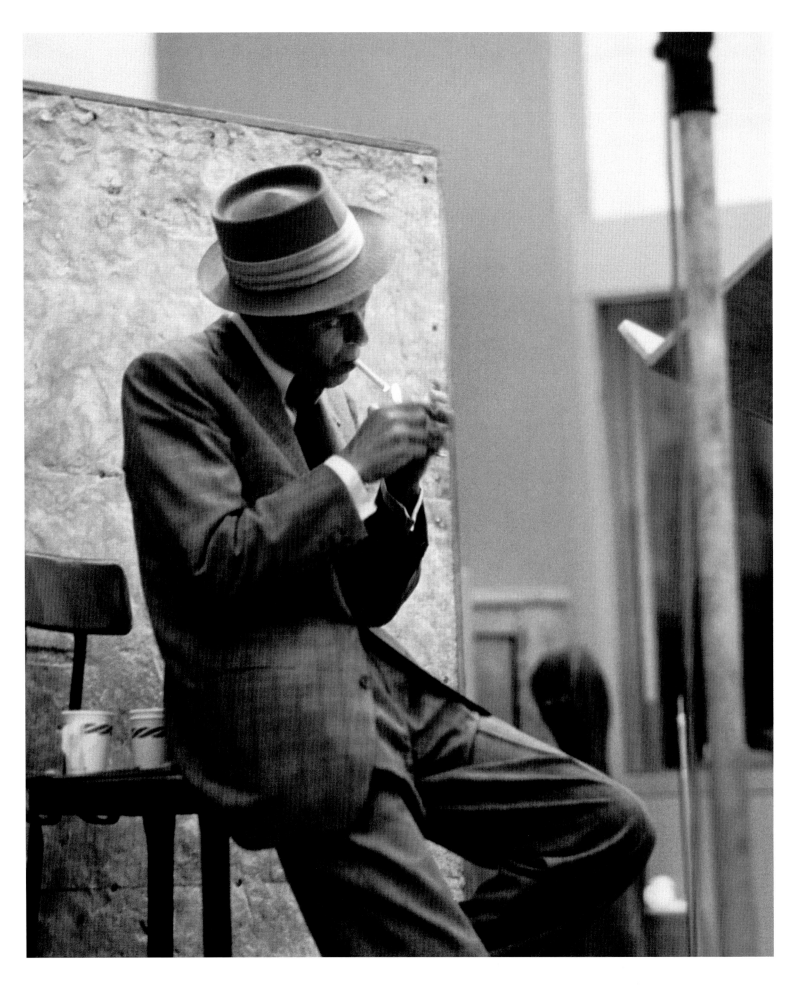

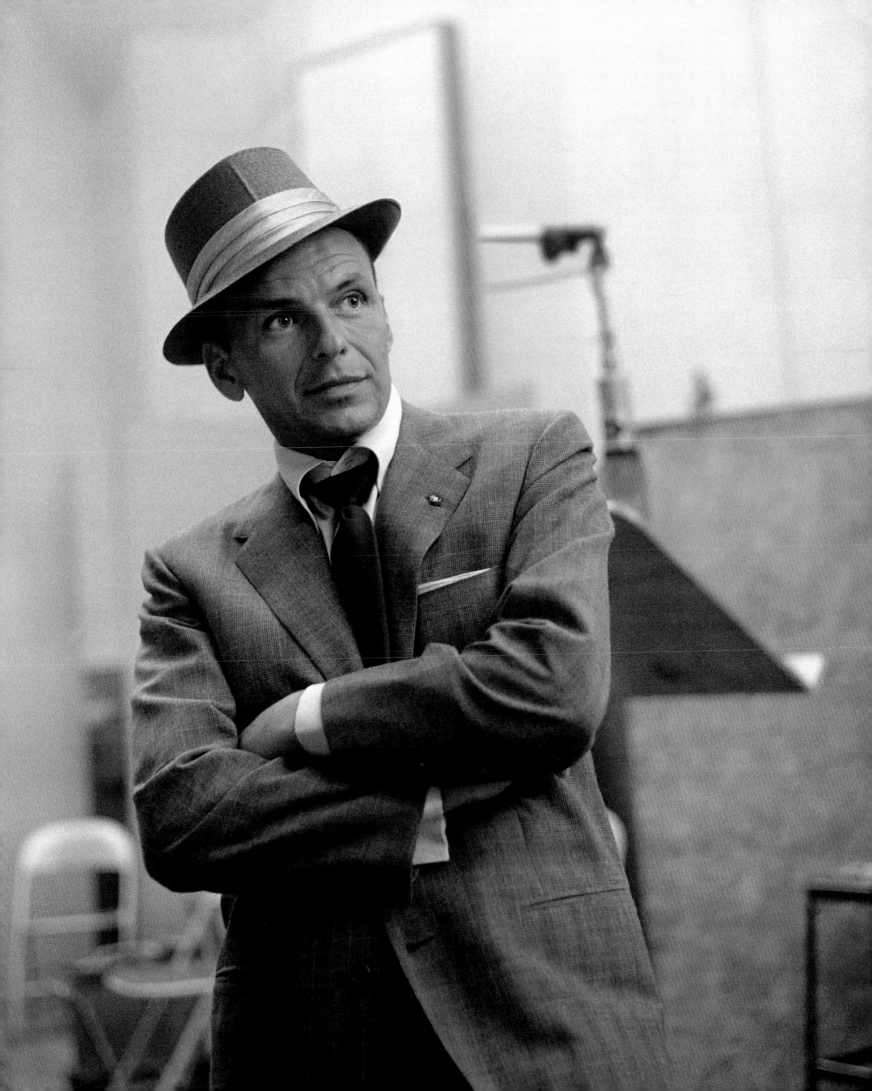

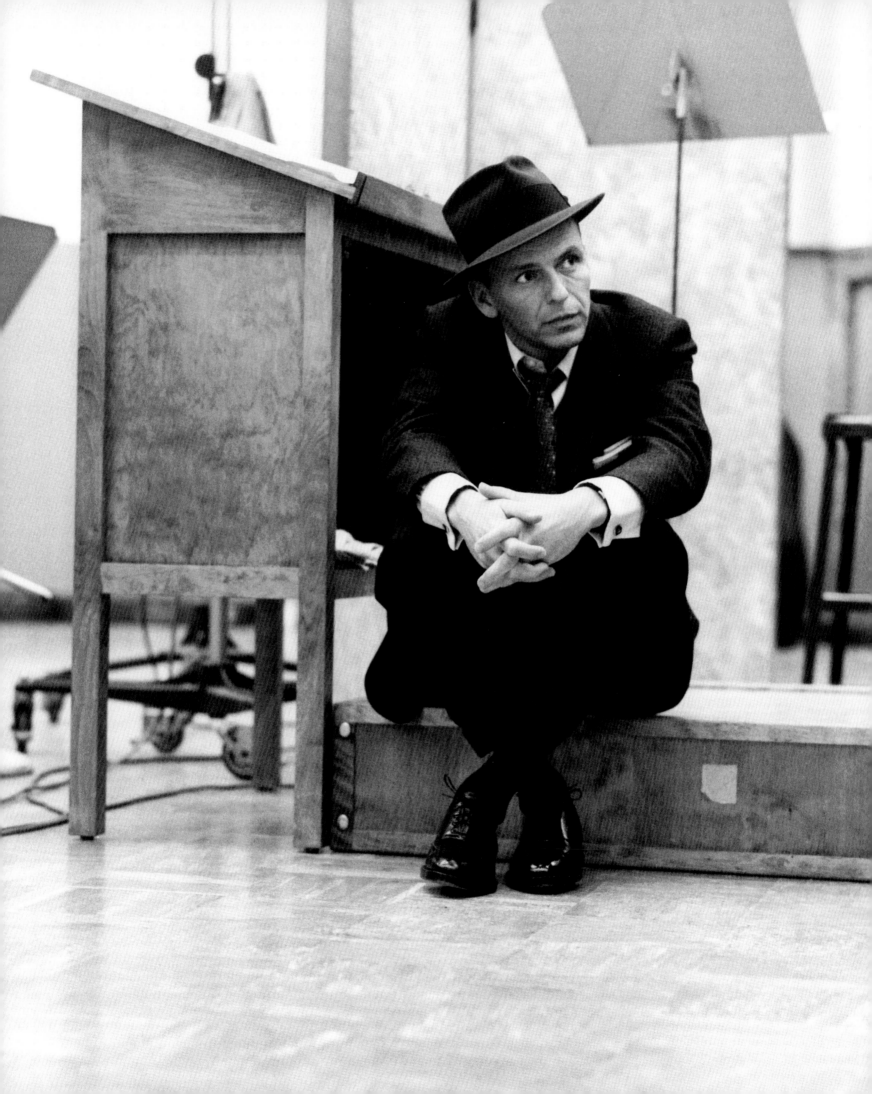

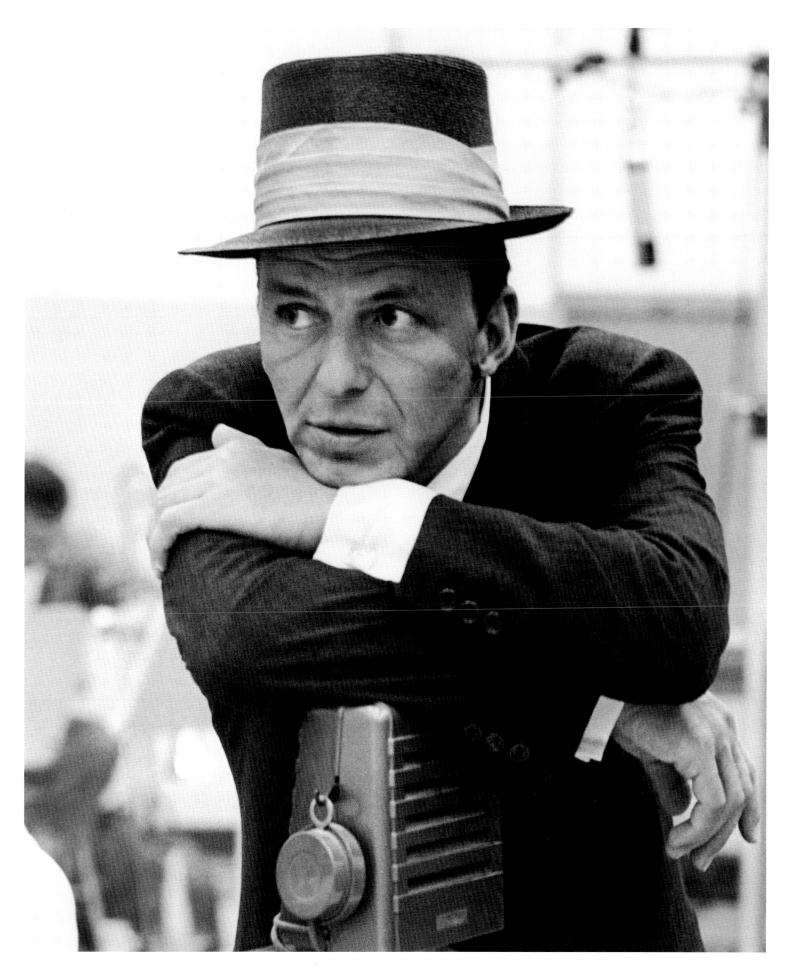

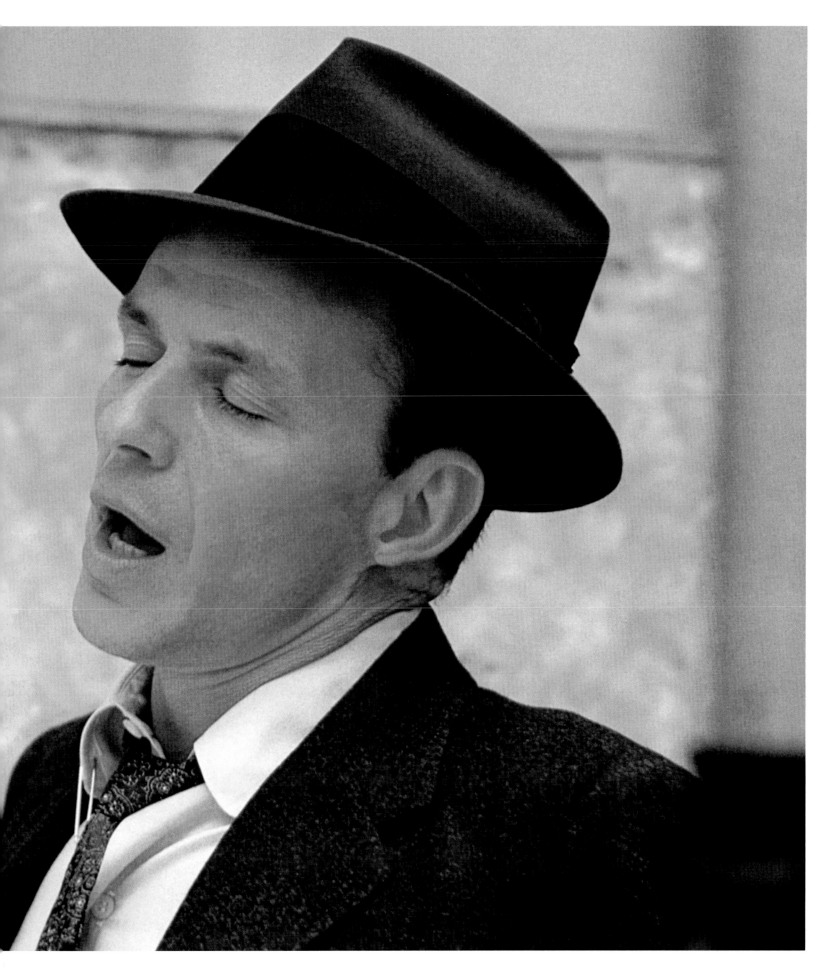

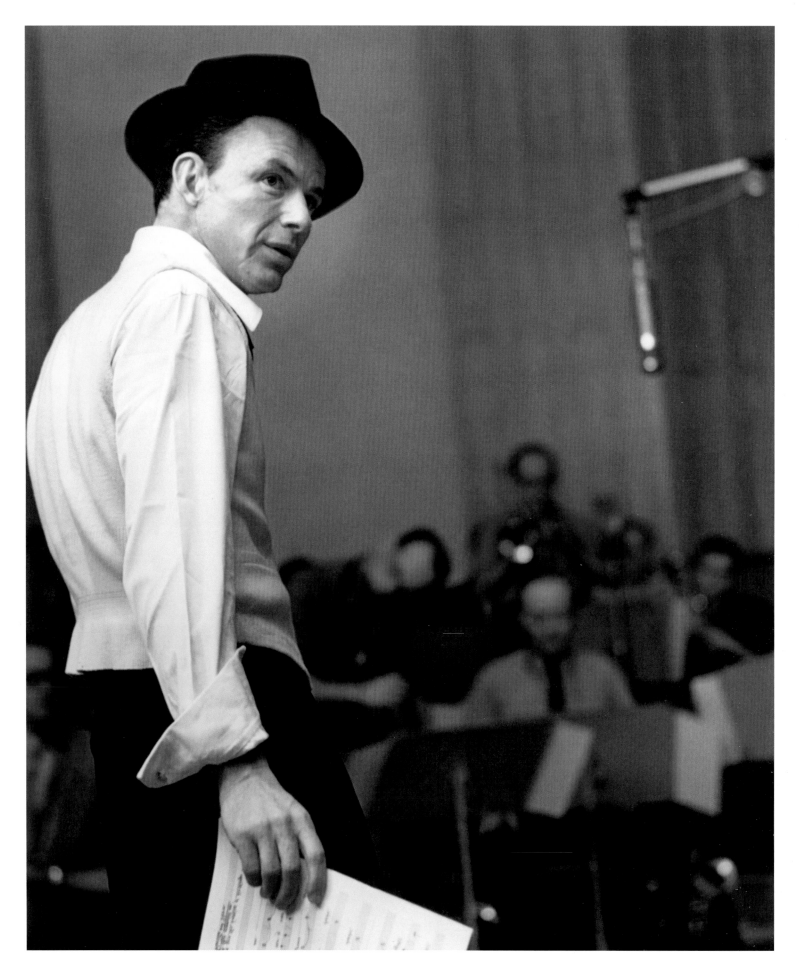

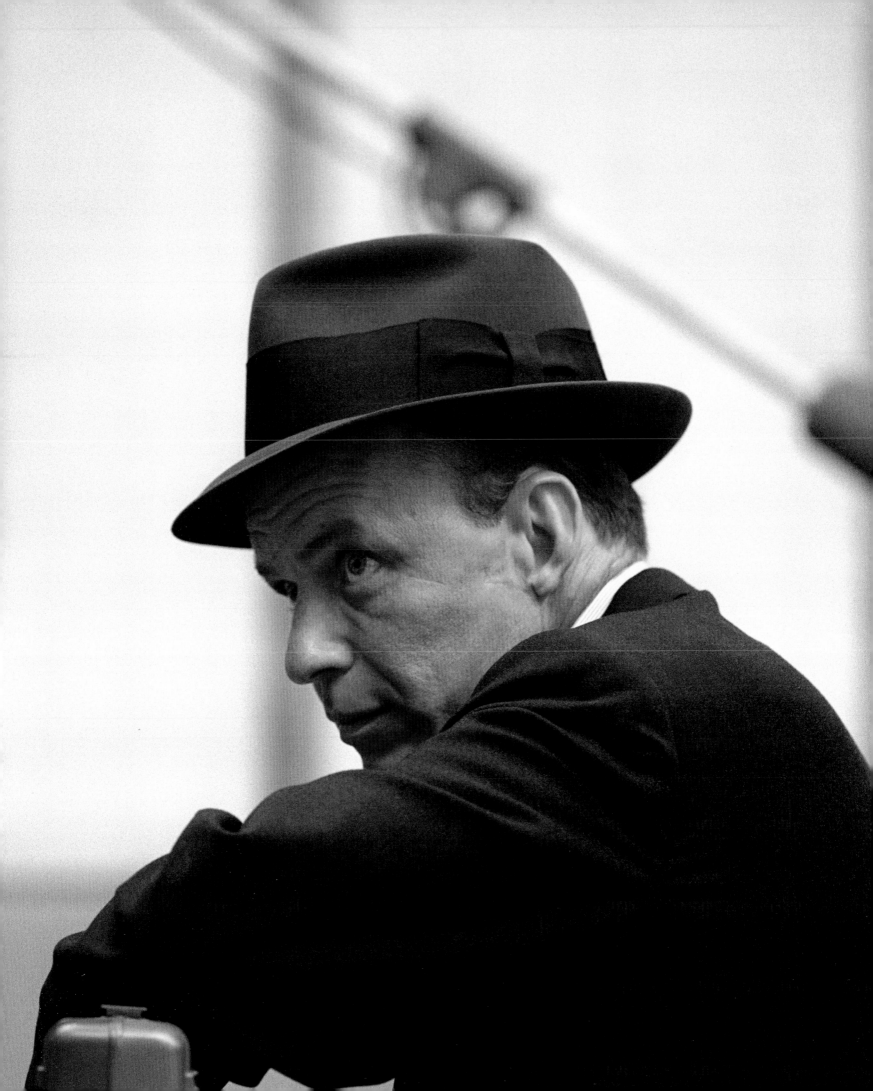

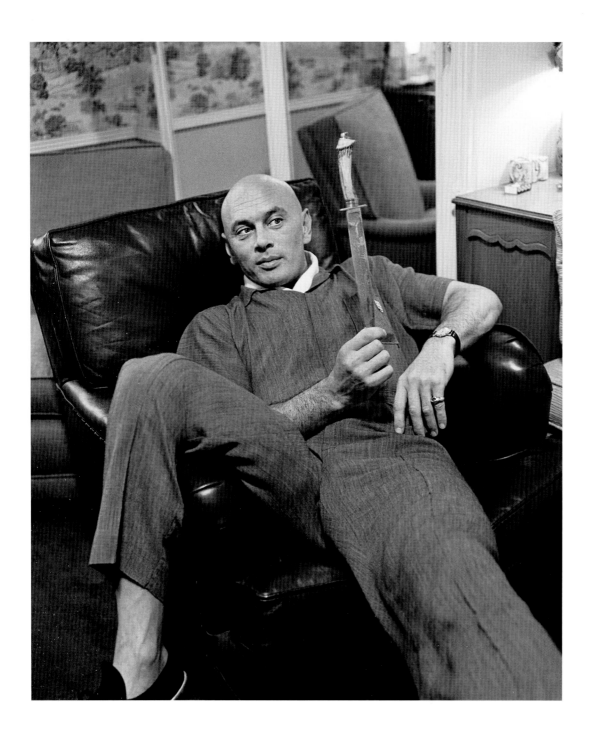

YUL BRYNNER

He was an avid stamp and coin collector. He was a very bright and nice man.

*Yul Brynner photographed at his Beverly Hills home playing with a prop from **The King and I** and examining his stamp collection. Avery also photographed Brynner on the backlot of 20th Century Fox with his 1958 Mercedes 300 SL. For the **Saturday Evening Post** article, 'I Call on Yul Brynner', 22 November 1958.*

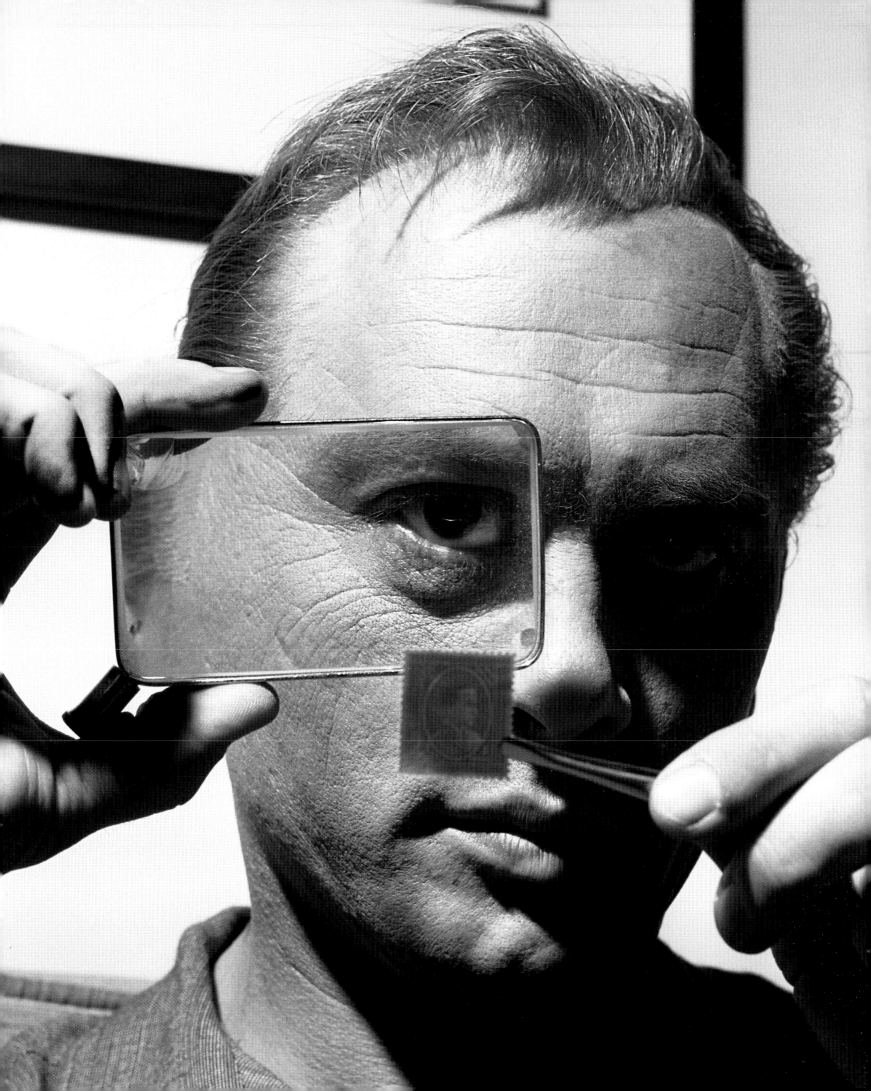

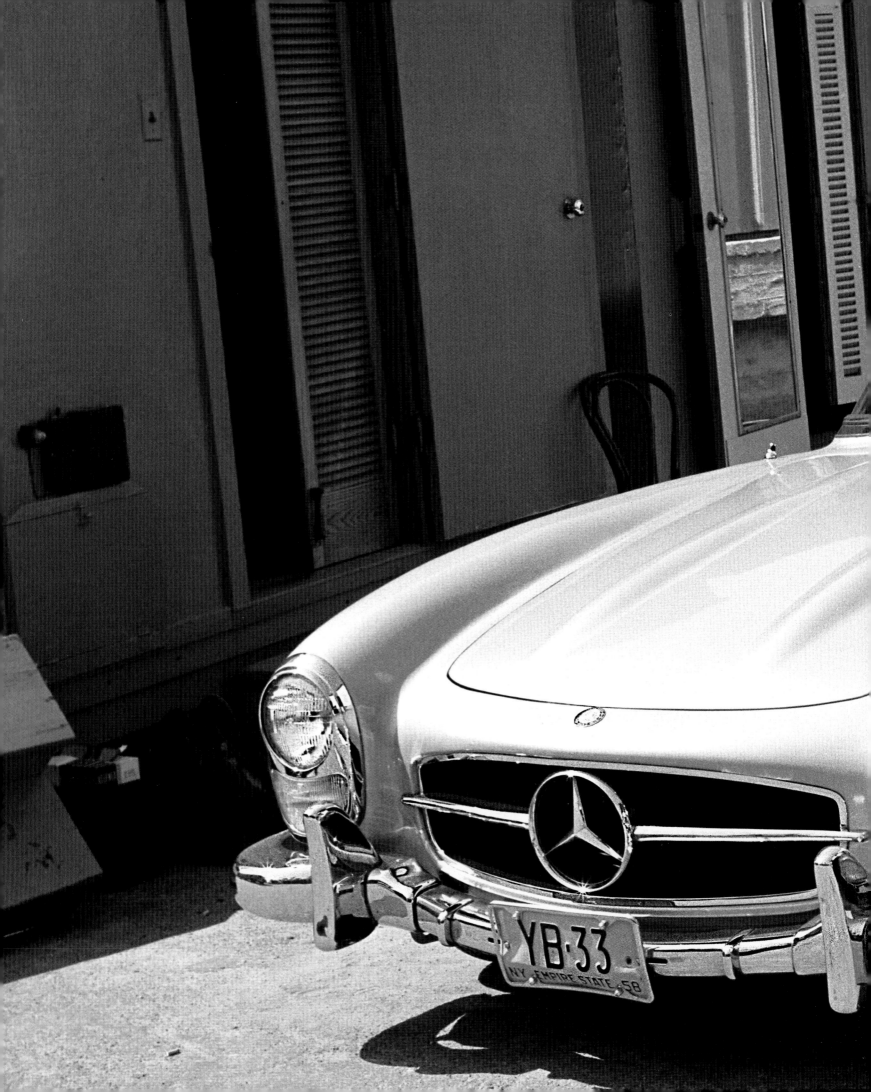

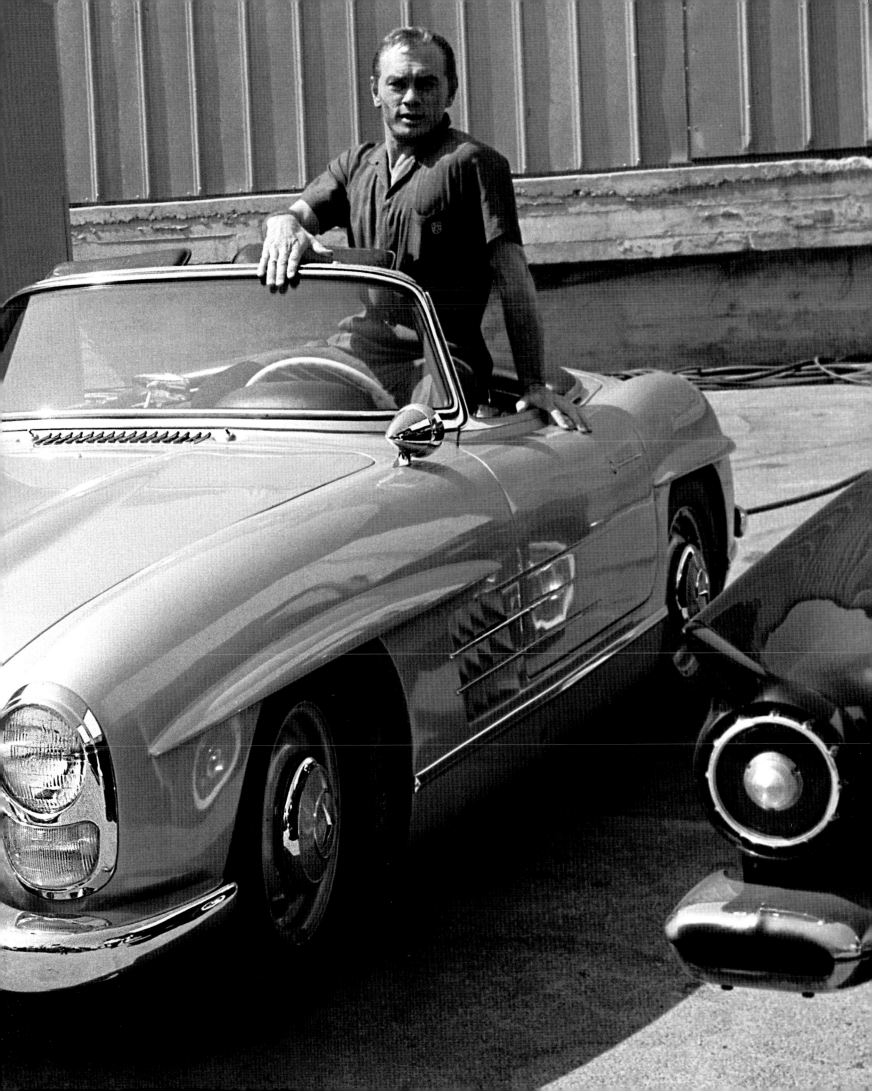

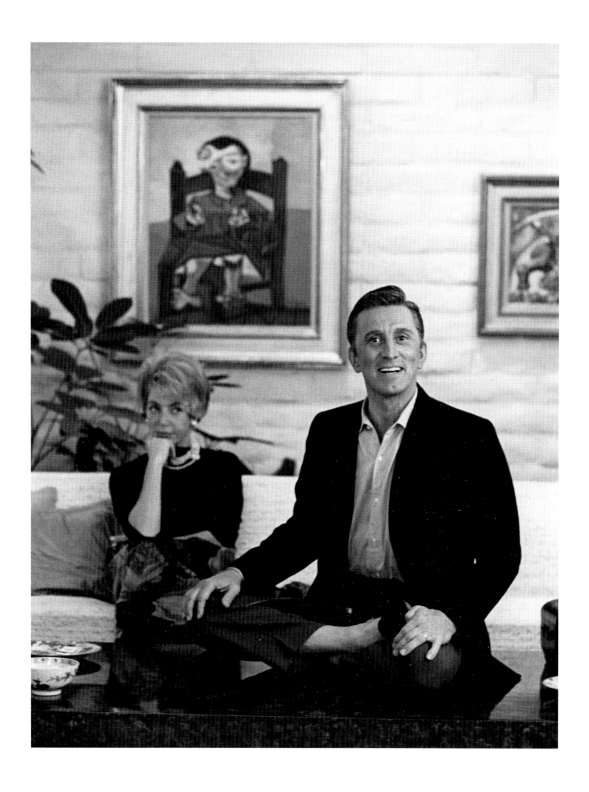

KIRK DOUGLAS

They had a wonderful painting collection of Impressionists. That's one of the paintings behind him and I'm not sure who the painter is but it looks almost like it could be a Picasso, but I'm not positive.

Kirk Douglas photographed at home in Beverly Hills with his wife Anne and sons Peter and Eric. For the **Saturday Evening Post** *article, 'My Awful Wedded Husband', 24 November 1962.*

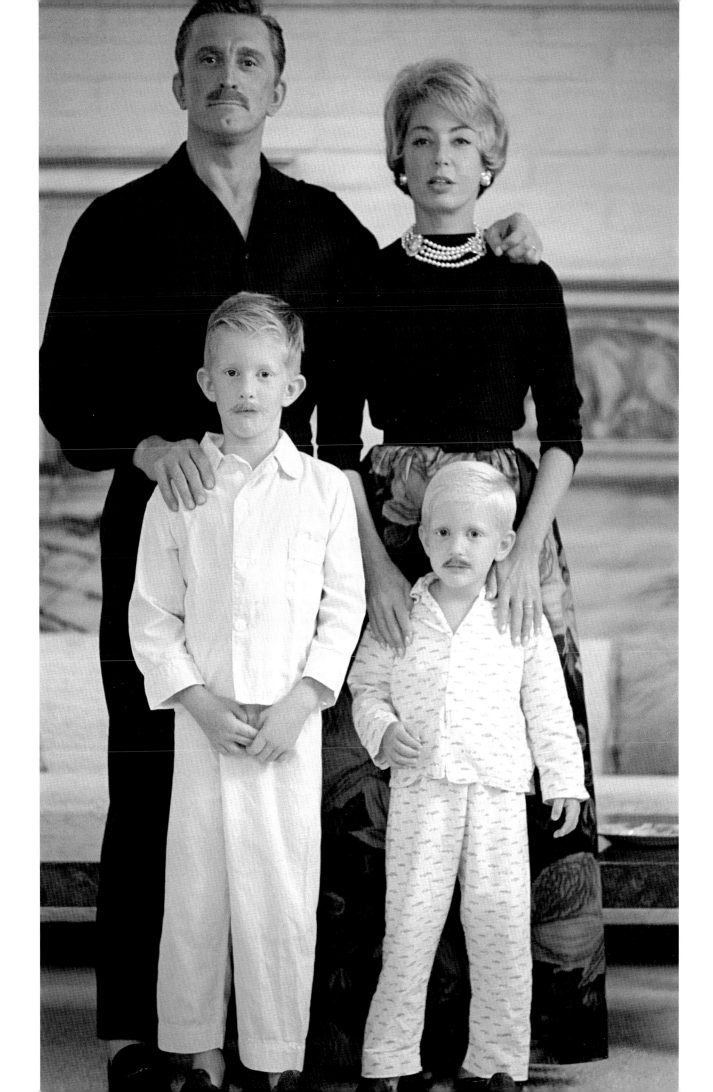

AUDREY HEPBURN

After working all morning, she wanted to take a lunch break and I went with her. When we were going down the street (she was cycling and I was walking), I saw her little car back there – one of the early Thunderbirds, which was very popular – and her little dog called Famous, and I asked her to stop to snap this photo [see p.53]. Even though her clothes are so casual, she looked so stylish and was so far ahead of most of the ladies in showbusiness, as far as fashion was concerned. She was one of the nicest people that I've ever worked with, from inside or outside [the industry]. A great lady at all times, she possessed class and great beauty, and was always compassionate to the dispossessed and needy later in life, with a heart of gold. She was so giving that everybody that I knew loved her – I didn't know anybody who didn't love Audrey Hepburn.

Audrey Hepburn photographed on the Paramount lot, at home with husband Mel Ferrer and at the ballet in Los Angeles, 1957.

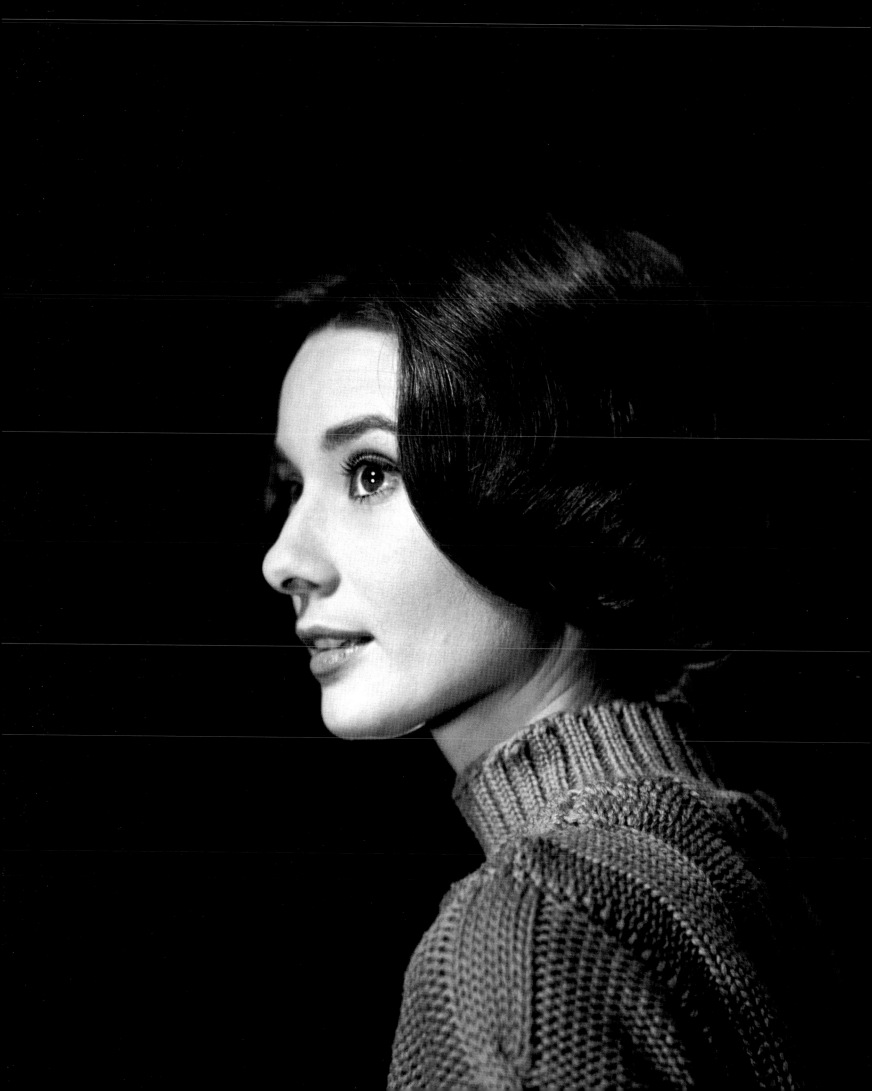

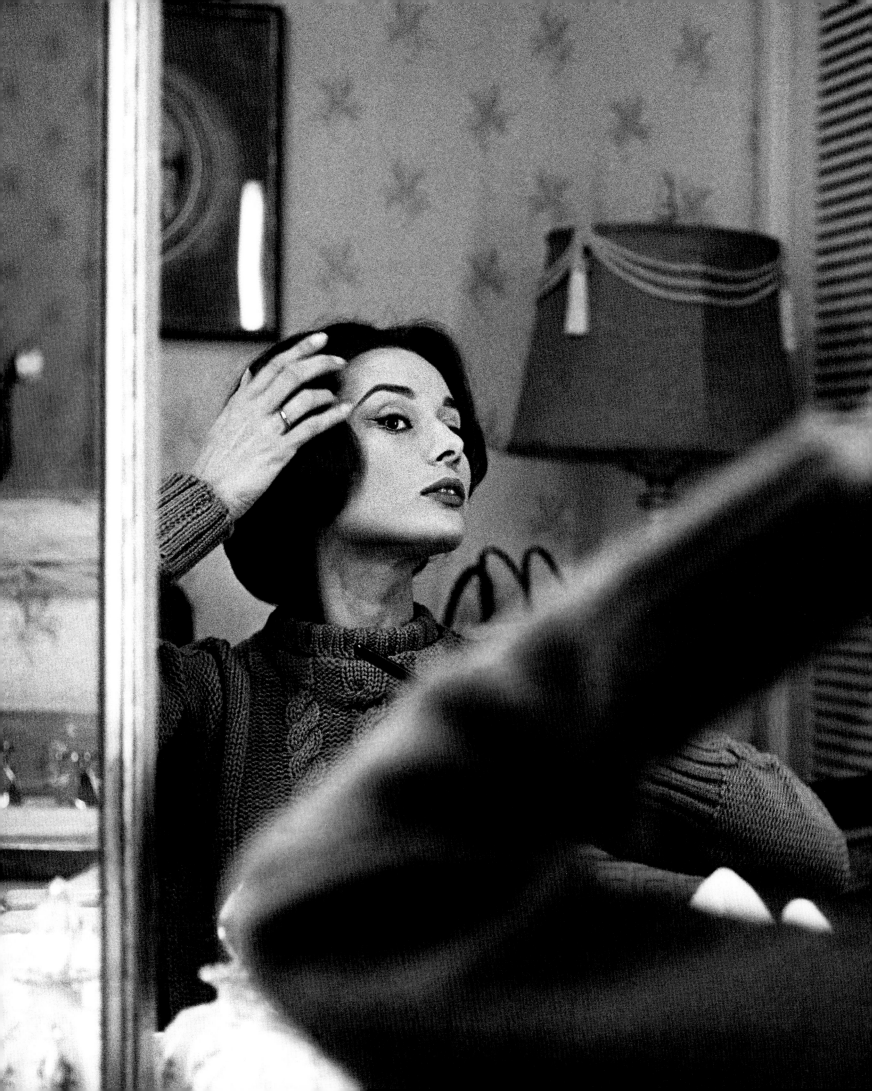

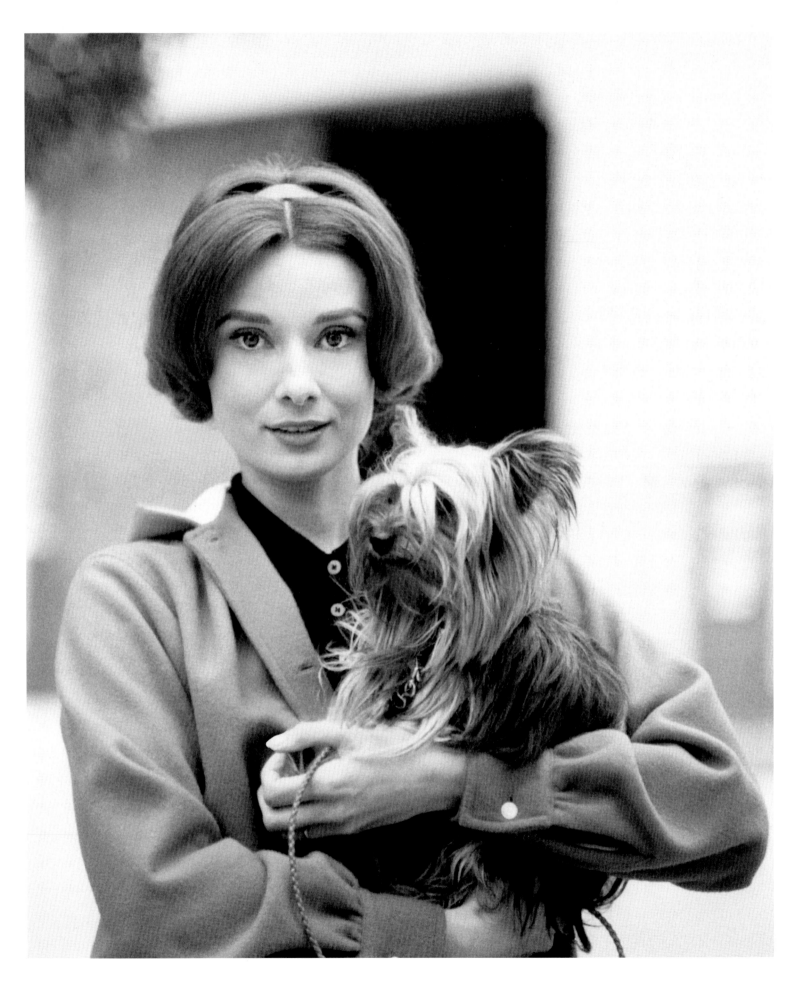

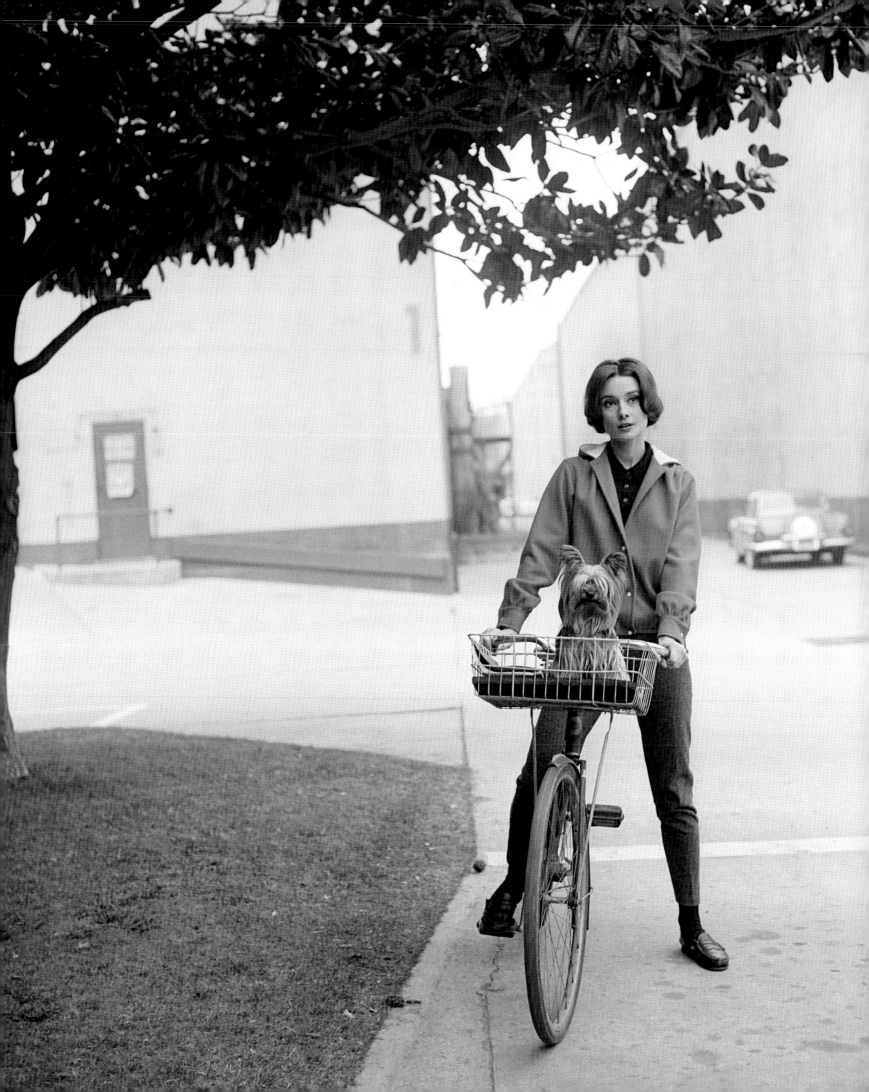

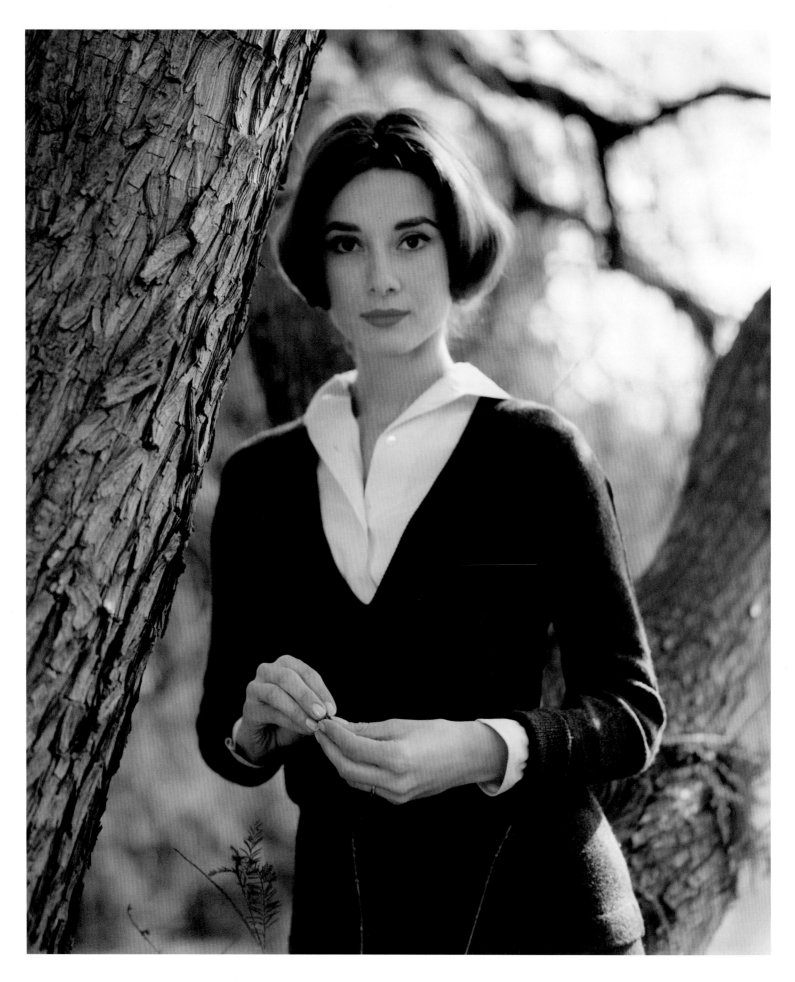

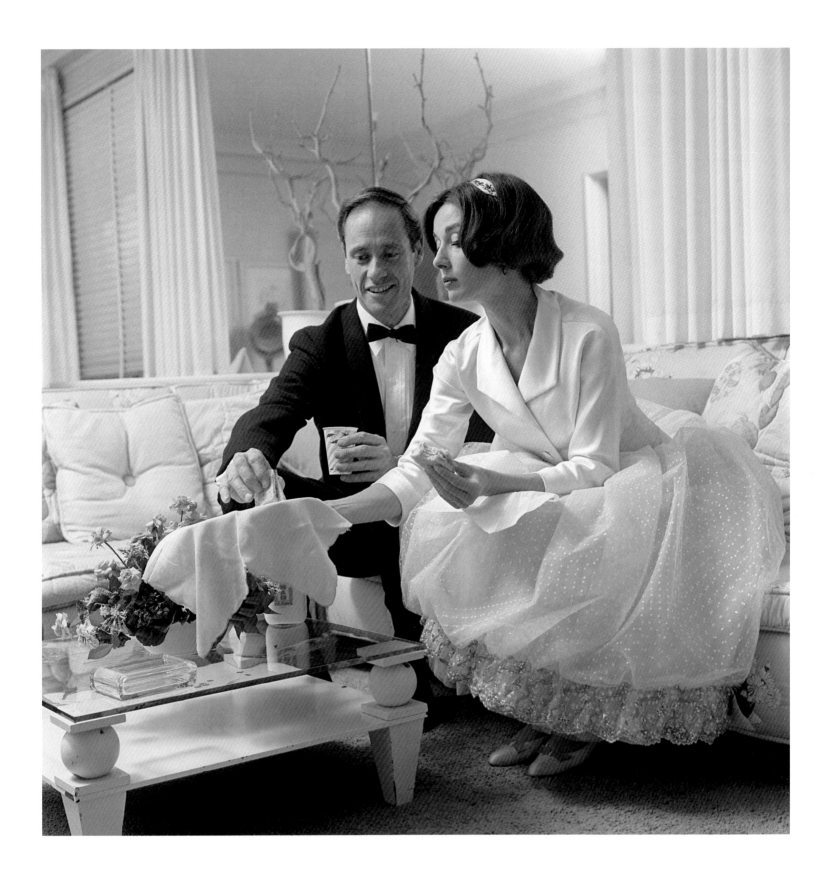

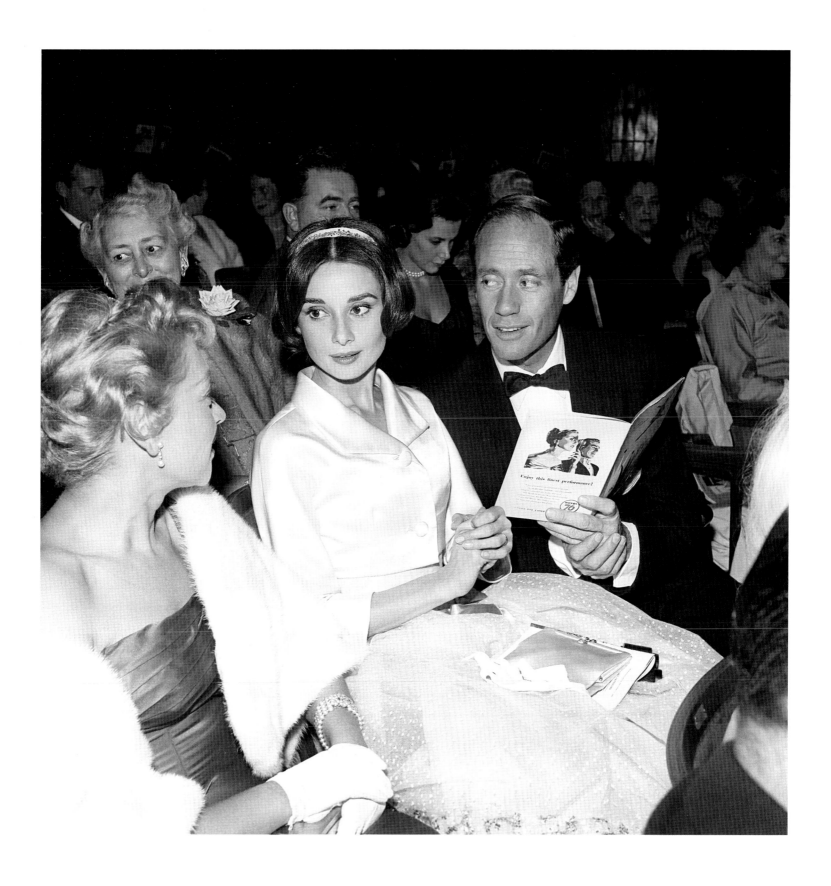

ROCK HUDSON

We had worked together many times and I was always very fond of him. He was always cooperative and very thoughtful. He loved the most popular recording stars of the time and we shared the same likes in many of his choices. A great guy and a willing subject.

I had him washing his car. I told him to tuck his tummy in – he did and he looked a lot better.

Avery photographed Rock Hudson entertaining some Hollywood friends at his home in the Hollywood Hills, serving a barbecue to actor Bob Preeble, script girl Betty Abbott, actress Julia Adams, script writer Leonard Stern, and actress Lori Nelson. He was also photographed at home alone and with his trainer at the studio gym. For the **Saturday Evening Post** *article, 'How to Create a Movie Star', 27 September 1952.*

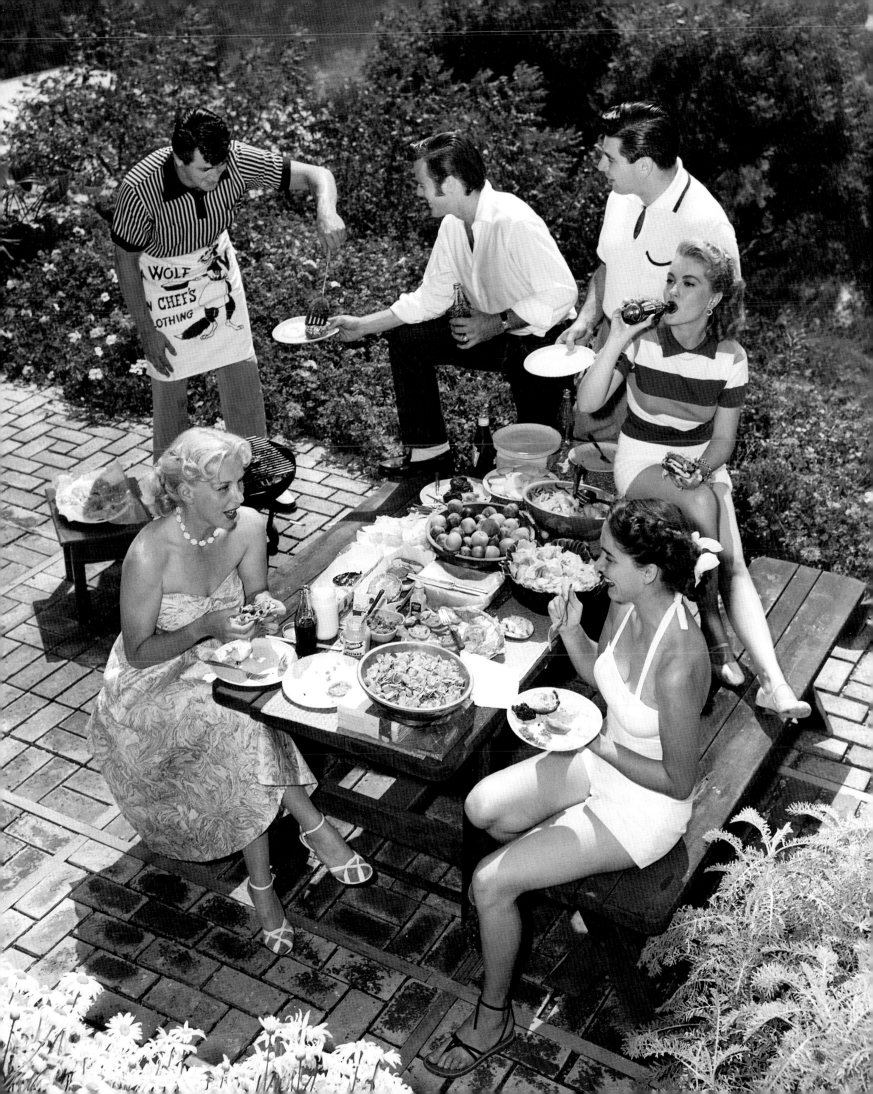

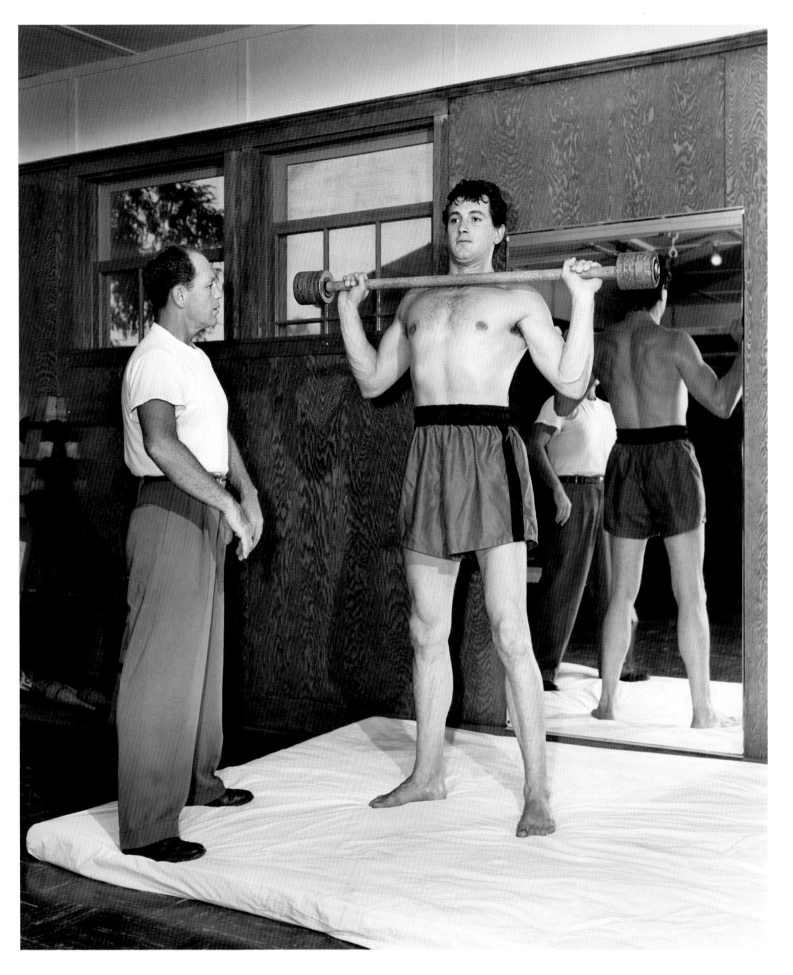

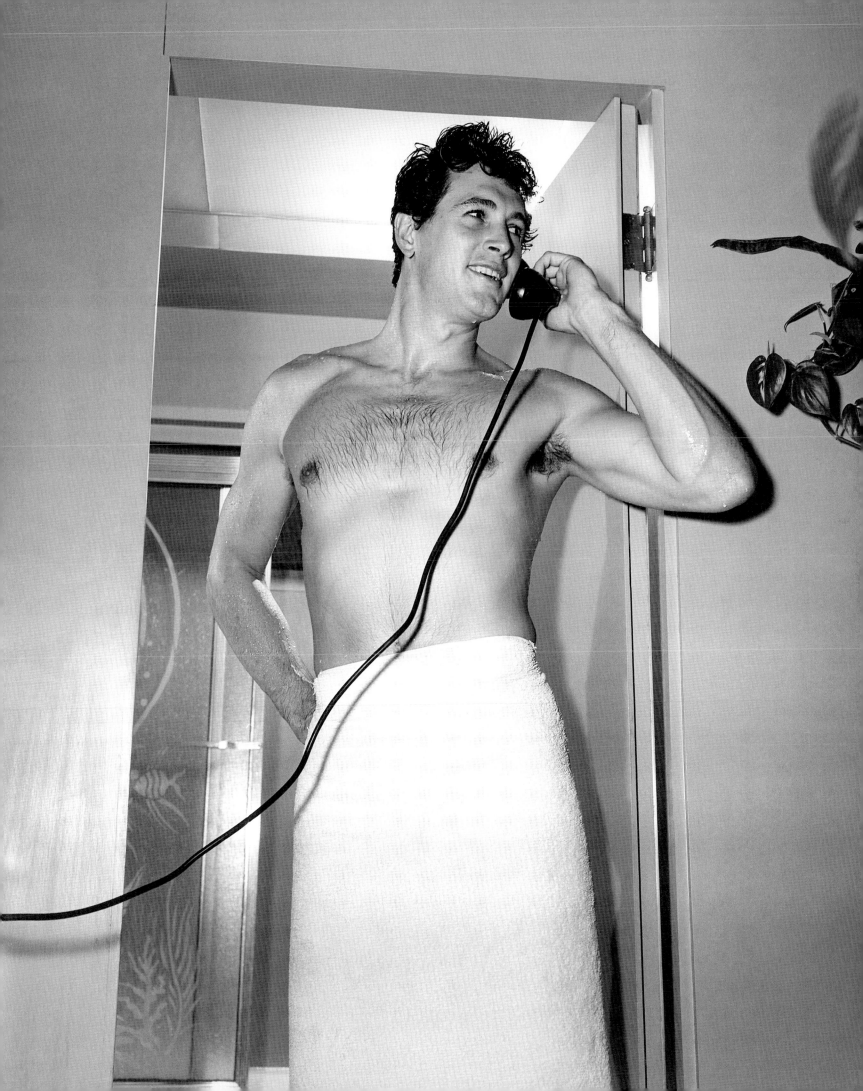

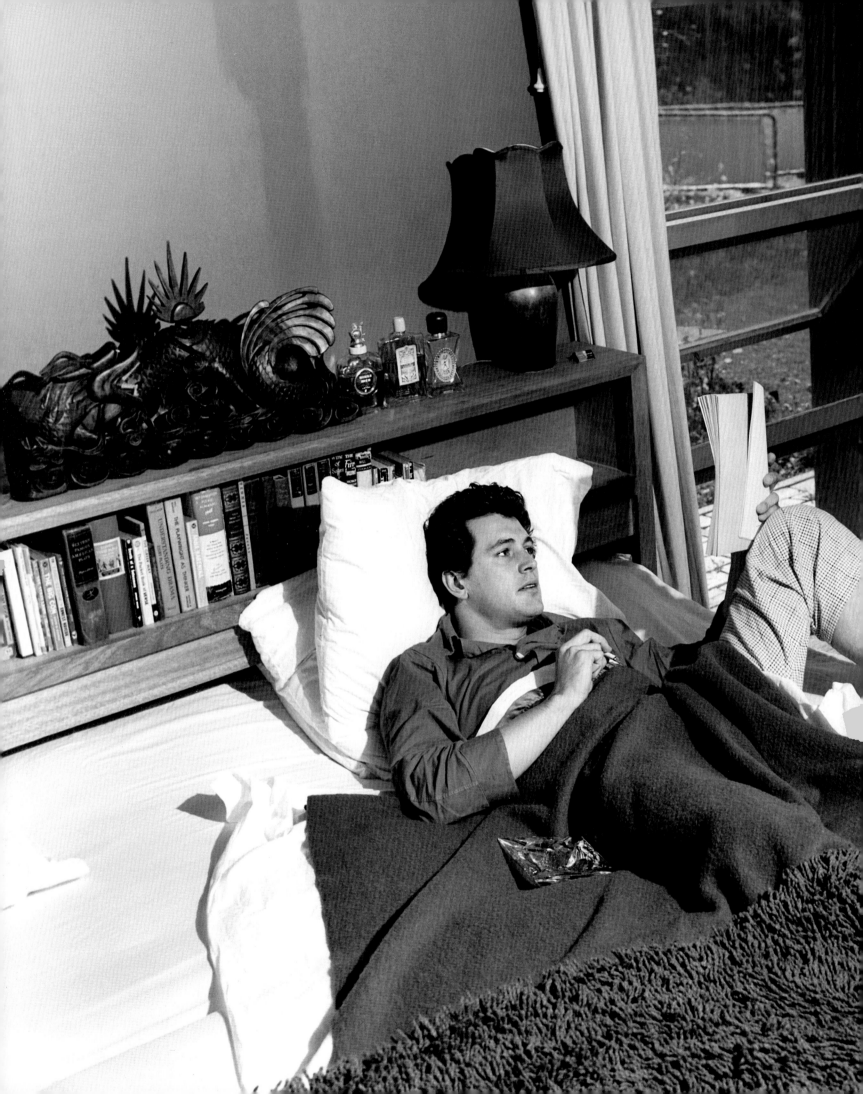

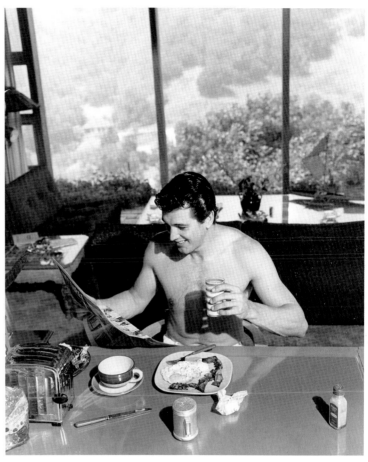
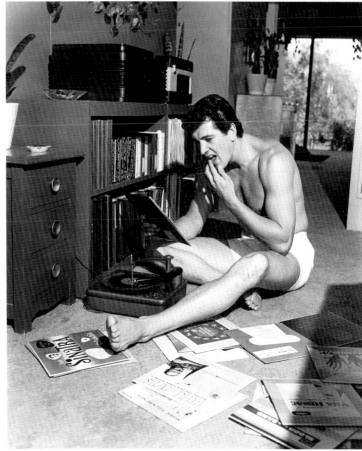

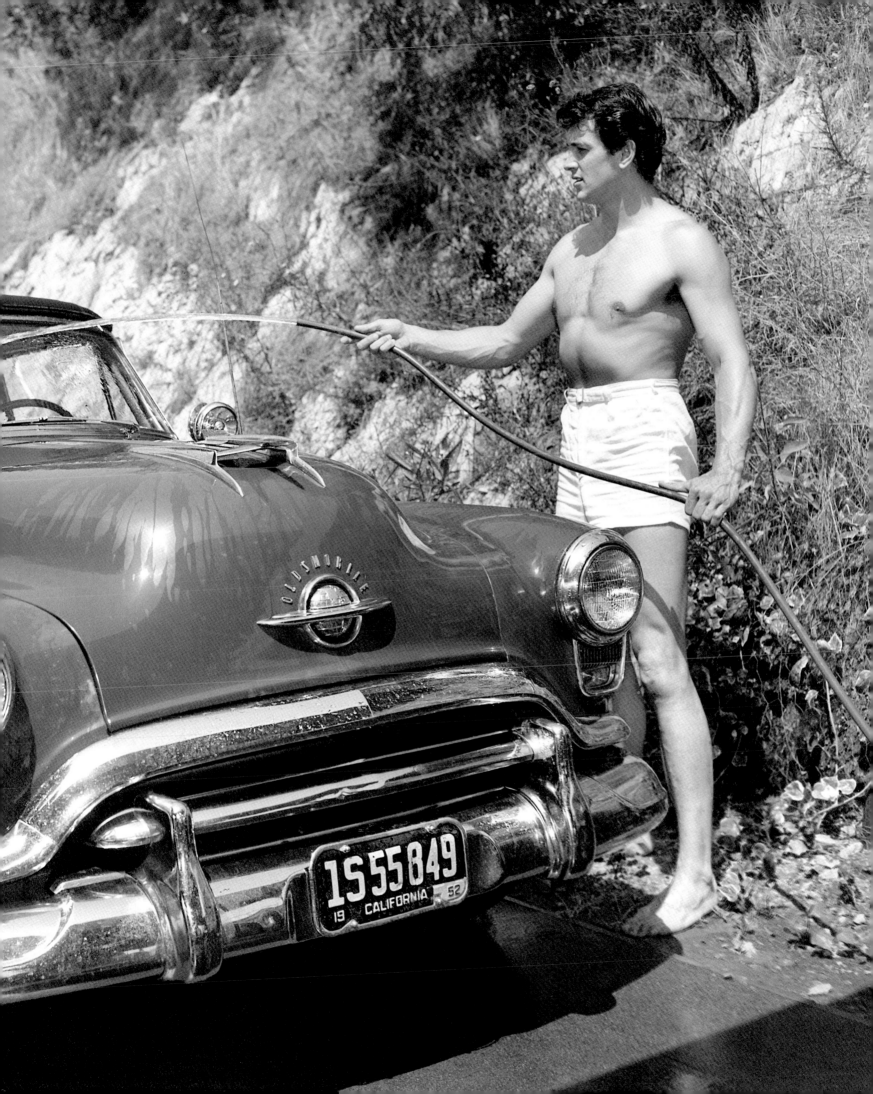

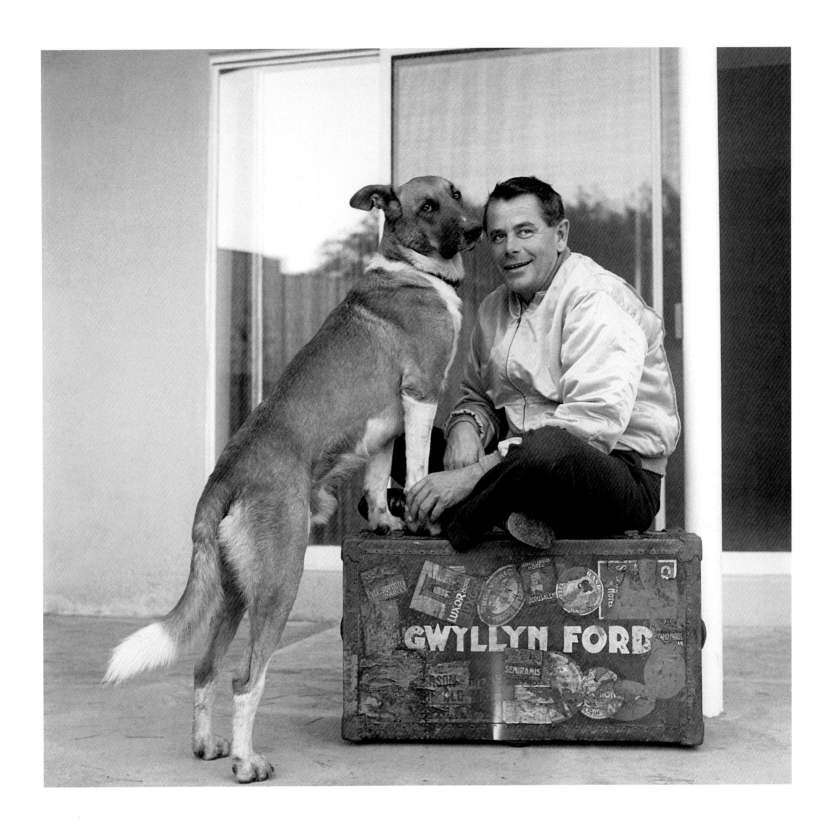

GLENN FORD

I got nothing from this guy, he came off very distant and quiet. I later found out that he was in the middle of a divorce from his wife at the time of the shoot.

*Glenn Ford photographed at his Beverly Hills home with the family dog, and on the set of **The Sheepman**. For the **Saturday Evening Post** article, 'I Can Always Escape', 4 January 1958.*

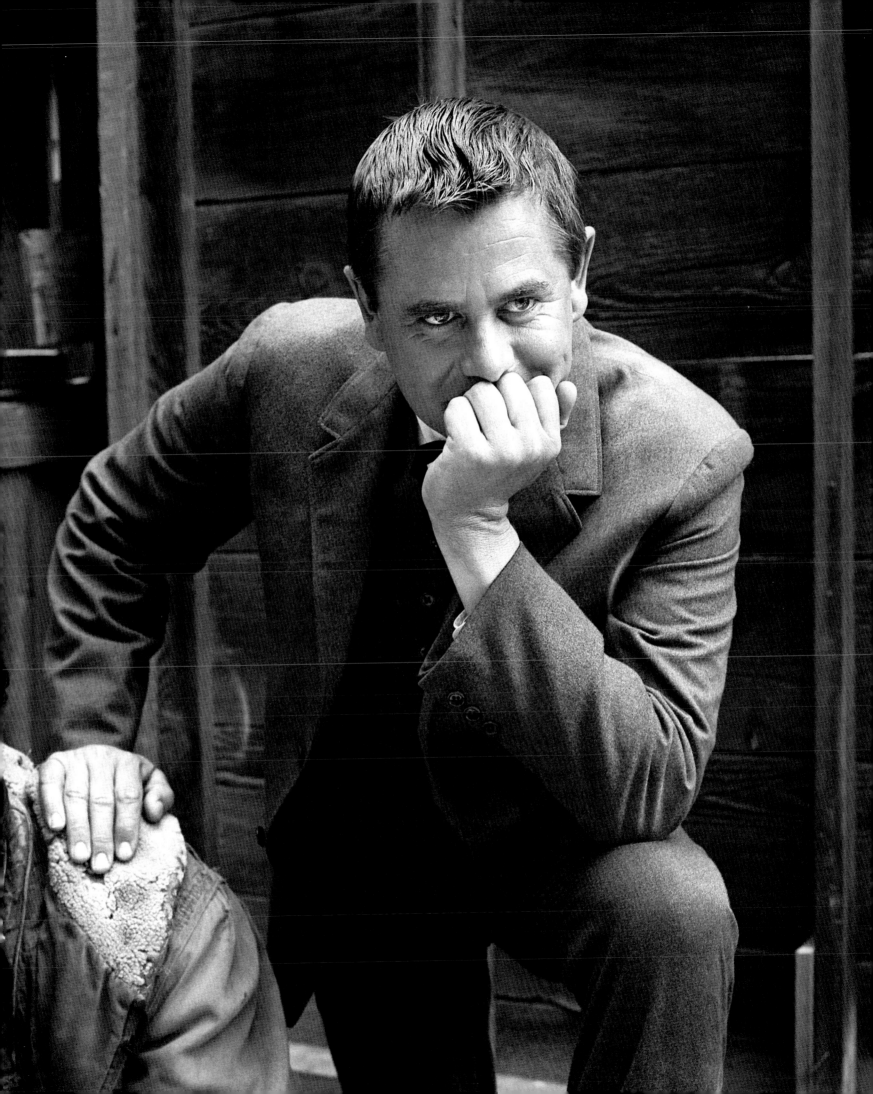

REBEL WITHOUT A CAUSE

This was a tough kid. James Dean. A rebel. All my photos on *Rebel Without a Cause* are gone [except these two]. I don't know what happened to them – they may show up someday.

People told me before I went to see him at Griffith Park Observatory that he had almost all the photographers kicked off the set. When I went there, I had just bought a new camera called the Hasselblad with a 250mm lens (which made it look impressive). So I stood way back and I only made a couple of snapshots of him when he wasn't really working – he was relaxing. He got curious about the camera and he came over – I gave him a lesson on how to focus and shoot the camera. I told him what it was, where it came from and what the principal was mechanically.

From thereon, any place that I went, when he saw me and he wasn't actually filming, he would give me all kinds of wonderful photos. I remember that he did a whole series of photos with Natalie Wood, romancing her under the tree in front of the Observatory – he was putting his arm around her shoulder, nose to nose, and so many other great things. But I don't have any of it. All I can tell you is that it was wonderful.

*James Dean and Natalie Wood photographed on the set of **Rebel Without a Cause** at Griffith Park Observatory, 1955.*

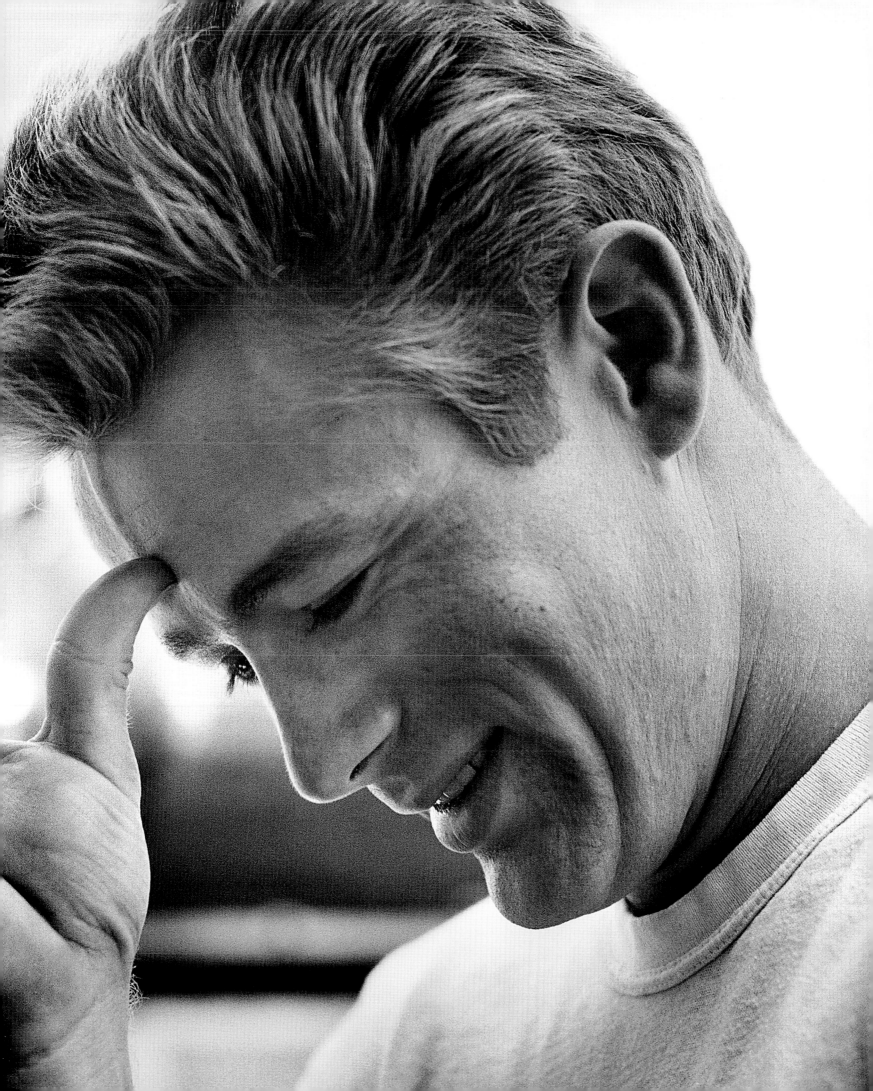

GIANT

I was on assignment in Marfa, Texas, covering the film *Giant* and the people in the film – but focusing mostly on James Dean. I knew what a terrific and inventive subject he was. Anytime I pointed my camera at Jimmy and he wasn't on the set working, he would perform for the camera at every opportunity, giving me many wonderful and creative images to record. He also borrowed my camera on occasion to shoot pictures of Elizabeth, George Stevens or some of the extras on the set.

Even though Jimmy had been told not to drive his car during the filming, he would have his script man drive through the open fields at night while he sat on the front fender with a .22 rifle in hand, shooting at rabbits that were frightened out of the brush and caught in the glare of the headlights. George Stevens didn't know about this extracurricular activity, I'm sure.

The cast had a table (lunch was catered) and we were sitting there eating. I sat across the table from Elizabeth Taylor. I had put my Hasselblad camera down next to my plate. Next to her was Rock Hudson and the assistant director and next to me was James Dean and the director George Stevens. After finishing lunch, Liz pulled her chair back to get a little sun and when I saw her face up in the sun, with the light on it – it was just exquisite and I couldn't resist making a shot. It has become one of her favorite shots and is one of my favorite shots – it was just so candid and she looked so terrific. It's so odd because her violet eyes are such an important part of her beauty and yet her eyes were closed in this photo – but still her face is incredible.

Liz and Rock Hudson palled around together a lot – she was very close to Rock and you can see just by looking at her expression how much she thought about him. And I did too – I thought he was a really nice man.

Dean carried around this Bolex camera everywhere and he did a lot of filming on his own when he wasn't in a scene.

*James Dean, Elizabeth Taylor and Rock Hudson photographed on the set of **Giant**, 1955.*

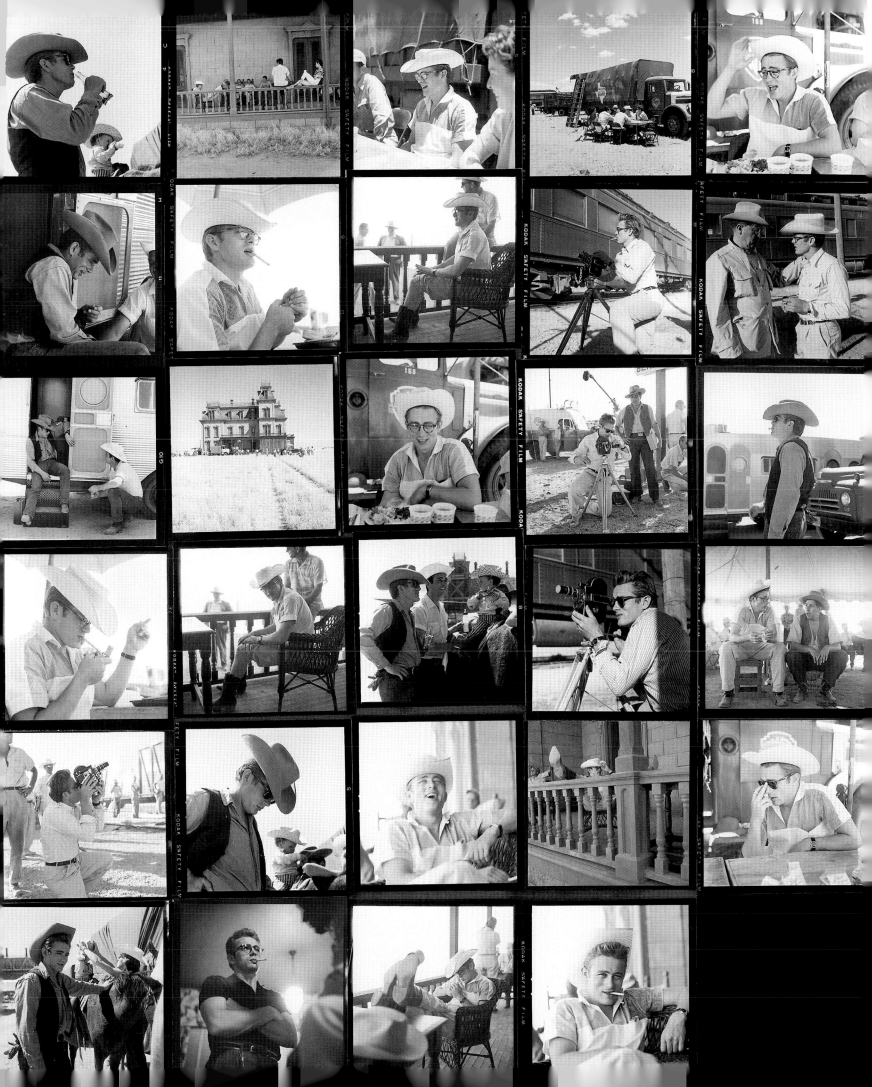

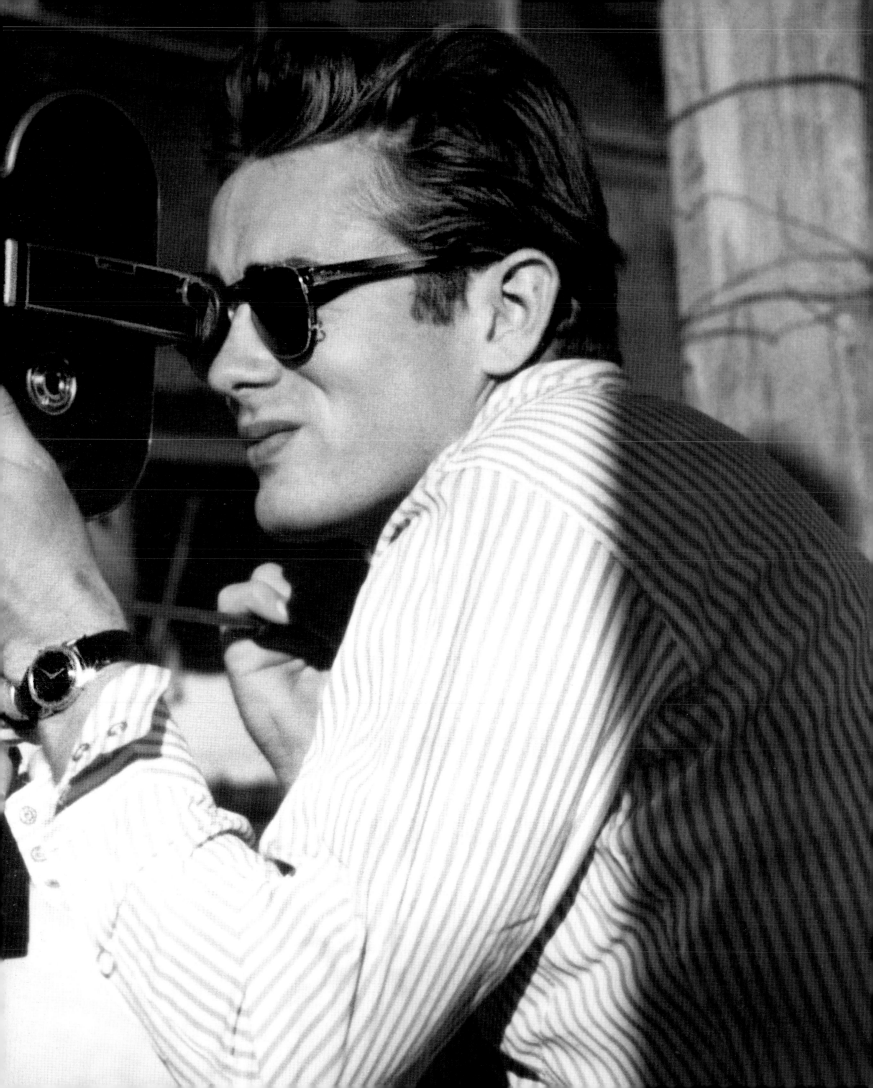

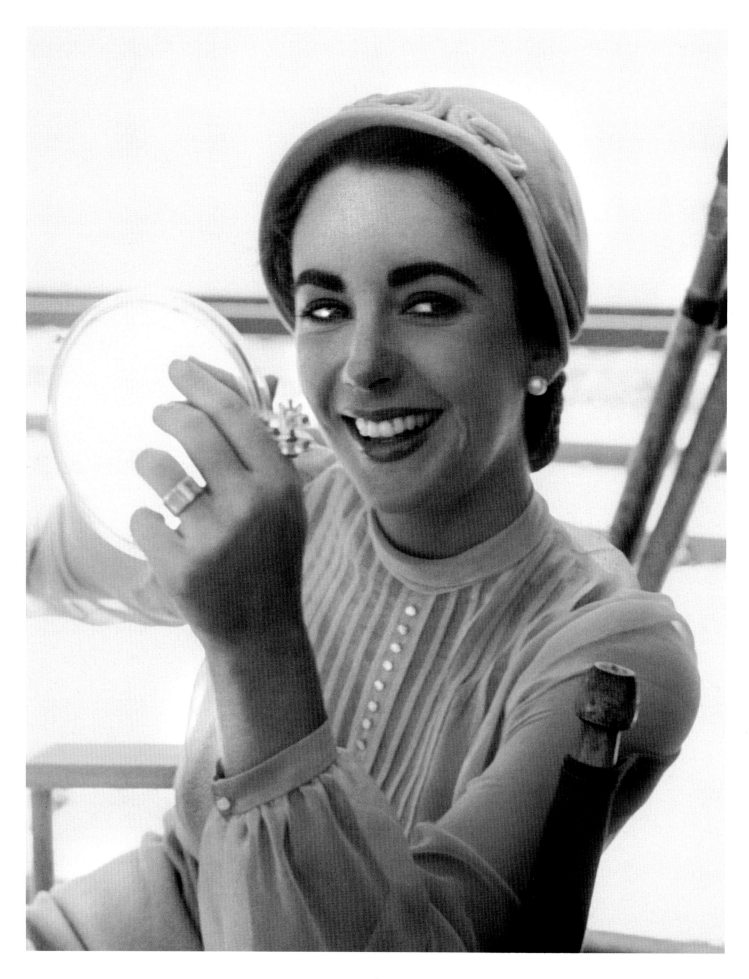

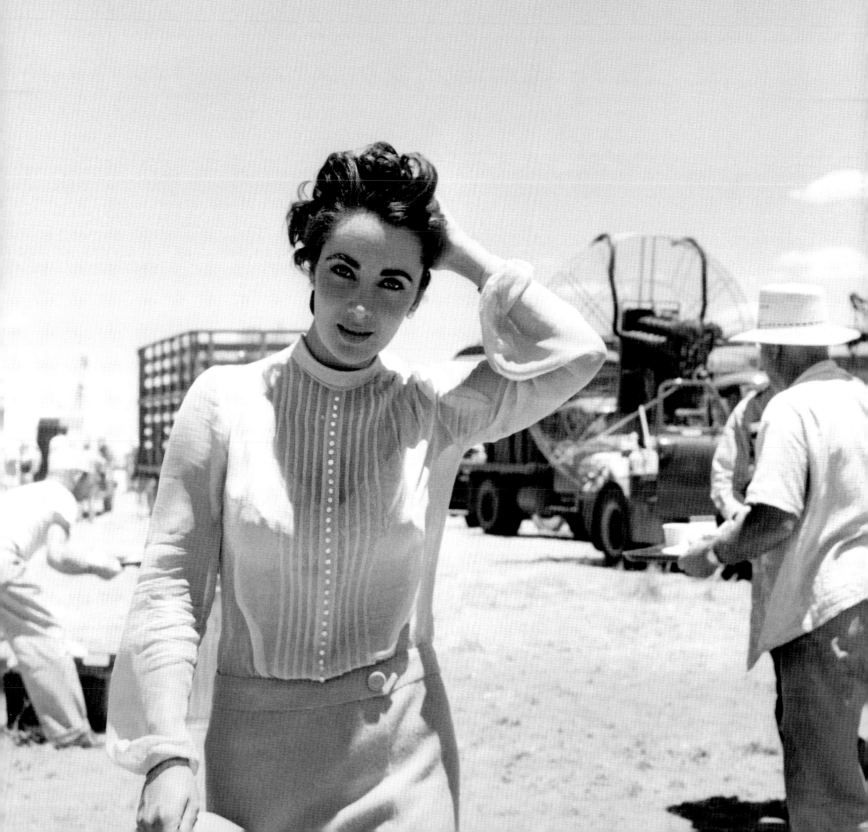

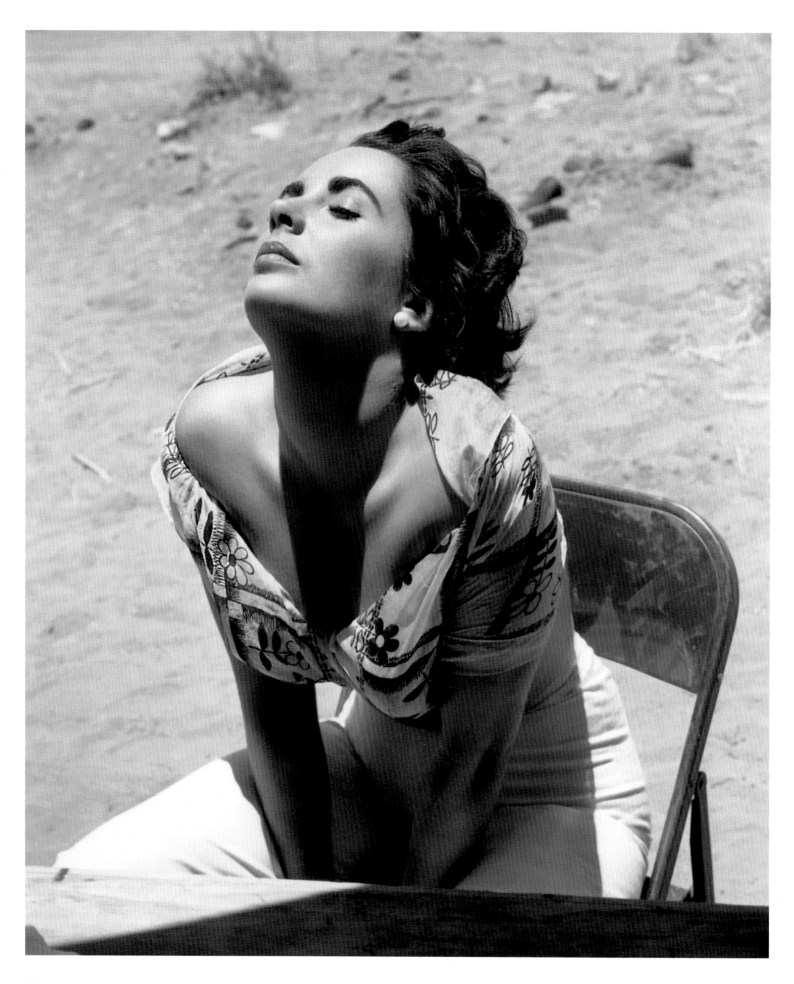

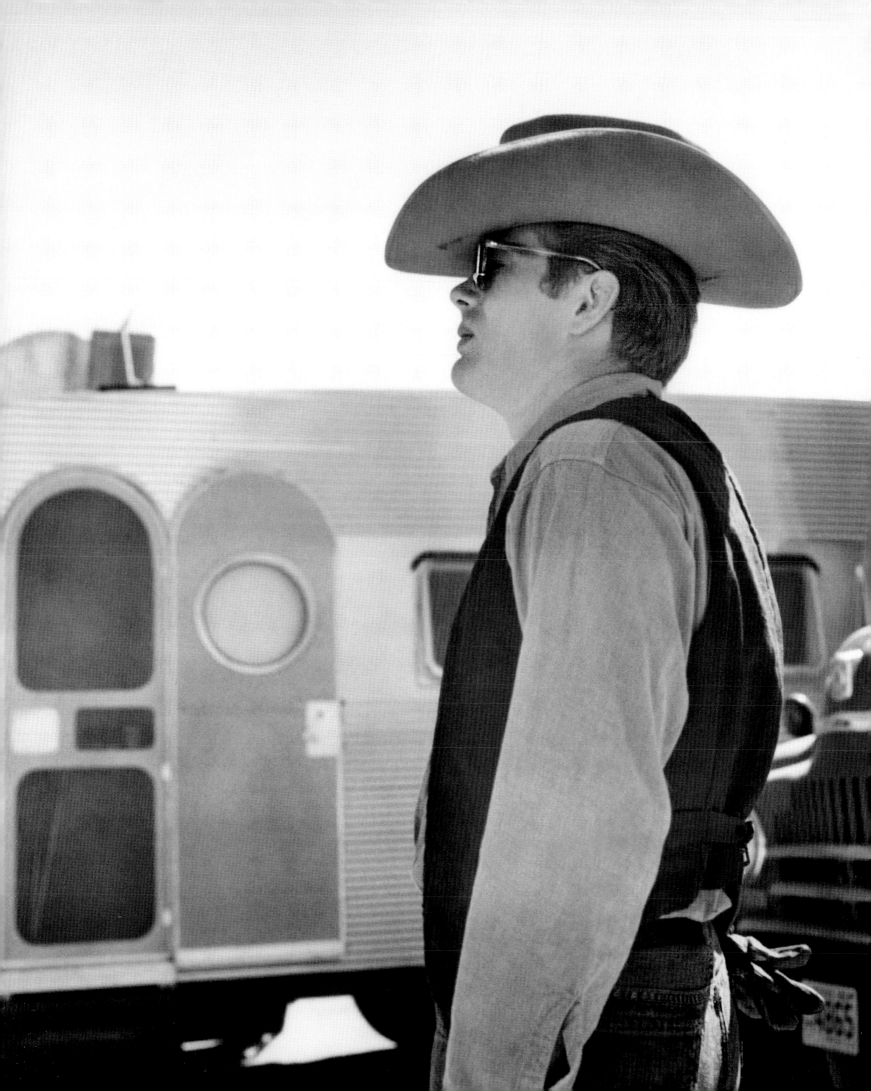

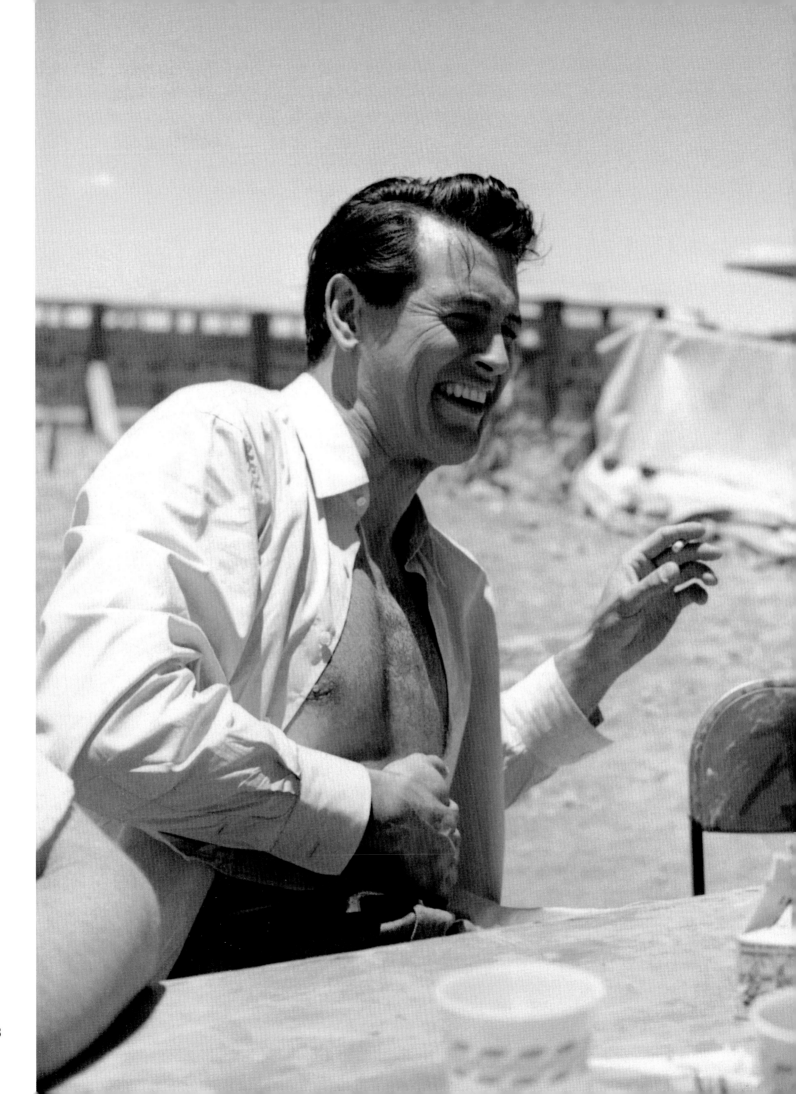

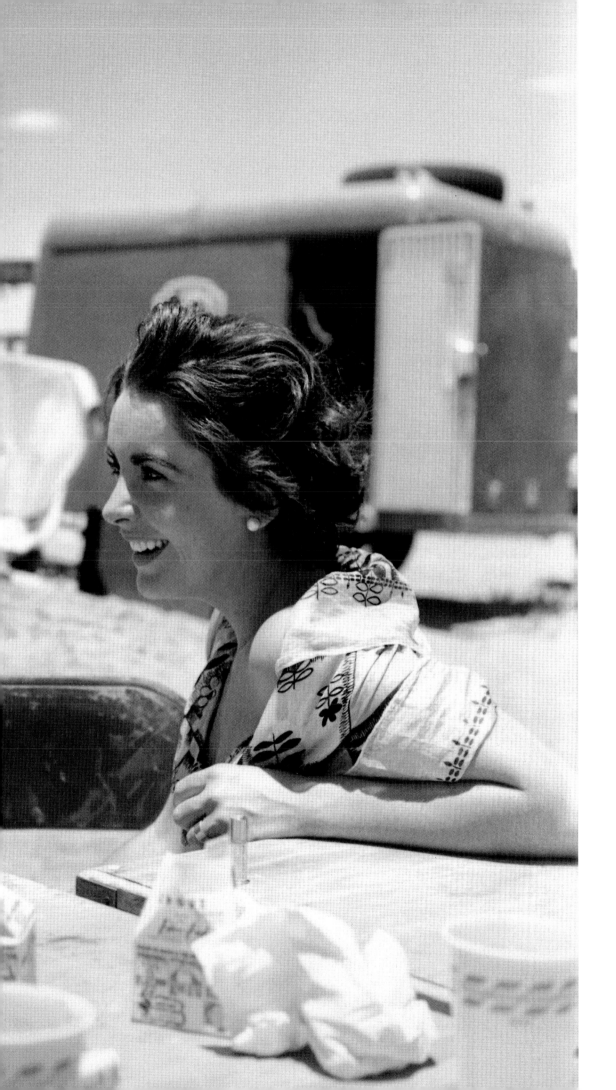

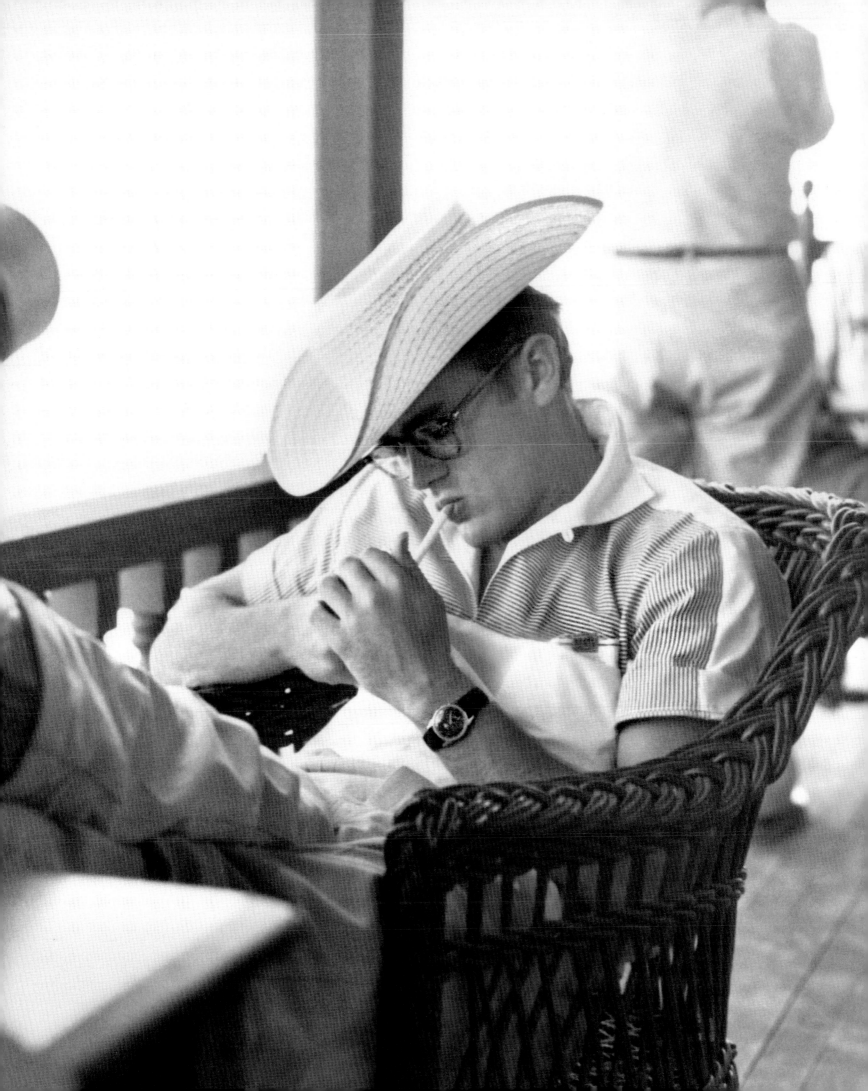

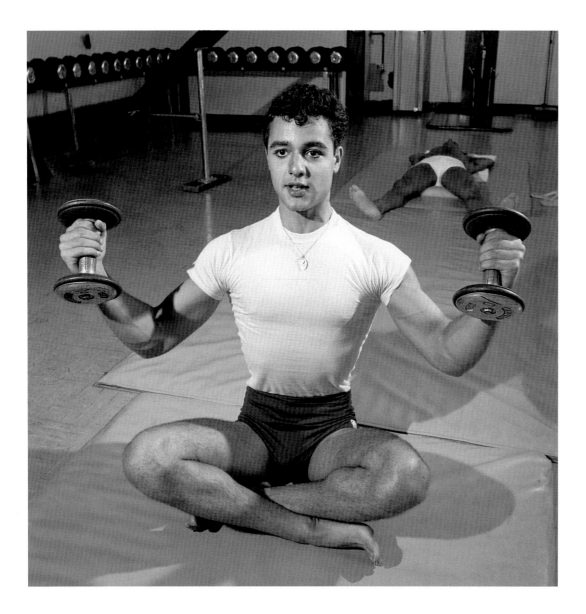

SAL MINEO

Sal Mineo was an American actor. One of his earliest roles was the young prince in *The King and I* and he had his breakout performance playing John 'Plato' Crawford in *Rebel Without a Cause*. He was nominated for an Academy Award for Best Supporting Actor for the role and became a popular teen sensation – a fact helped by his babyface good looks, which the *Saturday Evening Post* described as 'a delicate, almost girlish face, wild black hair he deliberately musses up for effect, eyelashes half an inch long, full, sensuous lips and enormous glowing brown eyes.' In 1957, Mineo had a brief pop career and two of his singles reached the *Billboard* Top 40. This was perhaps an influential factor in his securing the role of the drummer Gene Krupa in *The Gene Krupa Story*.

Avery photographed Mineo on the set of the film, and also photographed him in the gym – reflecting his upbringing as a member of a tough street gang in the Bronx. A year after *The Gene Krupa Story*, Mineo was nominated for a second Best Supporting Actor Academy Award for his role in Otto Preminger's *Exodus*. The 1960s and 1970s saw Mineo pursue a successful theater career, which was tragically cut short by his untimely death in 1976 in a random stabbing attack.

Sal Mineo photographed at the gym and on the set of **The Gene Krupa Story***.*
For the **Saturday Evening Post** *article, 'The Boy Called Sal', 31 October 1959.*

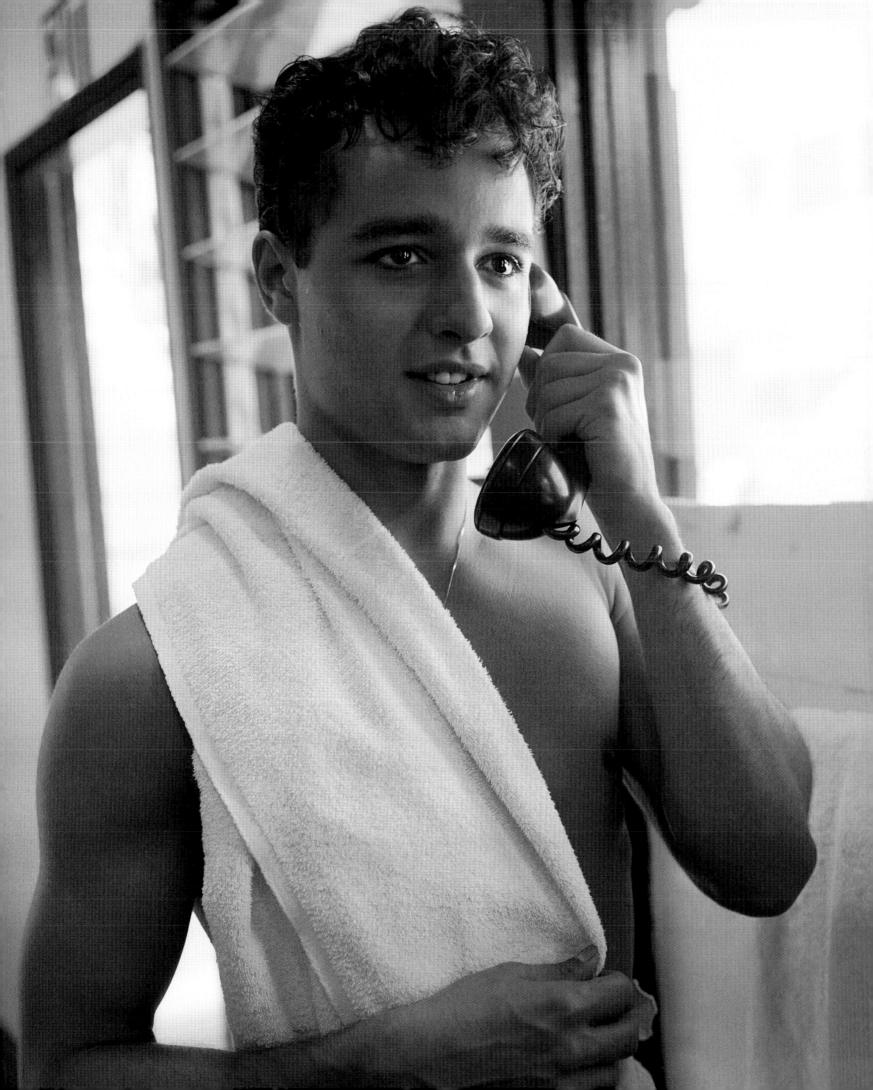

JACK PALANCE

Very macho, ambitious and physical when working out at the gym with his sparring partner.
He didn't pull any punches. However, he did seem to like his children.

*Jack Palance photographed at home with his wife Virginia and daughters Holly and Brooke; and working out in the gym. For the **Saturday Evening Post** article, 'Hollywood's Frightening Lover', 13 November 1954.*

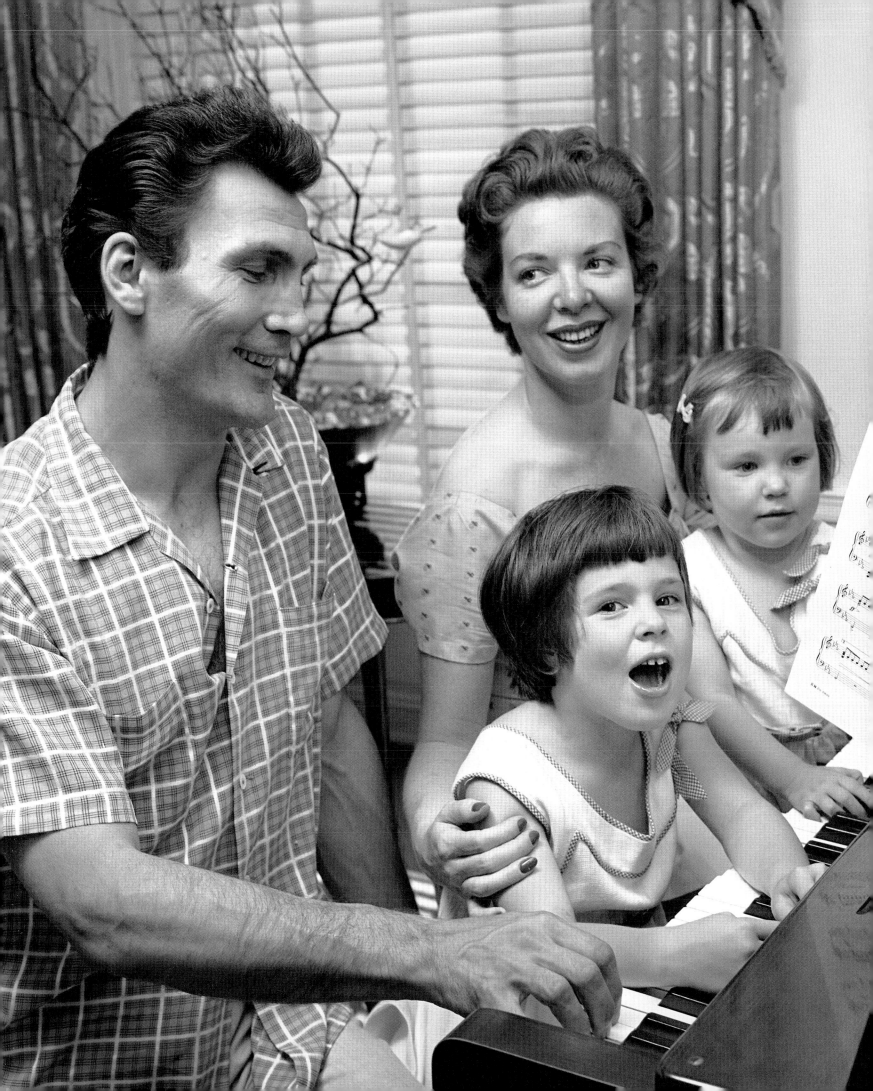

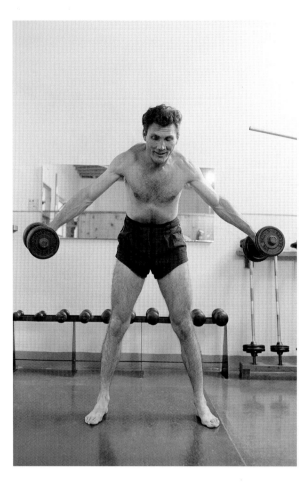

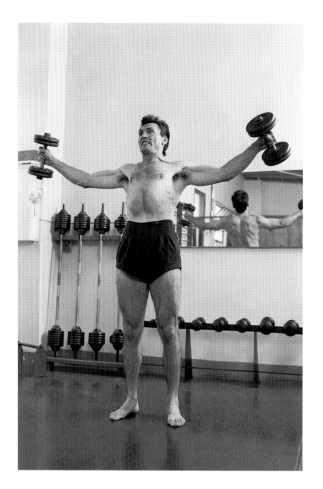

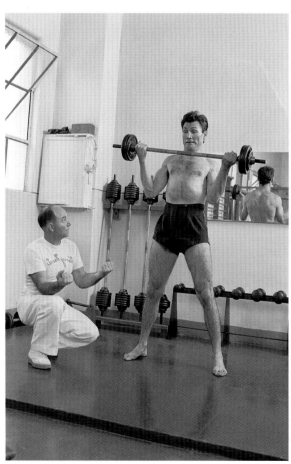

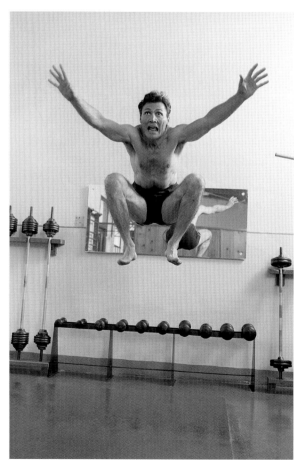

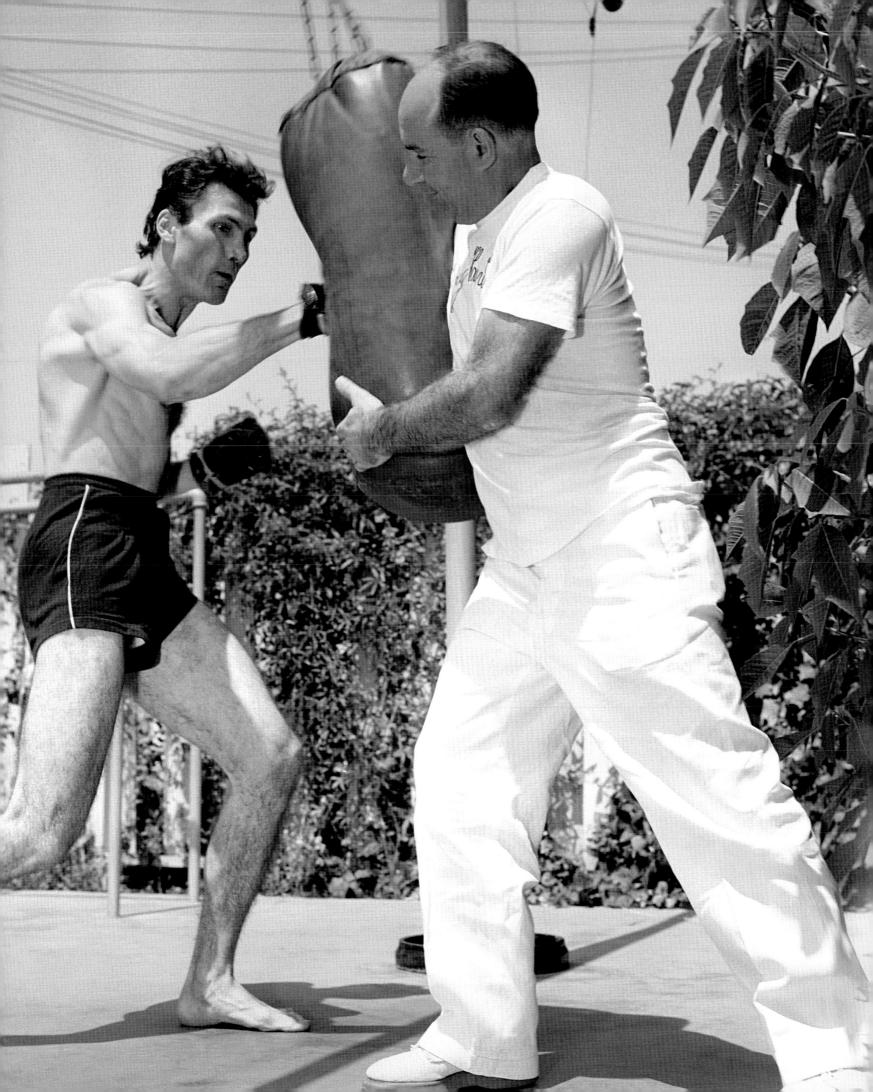

GEORGE STEVENS

George was overseas with me when I was in England and Europe after we invaded. He shot a lot of wonderful footage of the landing at Normandy using a little Kodak 16mm color camera. I had all the film sitting in the storage room but we didn't have any cameras. So I asked him how much film he wanted – I gave him a suitcase of 16mm cartridges – that's what he used for the invasion pictures. In fact, his son finally edited the footage in a feature film about his father. ... We went shopping together in Paris when we finally took France. We had a few moments together. He was truly a nice man.

 Here are George and his son at the premiere of one of his fine films, *Shane*. George Jr. was also very nice and a gentleman – he was head at the American Film Institute for many years.

 ... They [George, Ed Wynn and Millie Perkins] were working on *Diary of Anne Frank* – reviewing footage and filling in gaps where they would need to re-record sound.

George Stevens photographed with his son George Jr. at the premiere of **Shane**; *with some of his many awards; with Cecil B. DeMille and with Billy Wilder. For the* **Saturday Evening Post** *article, 'The Man Who Made the Hit Called "Shane"', 8 August 1953. Avery captured Stevens again in 1959 working on* **The Diary of Anne Frank** *with Ed Wynn and Millie Perkins. For the* **Saturday Evening Post** *article on Ed Wynn, 'Grand Old Man's New Career', 4 April 1959.*

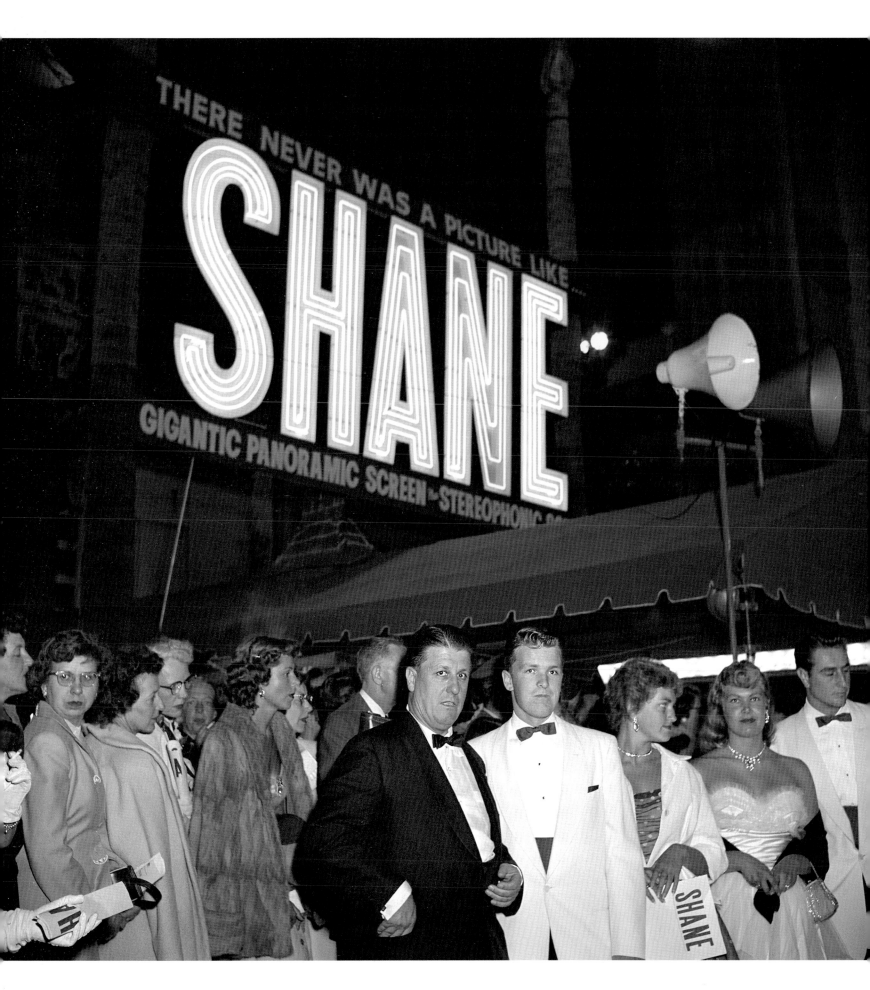

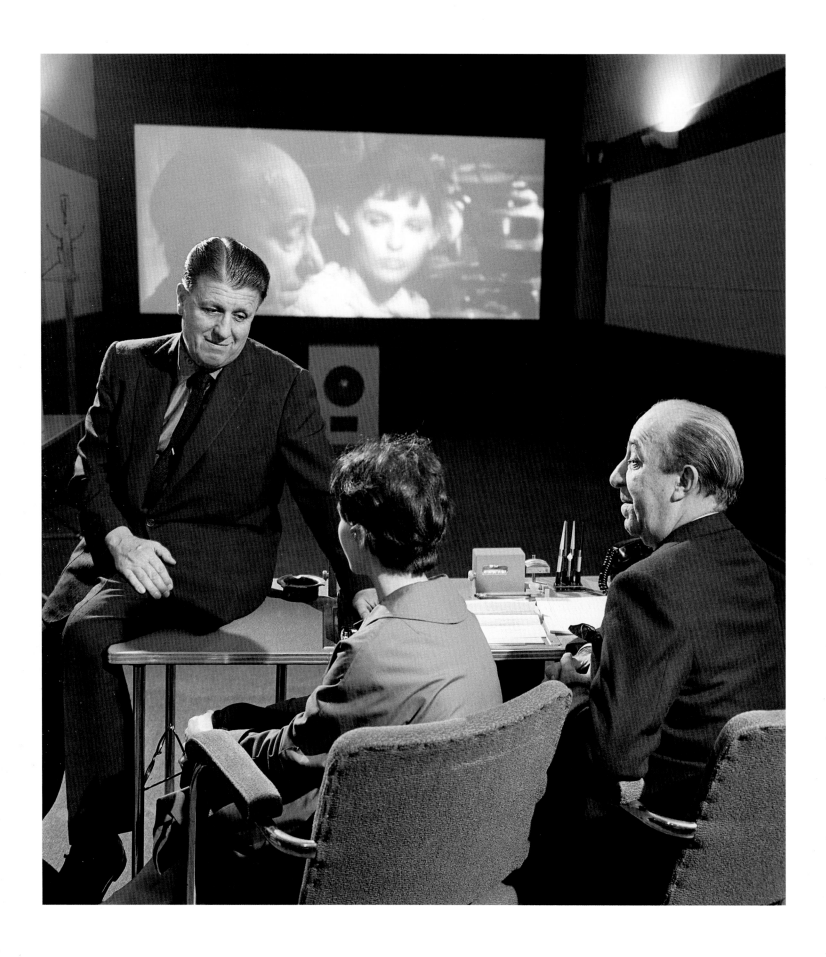

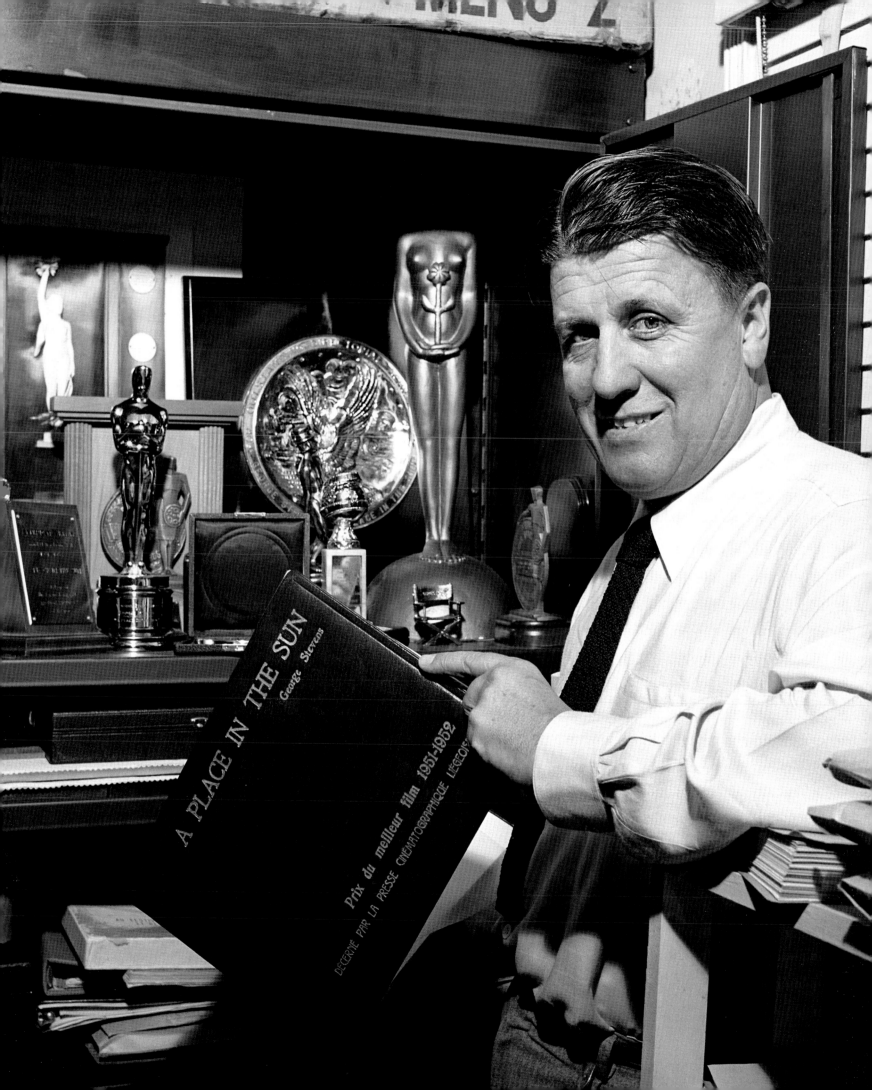

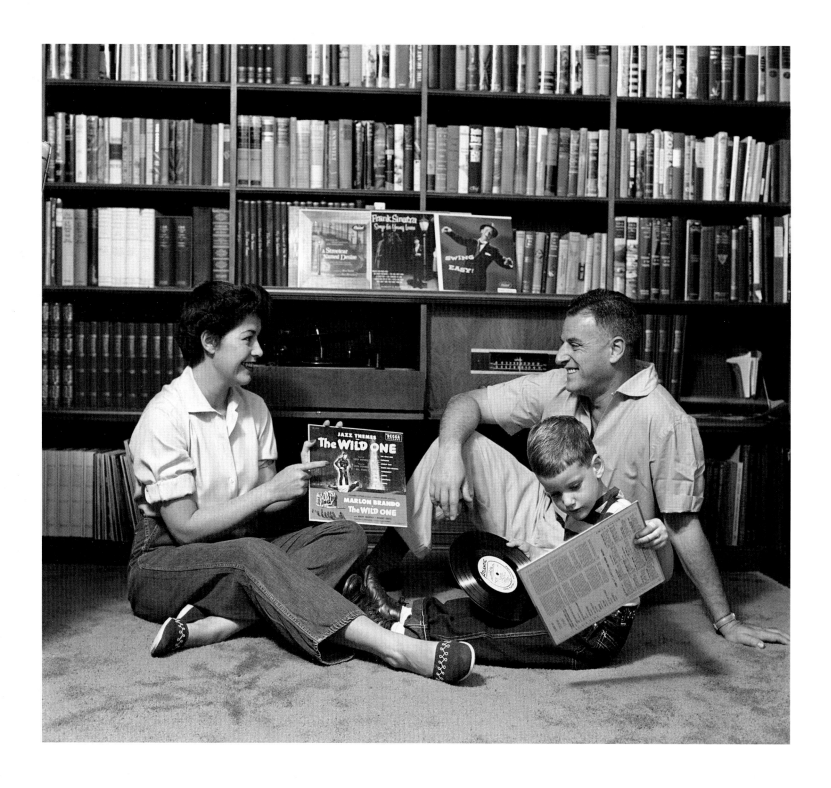

STANLEY KRAMER

He was a very meticulous director and a fine one at that. He was a nice man to work with
and I enjoyed the assignment very much.

Stanley Kramer at his Los Angeles home with his wife Anne and son Larry. Some of the album covers in the
*background were also shot by Avery. Kramer was also photographed by Avery on the set of **Not as a Stranger***
with Olivia de Havilland, Frank Sinatra and Robert Mitchum, 1954.

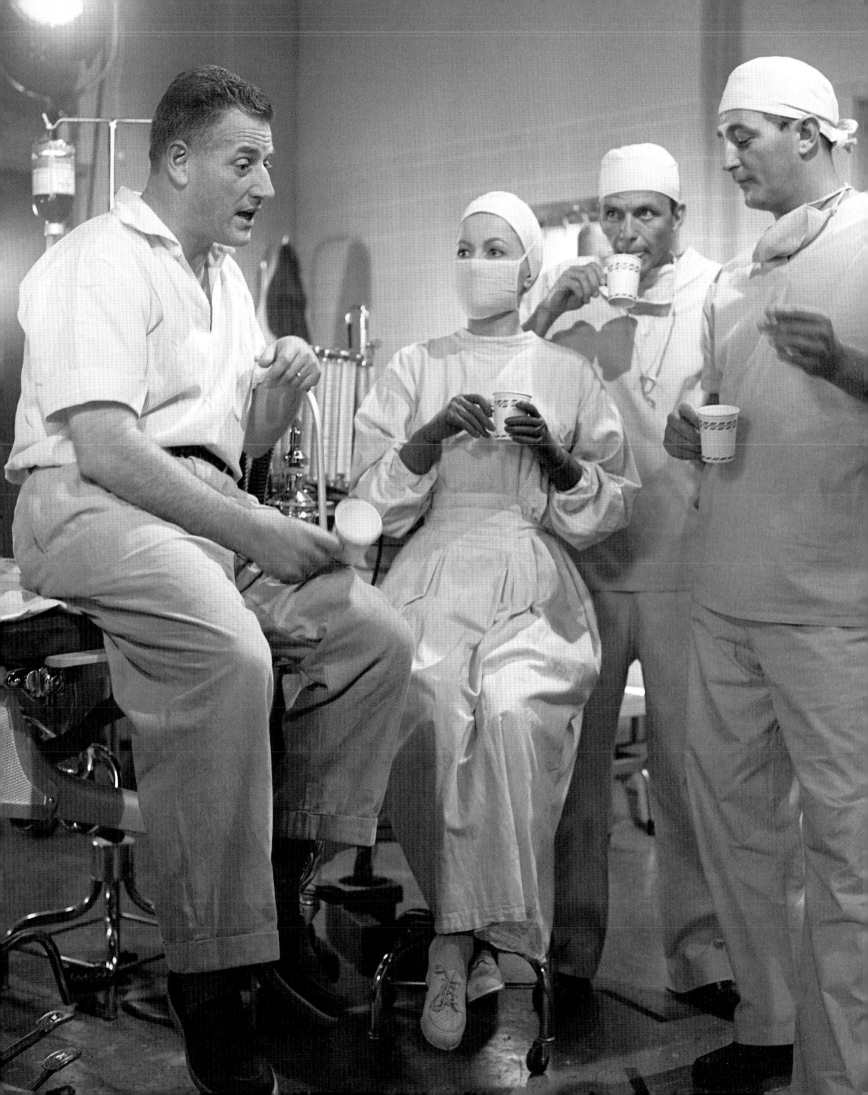

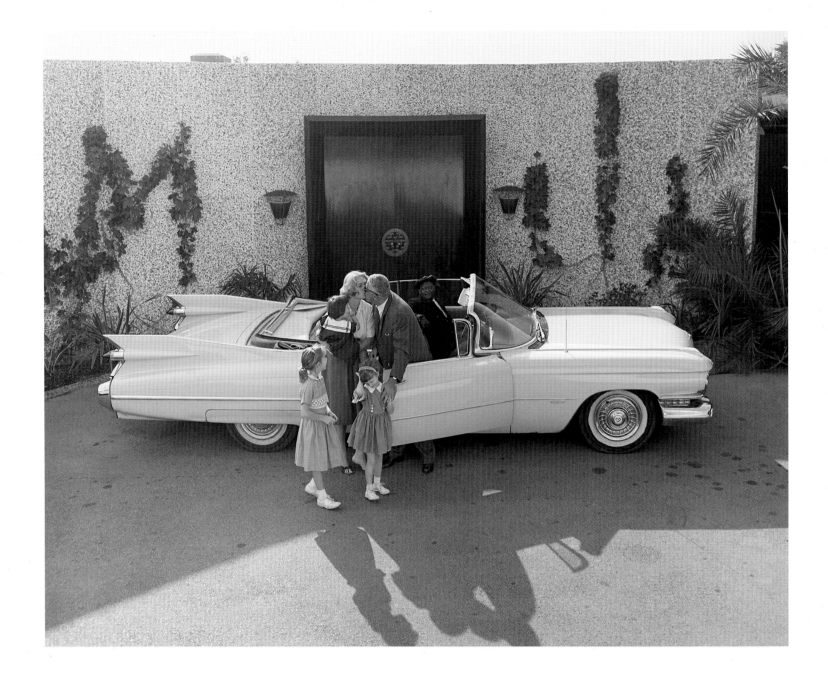

WILLIAM CASTLE

I thought this shot was so perfectly emblematic of Hollywood at that time. A big Hollywood
director, in his chauffeured Cadillac, greeting his family in front of his beautiful home.

*William Castle photographed at home with his family, 1959; and on the set of **13 Ghosts** with Vincent Price,*
*1960. For the **Saturday Evening Post** article, 'Master of Movie Horror', 19 March 1960.*

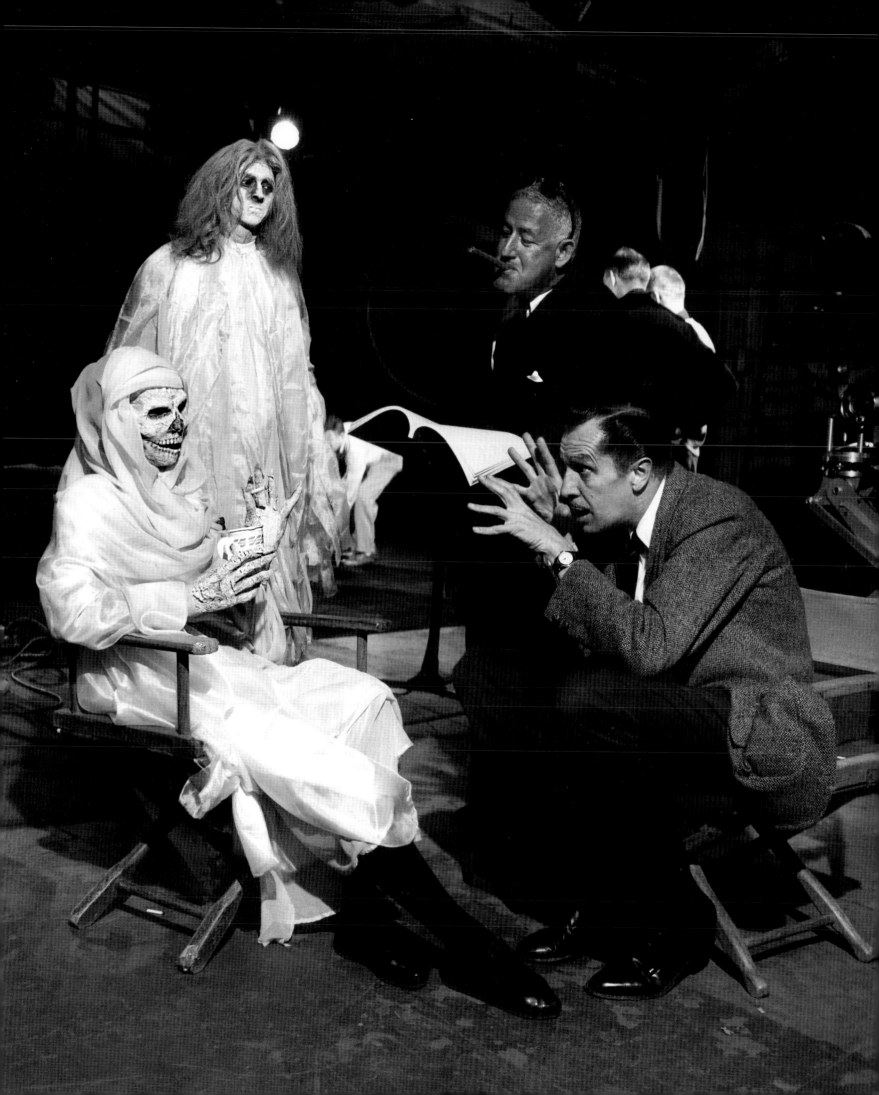

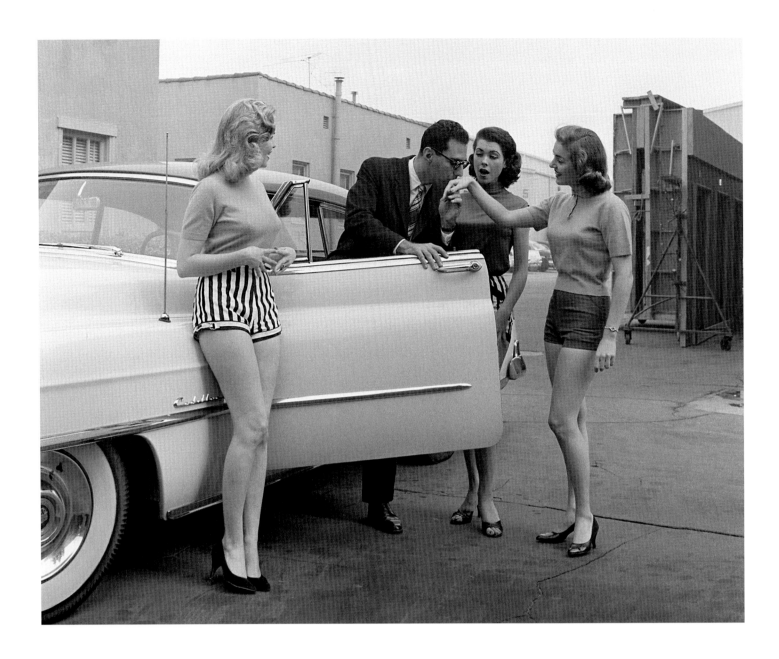

WILLIAM PETER BLATTY

William Peter Blatty is an American writer. He is most famous for his best-selling novel *The Exorcist*, which he adapted into an Academy Award winning screenplay for William Friedkin's legendary horror masterpiece. Before this, in the 1950s and 1960s, Blatty was a successful comedy writer, including several collaborations with Blake Edwards, such as *A Shot in the Dark*. In 1958, Sid Avery photographed Blatty in character as 'Prince Khairallah el Aswad el Xeer of Saudi Arabia'. What started as a prank between friends, developed into an 'undercover' assignment, with Blatty posing in disguise in several settings, including on screen in Groucho Marx's TV game show, *You Bet Your Life*. As Blatty wrote at the time, 'With the aid of a distinguished looking straight man and a pair of dark glasses, for ten ridiculous days I hoaxed Hollywood as Prince Xeer, black-sheep son of King Saud of Saudi Arabia.' The result was a ten-page witty feature in the *Saturday Evening Post*.

*William Peter Blatty photographed in 1958 for the **Saturday Evening Post** article, 'They Believed I Was an Arab Prince', 29 March 1958. The original caption reads, 'The 'prince' charms girls from the Bob Cummings Show at a TV Studio.'*

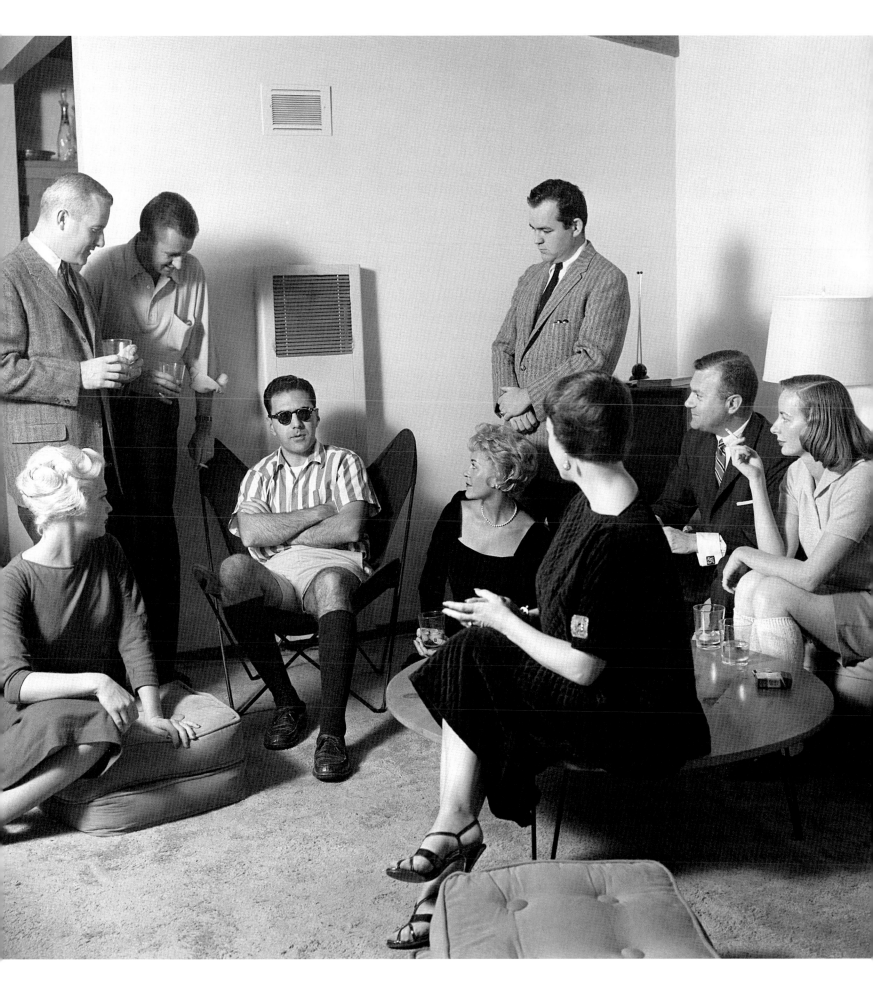

STARLETS

In 1939, I opened a tiny studio on 6263 Hollywood Boulevard, specializing in portraiture, photojournalism and publicity photography. A theater had opened up, a nightclub rather, a place called the Florentine Gardens. I was able to get from them the assignment of photographing all of the chorus girls for the lobby displays. Most of them were nude photographs that were enlarged quite a bit and put up in the lobby. I remember shooting almost all of them nude, or draped, because that seemed to make the lobby look more exciting. There were many girls in the show that went on to other things, and one of them was a girl named Yvonne De Carlo. When it became time for me to photograph Yvonne, for one reason or another, perhaps because she was so well-endowed, I decided not to do the photograph of her in the nude, but rather to shoot one of a series of photographs using drapes to partially cover her chest. A couple days after the session, my partner Cookie and I were sitting in the office and there was a knock on the door, and there was a rather portly, short woman with a heavy accent standing there looking a little disturbed. And I said, 'Yes, can I help you?' And she said, 'Are you the photographer at the Florentine Gardens that's photographing the girls?' And I thought, 'Uh oh,' this is an irate mother who's going to complain because I've disrobed her daughter and photographed her. And I said, 'Yes, that's true.' And she said, 'I'm Yvonne De Carlo's mother and I'd like to know what's wrong with Yvonne.' I said, 'Nothing's wrong, she's a very beautiful girl.' And she said, 'Well, then, why didn't you photograph her nude like you did the other girls?' Her reaction was a twist that I hadn't really expected. Somehow I talked my way out of that one.

… This is Jayne with her pink Cadillac – just coming out of Dino's restaurant.

… Inger Stevens. God, I really loved that girl. I did a lot of shots for covers of magazines for her. She would come into the studio and bring a bottle of something and we would share it during the shooting, and I had music on. After one of the shoots, I got a call from one of the women who was always with her, and she said, 'Sid, I've got some bad news.' She said, 'Inger killed herself last night.' Well, that knocked me out for the rest of the week.

Bruce McBroom also has fond memories of sessions with Inger Stevens: 'We did a shoot with this gorgeous Scandinavian actress, Inger Stevens. … I think he photographed her once or twice before and she liked the photographs. So he said to me one day that she was going to come into the studio and we were going to do all of these photographs and he asked me to call up her secretary and, 'Find out what kind of flowers she likes and what kind of wine she drinks.' I called up her secretary and she told me what flowers she liked and that there is a 'Chateau Laffite Rothschild, 1947.' I told Sid I didn't know where we were going to find this wine. Sid was a wine connoisseur, so he told me a couple of places to go to in Beverly Hills and 'Tell the guy it's for me.' So I said to him, 'When I go there, I should get a bottle?' and Sid said, 'Oh no, no, get a case.' When I actually got to the shop the guy only had three bottles, so I got those. I had a check from the studio and it was over five hundred dollars, but you just did what Sid said. I got back and gave him the receipt, and he never thought twice about it. … The photo shoot came and Inger asked Sid how he knew it was her favorite. It was a very successful shoot.

Yvonne De Carlo photographed in 1940; Mamie Van Doren and big band trumpet player, Ray Anthony, rather obviously strike a pose, 1957; Jayne Mansfield signing autographs in front of Dino's Restaurant on Sunset Blvd. in Los Angeles, 1961; Leslie Caron at home, 1955; Joan Collins at home, 1955; Tuesday Weld studies some cut-outs fashioned in her own image, 1960; Anne Francis photographed in 1955; Candice Bergen in an ad for Rexall, 1963; Inger Stevens photographed in 1964.

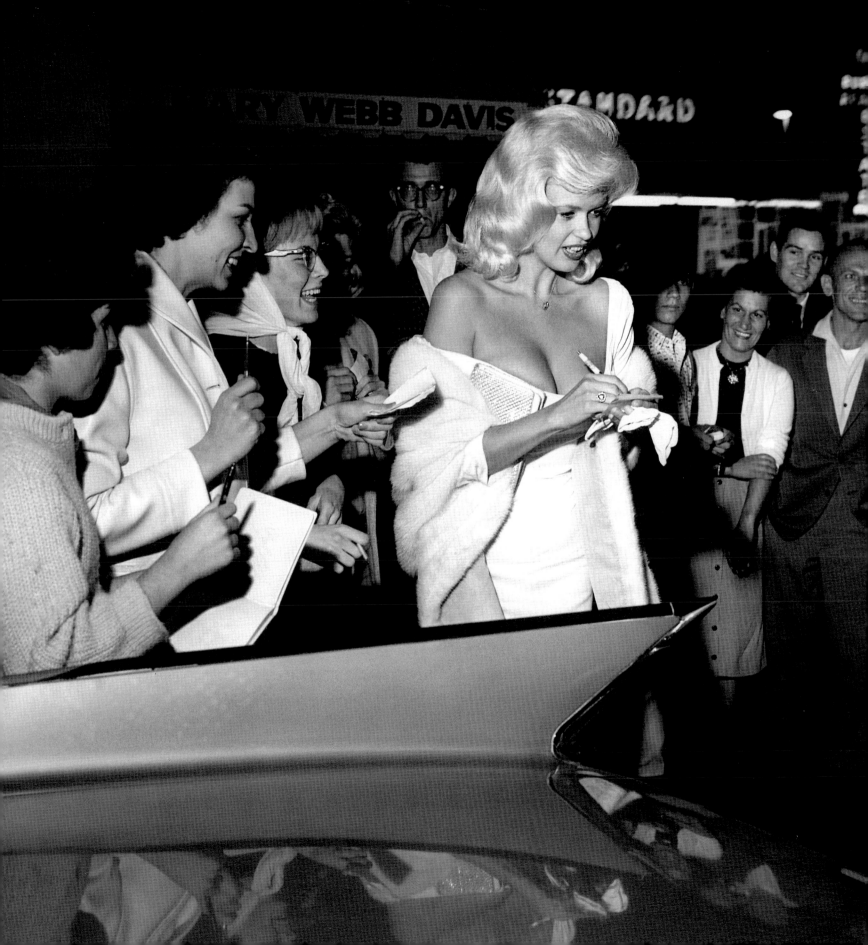

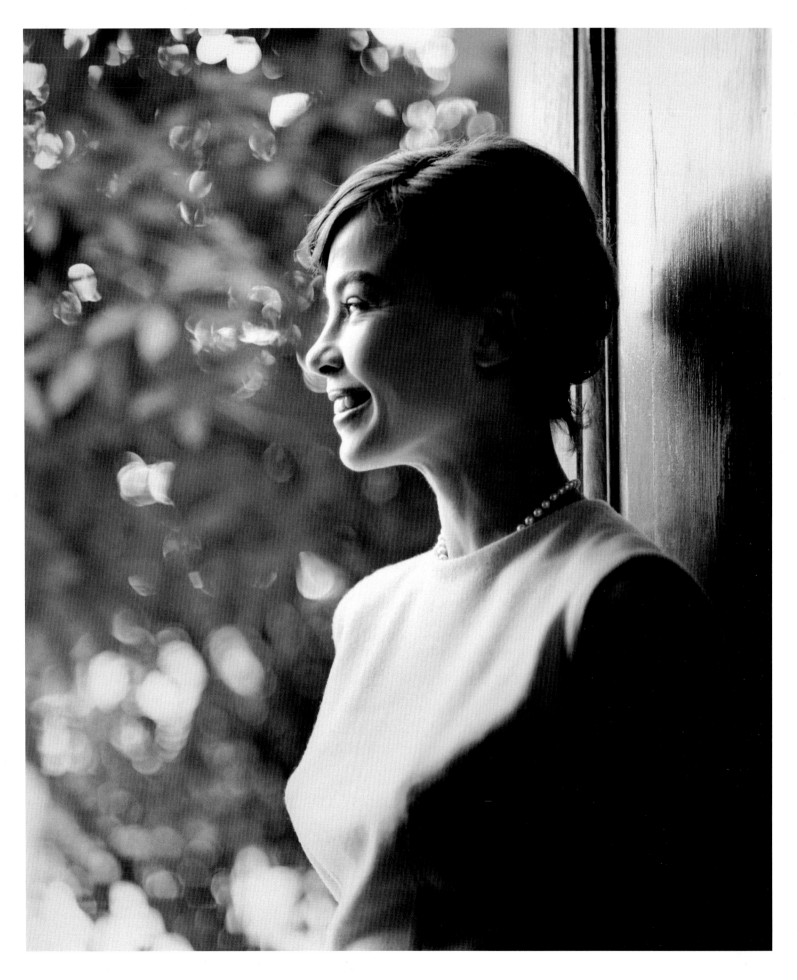

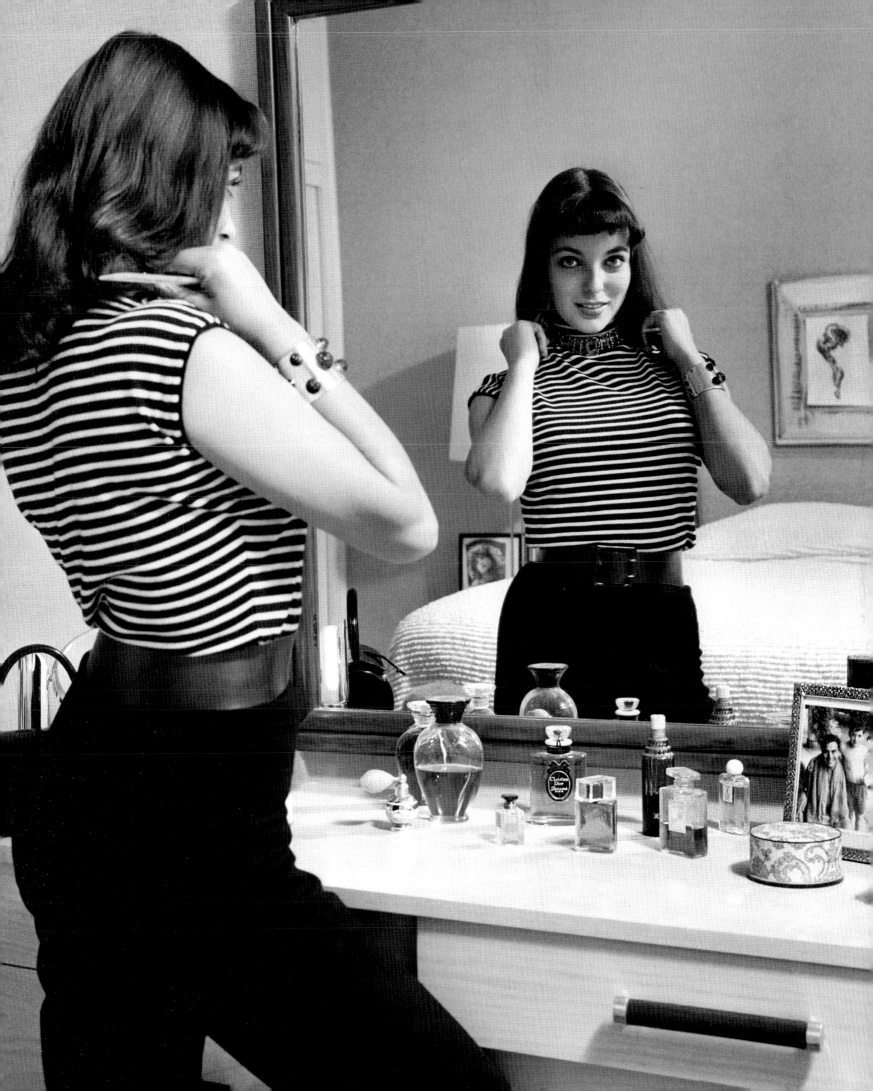

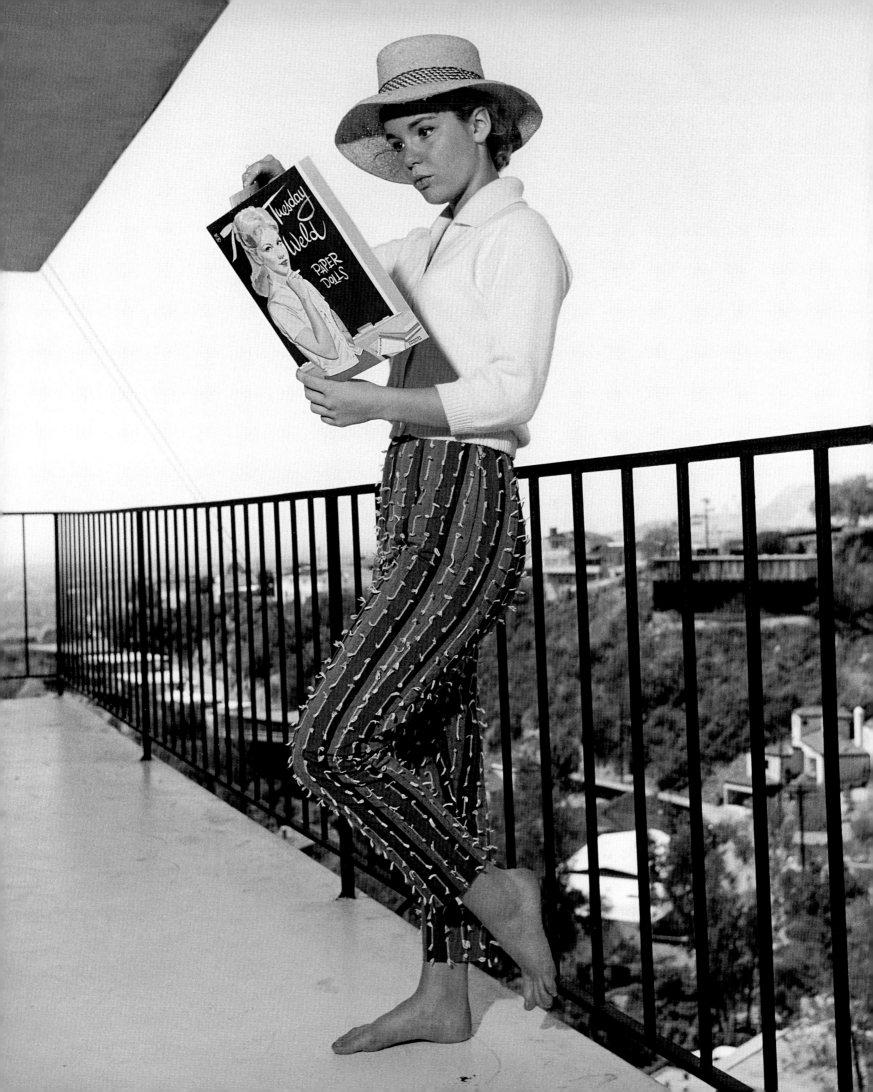

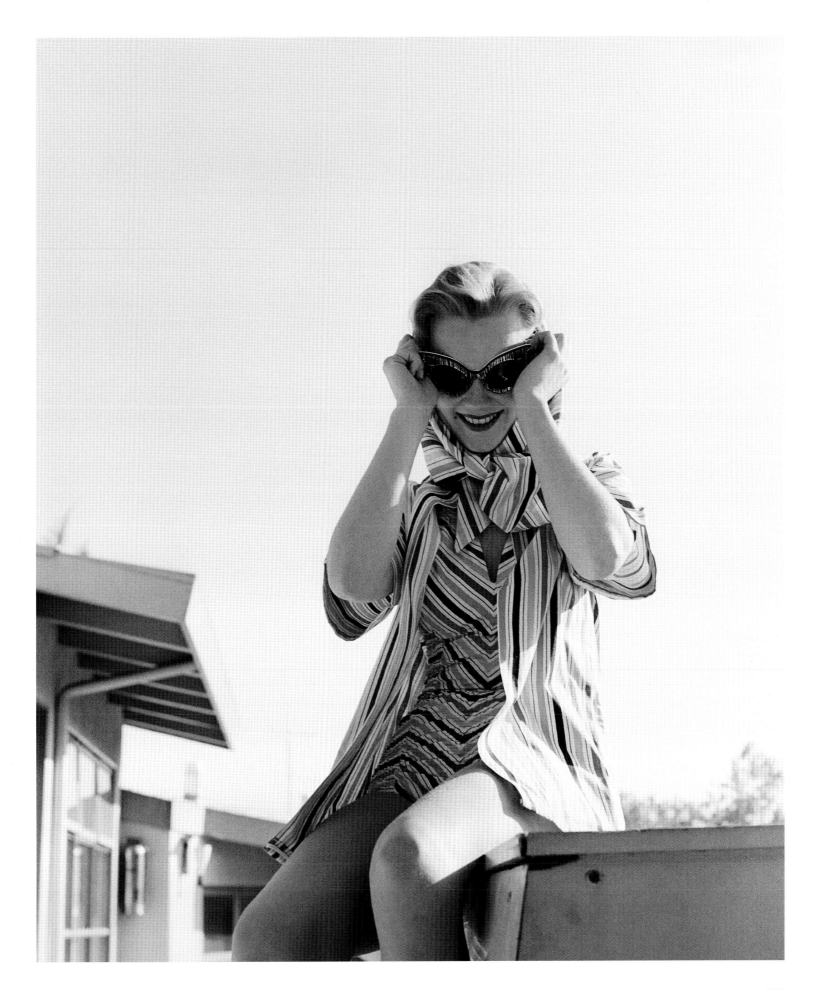

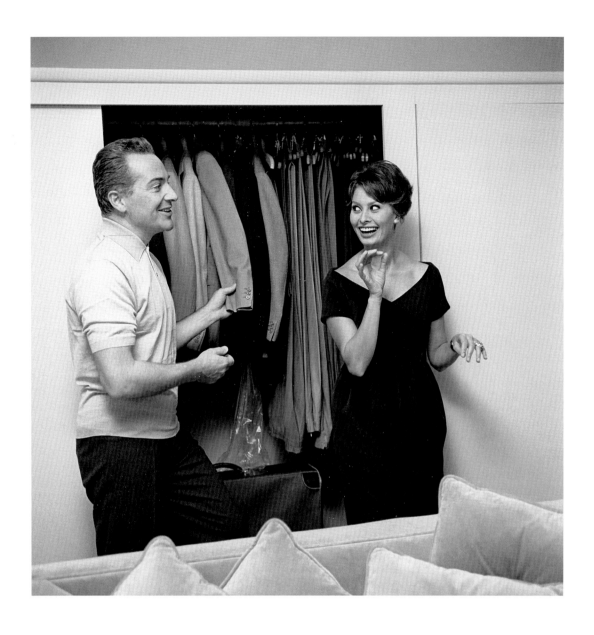

SOPHIA LOREN AND ROSSANO BRAZZI

These were two very handsome Italian actors telling naughty stories to one another, unfortunately in Italian, but very amusing nonetheless. I thought that these two people should have been a couple.

*Rossano Brazzi and Sophia Loren photographed in Brazzi's Beverly Hills home. For the **Saturday Evening Post** article, 'Rossano's Revenge', 31 January 1959.*

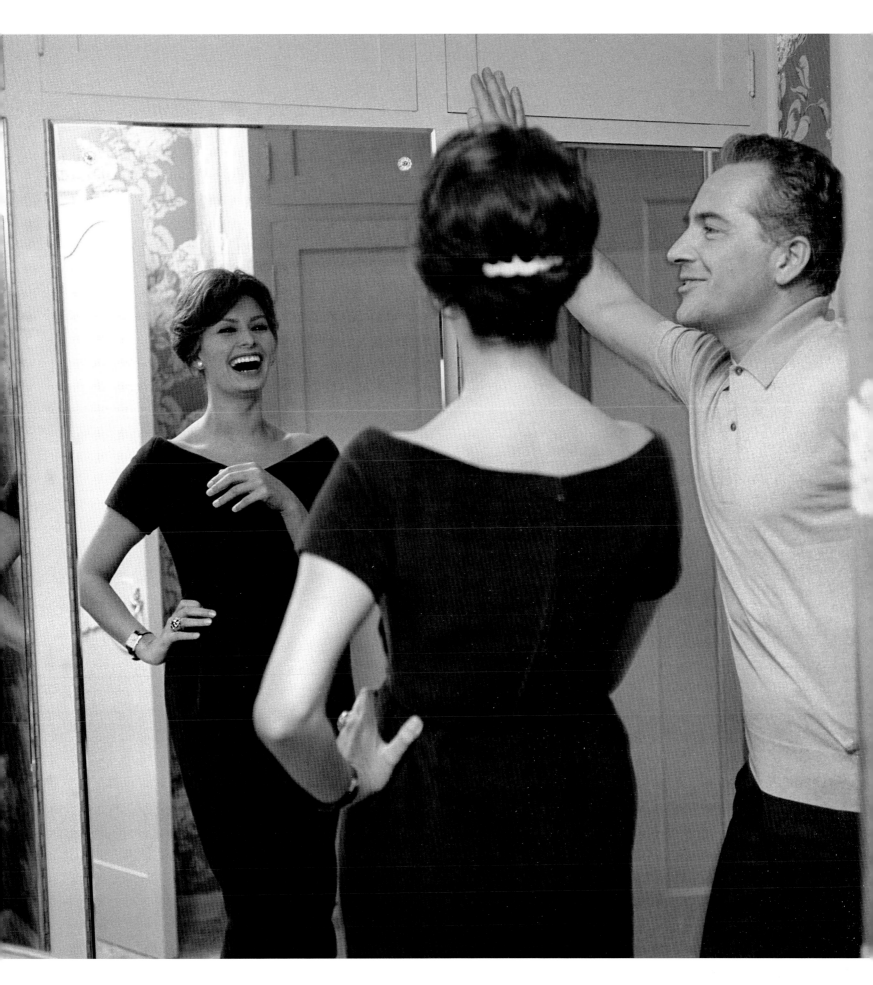

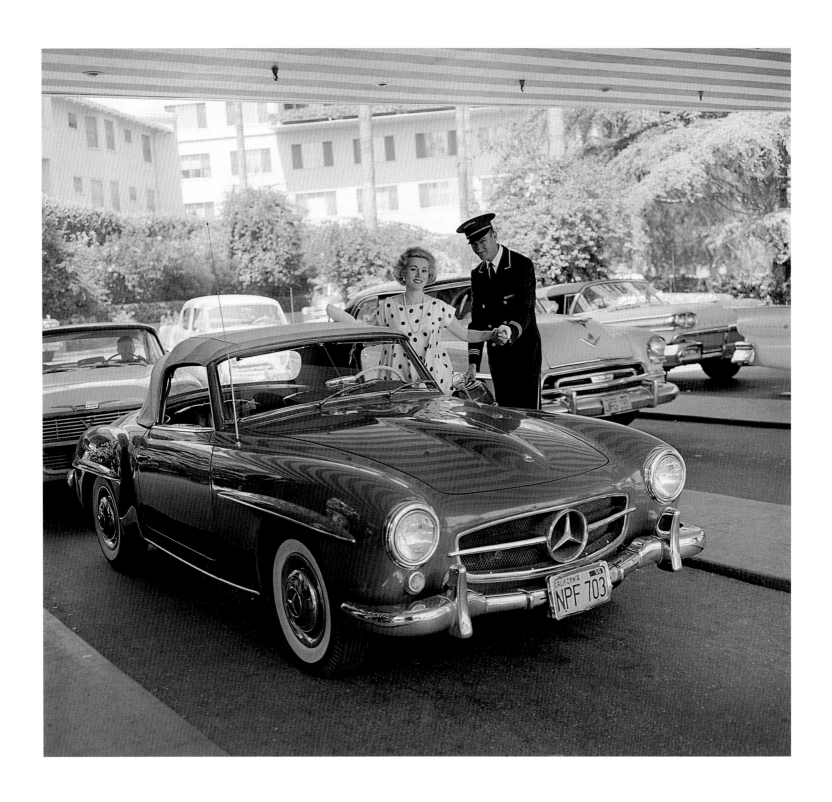

ZSA ZSA GABOR

I couldn't stand the phony way in which she talked down to people.

Zsa Zsa Gabor photographed with her 190 SL Mercedes at the Beverly Hills Hotel and at her Bel Air home.
For the **Saturday Evening Post** *article, 'I Call On Zsa Zsa Gabor', 13 September 1958.*

COMEDIANS

*Avery photographed several of the leading comedians on television, including: Harpo Marx in an advertisement for All-Pure evaporated milk, 1957; Ed Wynn having a snack during rehearsal break in the making of the film **The Diary of Anne Frank**, 1959 (actor Gary Merrill in the background); Danny Thomas and Jimmy Durante at a Christmas benefit in Los Angeles, California, 1958; Buster Keaton reflected in a funhouse mirror at the Avery Studio for a US Steel advertisement, 1964; Red Skelton backstage on **The Shower of Stars** set, 1955; Alan Sherman, 1963; Dick Van Dyke and Jerry Van Dyke, 1962.*

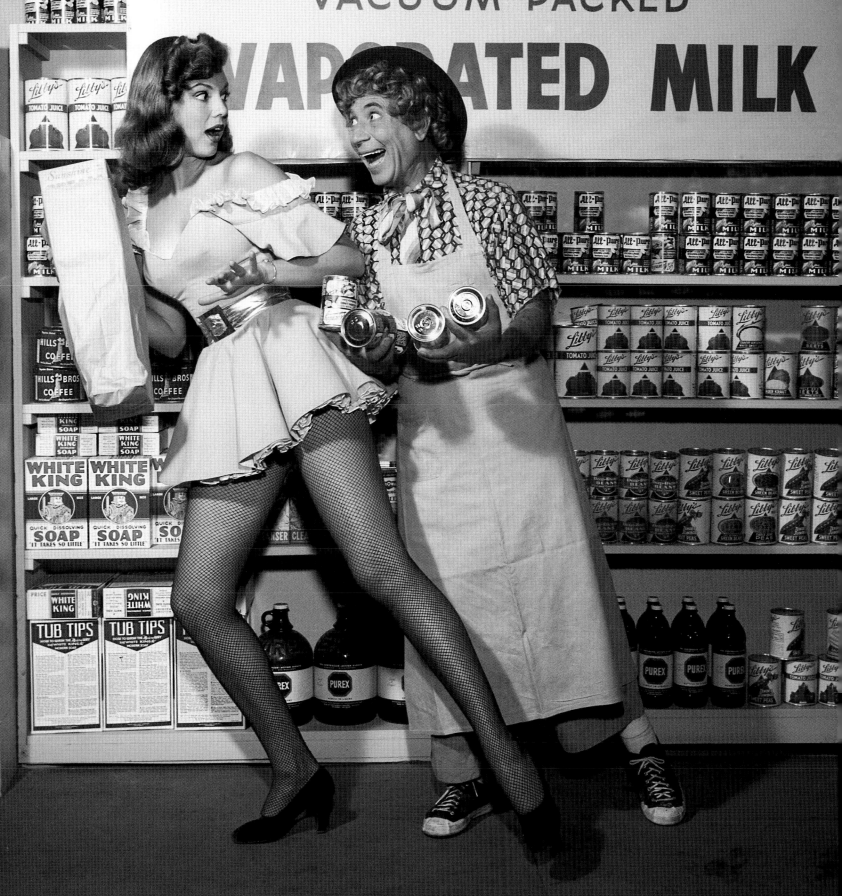

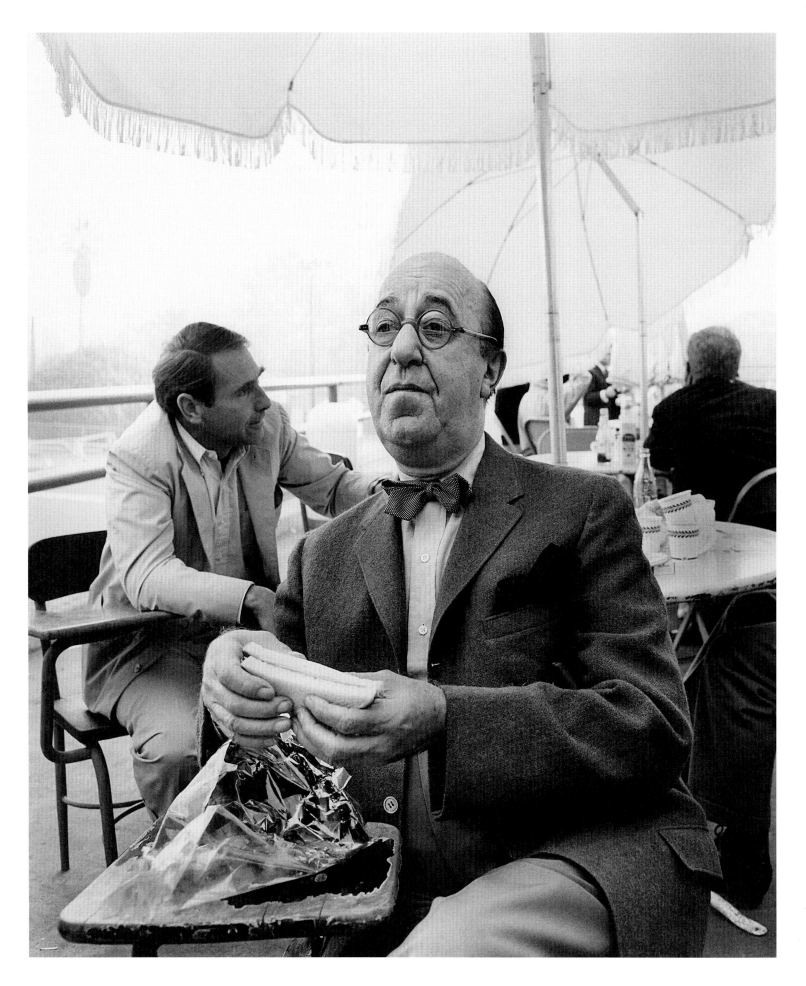

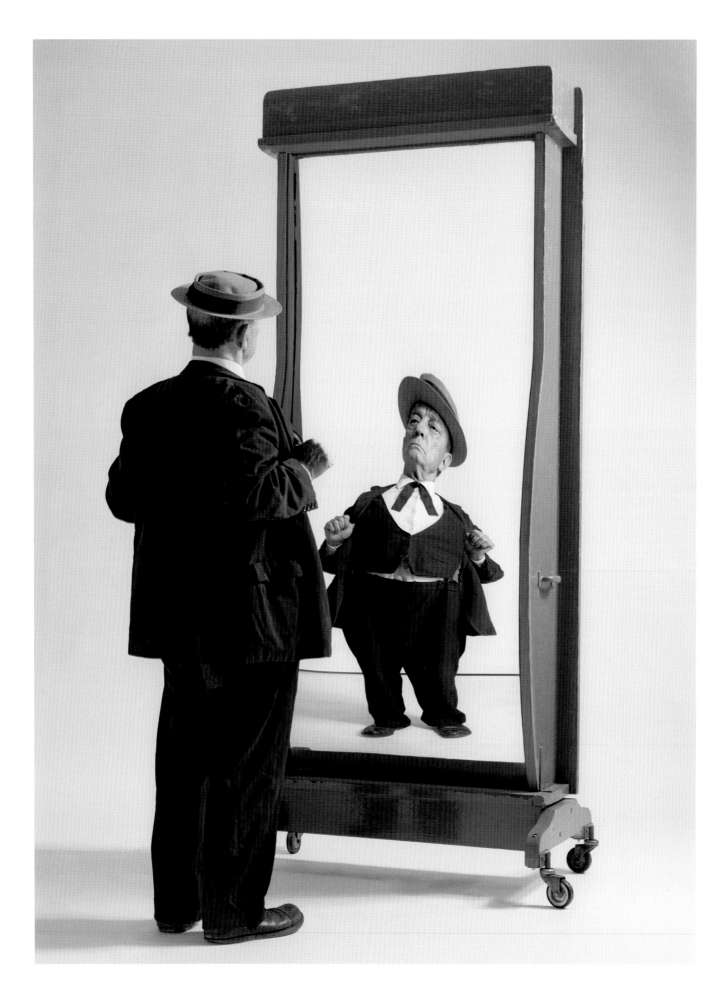

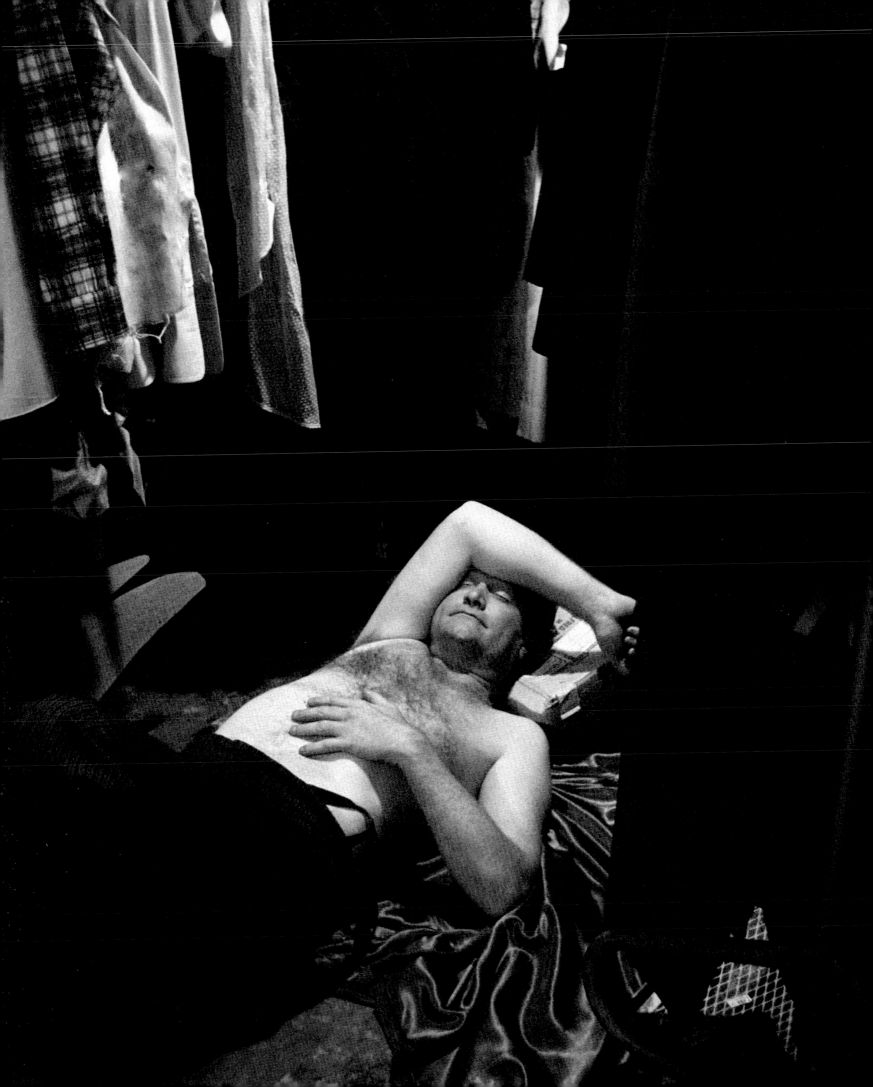

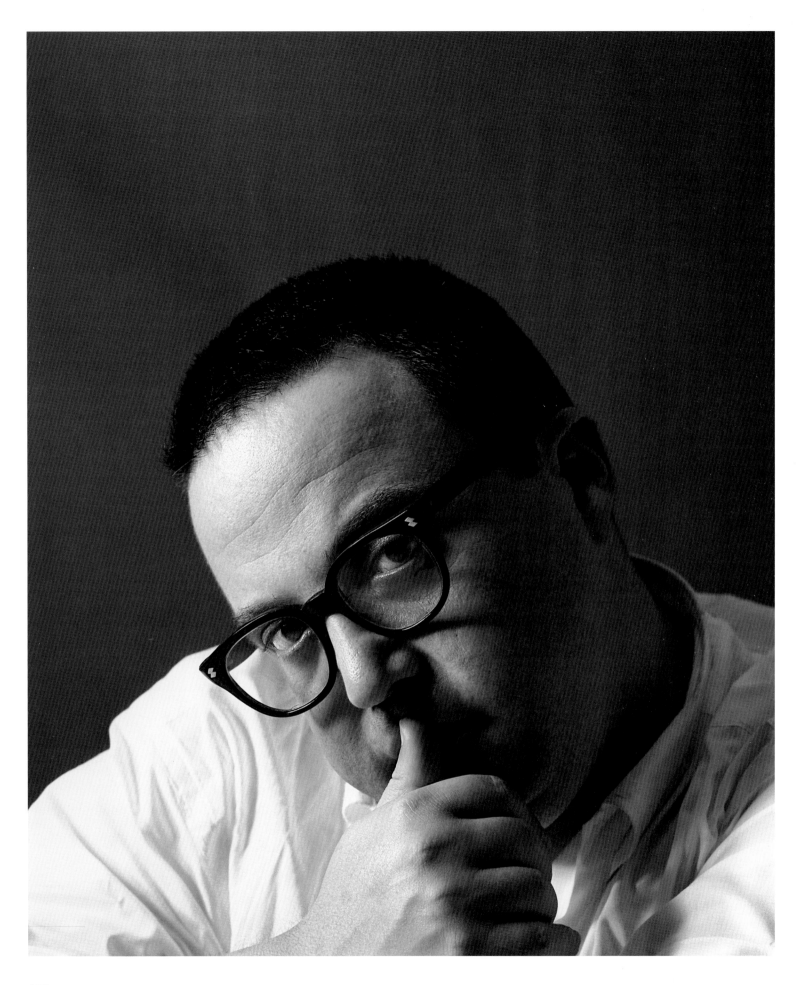

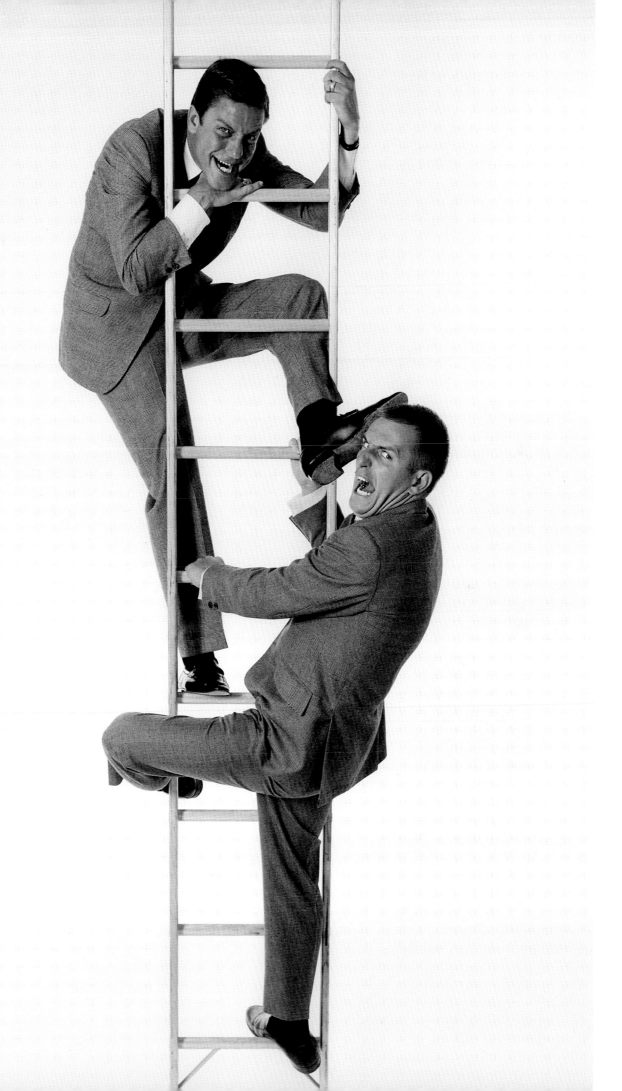

BOB NEWHART

This is the funniest guy on radio who came to Hollywood to make films. He was staying at the Beverly Hills Hotel – this was his first trip to Hollywood.

 … We went to UCLA and did a whole series of photos – of him shotputting and playing golf. This is his concept of the world's greatest hurdler in track. His sense of humor was really wonderful.

Bob Newhart is an American comedian and actor. Avery photographed him in 1961 as he was emerging as a prominent player on the stand-up circuit: the same year that his album, *The Button-Down Mind of Bob Newhart* became a worldwide bestseller. (Avery was also responsible for photographing the album cover.) It remains the twentieth best-selling comedy album in history. Newhart later starred in two incredibly popular television series, *The Bob Newhart Show* (1970s) and *Newhart* (1980s). Some of his most recent work includes *Elf* and *The Librarian* series of films.

*Bob Newhart photographed in the studio; at Lakeside Golf Club; and at UCLA. For the **Saturday Evening Post** article, 'Backstage with Bob Newhart', 14 October 1961.*

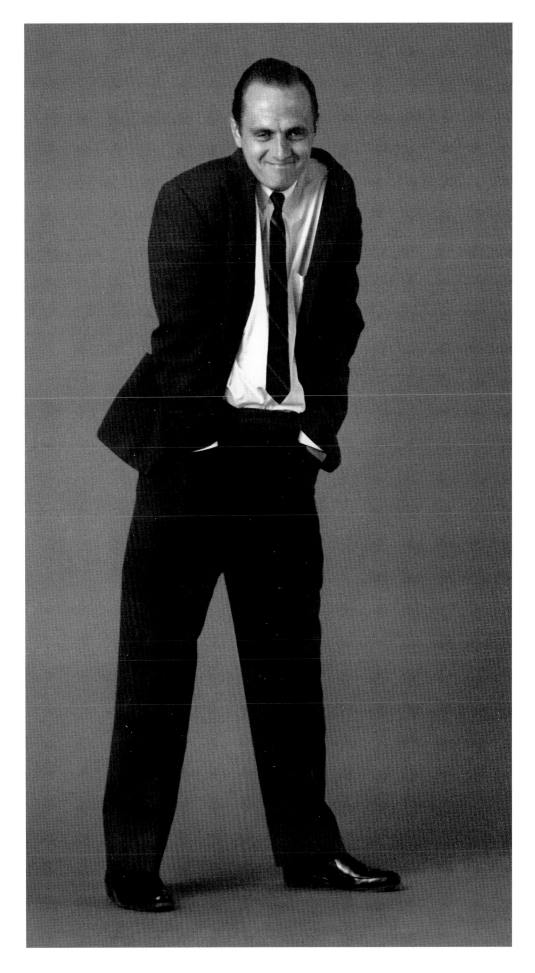

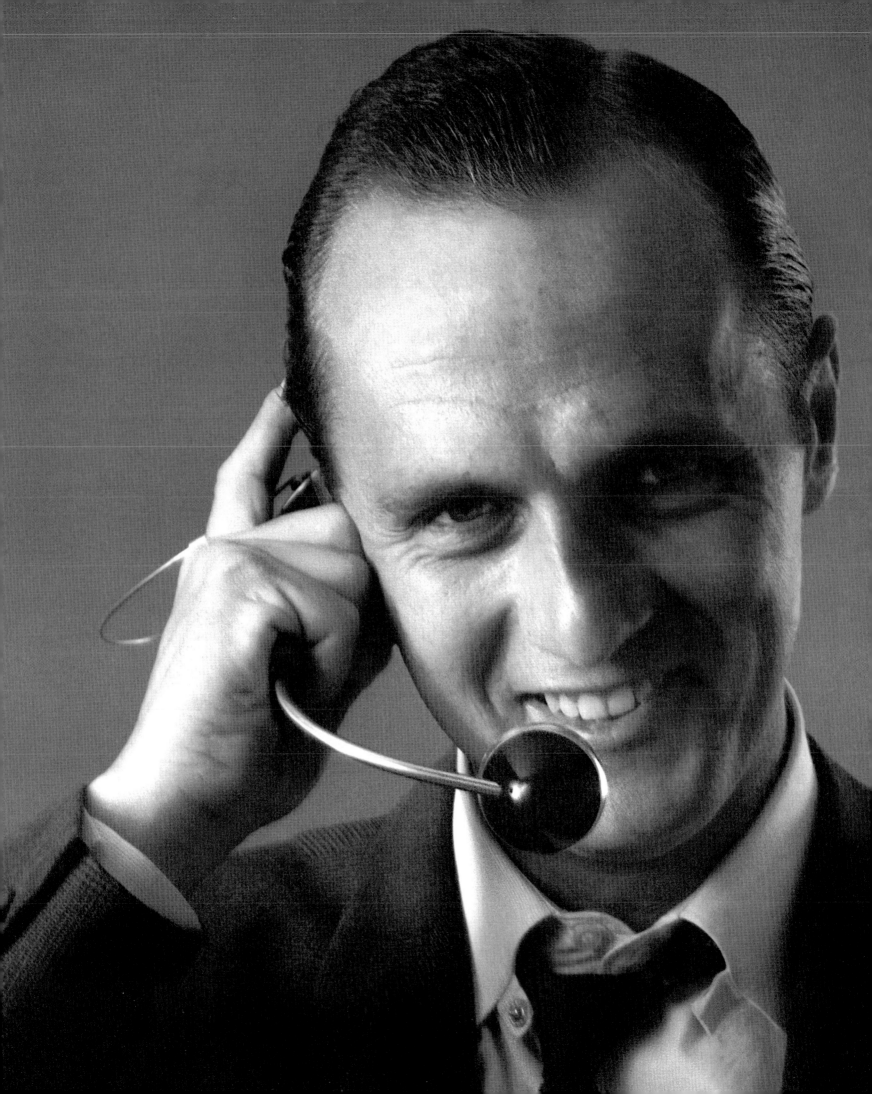

128

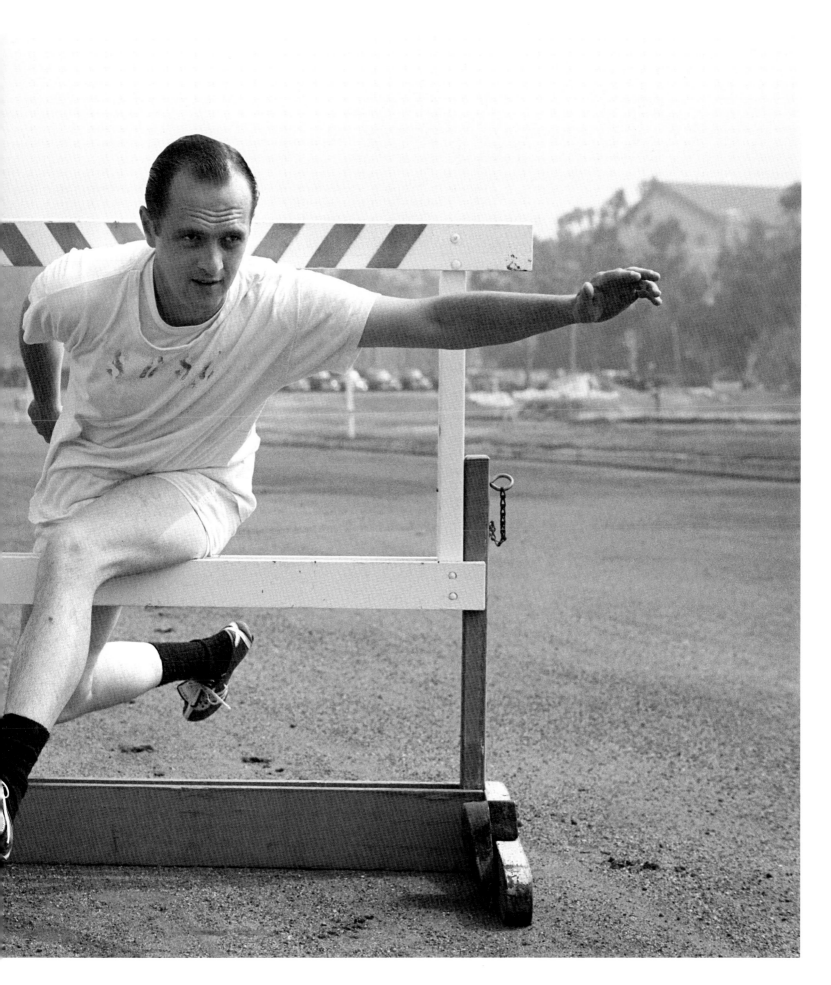

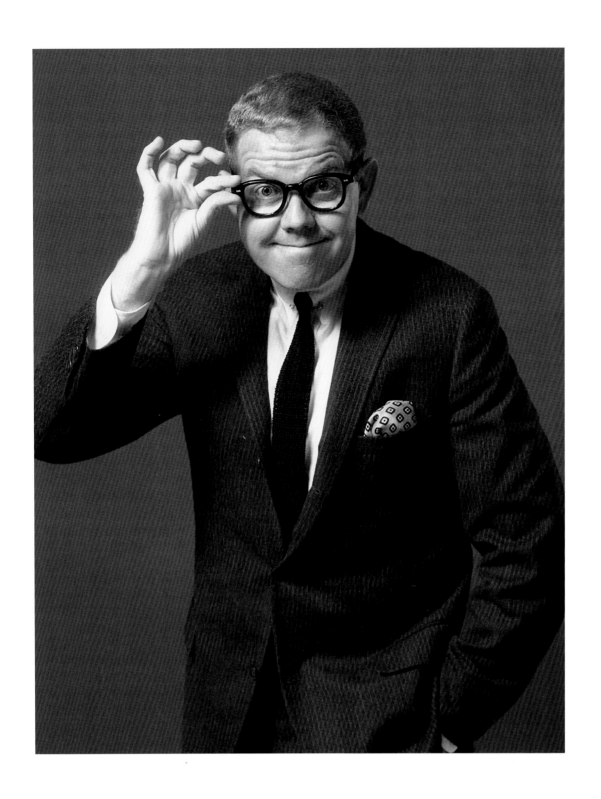

STAN FREBERG

Stan Freberg photographed for the **Saturday Evening Post** *article, 'His Private War', 1961.*

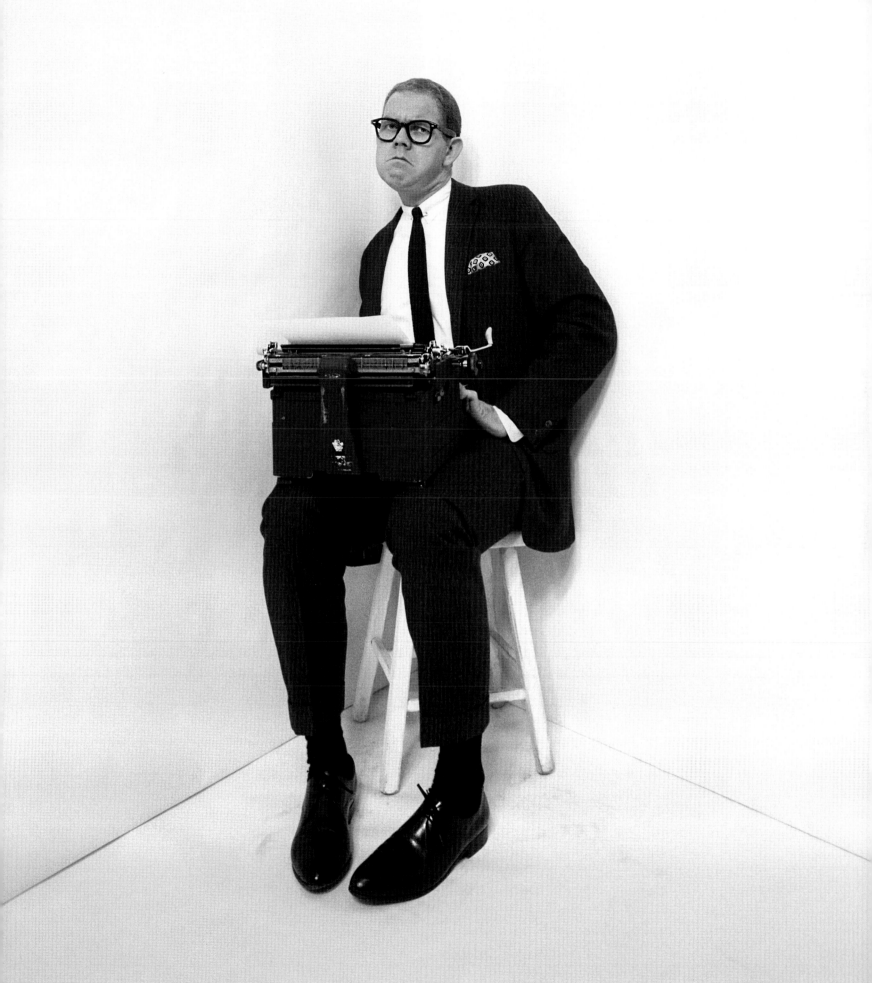

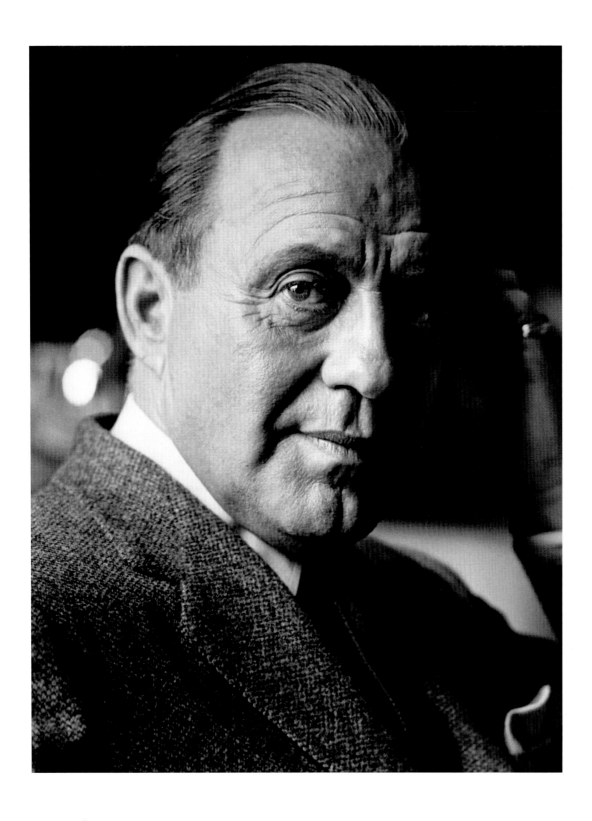

JACK BENNY

Jack Benny was one of my most favorite comedians. Pete Martin was Vice President and writer
for the *Saturday Evening Post*. He would come out to Hollywood quite often to do stories like 'I call
on Bing Crosby' or 'I call on Jack Benny' or 'I call on Elizabeth Taylor' or whoever it was. Every time
he came out (most every time), I would work with him and the particular subject.

Jack Benny photographed with Pete Martin at Republic Studios, 1957.

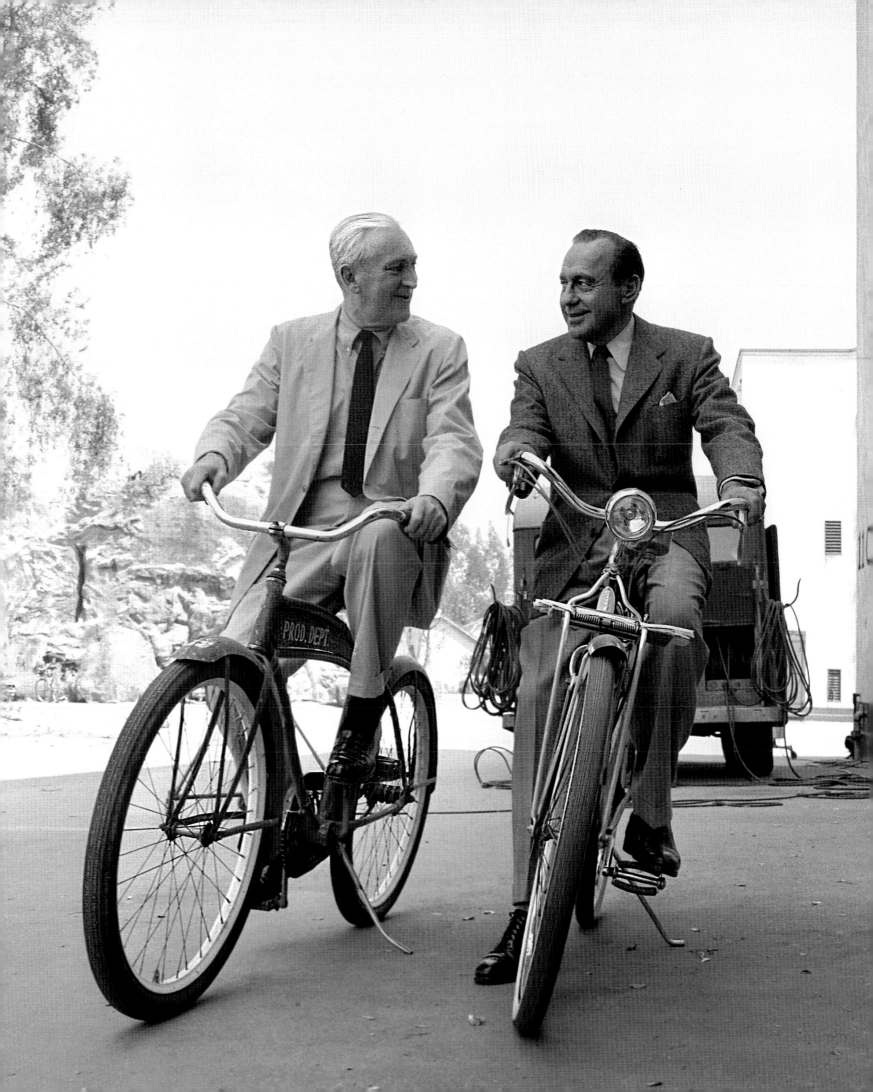

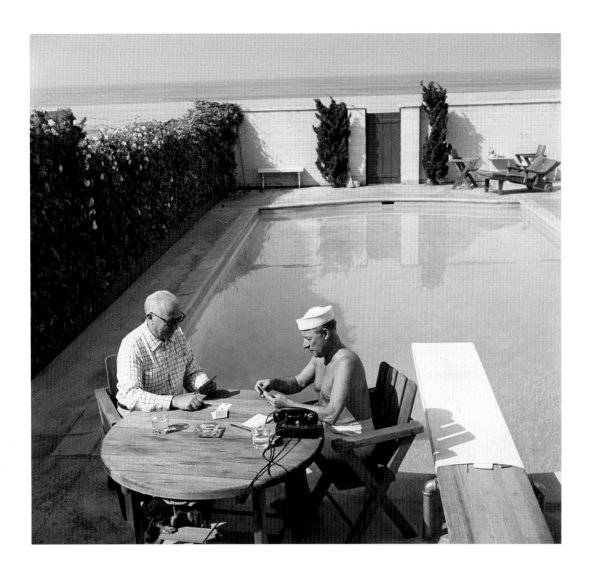

GEORGE JESSEL

George Jessel told me that he never had a meal at home besides breakfast. I thought that this shot of him with the tray of food in bed, in his monocle and robe, was so over the top Hollywood. He was really a put-on artist. He really overdid it and I thought that this was a good example of how far you would go to make yourself important in Hollywood.

 … These were some of the funniest comedians around – all at the Hillcrest Country Club where they would play pinochle or gin rummy together for pretty big stakes.

 … Out at an event – the girl on the left is Jeanne Martin (Dean Martin's wife). Bogart and Bacall were just passing by.

George Jessell photographed at home in Santa Monica; with Groucho Marx, Milton Berle, Eddie Cantor and Buddy Lester at the Hillcrest Country Club; and with Danny Thomas, Phil Silvers and Jeanne Martin (Humphrey Bogart and Lauren Bacall in background), out on the town. For the **Saturday Evening Post** *article, 'Funniest Man at the Table', 17 October 1953.*

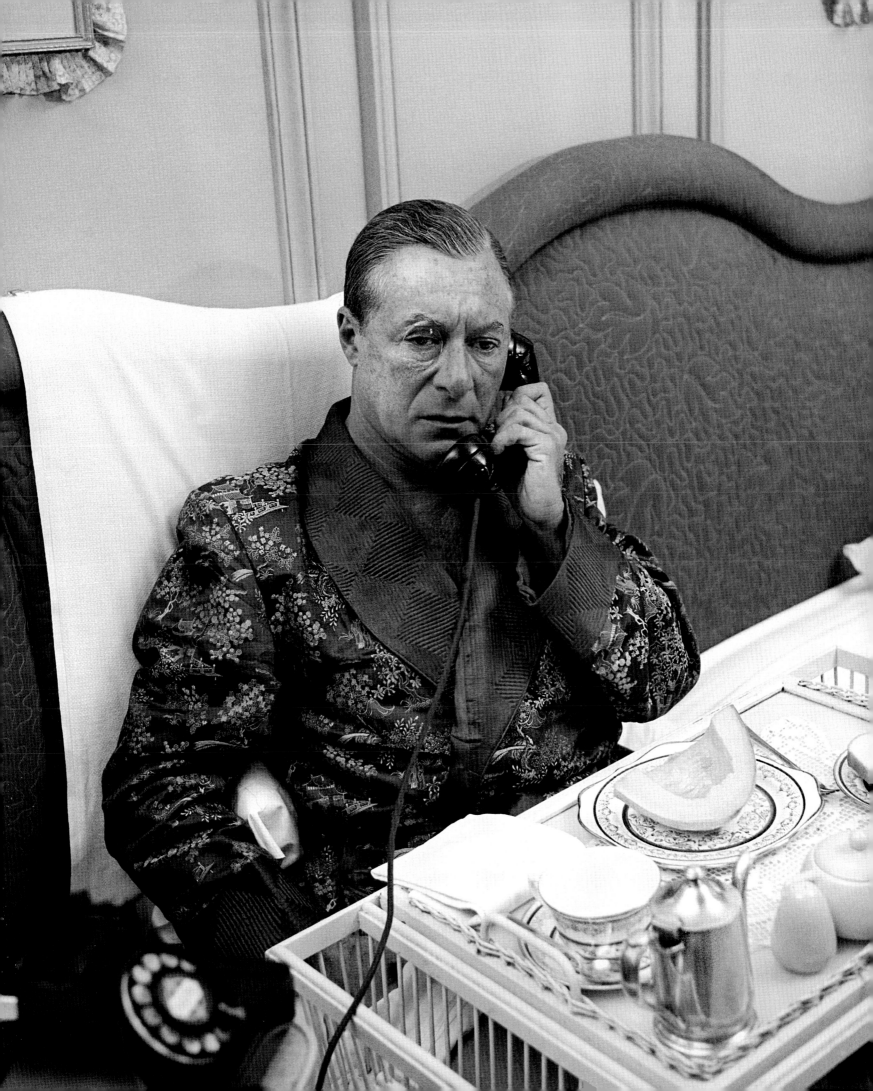

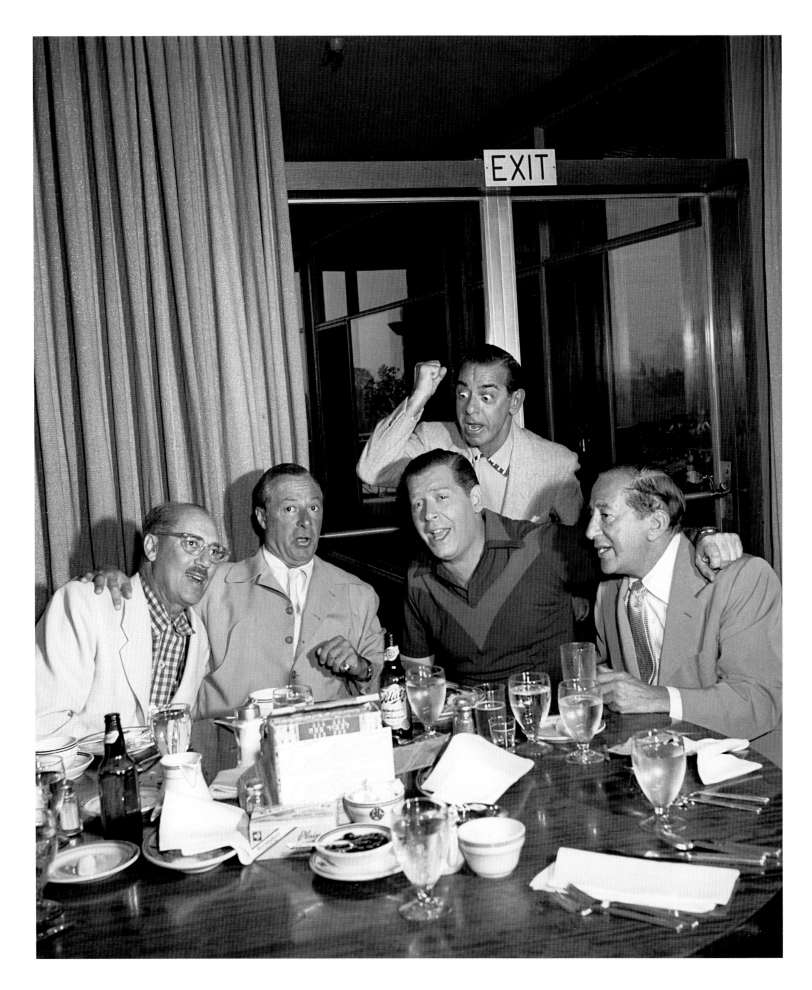

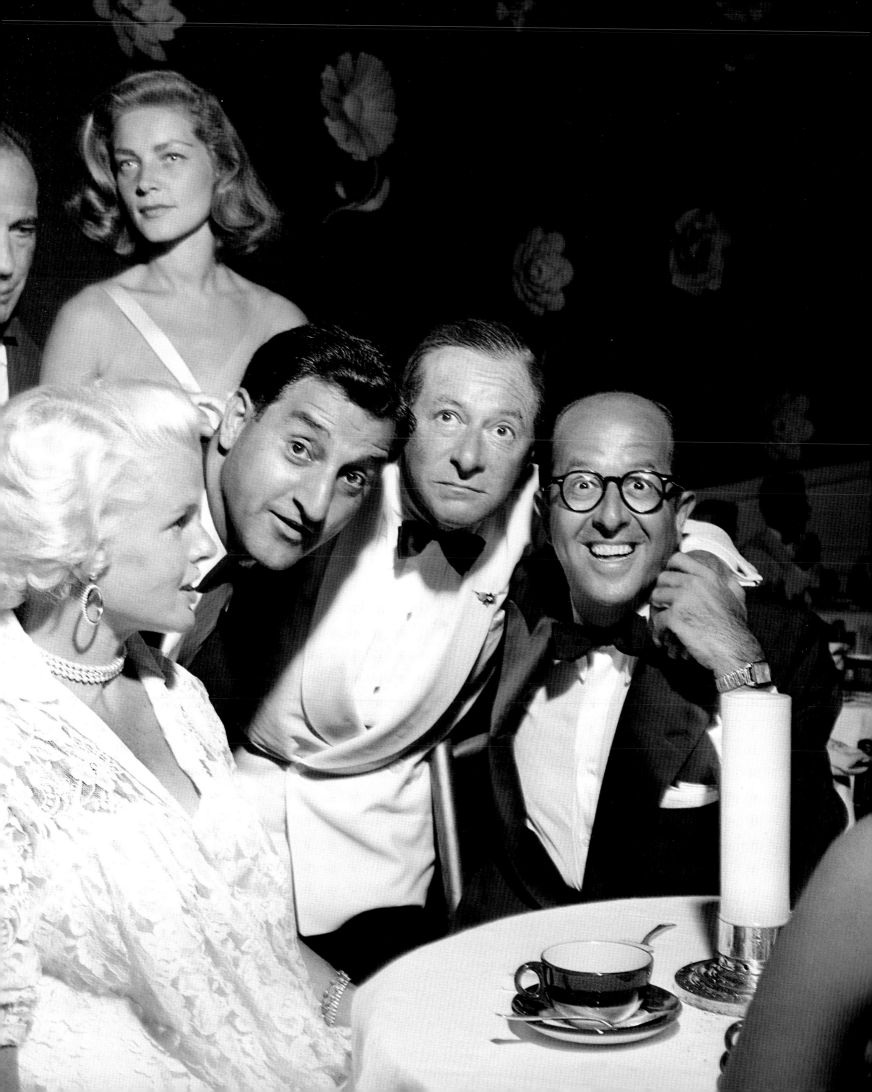

JOE E. BROWN

He was one of the nicest people in the business. He kept himself physically fit – unbelievable for a man of his age. Here he is at a UCLA football game – he was on the athletics board and was very fond of athletics. He went to all the games.

*Joe E. Brown photographed at home in Los Angeles with his wife Kathryn; and at a UCLA football game. For the **Saturday Evening Post** article, 'That Battling Buffoon Named Brown', 8 December 1951. The original caption relates that, 'Joe E. Brown (center) sits on UCLA's bench with athletic director Wilbur Johns and faculty representative David Bjork at this year's UCLA-Oregon football game. UCLA, Brown's pet team, has just scored.'*

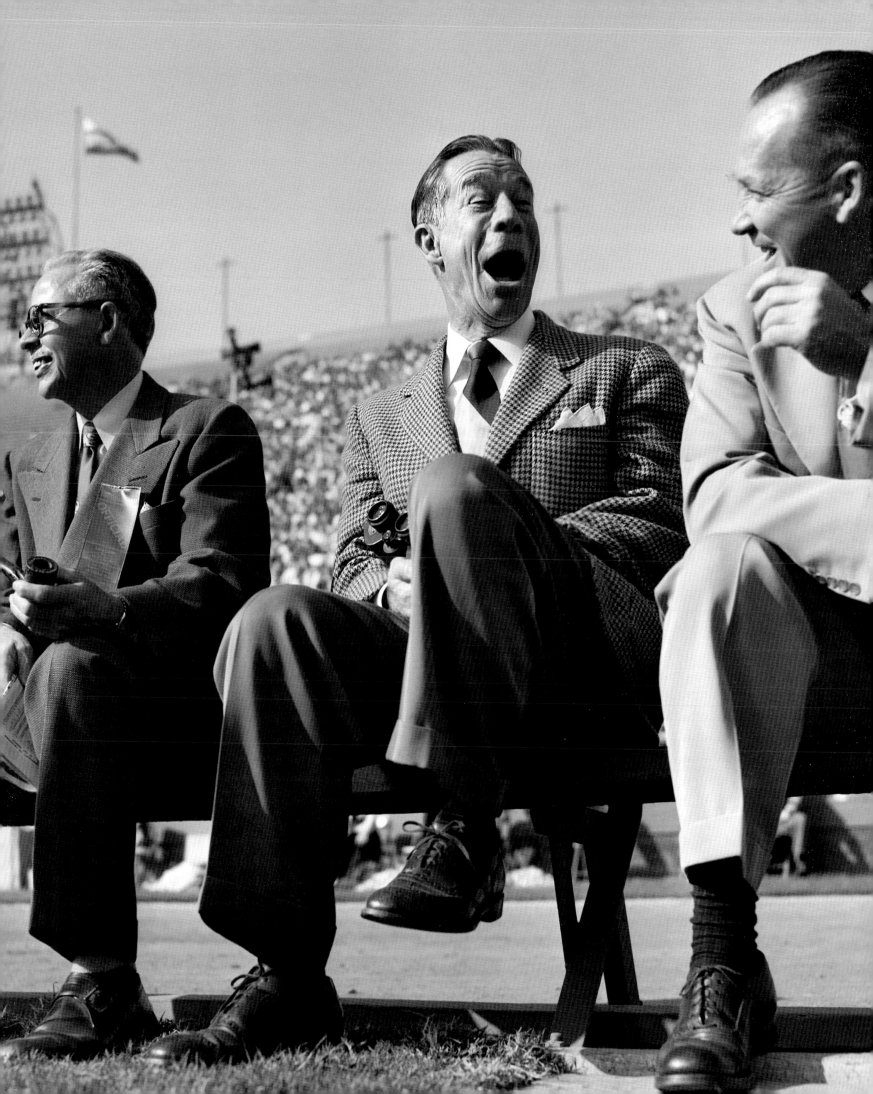

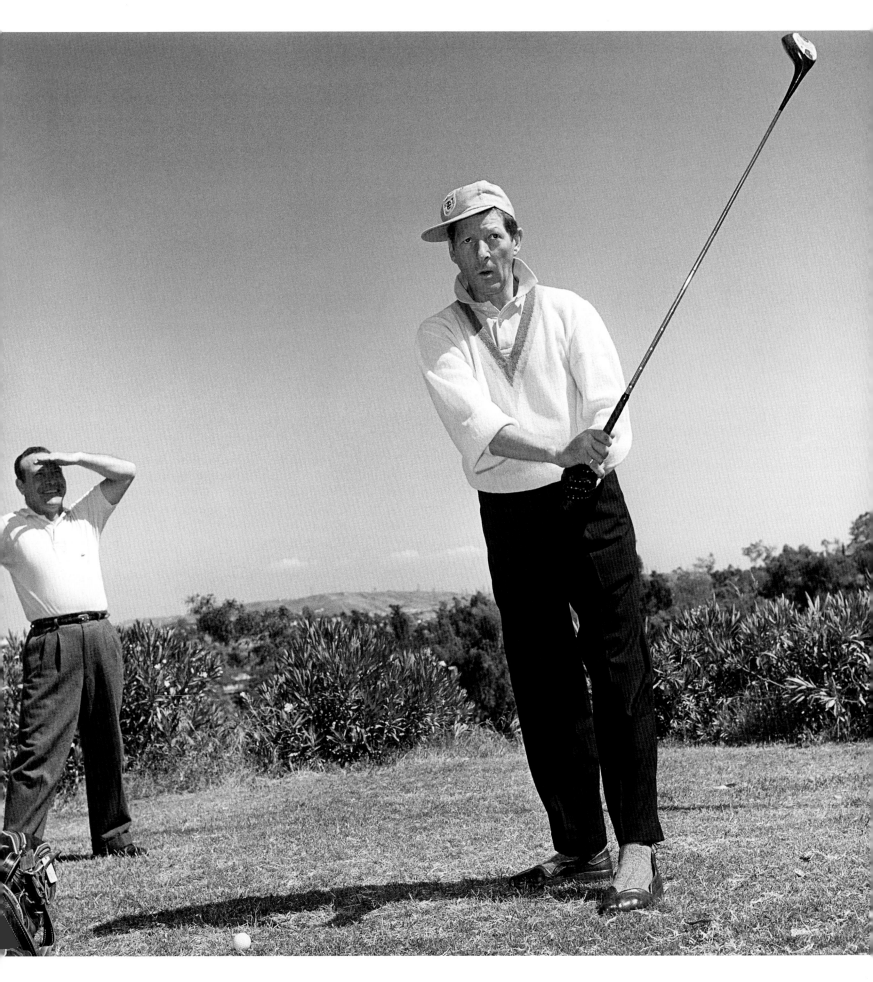

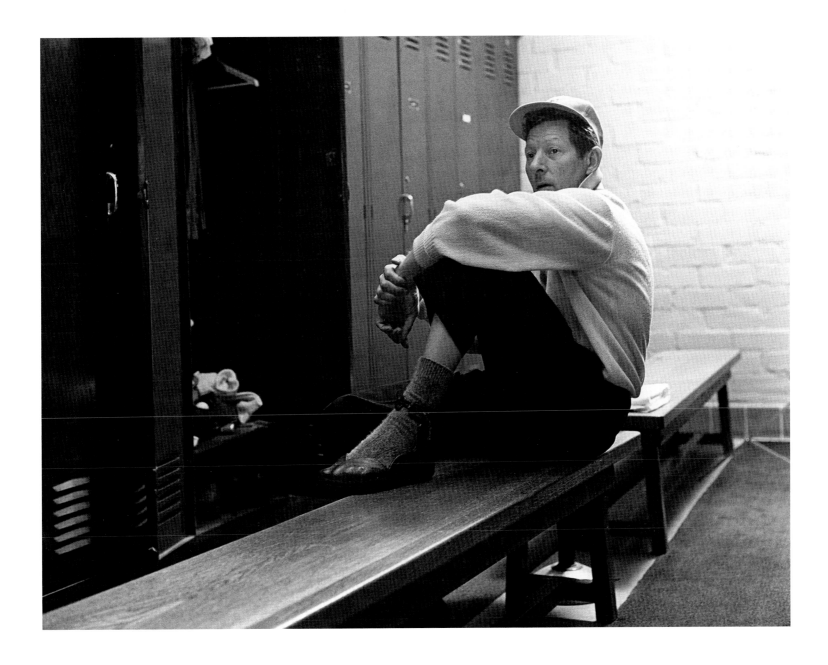

DANNY KAYE

He was really an extremely serious guy when you're with him but when he knows the camera is going to work, he always does some little gimmick to sort of liven it up.

He was a member of the Hillcrest Country Club (a golf course in Los Angeles). He has his spare shoes on that are molded to his feet so that they perfectly fit him. After I saw that (and I was having a foot problem), I had a pair made and they killed me. I stopped wearing them.

*Danny Kaye photographed on the golf course and in the locker room of the Hillcrest Country Club. For the **Saturday Evening Post** article, 'I Call on Danny Kaye', 9 August 1958.*

SAMMY CAHN

He was the hot songwriter of the day and he did a great amount of work with Sinatra, writing songs for Frank when he was at Capitol, Reprise and Warner. He had a typically beautiful home, right next to Art Linkletter on Mapleton Drive.

Here they are in their Hollywood home, in the swimming pool, chucking balls around. That's so Hollywood that I think it's wonderful.

*Sammy Cahn photographed backstage at a TV special, **The Frank Sinatra Timex Show: Bing Crosby and Dean Martin Present High Hopes**, and at home in Los Angeles with wife, Gloria, and children. For the **Saturday Evening Post** article, 'The Sammy Cahn Story', 1959.*

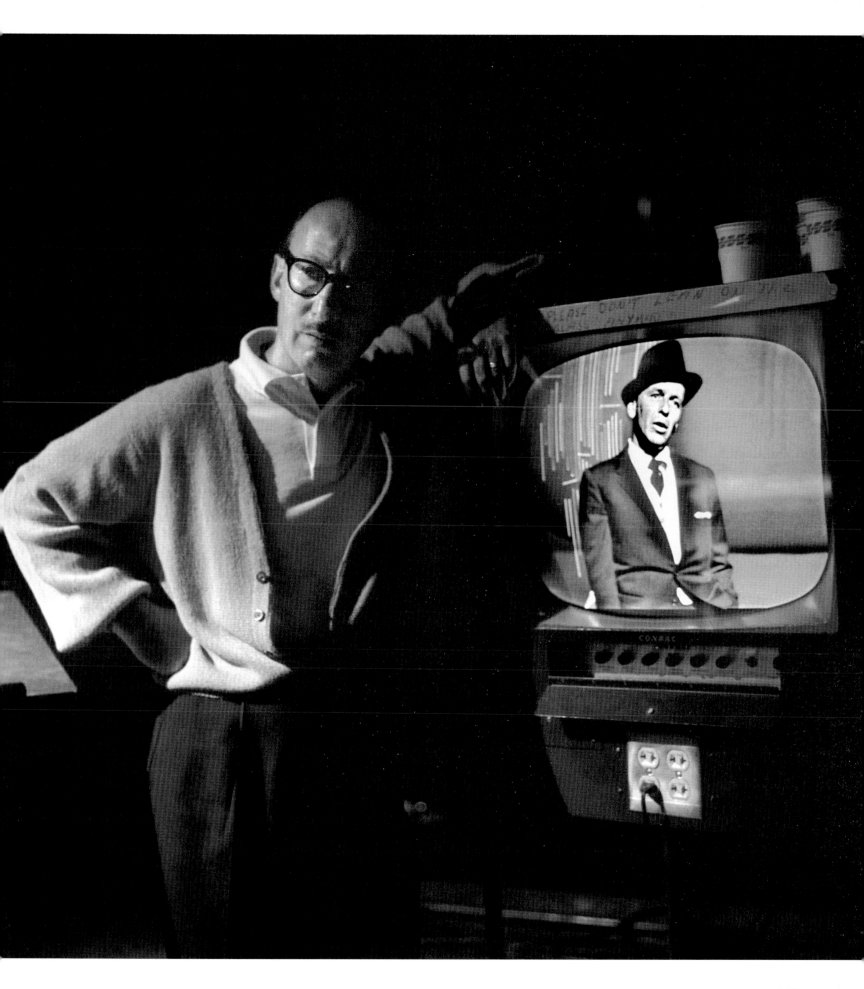

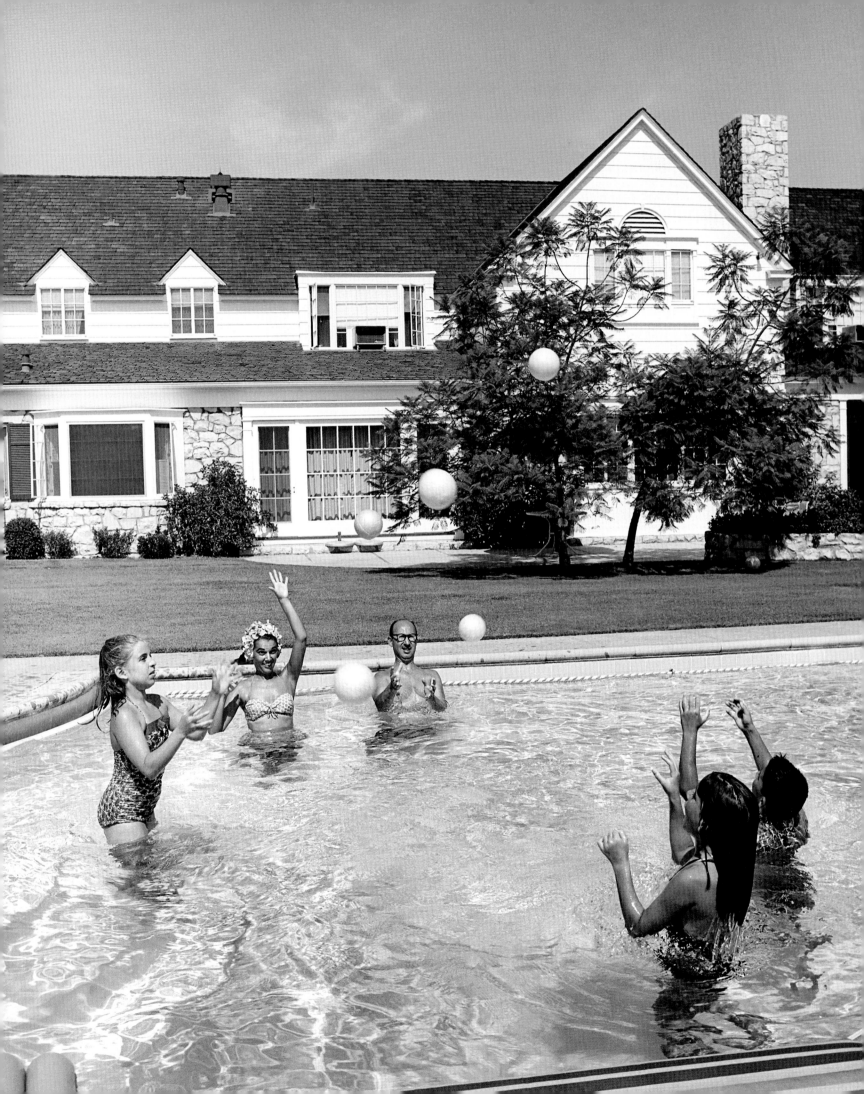

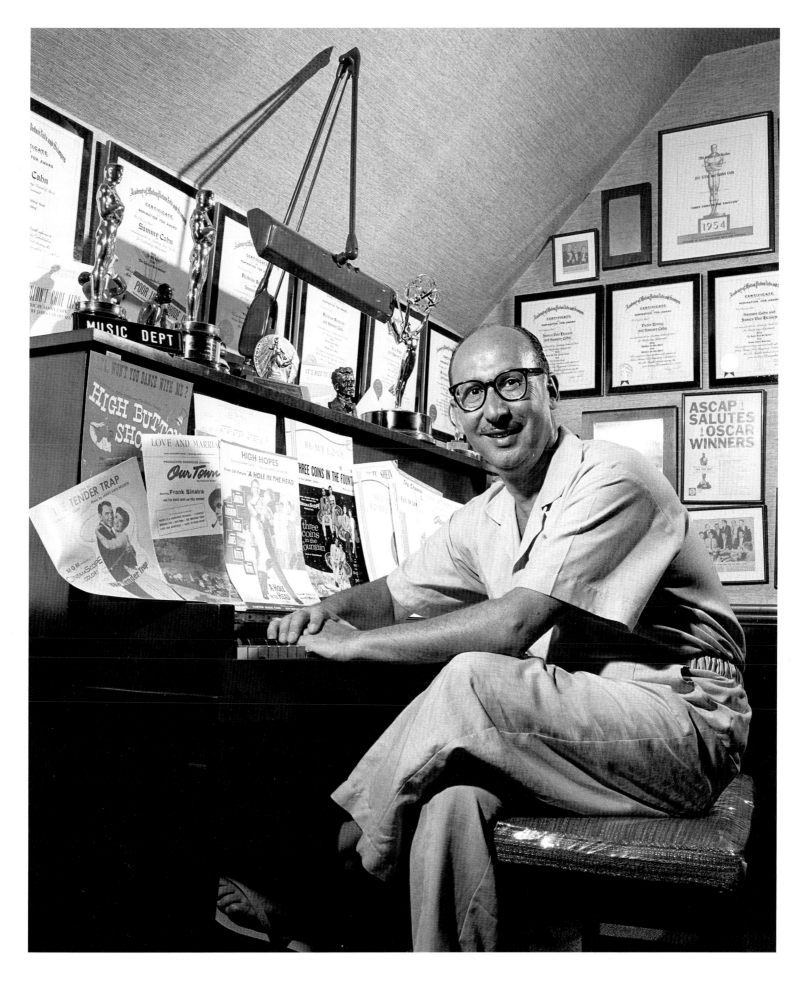

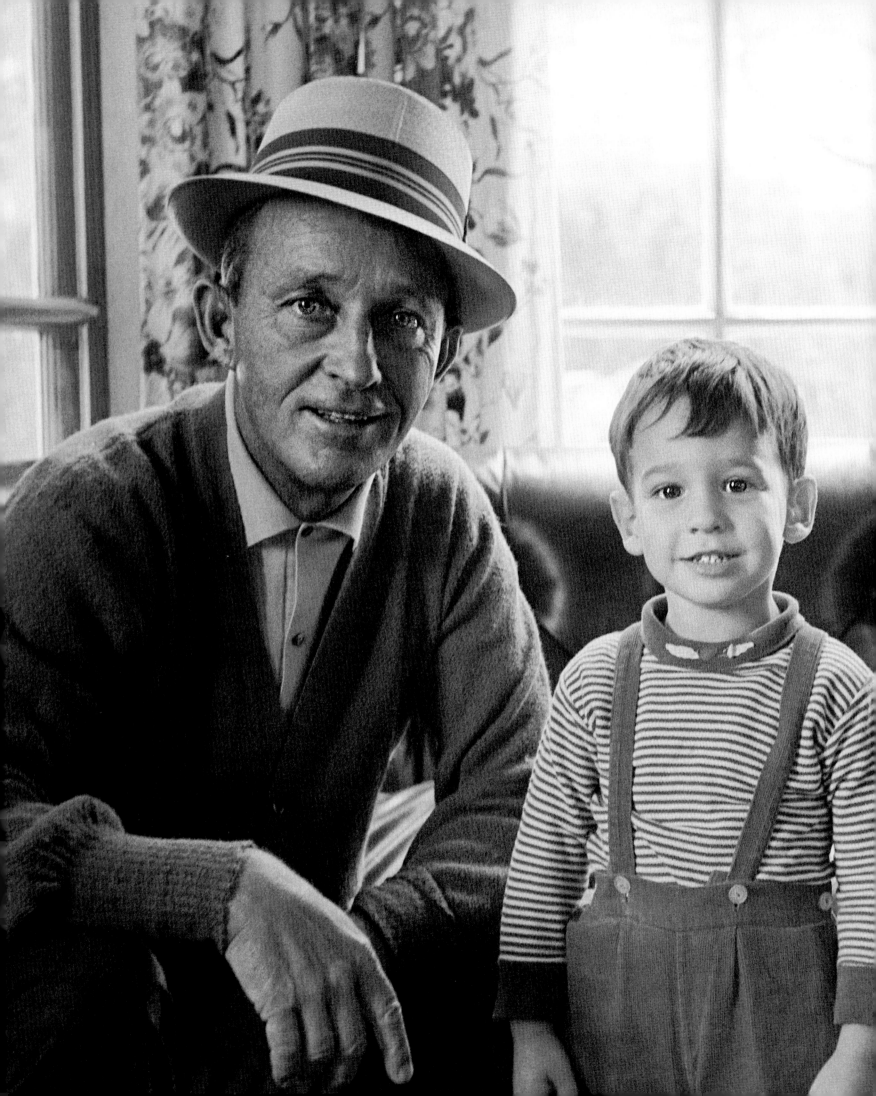

BING CROSBY

His older sons were not around – they had already left the coop. He was probably the toughest guy to photographers of anybody in Hollywood. He would do anything he could (although this picture doesn't look like it) to avoid letting you get pictures of him. And when you did get an opportunity, it was so few and far between that I considered it an accomplishment to get this picture. The reason he wears the hat is because he's quite bald and he has a piece that he wears. I guess photographers on occasion have taken pictures of Bing without his hair piece (something that I wouldn't have done) – so that kind of explains why he wears a hat.

*Bing Crosby photographed at his Holmby Hills home with his children, Harry and Mary Frances. For the **Saturday Evening Post** article, 'I Call on Bing Crosby', 5 August 1961.*

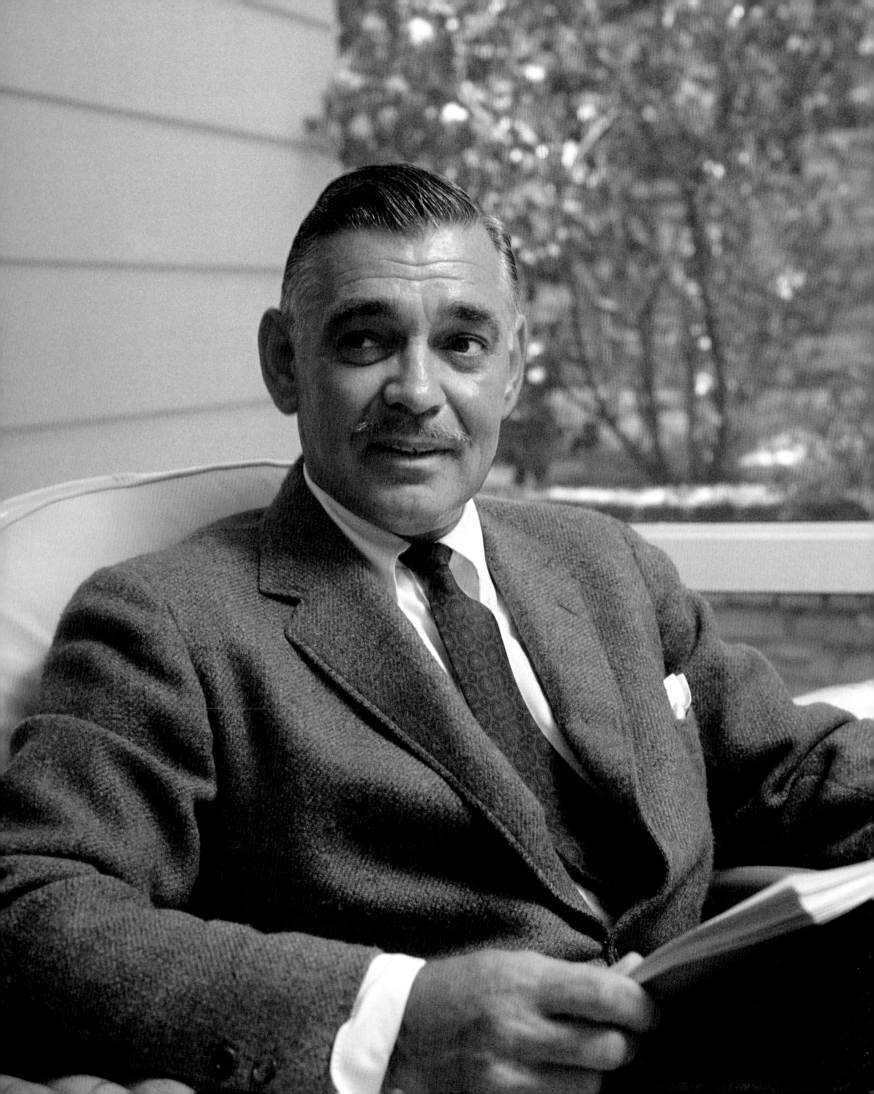

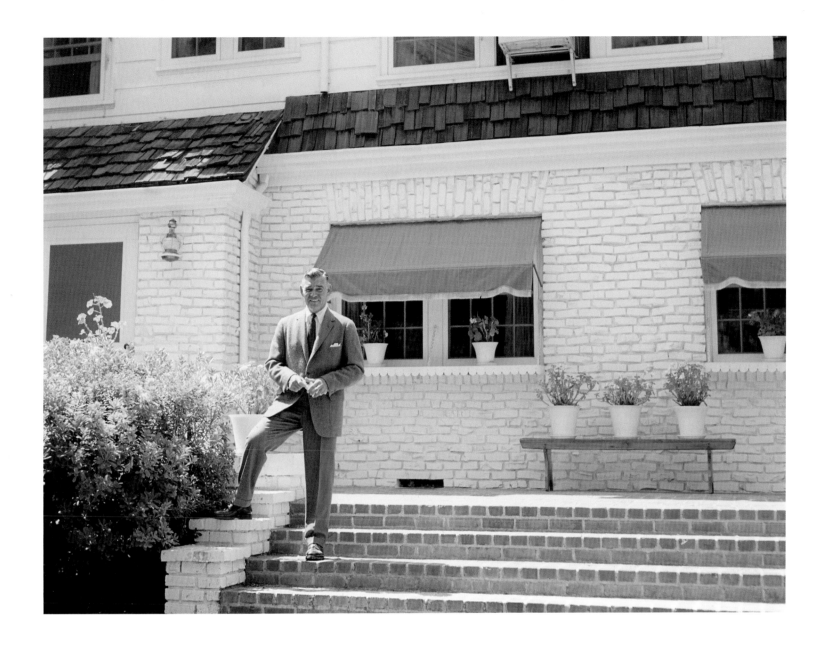

CLARK GABLE

The only time I was in awe of a celebrity in my career, as he was known as 'The King' – but somehow he made me feel welcome. He wouldn't allow anyone inside his home but I shot this on his porch. I made a considerable amount of shots of him in the garden. He was very relaxed during our shooting session, not only at home but on the town. I was so thrilled to be in his presence.

*Clark Gable photographed at his Encino, California, home and on the Paramount lot with Doris Day and producer William Perlberg (Perlberg was the producer on Gable's picture, **Teacher's Pet**, being made at Paramount). Photographed for the **Saturday Evening Post** article, 'I Call on Clark Gable', 5 October 1957.*

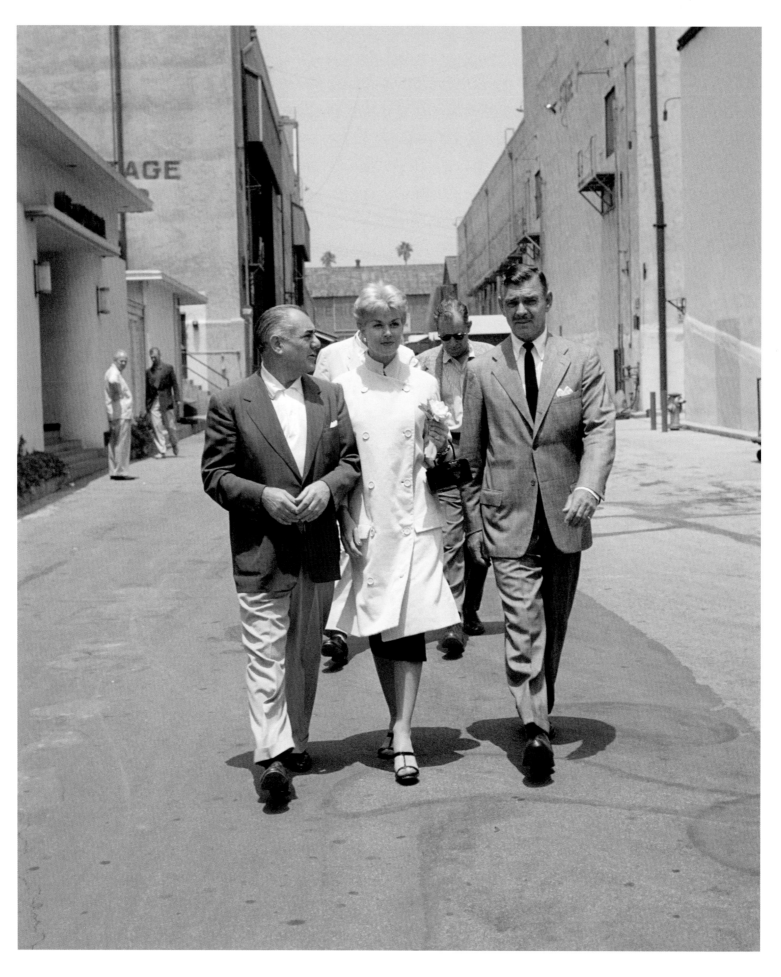

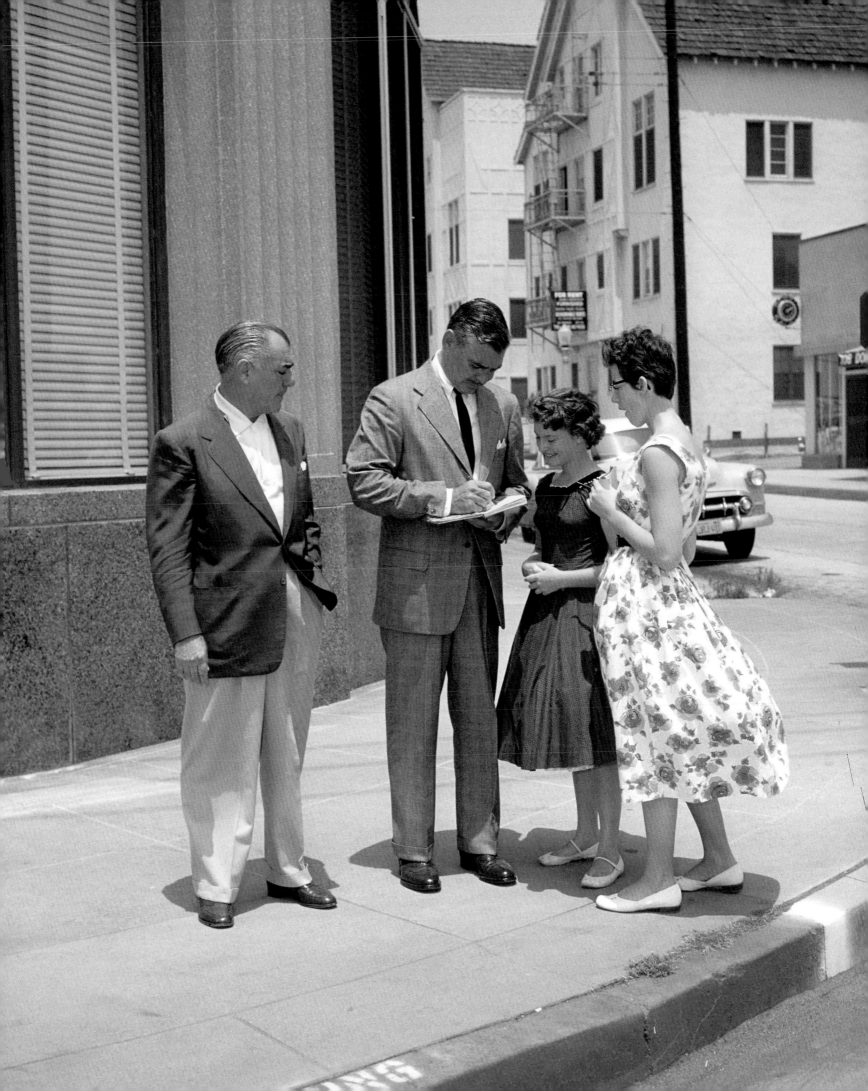

DEAN MARTIN

Talk about 'relaxed' – he was the epitome of cool. Loving father, extremely funny and talented, and a great joy to work with.

Dean was leaving his restaurant, Dino's, on Sunset Boulevard. All these fans would hang out there because celebrities always came to his restaurant.

… You can see what his lunch was composed of – it looks like a martini, an egg and maybe a muffin. He was a very popular singer, actor, entertainer, good golfer and an all around nice guy. He was always one of my favorite people. I thought of the whole Rat Pack, he was the one that had the greatest sense of humor. He was naturally funny.

His eldest son, Dino, was later killed (he was in the Air National Guard and his plane flew into a mountain). Dean was a great family man – even when he was working in Las Vegas, he would always get to bed early so that he could get up early and play golf.

Avery spent a considerable amount of time with Dean Martin and photographed him on a number of occasions. In 1959, he captured Dean at work in the studio with Sammy Cahn and Louis Prima. In 1961, while working on an assignment for the **Saturday Evening Post** *('I Call on Dean Martin', 29 April 1961), he photographed Dean leaving his restaurant, arriving home in his 1960 Facel Vega HK500 and surrounded by his family at his Brentwood home (with wife Jeanne and children Claudia, Gail, Deana, Gina, Dean Paul and Ricci).*

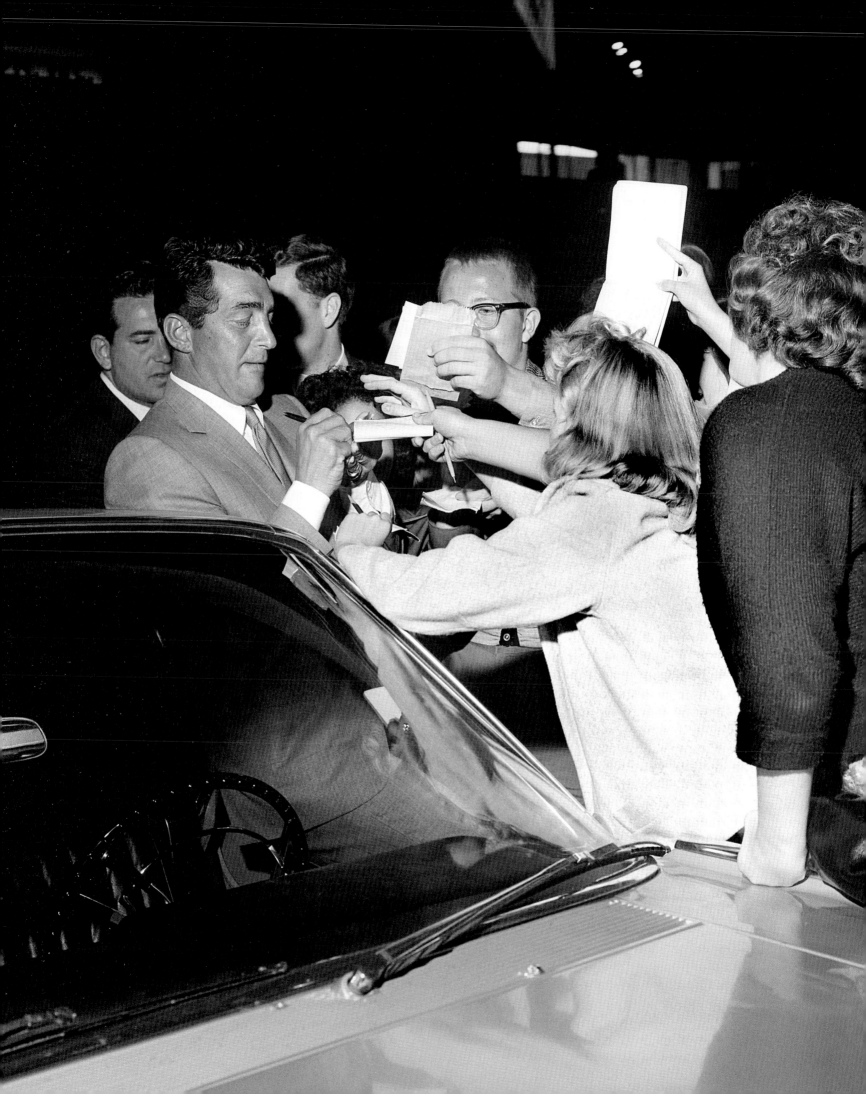

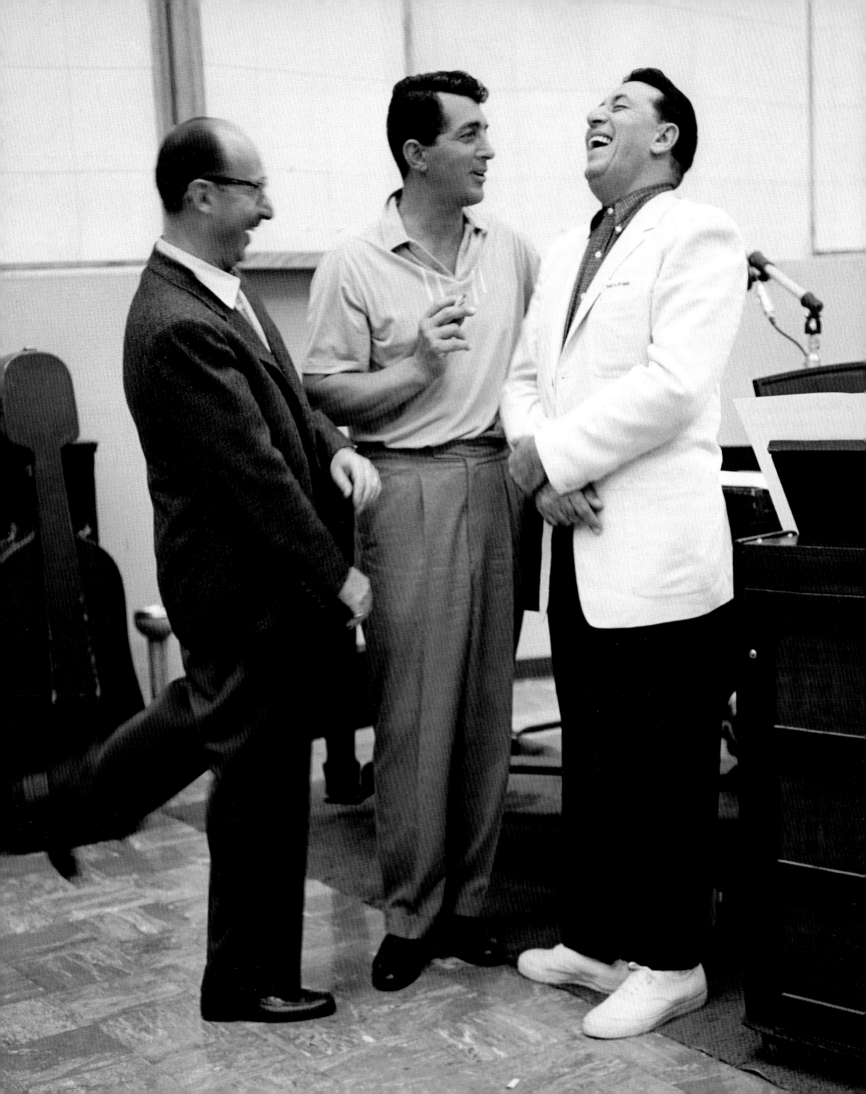

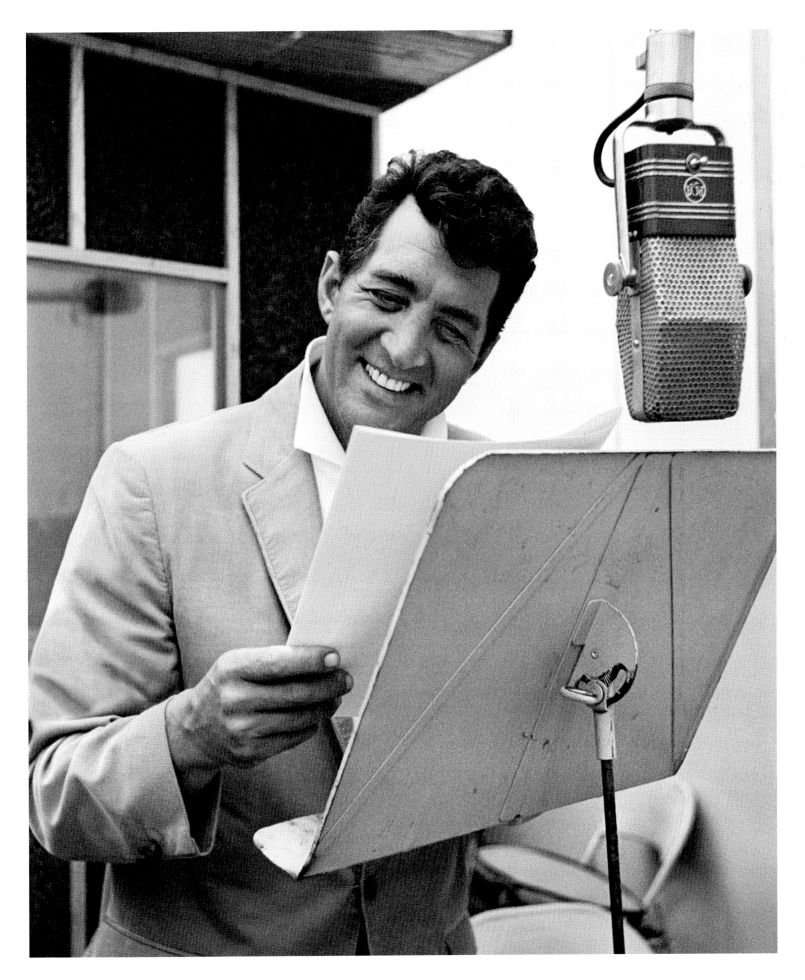

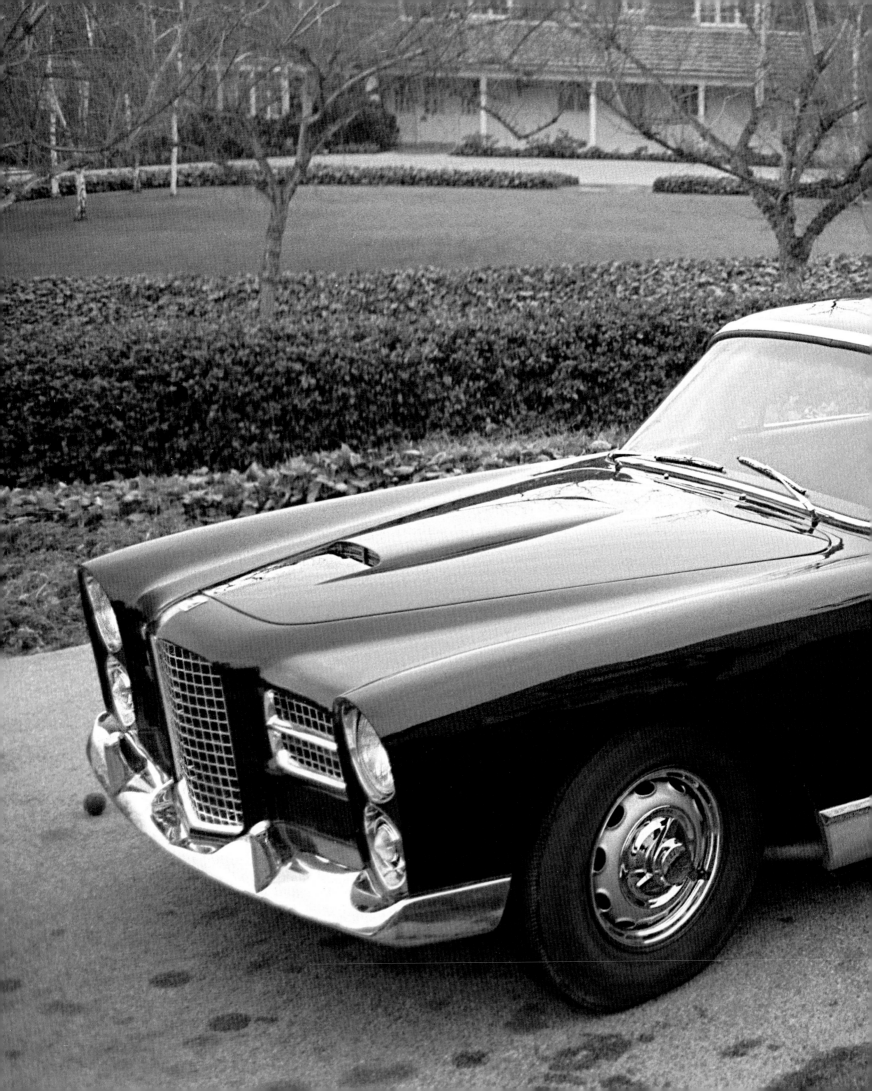

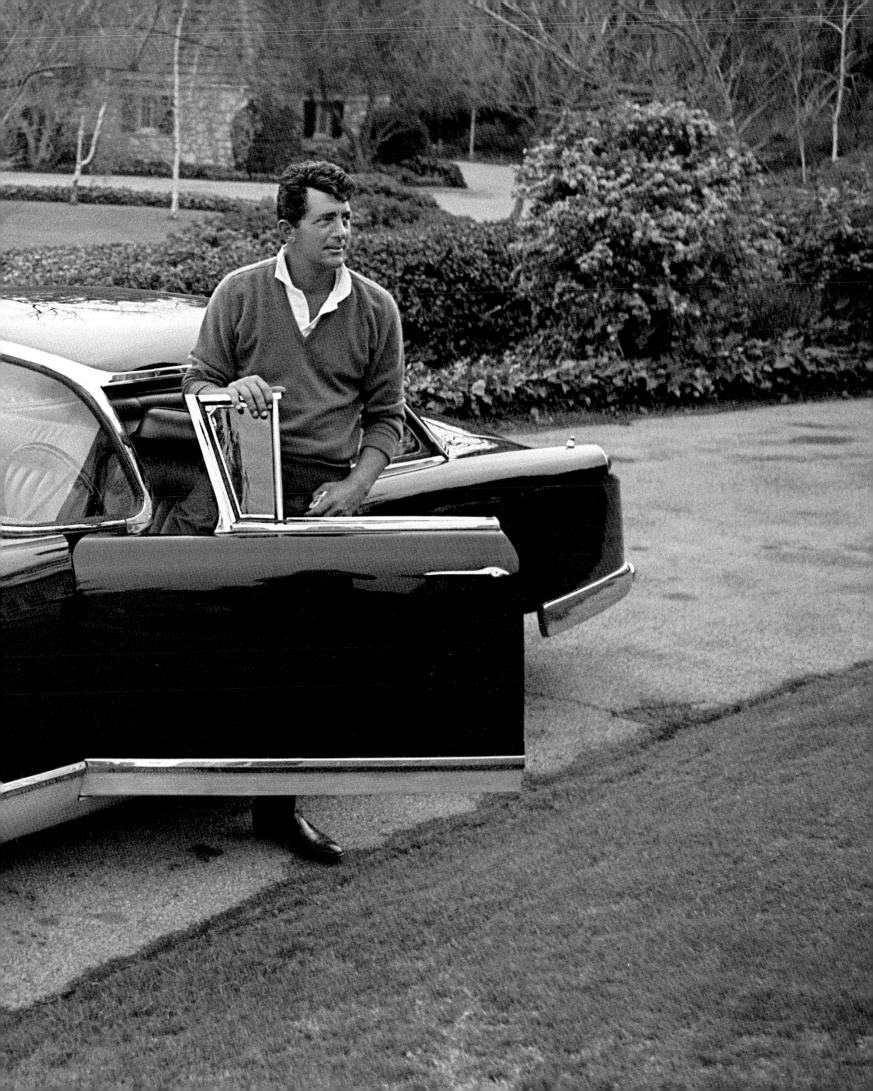

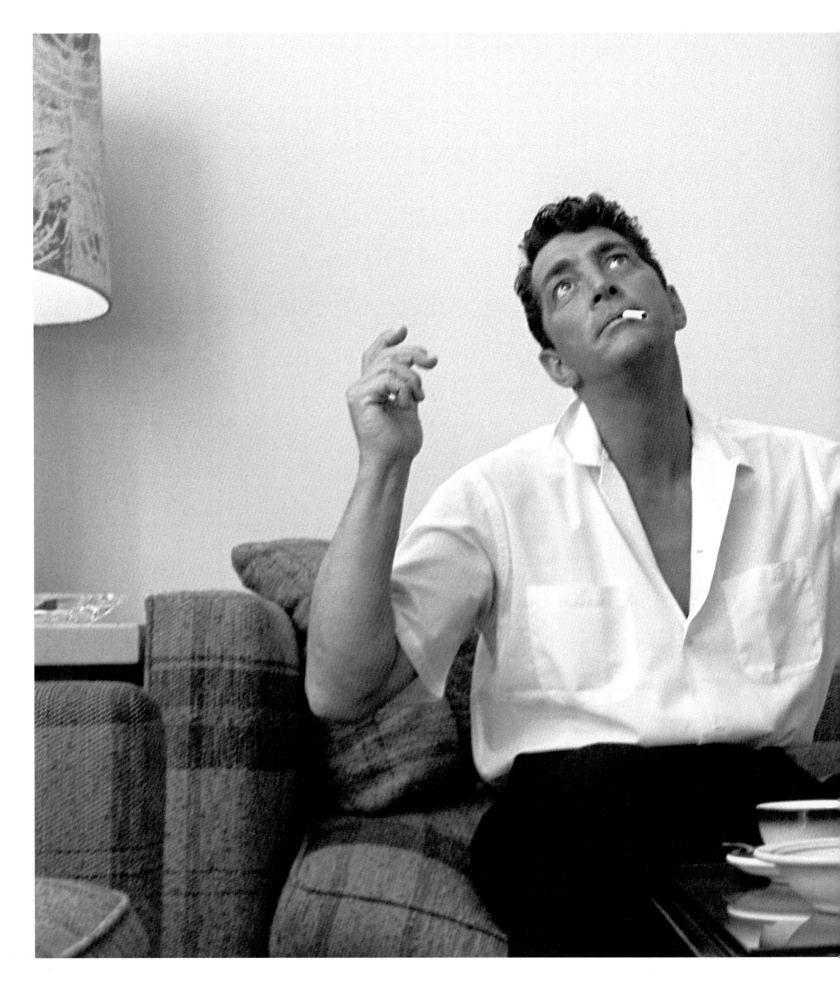

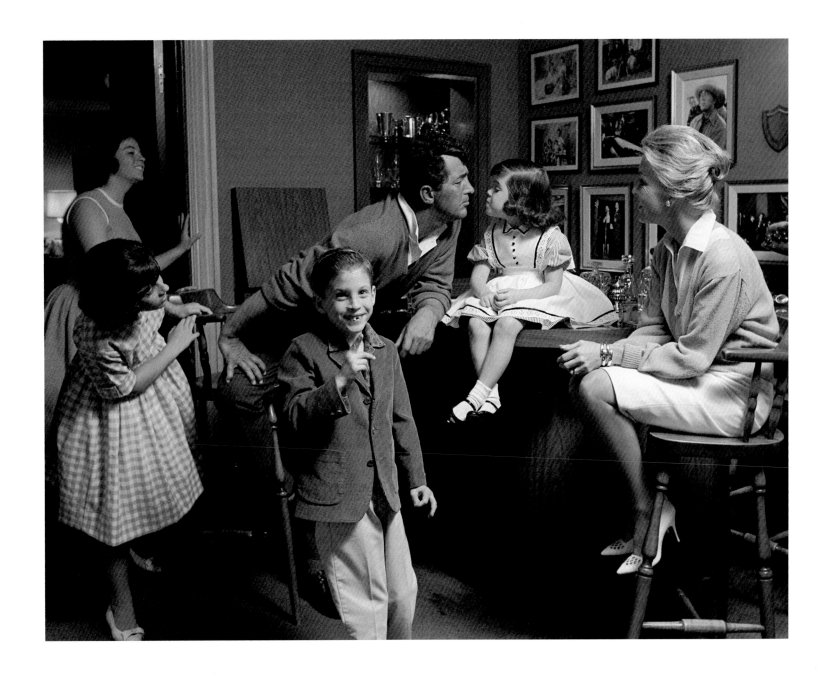

Deana Martin fondly remembers Sid's time with her family in a letter to his son, Ron:

With pride I can say I am fortunate to have known Sid Avery – if you have a few hours I'll tell you the many reasons why! In this short parcel of printed real estate, I will tell you Sid Avery was always a gentleman and the very definition of a great photographer. I recall his visits to capture the Dean Martin family on film at our home in Beverly Hills. We were all nervous, but soon found ourselves feeling at ease with Sid (he even had a sense of humor that equaled my father's.) It didn't take long for us to feel comfortable and safe through the lens of Sid Avery's world. To this day, Sid's silver framed photos fill and adorn our home. He was a noble man, a giant in his field and he remains a National Treasure.

My husband John and I spent many cherished evenings with Sid and his lovely wife Diana. We'd never tire of hearing the stories of his encounters with Hollywood royalty and his life experiences; I miss him deeply. Sid Avery loved his family and his work – and I love Sid Avery!

Memories are made of this.

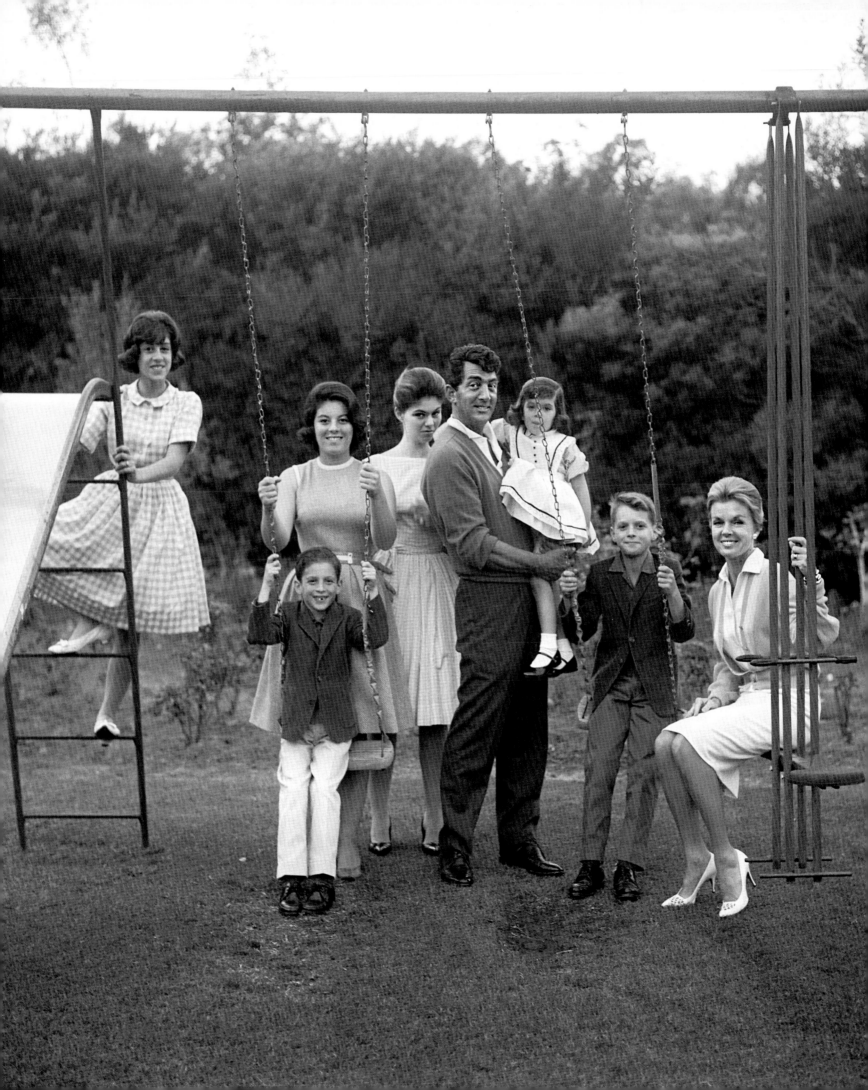

SAMMY DAVIS JR.

This is Sammy in his den [see p.168], alongside his pool, hanging up some of the photographs he'd taken. He was a wonderful photographer.

Avery spent a lot of time with Sammy Davis Jr. and photographed him on several occasions, including: at his Hollywood Hills home playing the piano; entertaining guests – in the party photograph, Sid's wife, Diana, is pictured in the centre of the shot; practicing his six shooter quick-draw with Tommy Sands and Bob Six; relaxing with his drummer, Michael, and his secretary, Jim Waters; and playing by the pool.

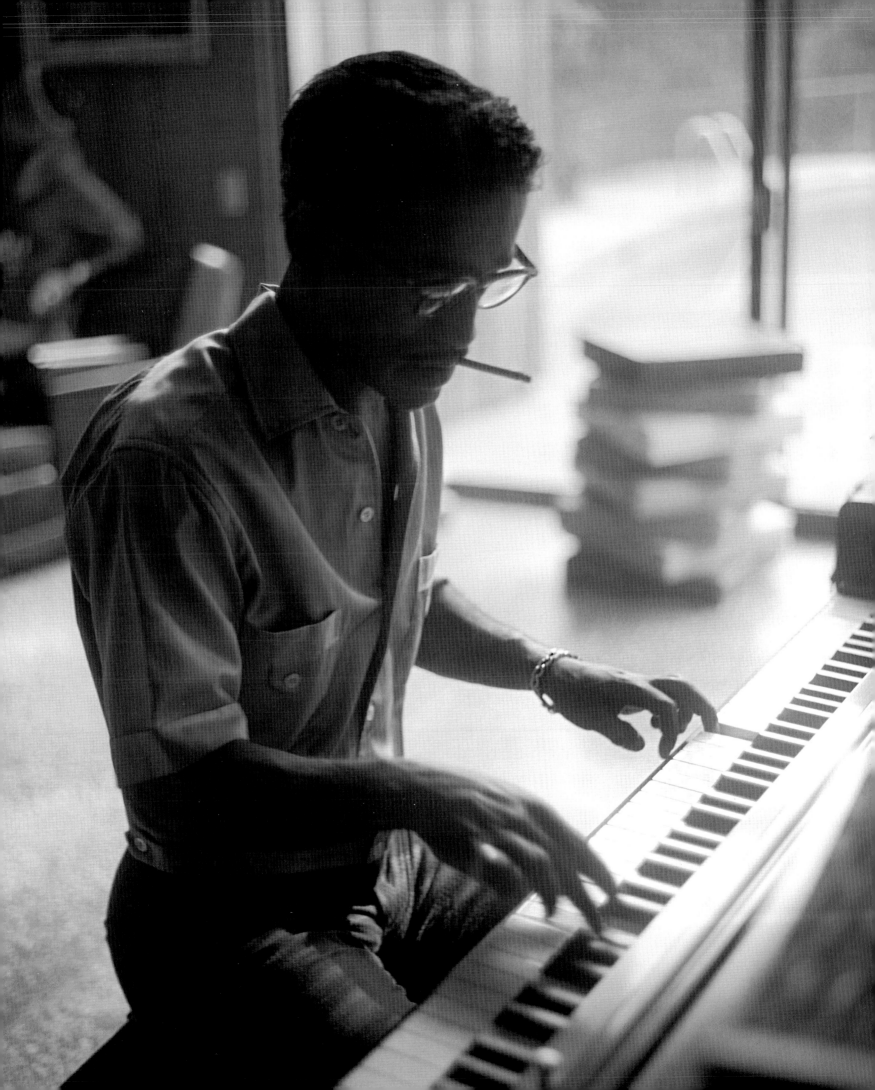

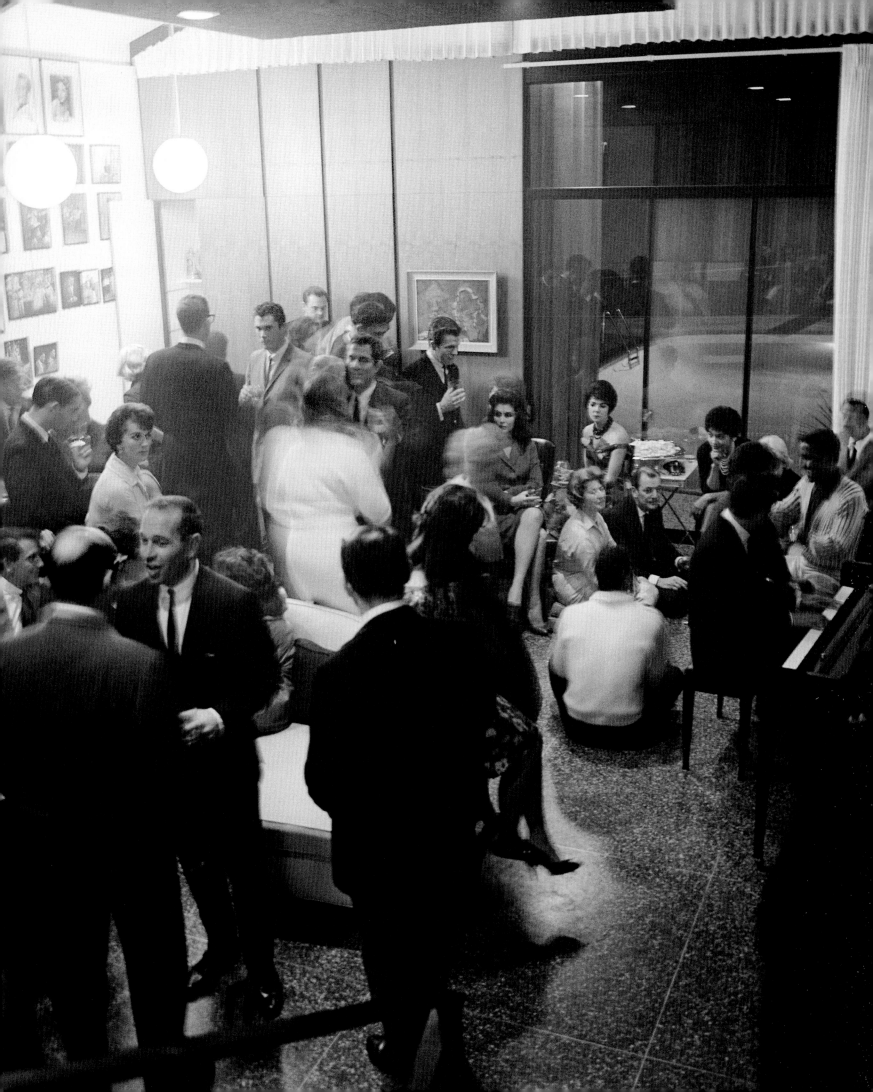

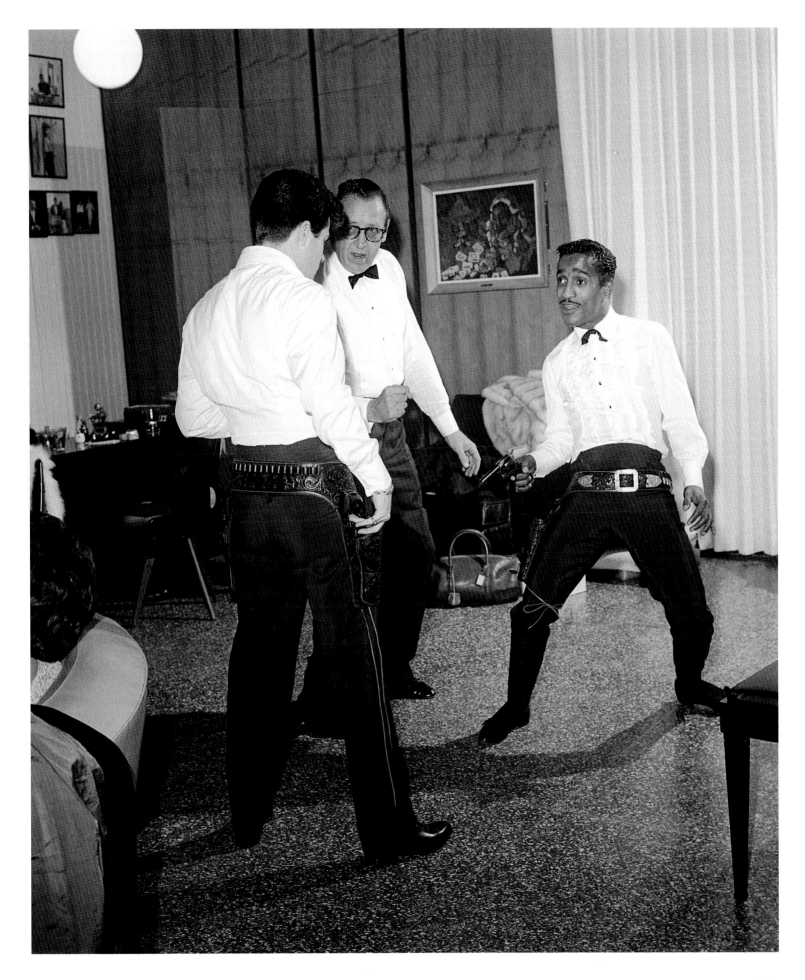

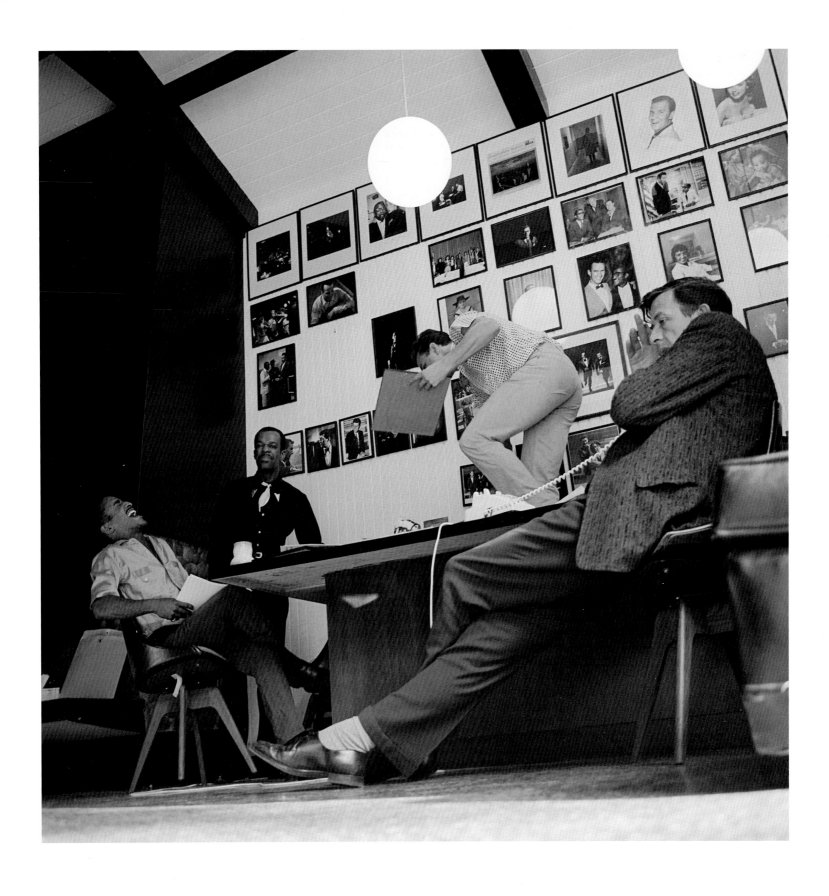

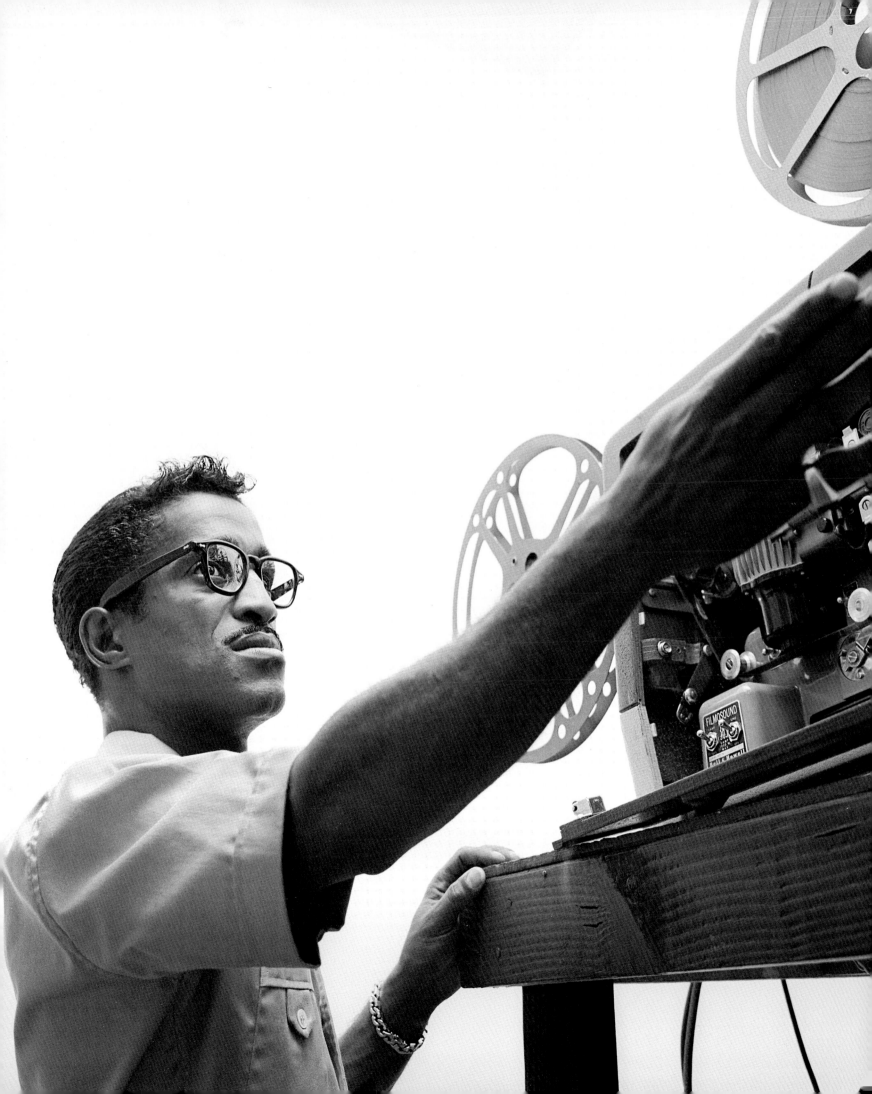

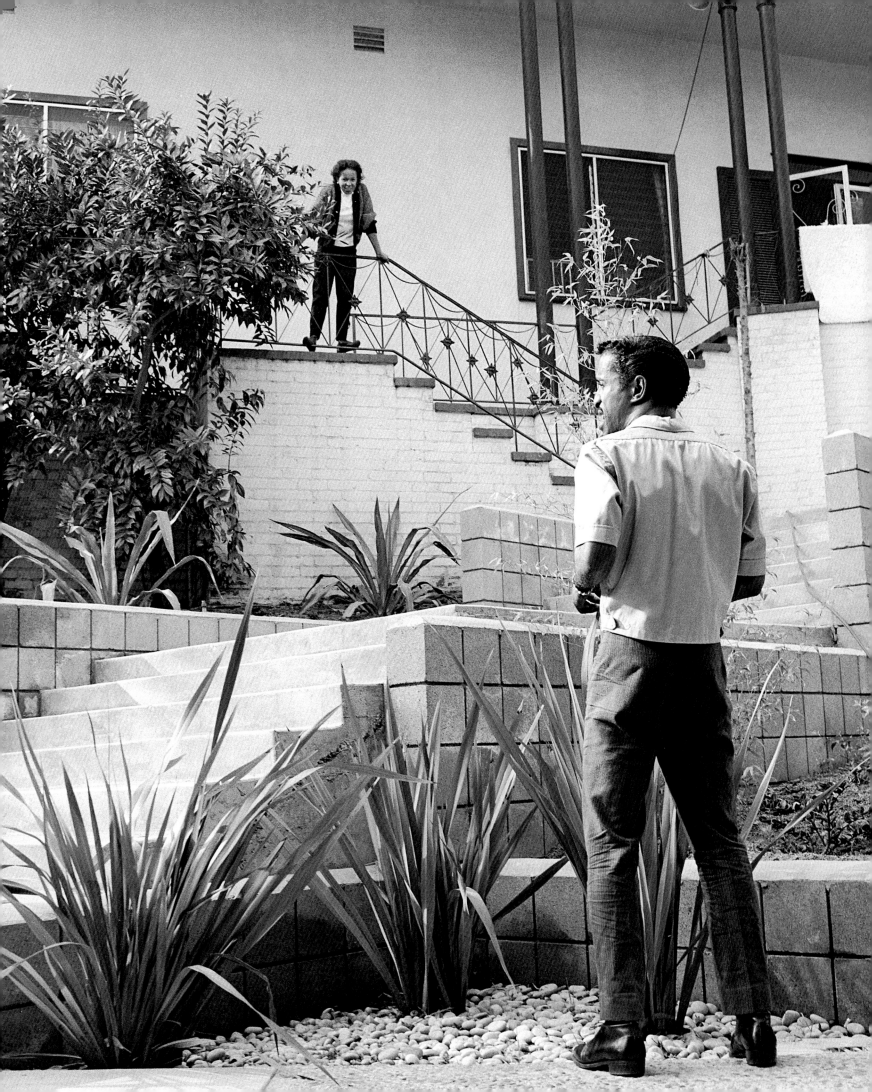

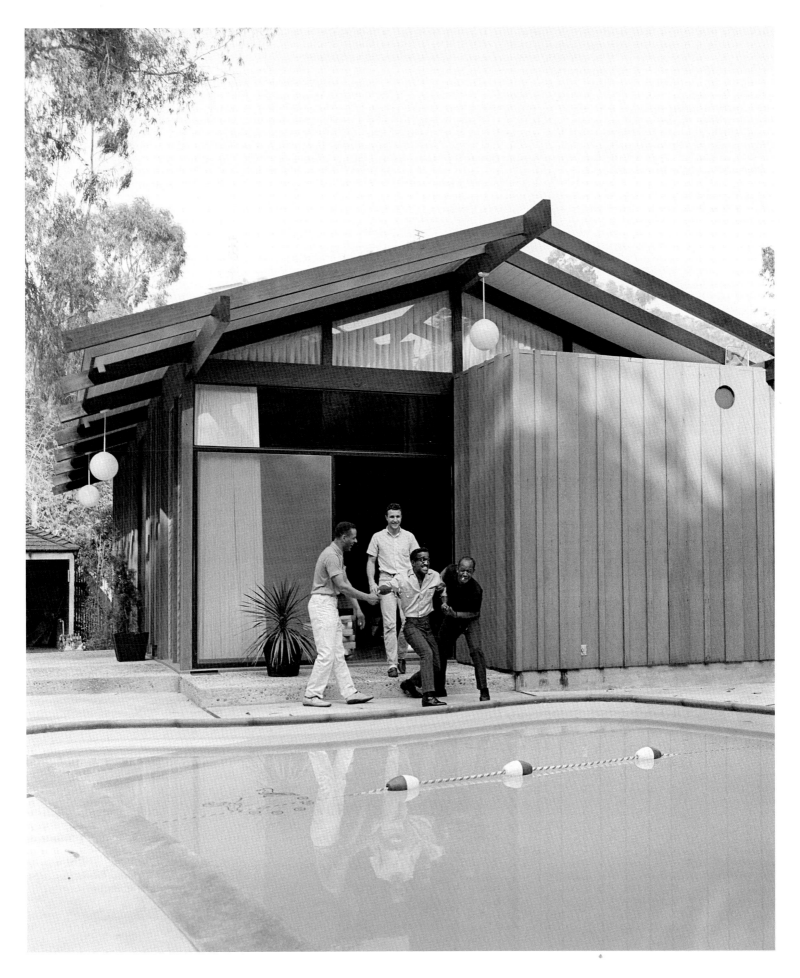

HUMPHREY BOGART AND LAUREN BACALL

When I got the assignment from the *Saturday Evening Post*, I called Bogie's agent and said that I need to get some shots of him at home with Betty [Lauren Bacall] and their son. He said not to worry and that he would call me back. He called me back and said, 'He won't do it.' So I thought, well, if his agent can't do it, maybe I can talk to his PR people. They said, 'Oh, don't worry, we've worked together on many assignments and we would love to get him in the *Saturday Evening Post*.' They called me back and said that he won't do it.

Well, I decided to call the studio because he's under contract to Warner Bros and he has to give a certain amount of time every year to PR. So I called them and the PR guy said, 'Don't worry about it, Sid, I'll set it up and call you back.' He called back and said that he wouldn't do it. I asked him, 'Well, where is he working?' He said that he's on the lot and working at Stage 7. So I hung up and called Stage 7 and said, 'Is Bogie there?' Bogart came to the phone and I told him who I was and what I wanted. He was indignant that I would bother him when he's already turned me down. So, he hung up and I called back the next day, stated my case and told him that the *Post* would run some old pictures for a nice new fresh story and it just didn't make any sense – and couldn't he just give me five minutes. So, eventually, he broke down and said to come to the house. He gave me the address on Mapleton and said, 'Be there at 8 a.m. and I'll give you five minutes.'

I knocked on the door and it took about two-three minutes for him to answer. When he opened the door, he was still sticking his shirt into his pants and said, 'OK, kid, come on in. Do you want a drink?' I thought, well, if he's going to have a drink, then I better have a drink. So I said yes. He took me to the den, over to the bar, and poured me a water tumbler full of whatever he was drinking (I think it was Scotch or Bourbon). He took one upstairs to finish dressing, while I surreptitiously poured mine out in a potted plant. So he came back down and asked, 'What do you want to do?' I said, 'Well, what are you doing?' He responds, 'Can't you see we've just moved in, Betty's pregnant and that's why I didn't want to take any time to do this. We're unpacking.' So I said, 'Well, go ahead and unpack.' So I got a shot of him unpacking, putting a picture on the wall.

I think the liquor was starting to work a little bit, plus maybe because of the fact that I wasn't too pushy, so he says, 'Would you like another shot?' I told him, 'Well, I've already used up my time.' He says, 'No, no, what else would you like?' So I said, 'Could you and Betty, your three dogs and Stephen sit for a shot in front of the fireplace?' He said, 'Yeah, that's no problem.' When I got the shot, I said 'Thank you, thank you. I've got more than enough – I appreciate it.'

He then said, 'Well would you like something with me and Stephen – we have a model of the Santana.' I said, 'Yeah, I'd love it.' So I took a shot of him and Stephen looking at the model – it's a beautiful sailboat. Also, above the case, there were a couple of his Oscars.

I thanked him again and said goodbye. Then he says, 'Well, would you like something outdoors? We could take the dogs to go outside.' I said, 'Wow, I've already used up my time.' He said, 'No, no.' So, we went outside and took a few shots with Stephen and Betty and the dogs.

Then he said, 'How would you like a shot of me and my family with our new Jaguar?' I said, 'Boy, I'd love it. But I've already imposed myself on you and your family for too long.' He said, 'No, that's OK.' So he pulled the car around front and I took a picture in front of the house saying goodbye to Stephen.

At this time I said to Bogie, 'Look, I really appreciate it but I've got to go and you've been more than cooperative.' He then says, 'What are you doing this afternoon?' And I said, 'Well, I really want to get this stuff processed and sent in to the *Post*.' He says, 'How would you like to go sailing?' I said, 'I'd love it.' So he says, 'It'll be Pier 49, but goddamn take those shoes off – put on tennis shoes –

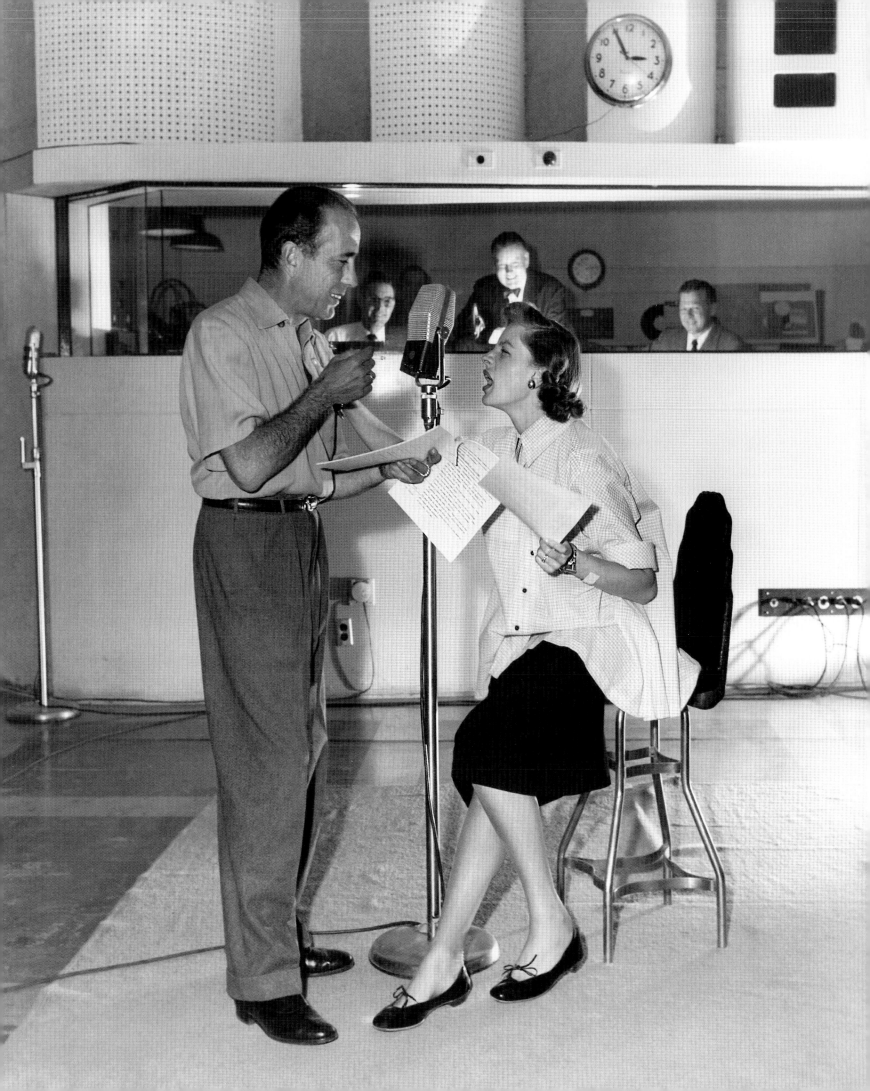

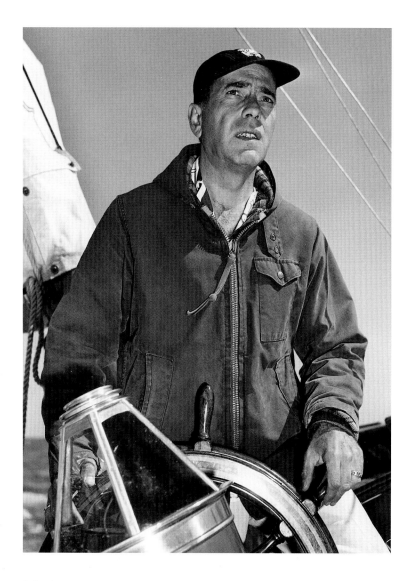

I don't want you screwing up my new teak deck.'

So later that day, we went sailing (I took pictures of him at the helm and working on the boat). We went out for about four hours. During our trip, he went down below to take a nap for a couple of hours. When he came back up, we shot some more. We came in and docked and I started saying goodbye and said, 'Thank you, it's really been unbelievable. I really appreciate it – you have no idea what this means to me.' He then says, 'What are you doing tonight?' I said, 'Well, I was really going to get this stuff processed…' He said, 'Why don't you come to Romanoff's – I'm having dinner with Mike Romanoff and another friend and maybe you would like to join us.' I said, 'Yes, I'd love it.'

When I said goodbye to him [after the dinner], he said, 'What are you doing tomorrow?' And I said, 'Well, I really need to get this stuff in.' He says, 'Well, Betty and I are doing a recording session at 7000 Santa Monica Boulevard – would you like to come and shoot it?' I said, 'Of course, I'd love it.' So I showed up and stayed there for a couple of hours, taking pictures of them doing a recording session.

For a tough guy on the screen, he turned out to be a real pussycat, loving husband, father, and one of my greatest subjects.

Avery photographed Humphrey Bogart at home with his wife Lauren Bacall and son Stephen; in his Jaguar XK120; on his yacht the Santana; at Mike Romanoff's restaurant; and in the studio with Bacall. For the **Saturday Evening Post** *article, 'The Adventures of Humphrey Bogart', 2 August 1952.*

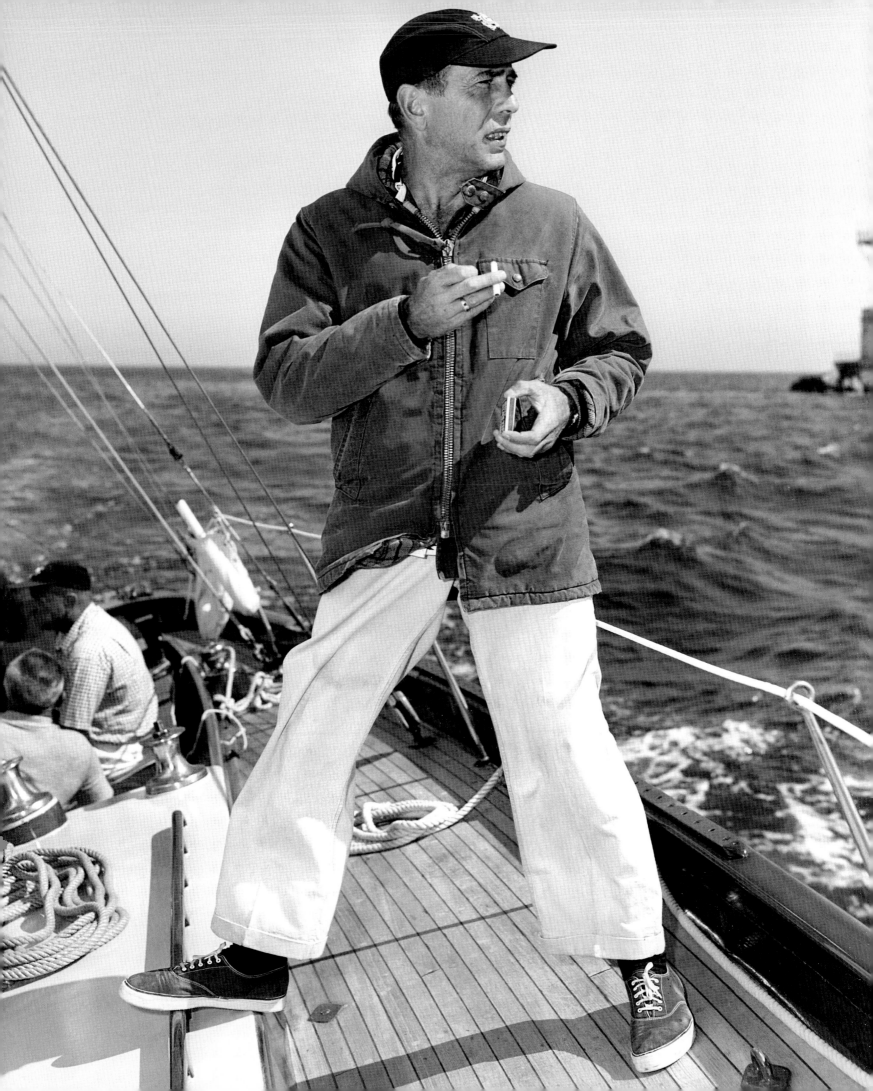

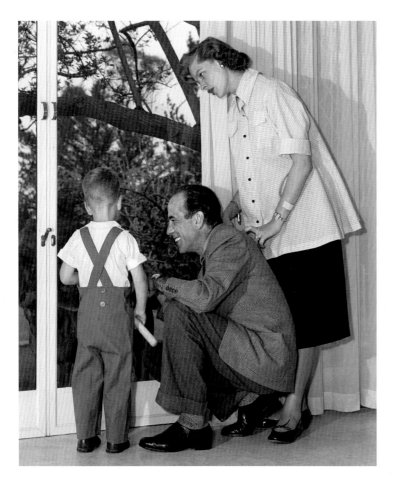

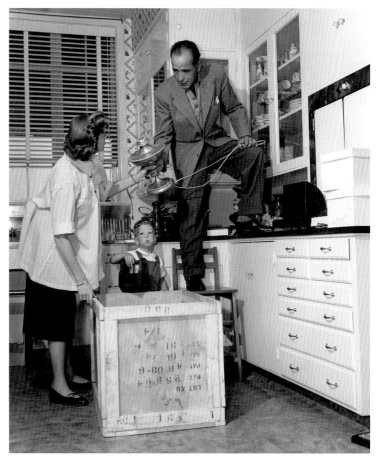

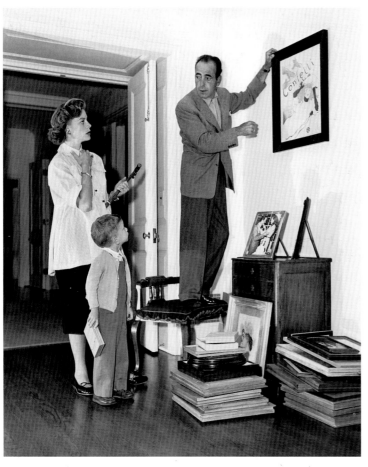

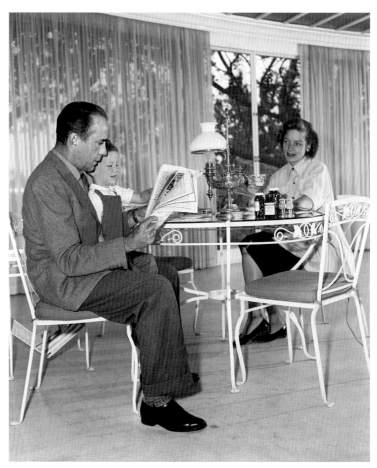

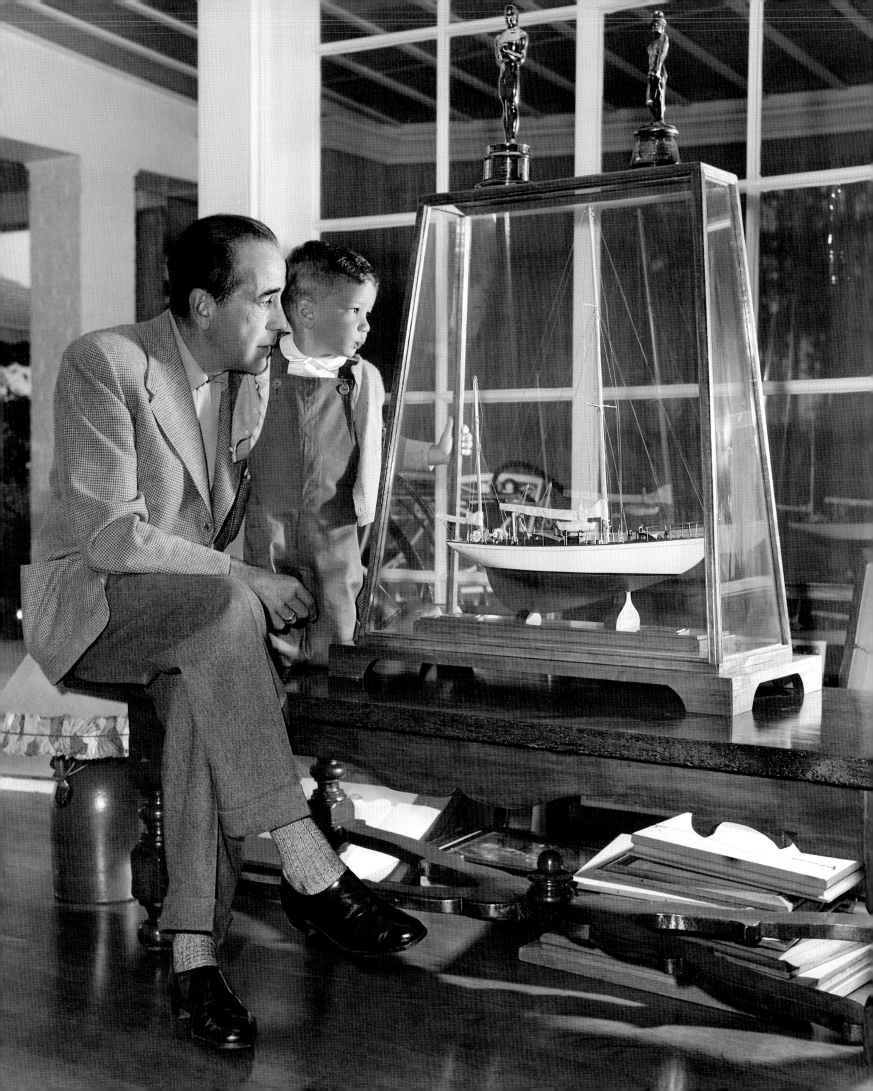

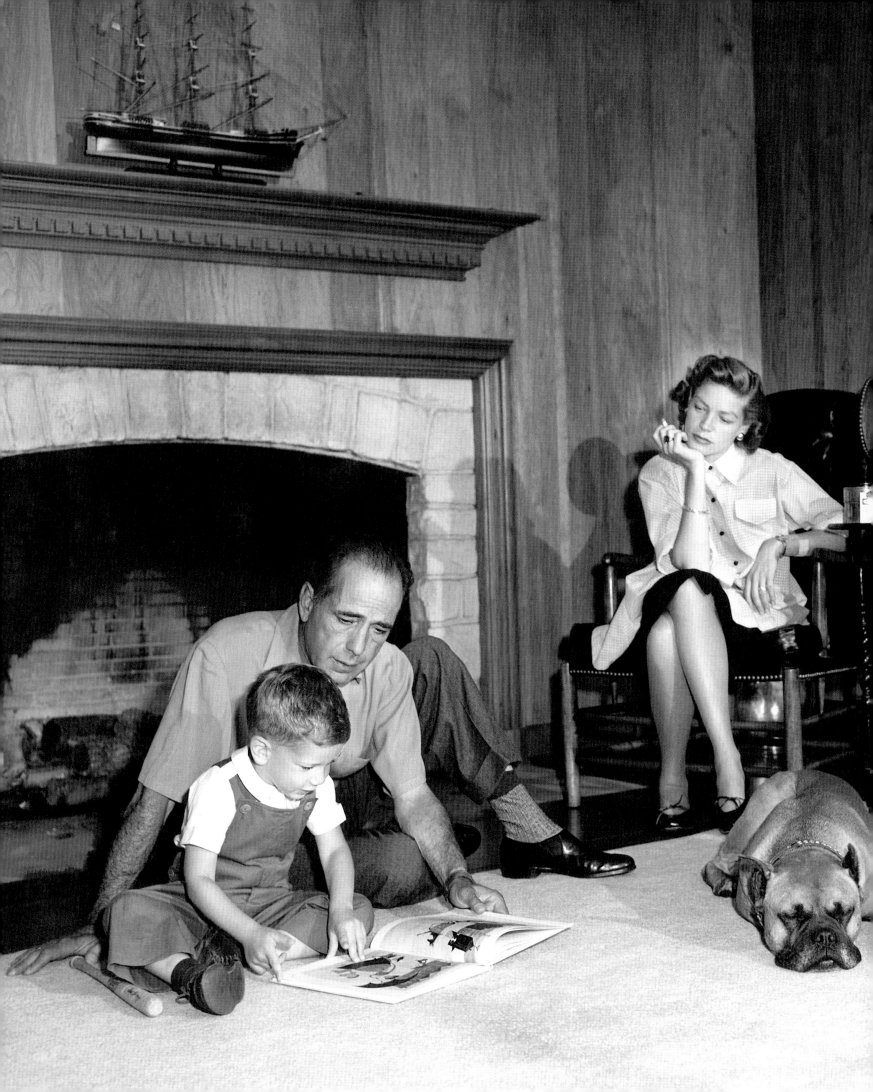

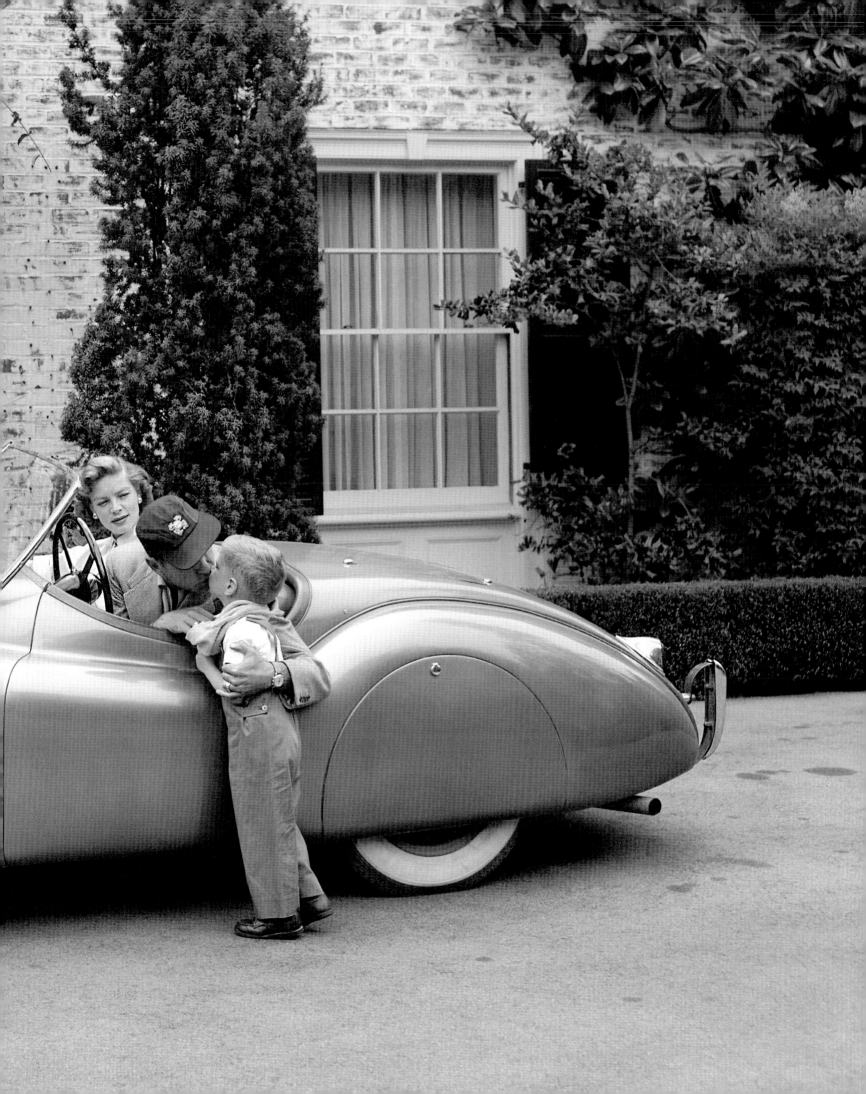

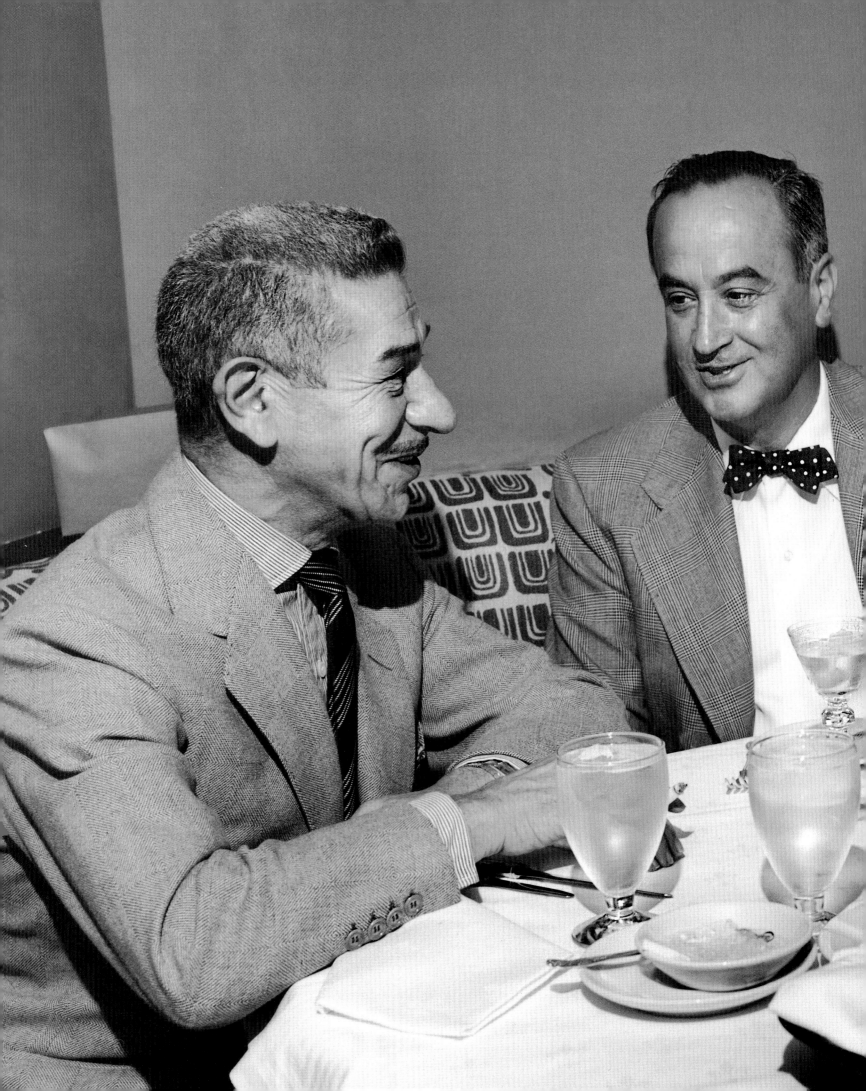

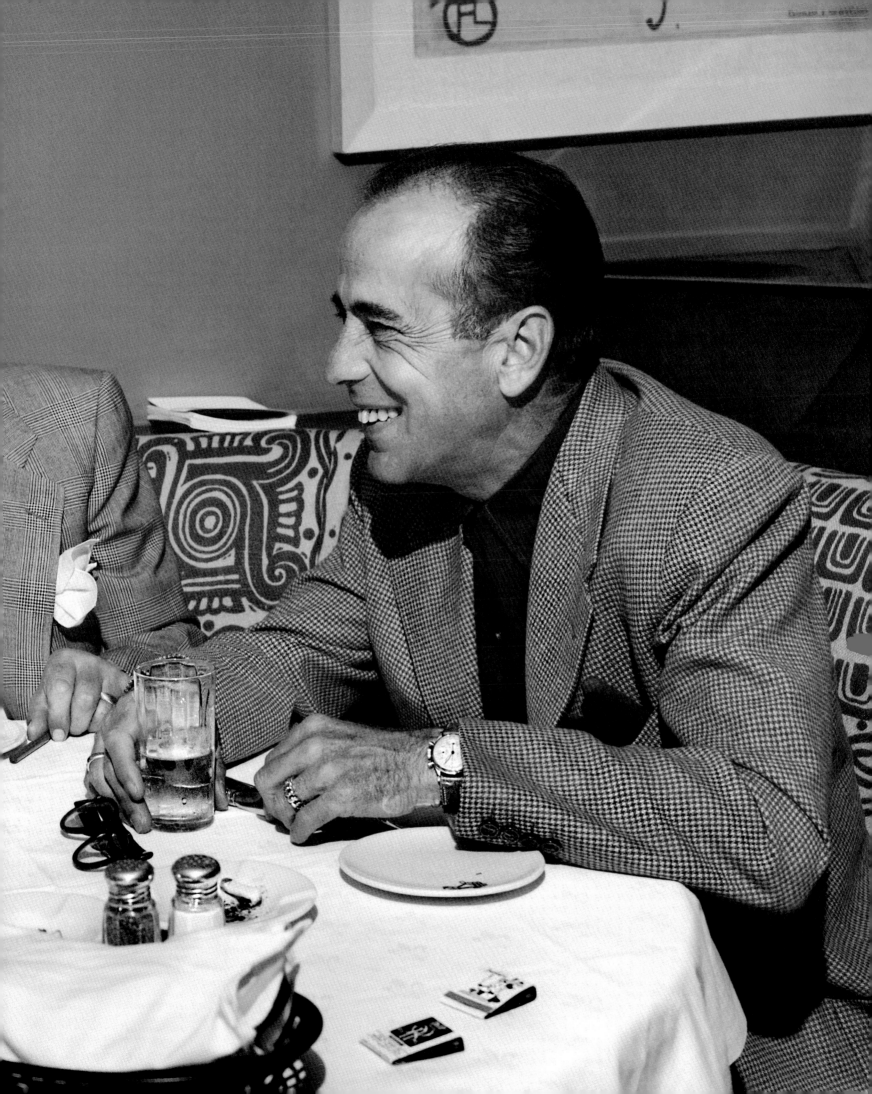

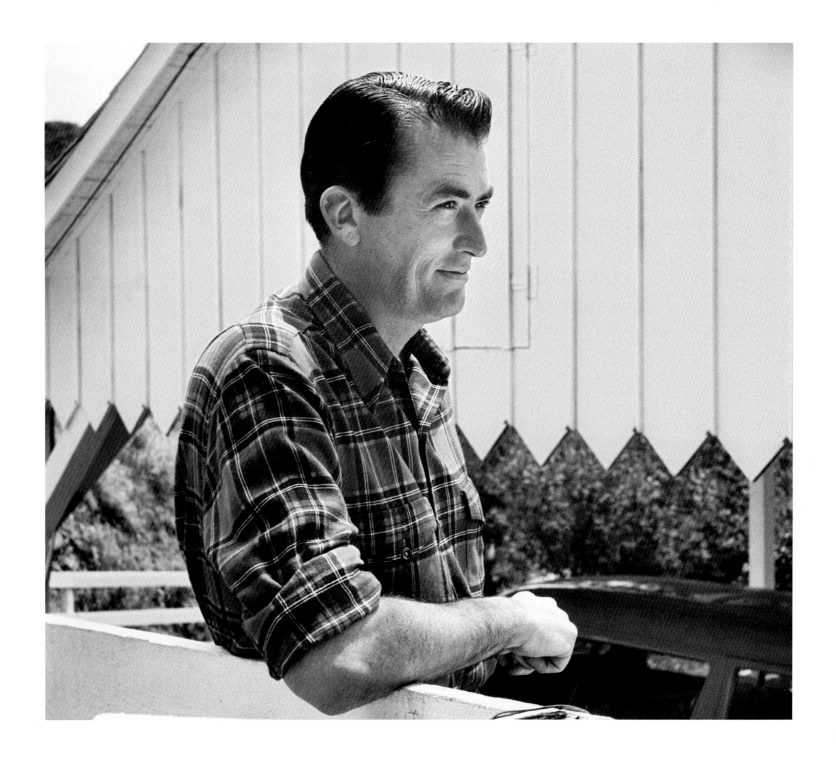

GREGORY PECK

*Gregory Peck photographed at home for the **Photoplay** magazine article,*
'Gregory Peck: Saint or Sinner?', September 1955.

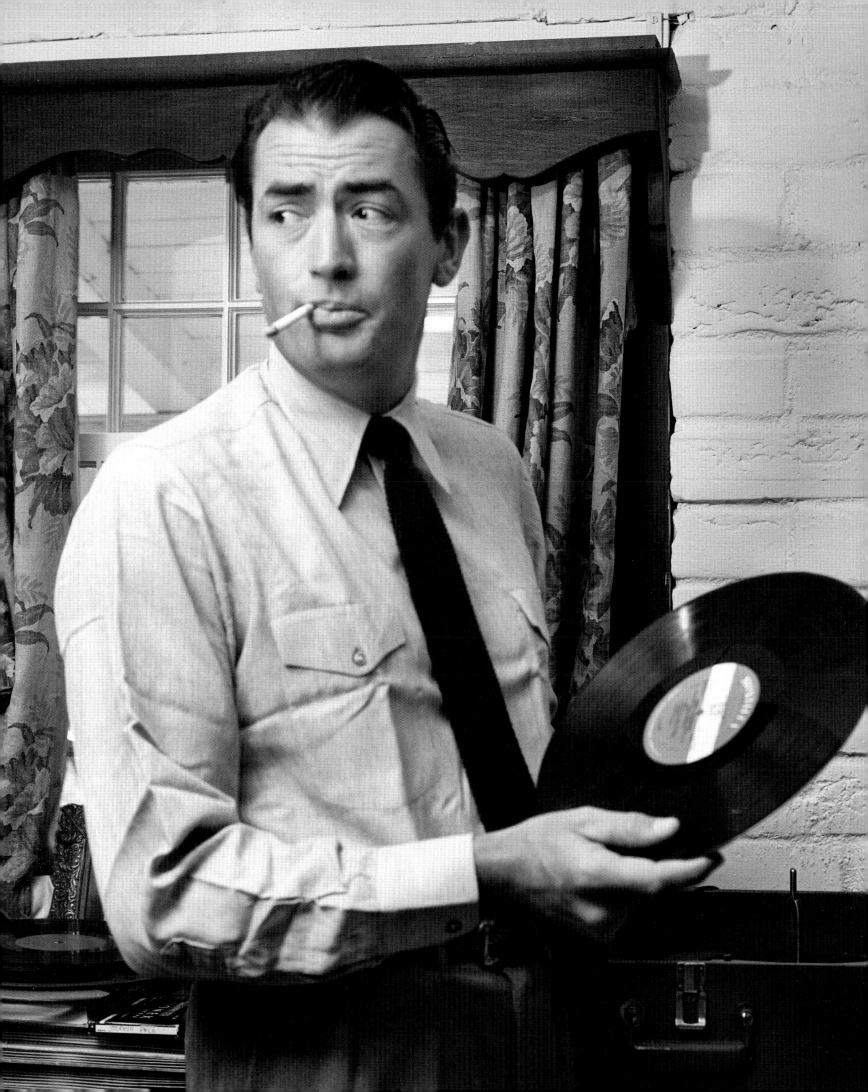

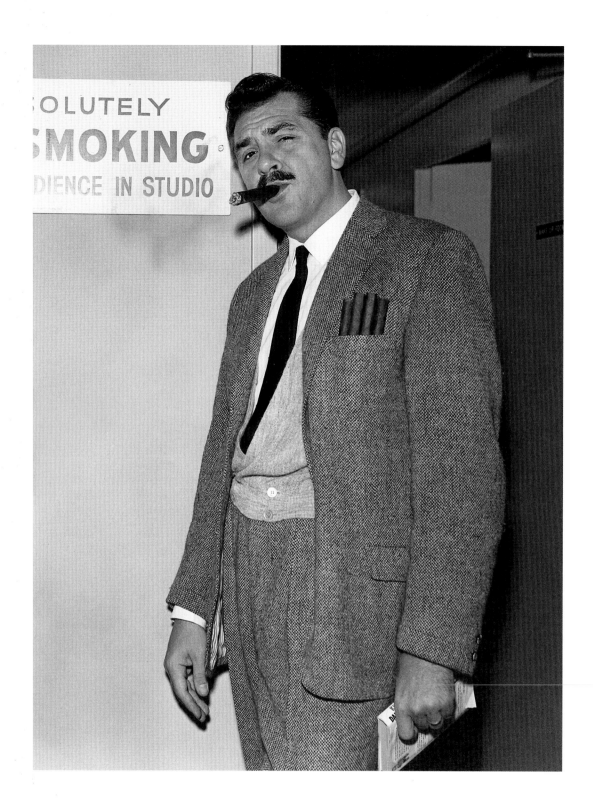

ERNIE KOVACS AND JOHNNY CARSON

This was [Carson's] first TV show at KHJ Studio on Vine Street. I just took a photo of him jumping up, having a good time. And I shot many many more.

Ernie Kovacs photographed in 1957.

*Johnny Carson photographed on **Carson's Cellar**, his first television show, 1953.*

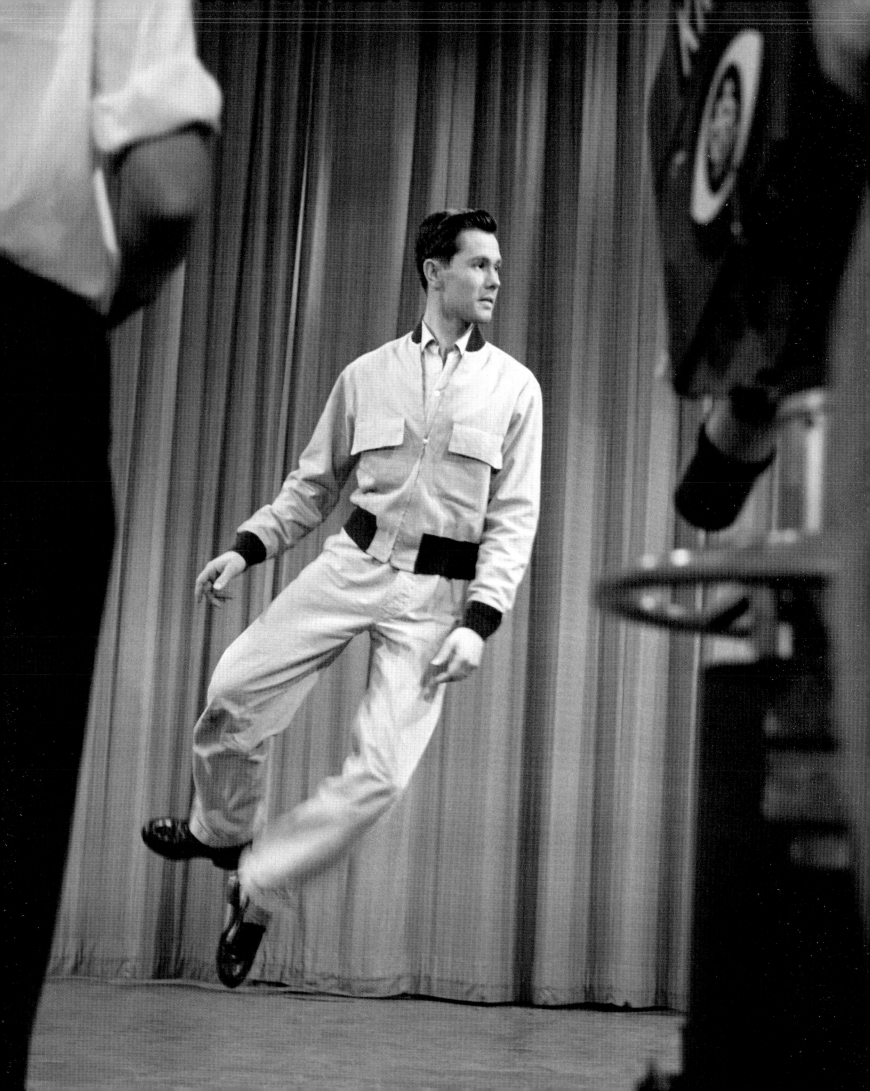

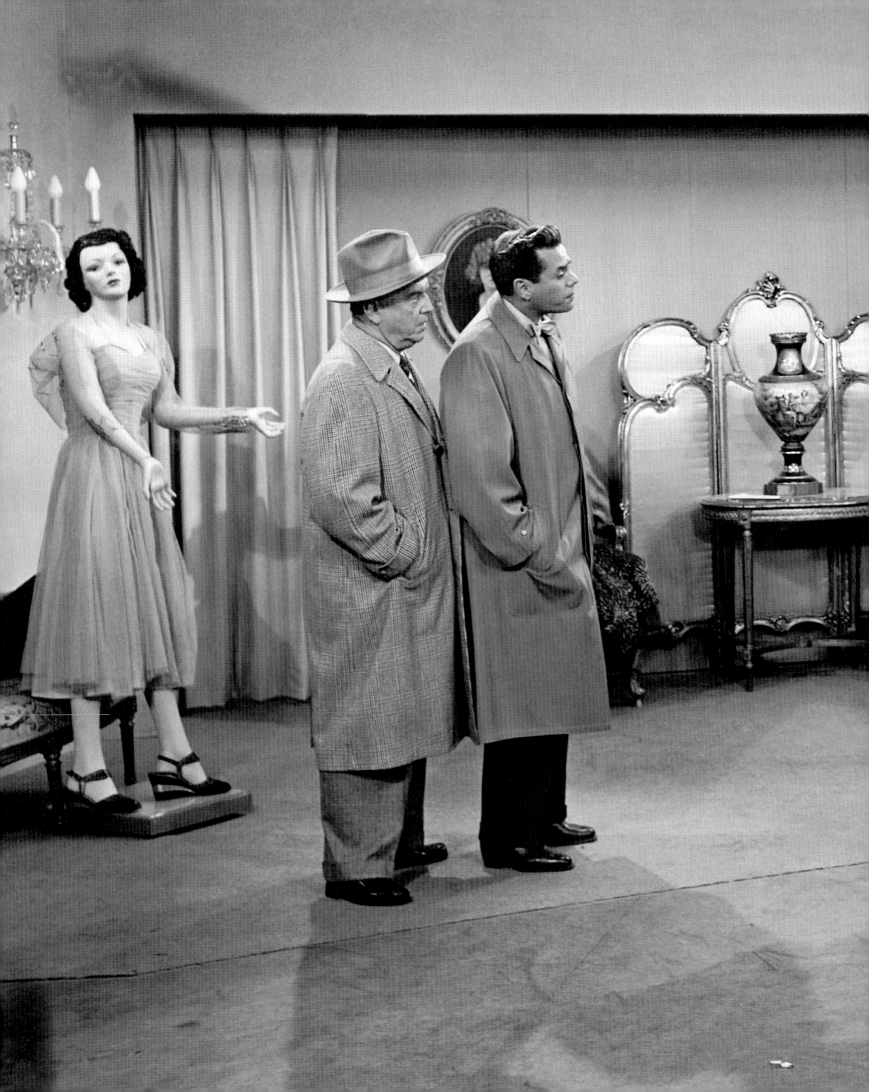

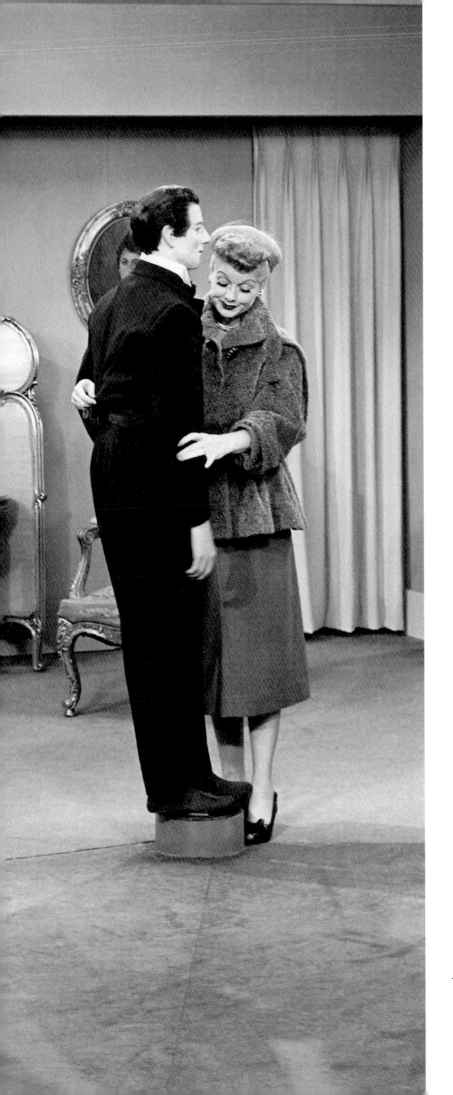

I LOVE LUCY

This was the hottest duo on television and the biggest threat to the film companies. I just like this shot – the fact that she's dancing with a mannequin – and it makes for good composition.

Lucille Ball, Desi Arnaz and William Frawley photographed in a scene for **I Love Lucy***. For the* **Saturday Evening Post** *article, 'Look What TV's Doing to Hollywood', 7 February 1953.*

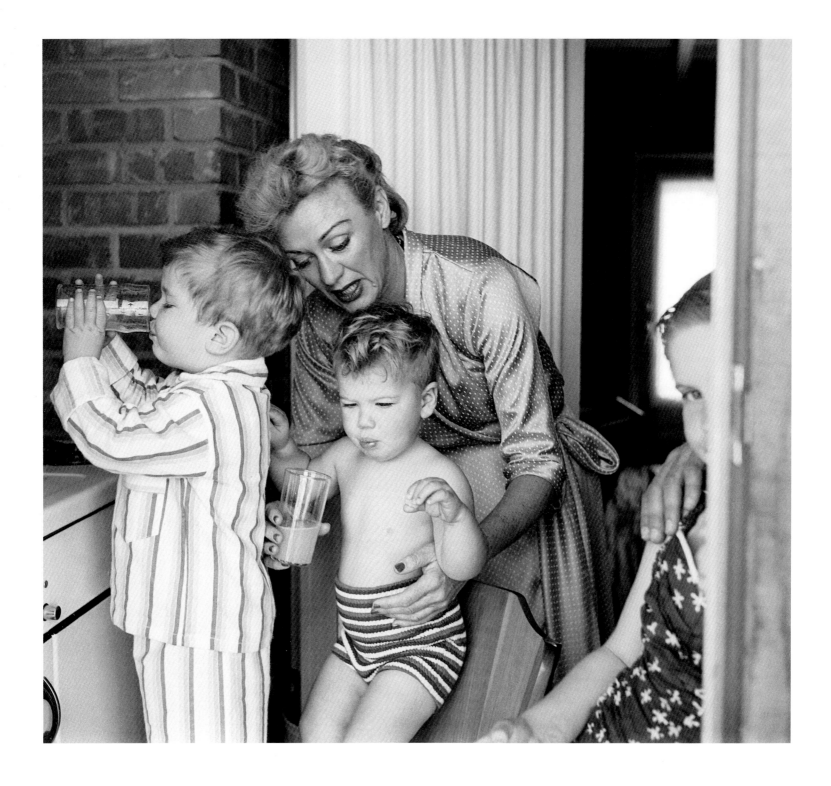

EVE ARDEN

Eve was hotter than a pistol on television. I spent a lot of time with her at home and at the show.

*Eve Arden at home with her children Douglas, Duncan and Connie; and with husband Brooks West (and their children in the background), Palm Springs. For **TV and Radio News**, 1956.*

EFREM ZIMBALIST JR.

Efrem Zimbalist Jr. photographed in his dressing room and on the Warners lot during filming of **77 Sunset Strip**, *1961.*

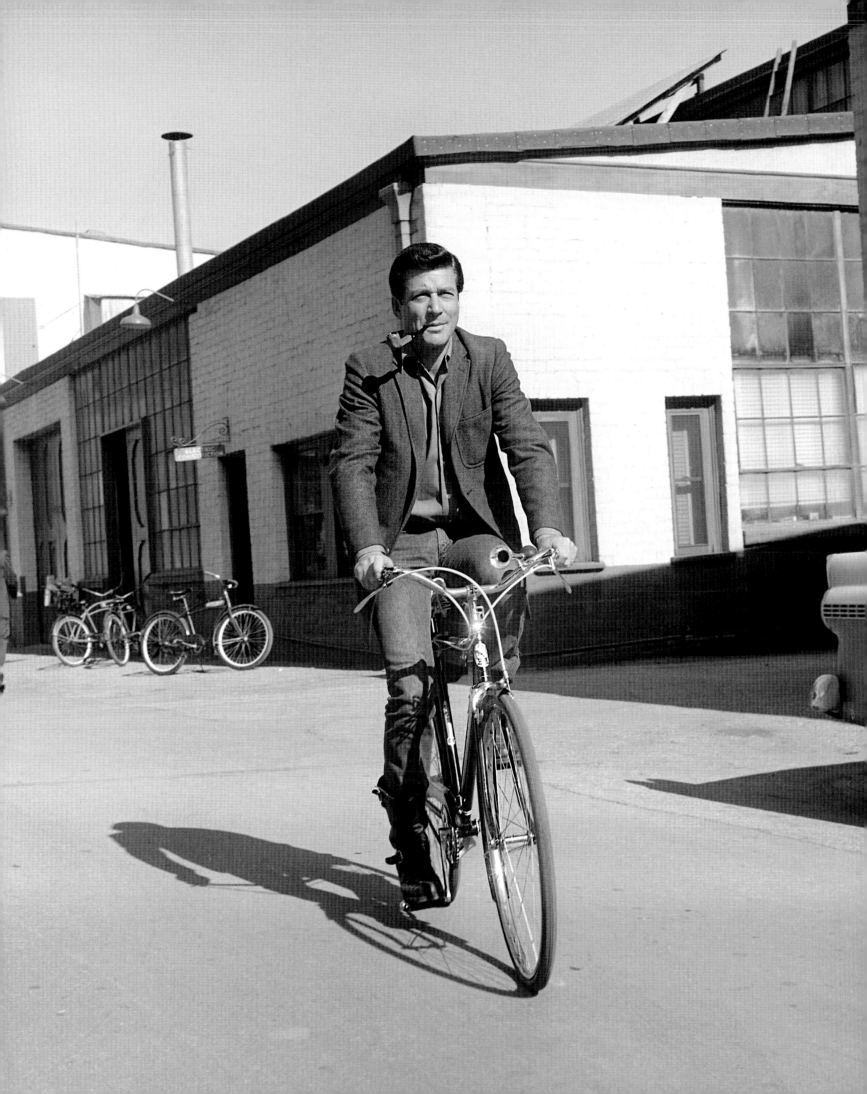

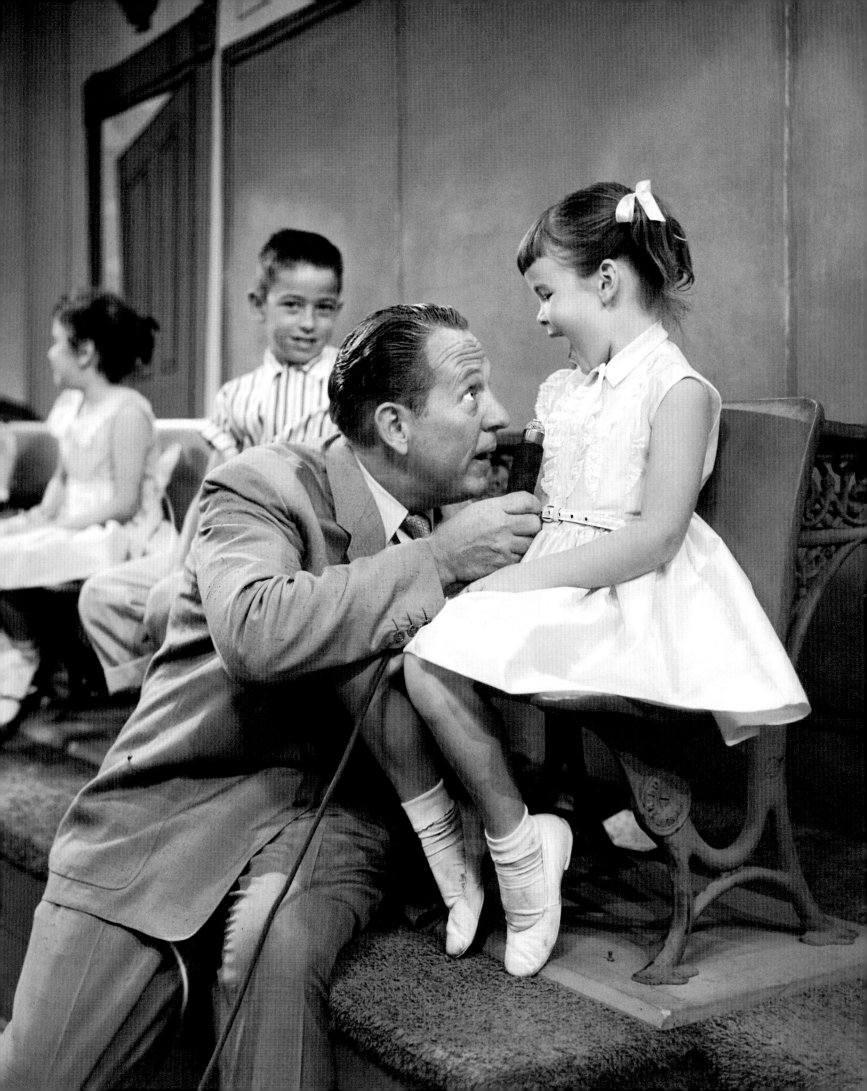

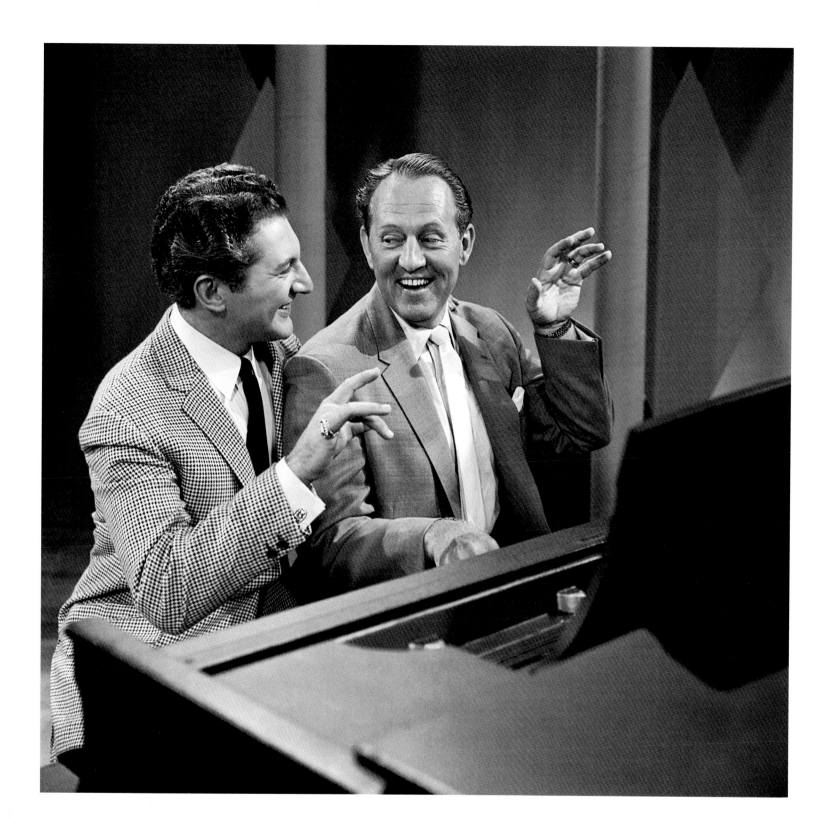

ART LINKLETTER

I took this photo [of Lee Liberace] without all the weird clothes that he used to wear, with the candelabras, etc. This was when he was just starting out. It's just different from all the other pictures you see of him.

*Art Linkletter photographed on his show, **House Party**, in 1956 and with guest Lee Liberace in 1957.*

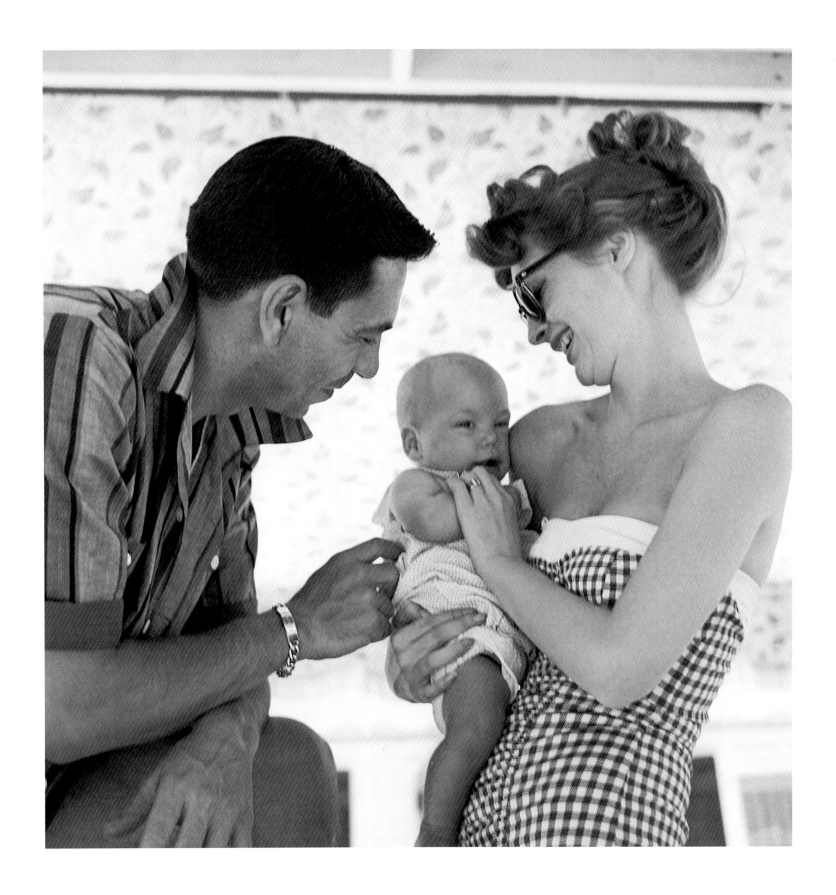

JACK WEBB

Jack Webb photographed with his wife, Julie London, and his youngest daughter, Stacy. Avery also photographed Webb viewing footage from his show, **Dragnet***, 1953.*

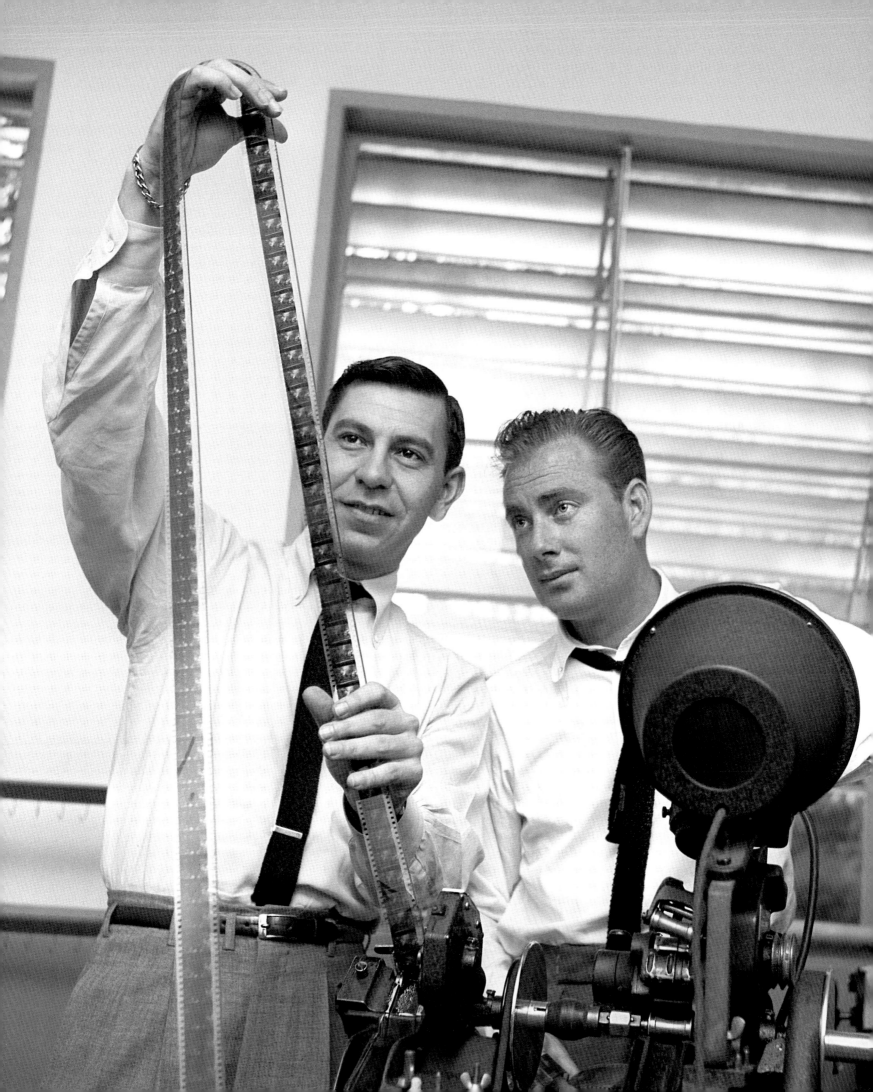

ALFRED HITCHCOCK PRESENTS

*Anthony Perkins and Janet Leigh visit Alfred Hitchcock in his studio office in advance of filming beginning on **Psycho**. Hitchcock was working on an episode of **Hitchcock Presents** starring Steve McQueen, 1959.*

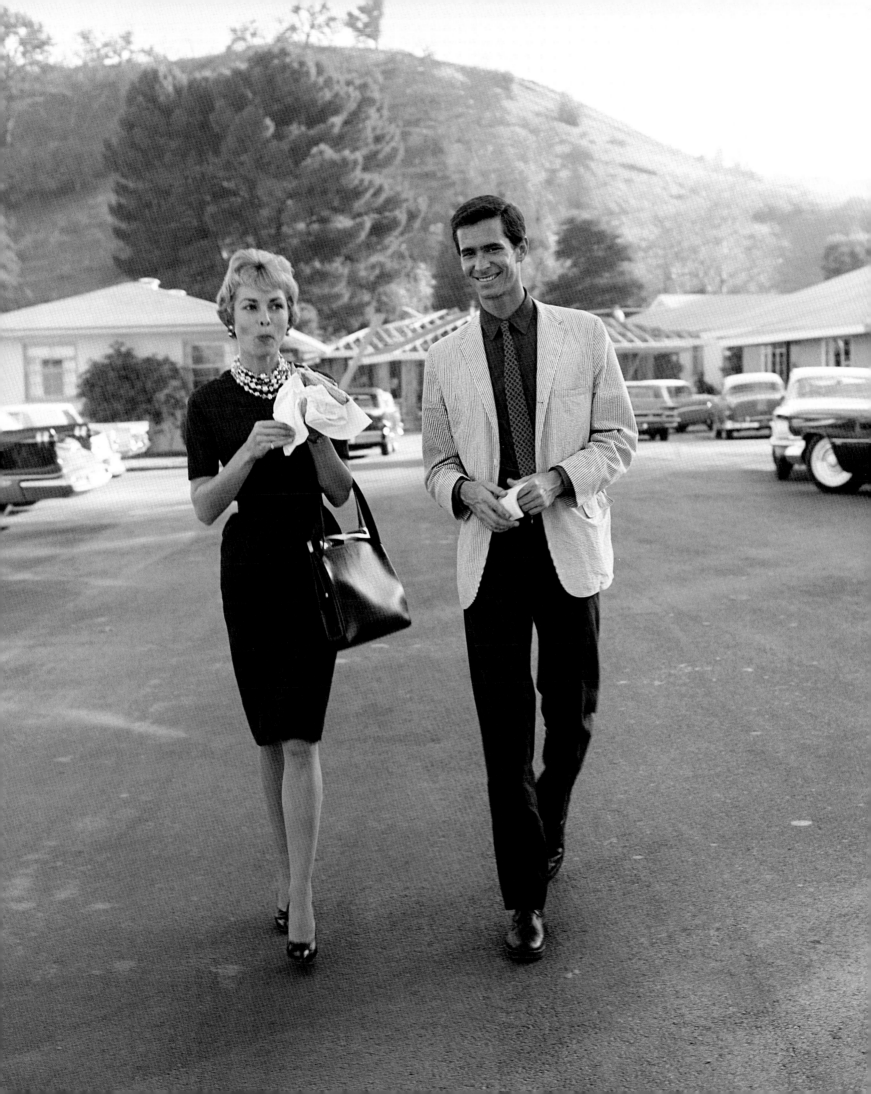

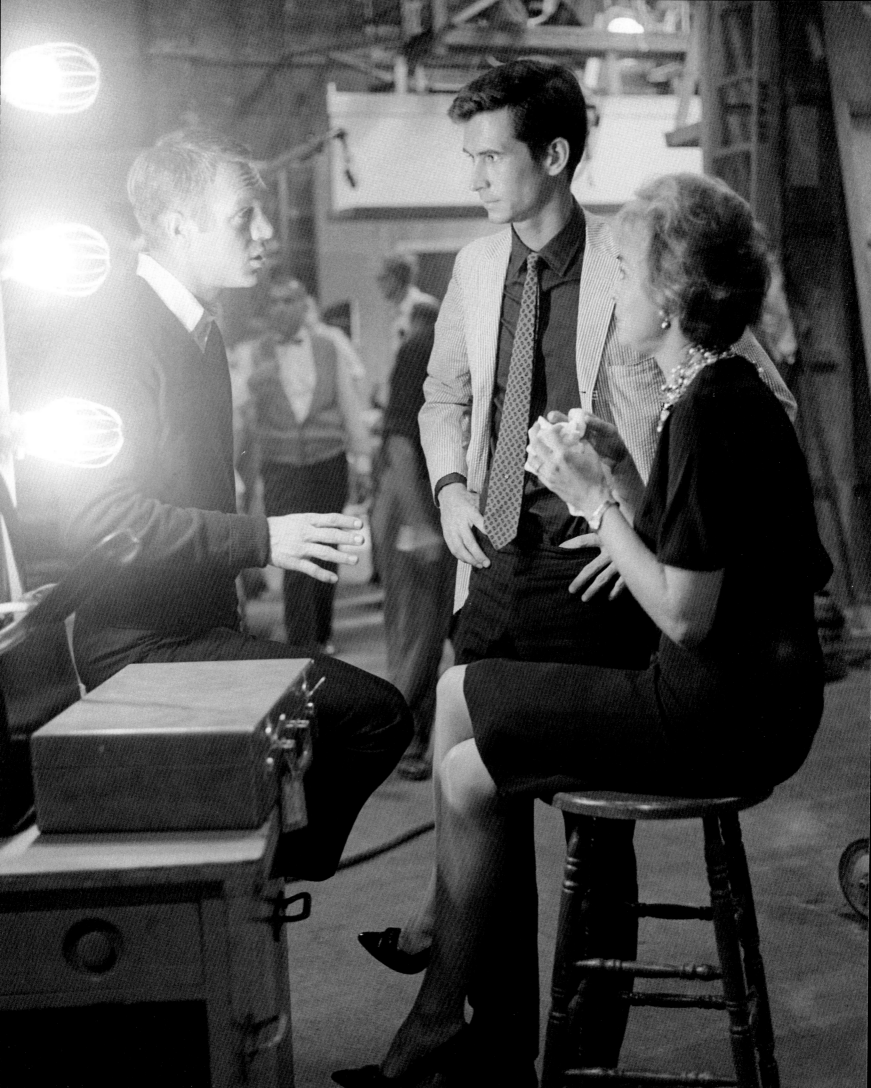

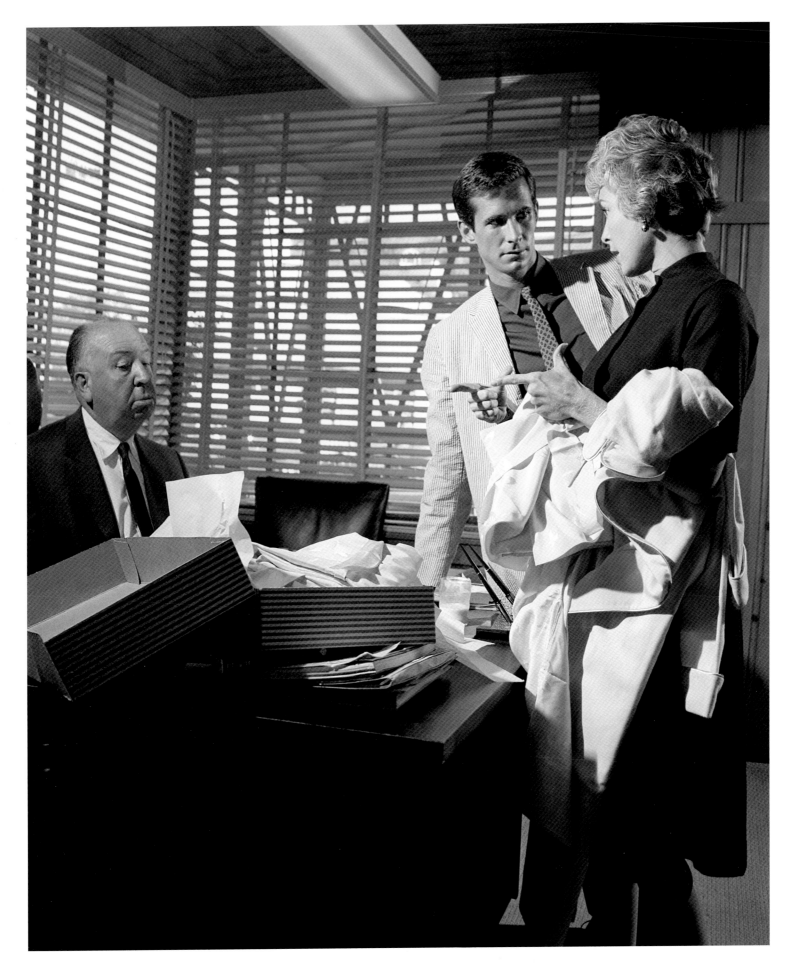

ANTHONY PERKINS

I had an assignment with Tony Perkins for the *Saturday Evening Post*. The title of the article
was 'Lonely Tony Perkins'. I thought this photo depicted the title a little bit.

He had a cat that he loved to play with. He also ate a lot of peanut butter sandwiches.

He was a little fastidious about his car [a 1957 Ford Thunderbird]. He cleaned it at least once a week.

Anthony Perkins photographed at home in Los Angeles and at a local opticians. For the **Saturday Evening Post**
article, 'Lonely Tony Perkins', 9 January 1960.

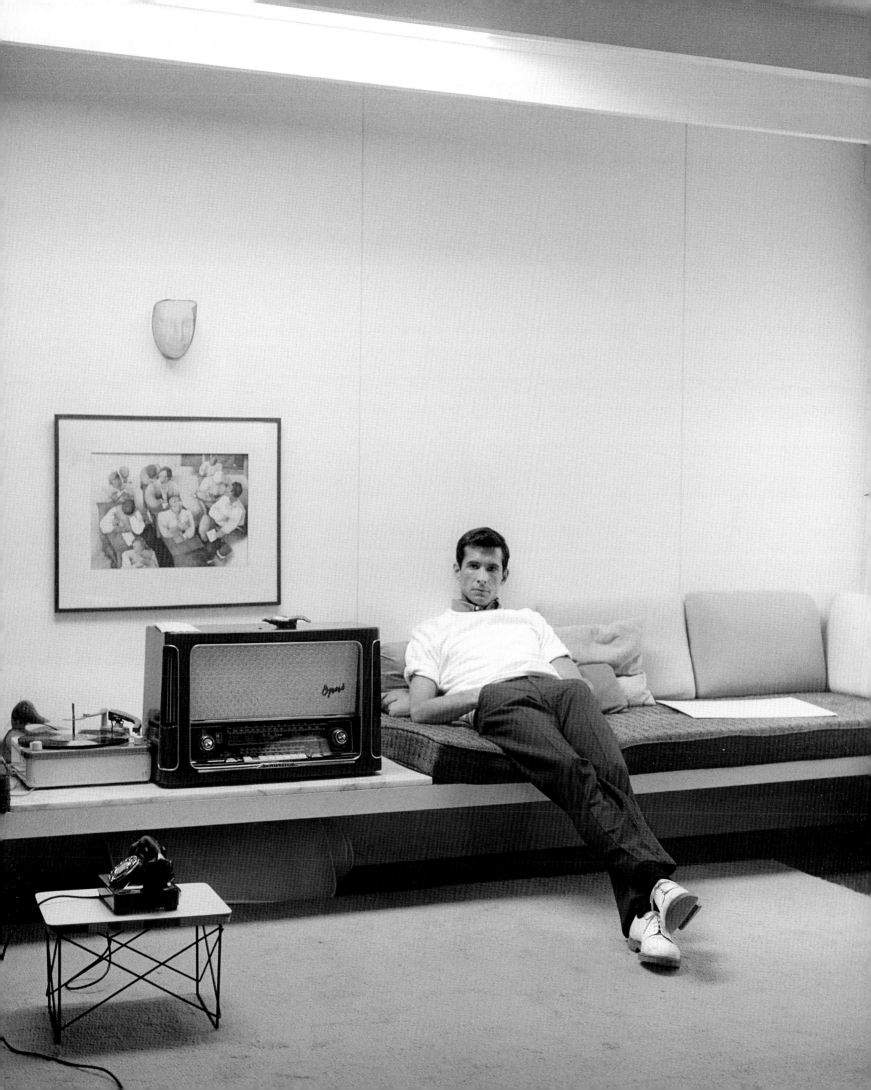

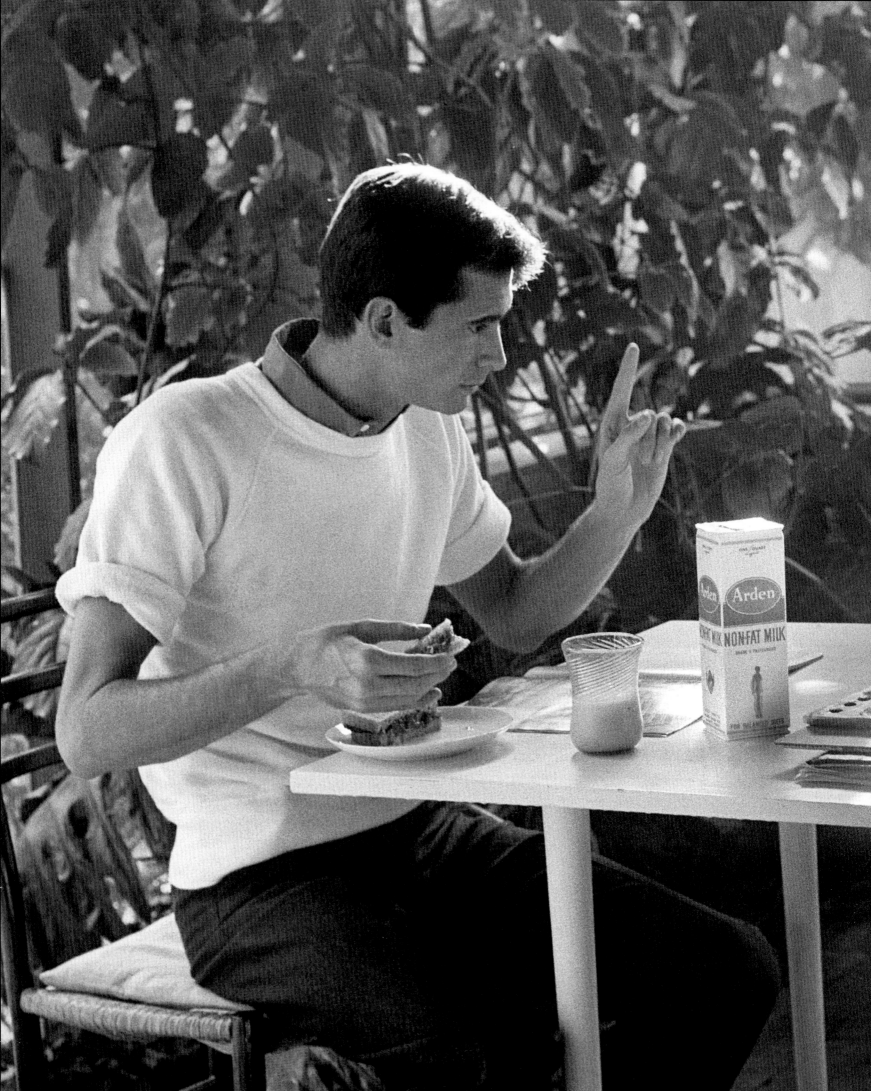

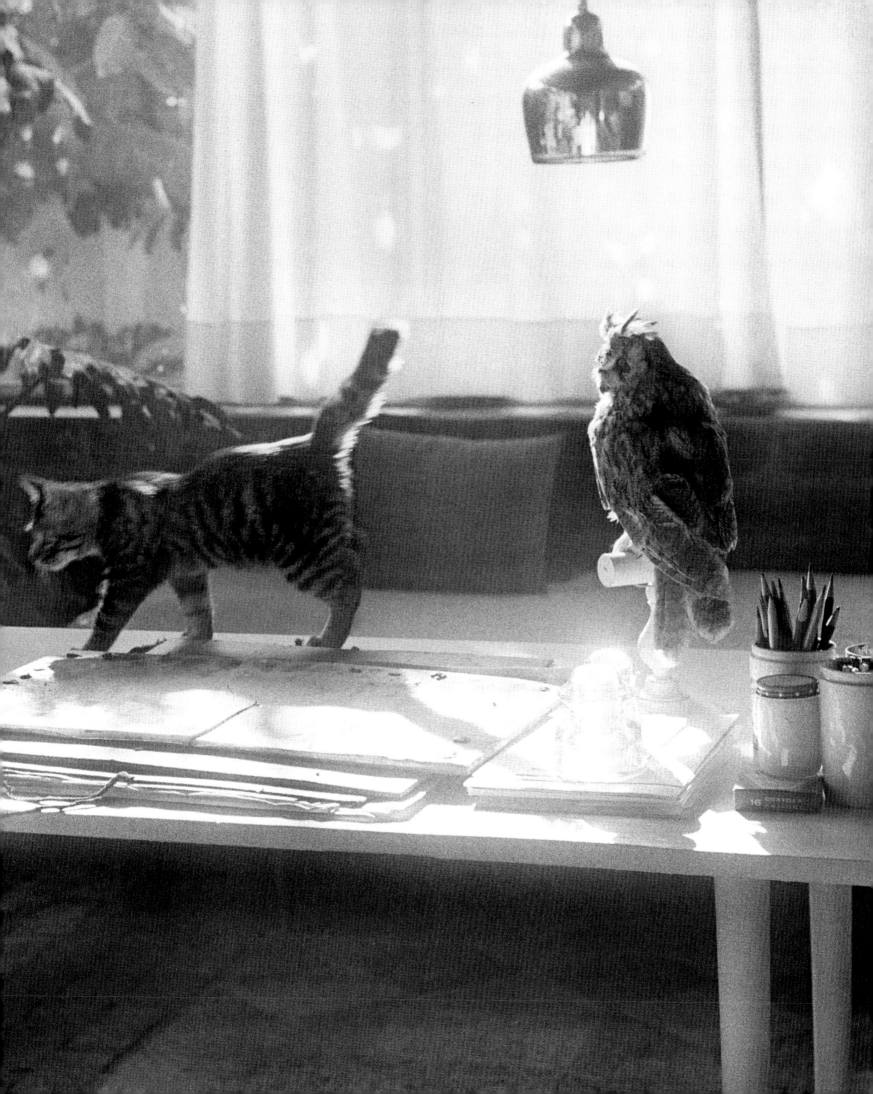

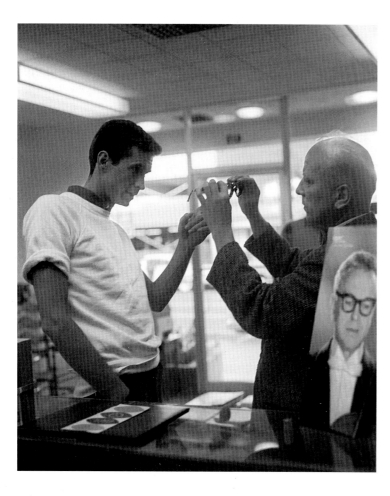

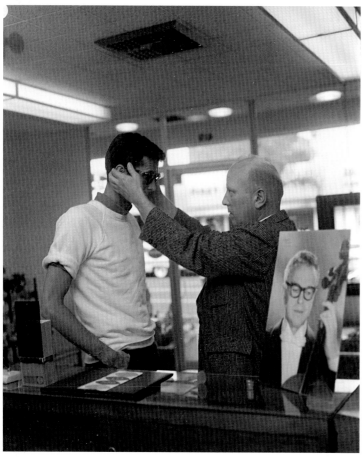

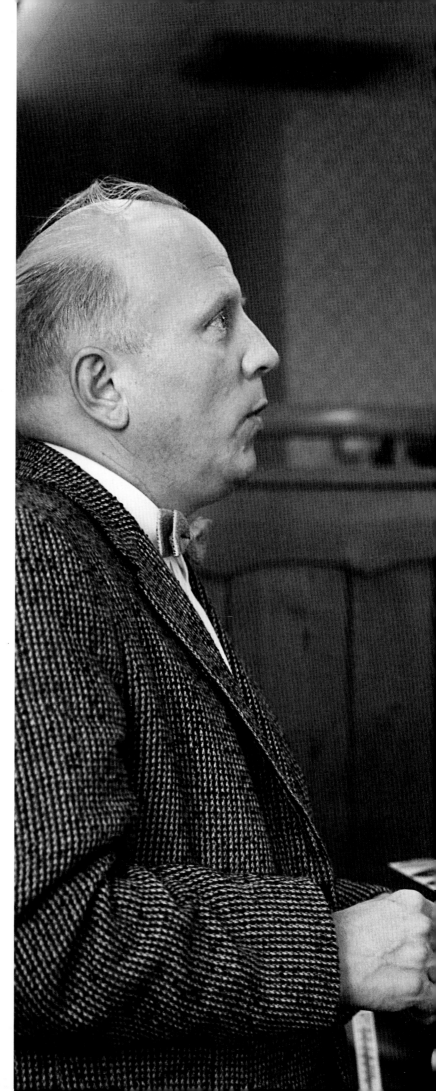

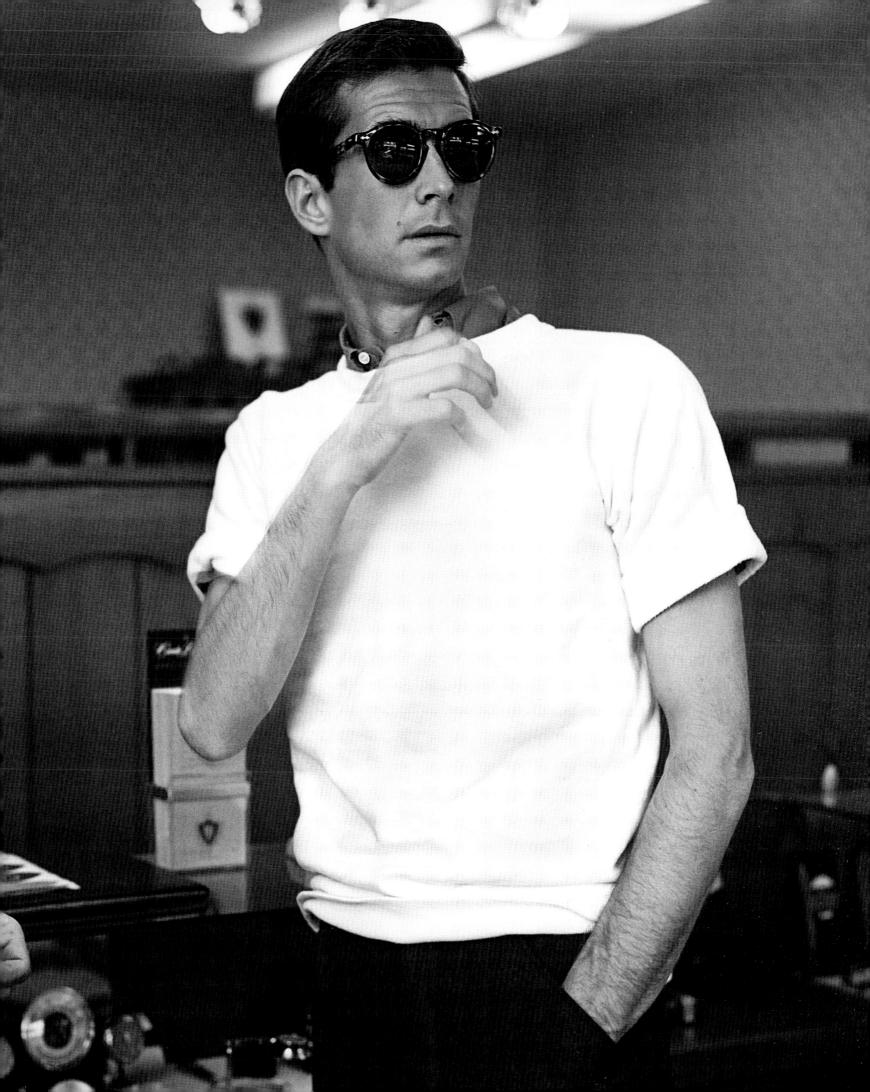

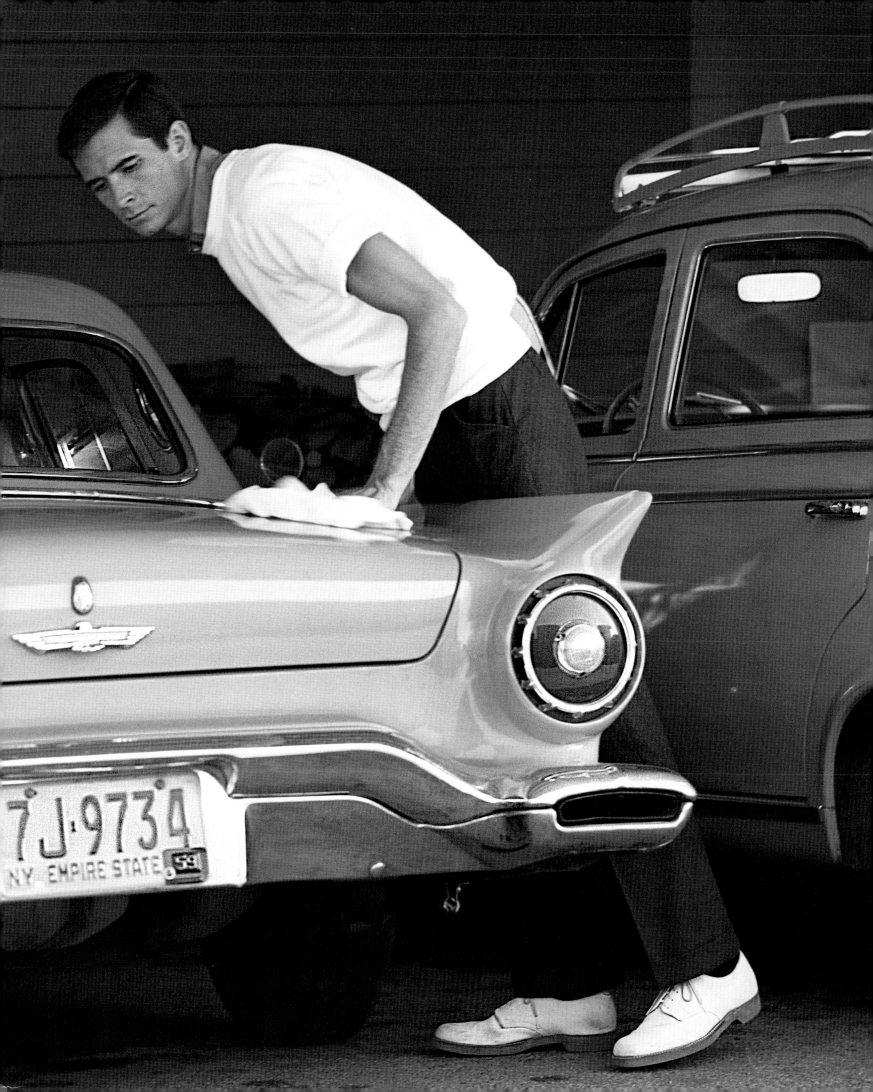

STEVE MCQUEEN

He was one of the toughie kids. He had a wonderful TV show at the time. He was very popular, plus he was a motorcycle rider par excellence. A great driver. Very cooperative, good father and husband. Lots of charm – my kind of guy.

After the family shoot, he said, 'Do you want to come down to Columbia Studios with me and you can come in the Jag if you like [a 1957 Jaguar XKSS]?' He had one of the most powerful and loudest sounding cars in the world. He put a broomstick on the throttle to warm it up. He went back in the house to get his jacket. His two PR guys said, 'Don't go in that car. You'll pee in your pants.' I said, 'No, I've been in fast cars before – I love it.' So I got in and I took some wonderful photographs of him driving down Nichols Canyon, scaring the hell out of everybody in the neighborhood. The sound of the open exhaust echoing off the canyon walls, and Steve skillfully drifting the car through many of the turns, it was the ride of my life. When we reached the bottom of the canyon, we came to a short straight away. Approaching us from the other direction was an elderly man in a late-1950s white Cadillac. The closer Steve's car got to the Cadillac, the more the man slowed down. Once we passed him, he seemed to come to a complete stop in the middle of the road. After we arrived at the studio, Steve's PR man came running up. He asked us if we'd gone through Nichols Canyon and seen an old man in a white Cadillac. Steve replied, 'Yes, we drove past him and he came to a stop.' The PR guy said, 'We must have come through there a good five to ten minutes after you, and he was still at a complete stop in the middle of the road.'

Avery photographed McQueen walking down Sunset Blvd.; at his Hollywood Hills home on Solar Drive, both alone and with his wife Neile and daughter Terry; at work with director John Sturges; at the Grand Prix Sports Car Center on Melrose Avenue and travelling down Nichols Canyon in his 1957 Jaguar XKSS. For the **Saturday Evening Post** *article, 'TV's Angry Young Star', 14 January 1961.*

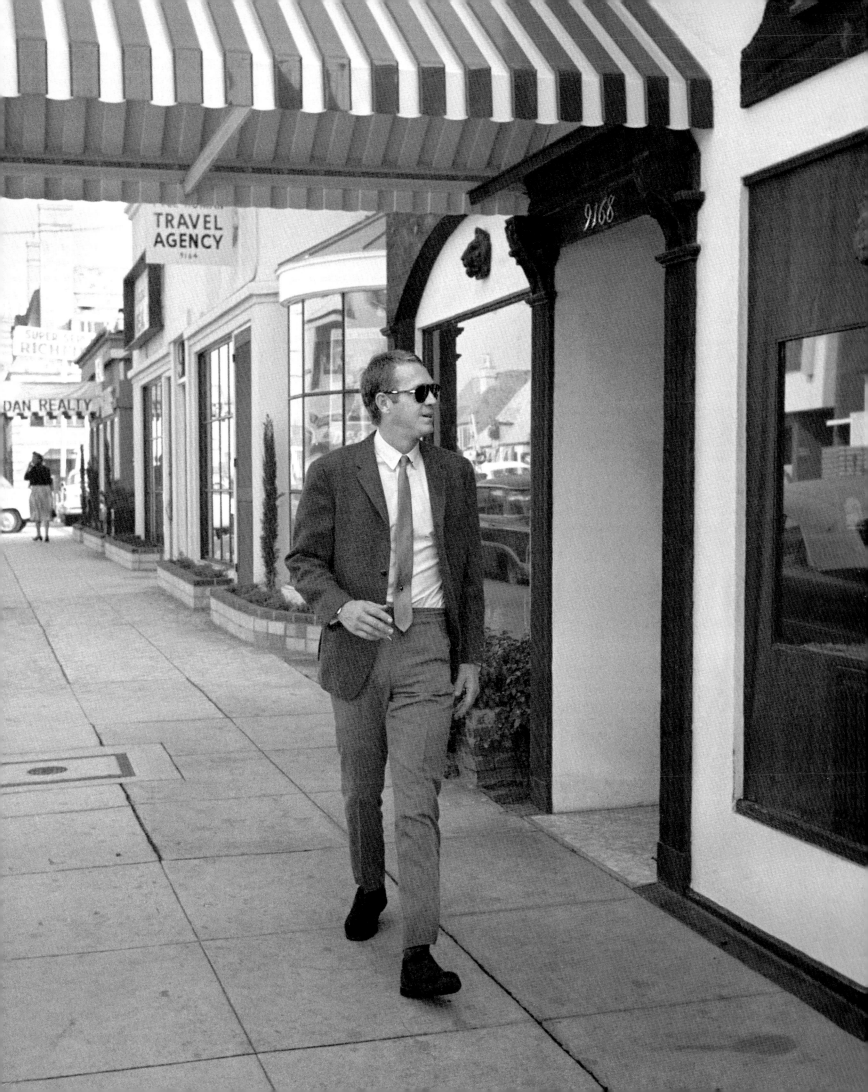

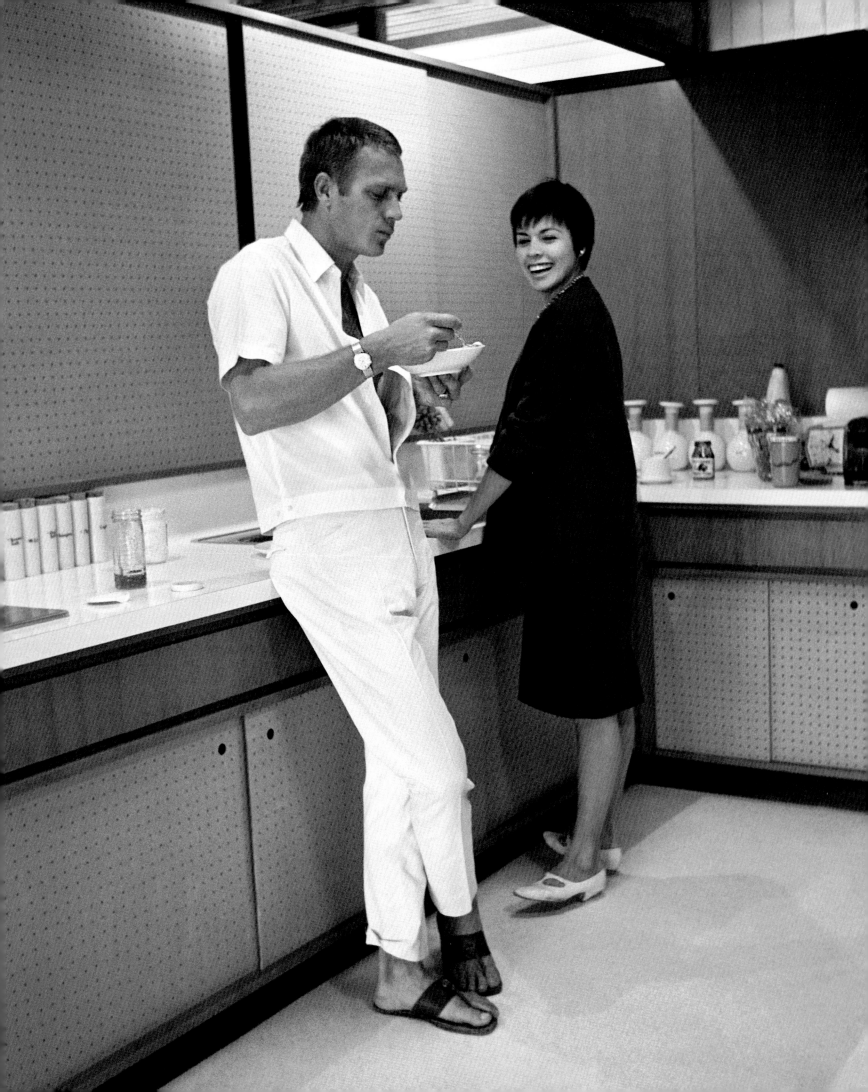

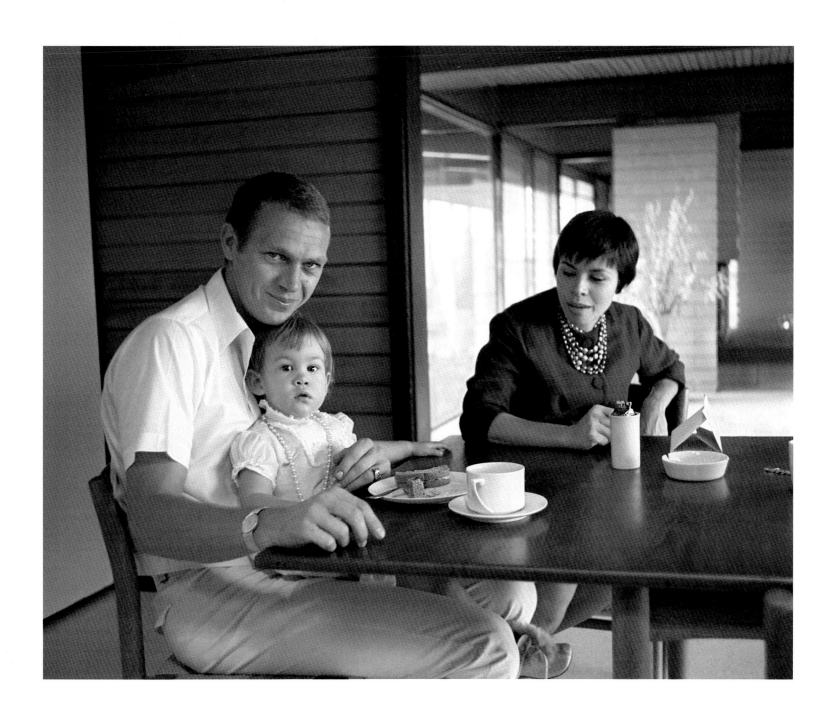

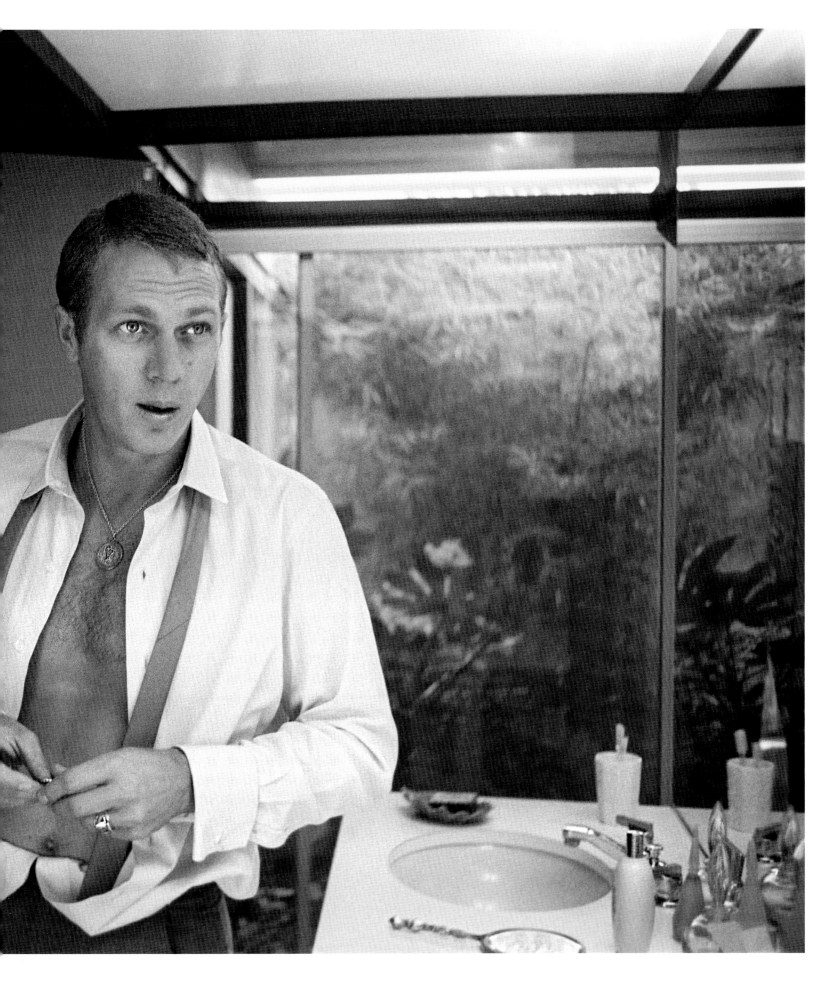

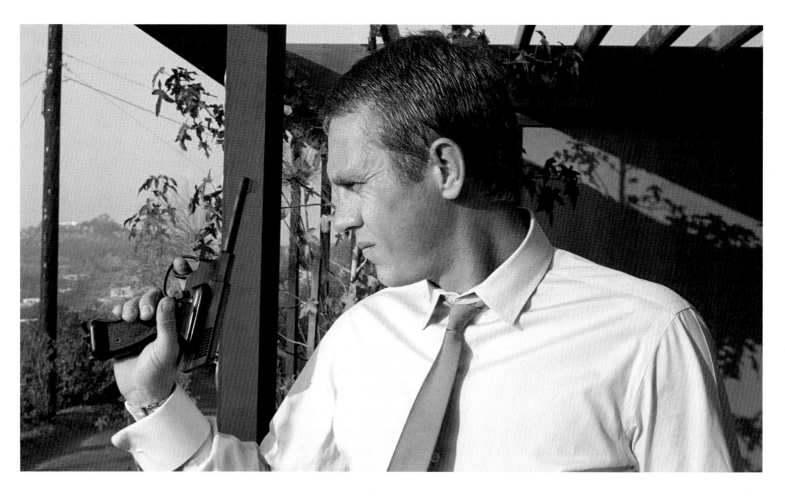

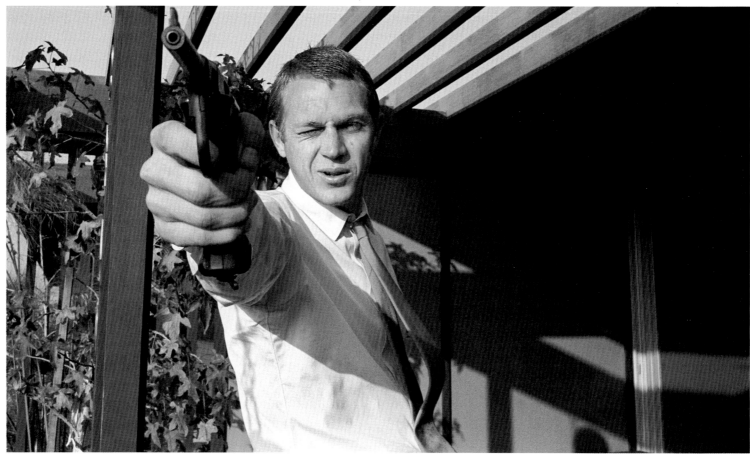

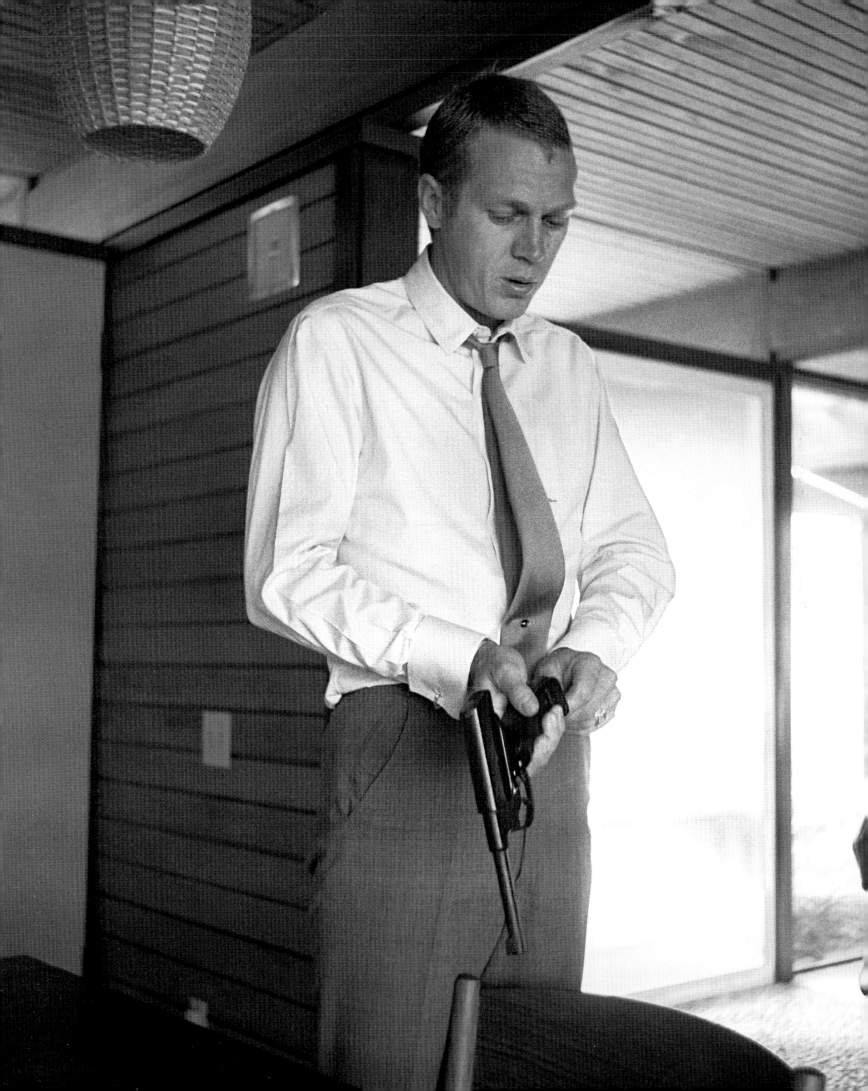

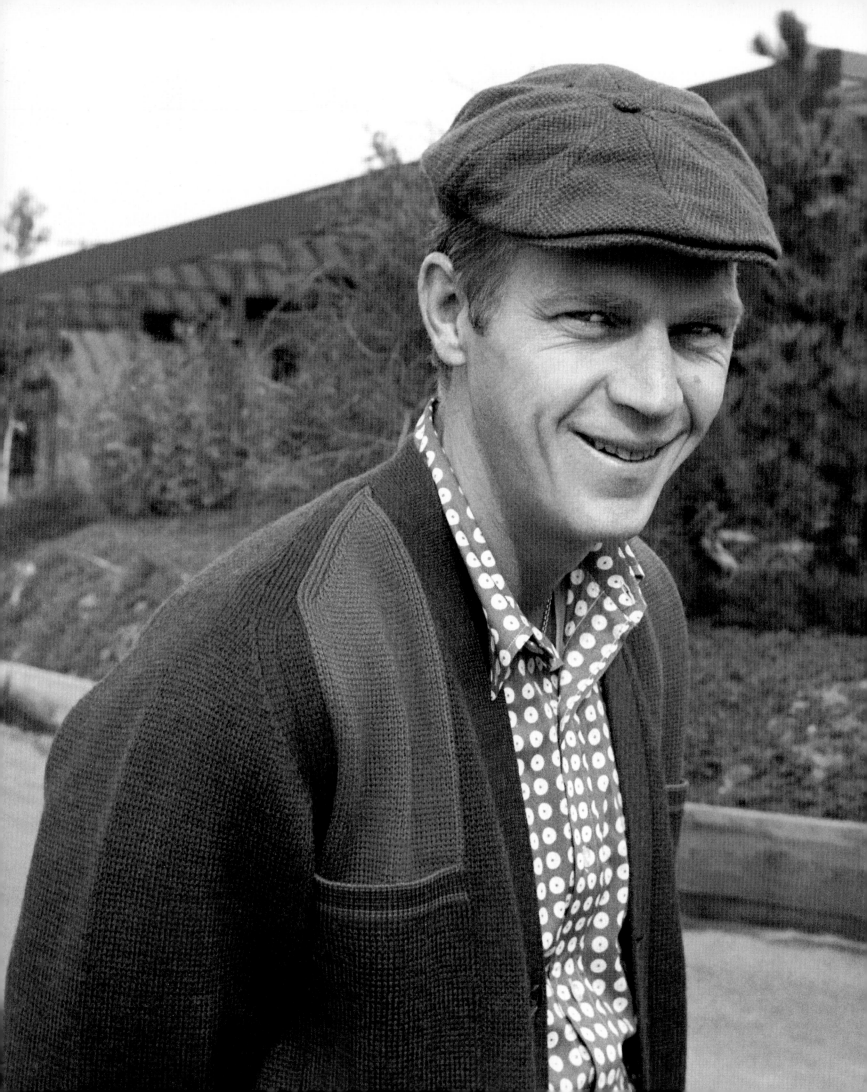

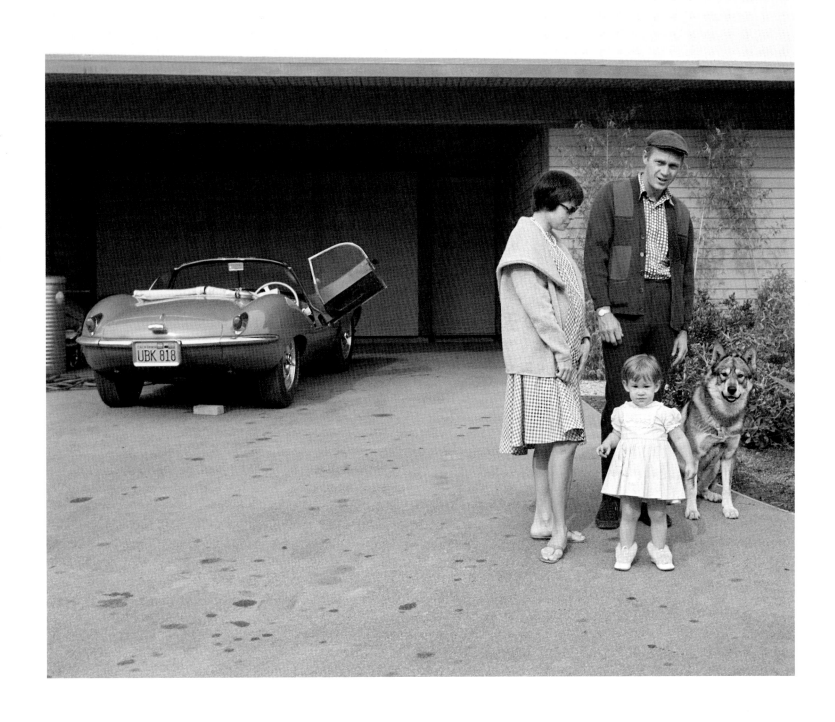

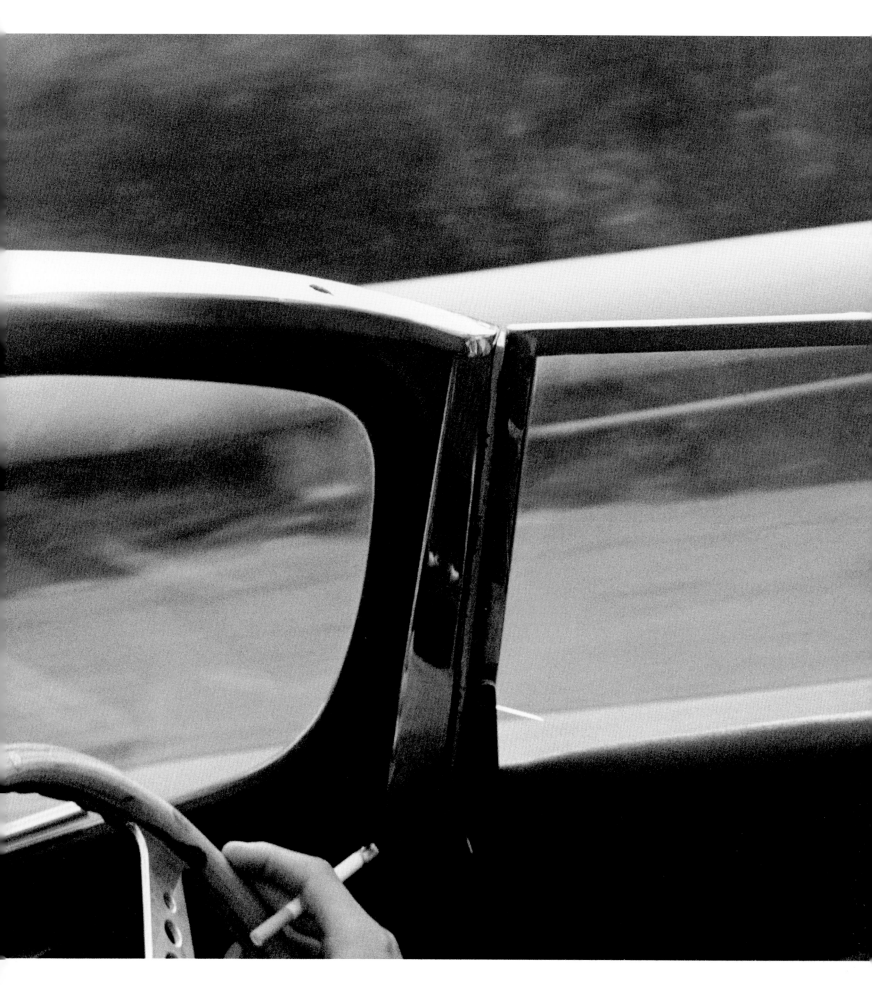

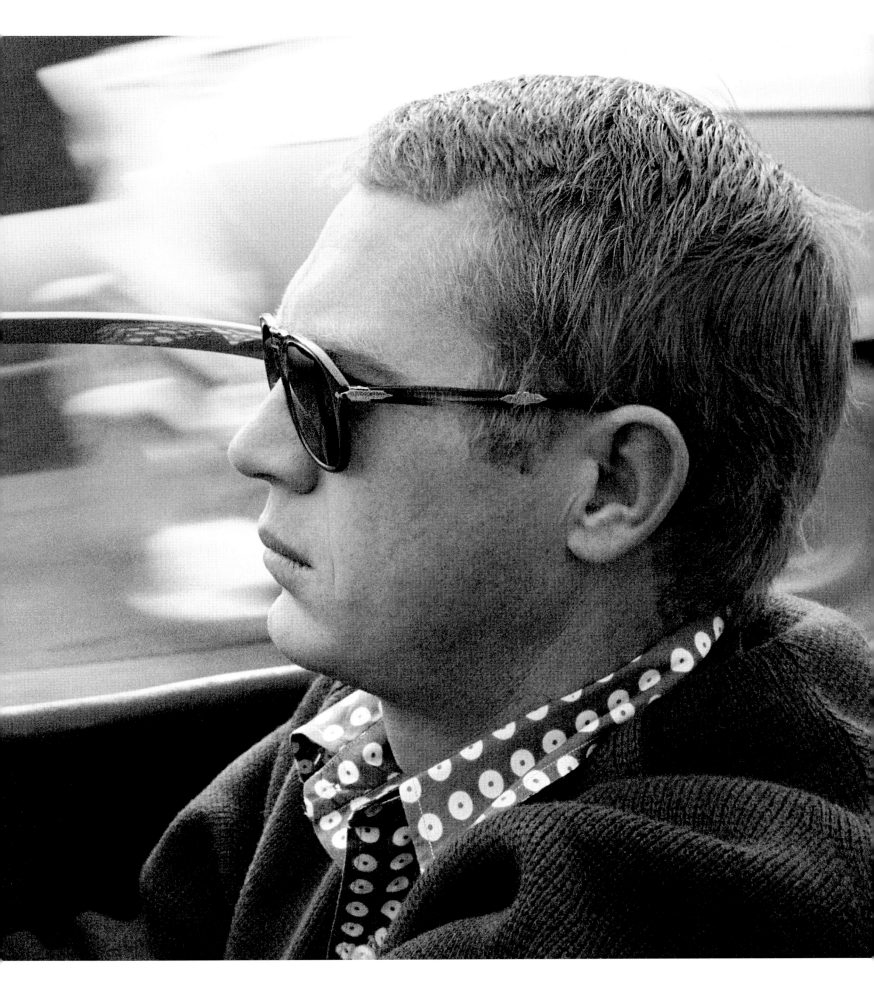

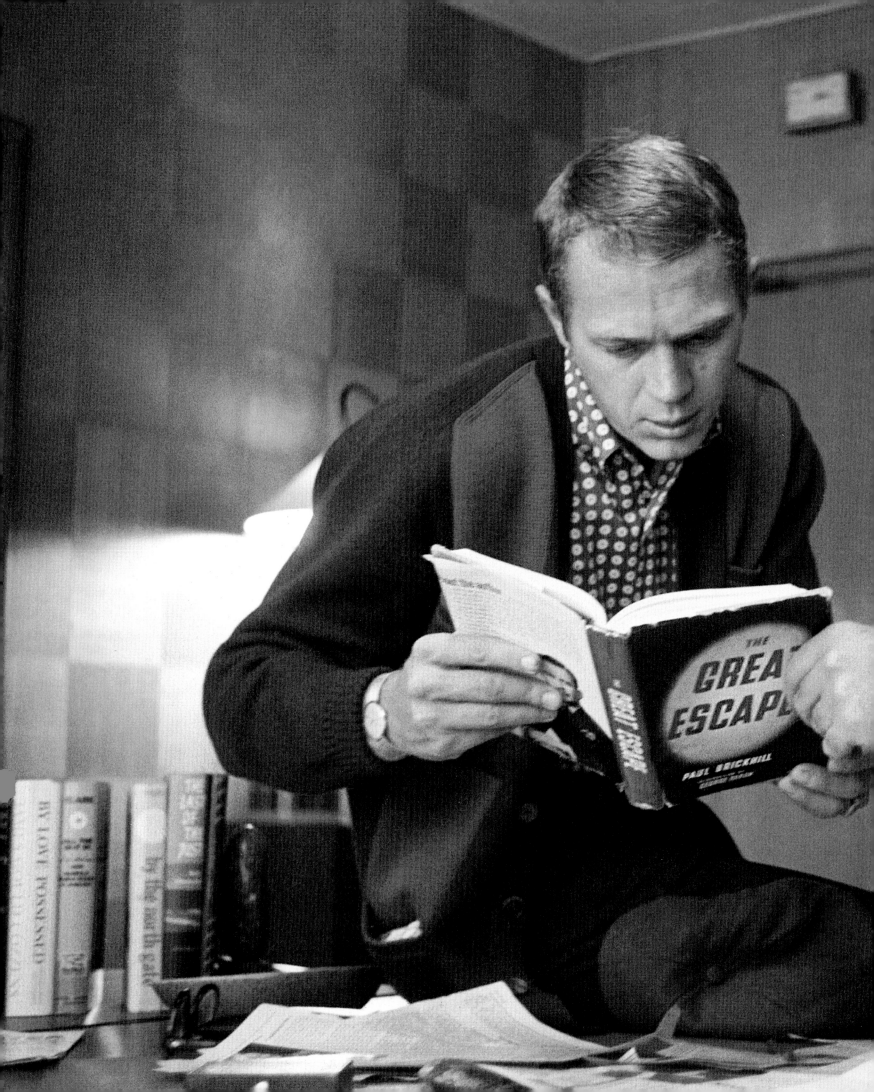

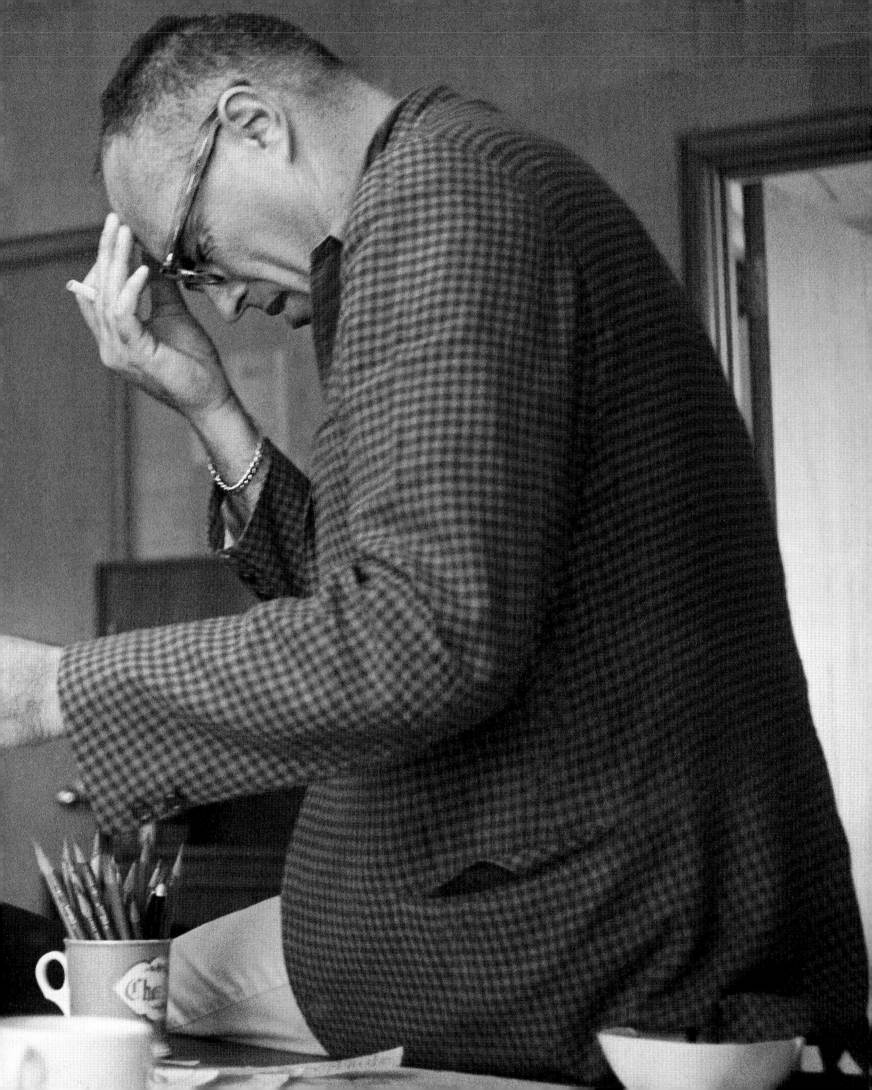

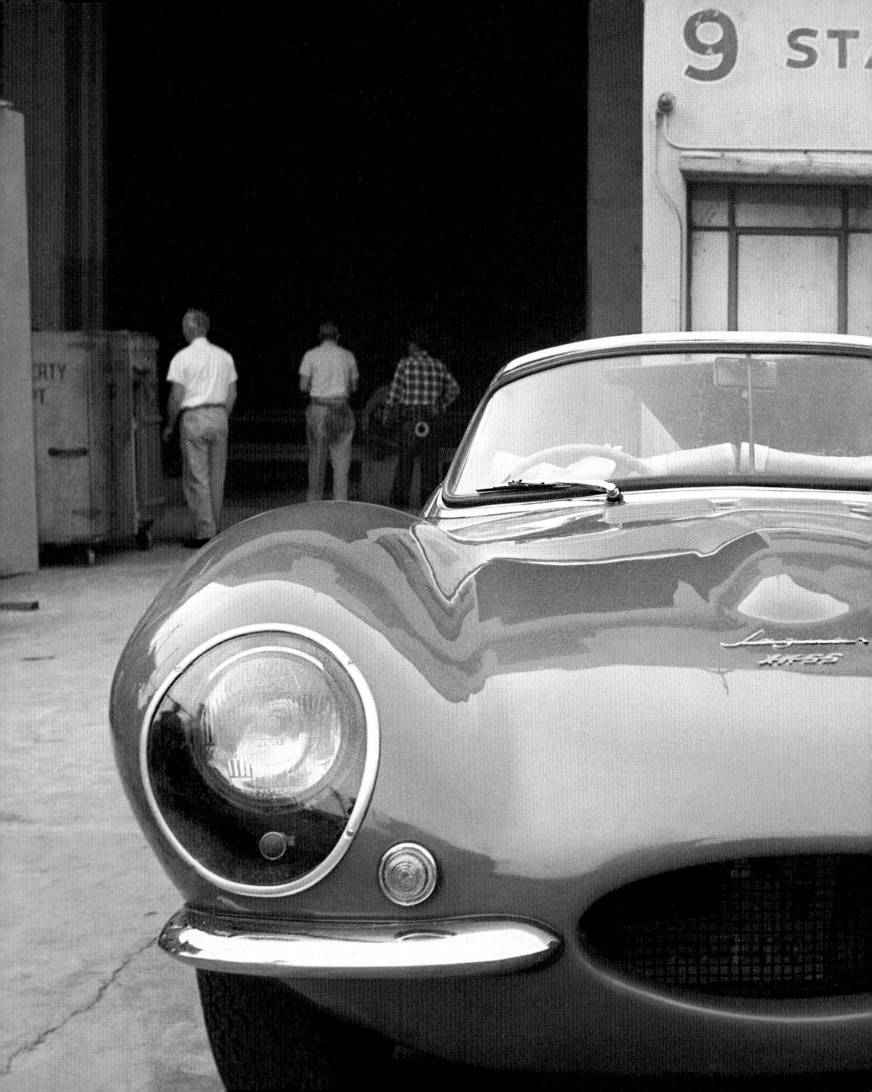

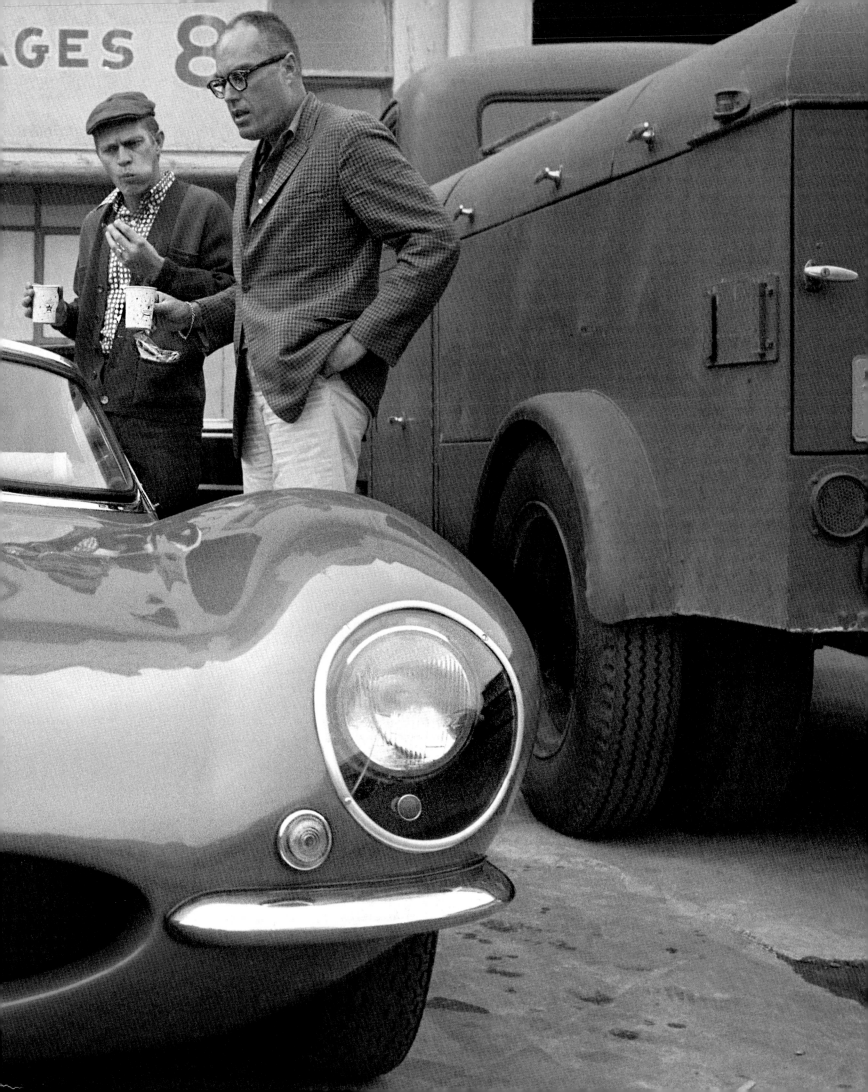

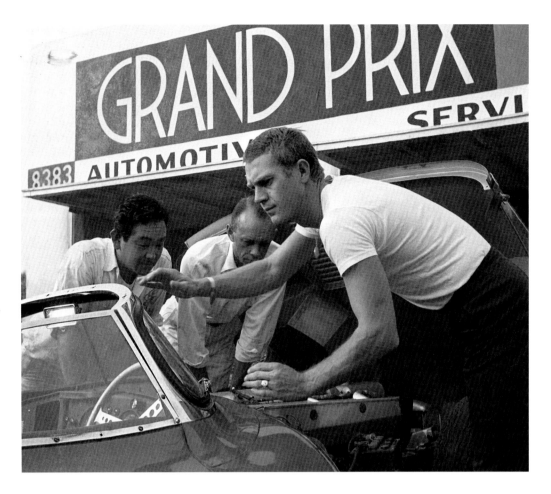

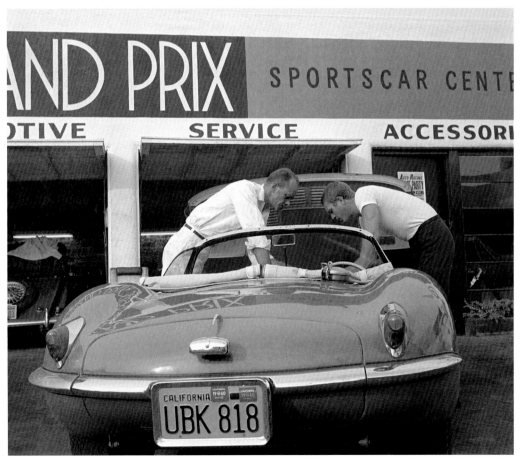

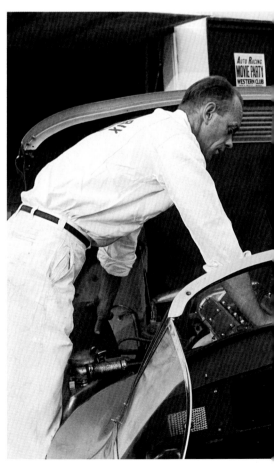

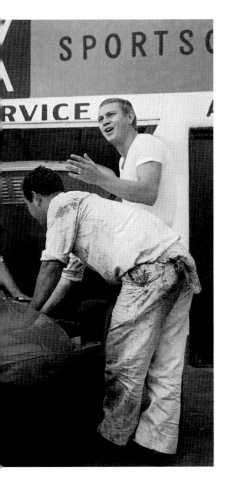

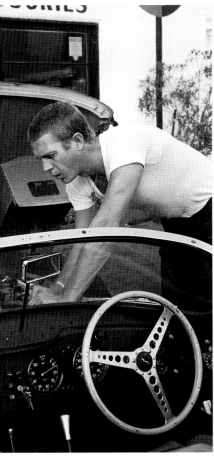

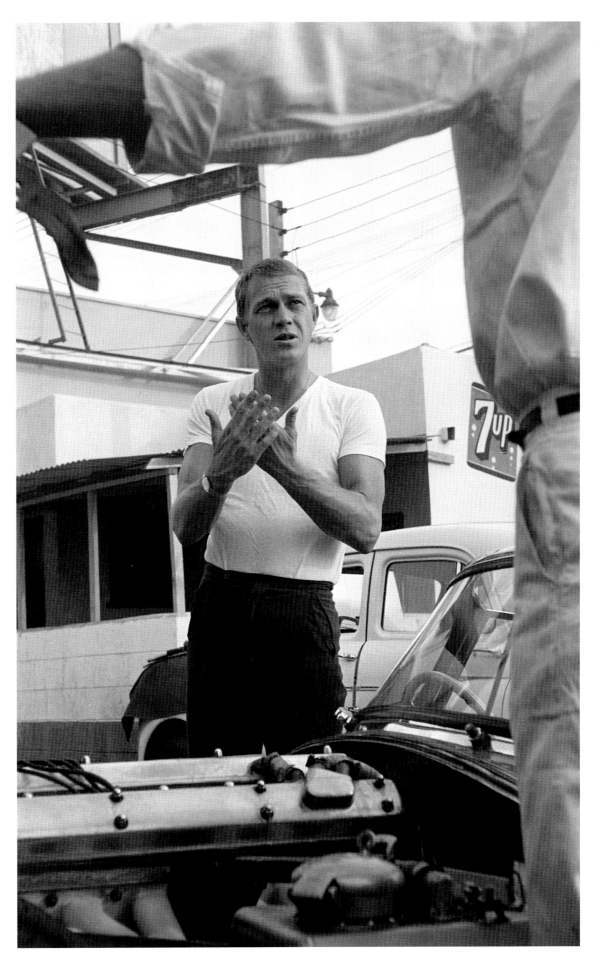

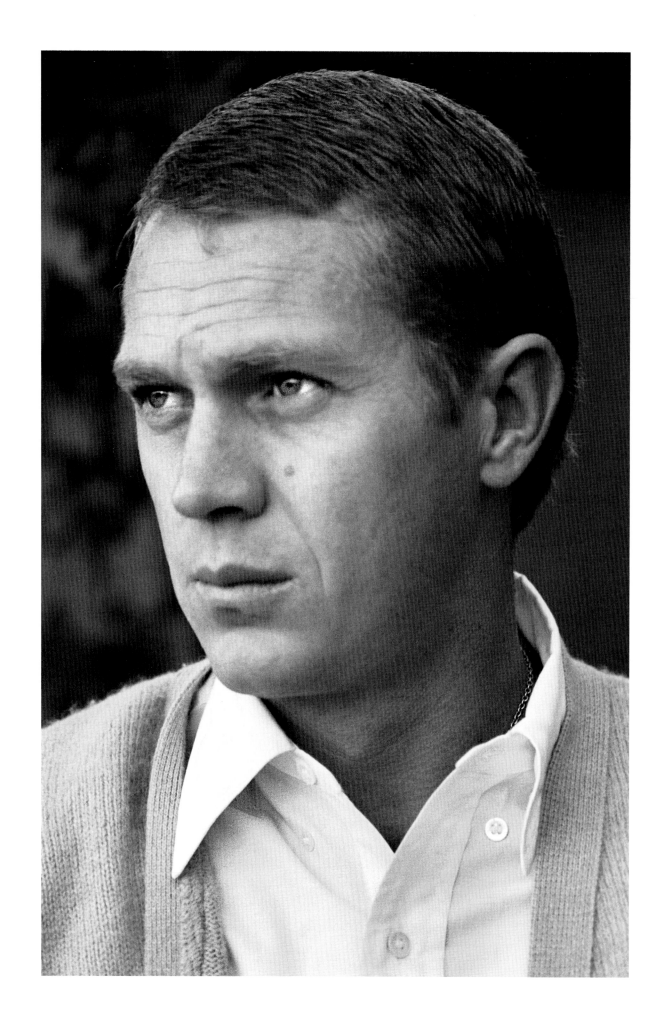

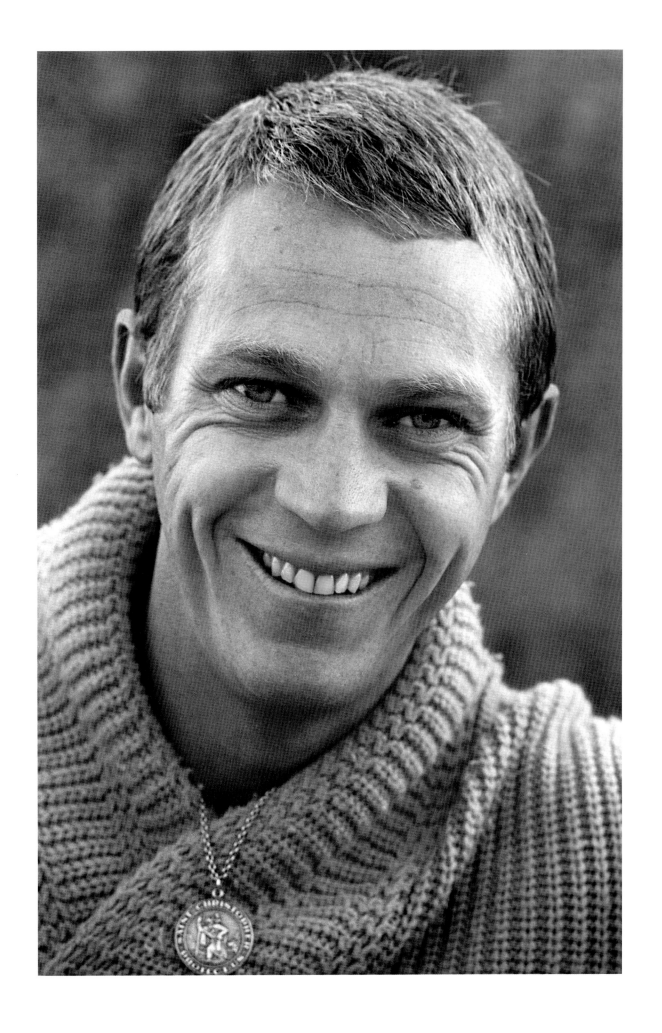

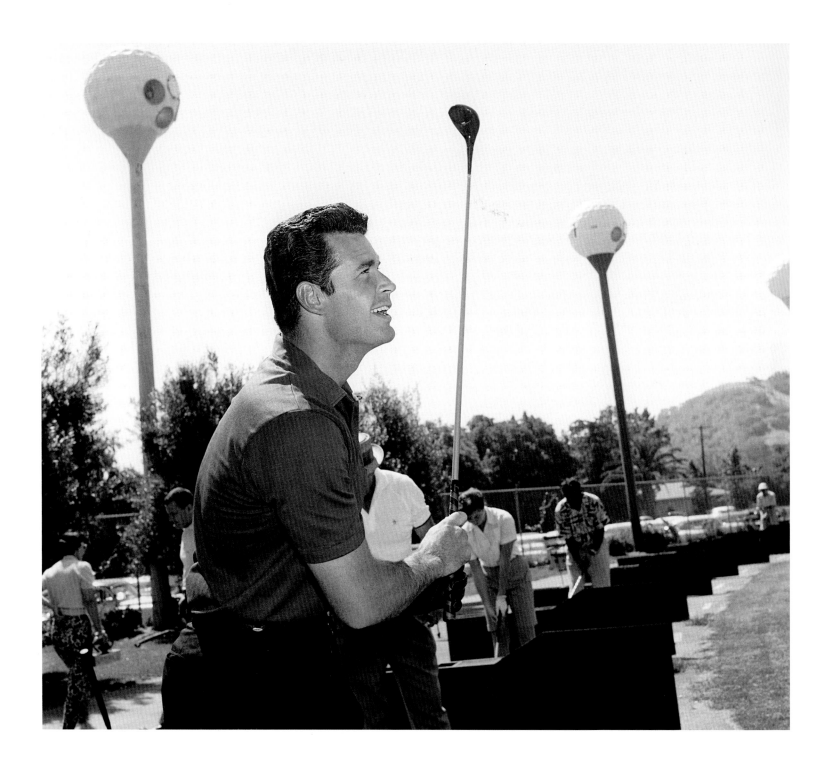

JAMES GARNER

A really easy person to work with. At this time, Garner was doing the TV show *Maverick*. He's a bit of a camera nut and a pretty damn good photographer – he's got his Rolleiflex there, taking pictures of his little family. I enjoyed working with him very much. He's a damn good golfer, good skeet shooter, good driver, just an all around good person.

*James Garner photographed at the driving range and at home with his wife Lois and daughters Kimberly and Gigi. For the **Saturday Evening Post** article, 'I Call on Bret Maverick', 11 October 1958.*

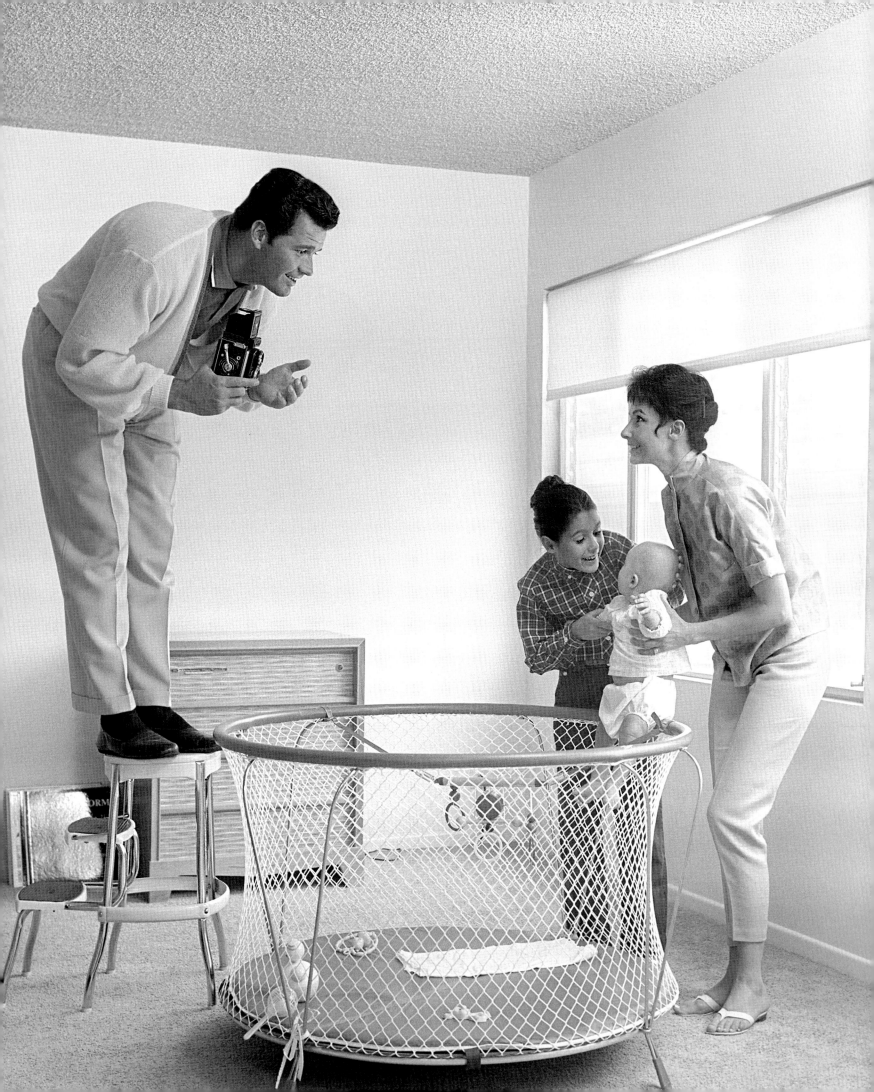

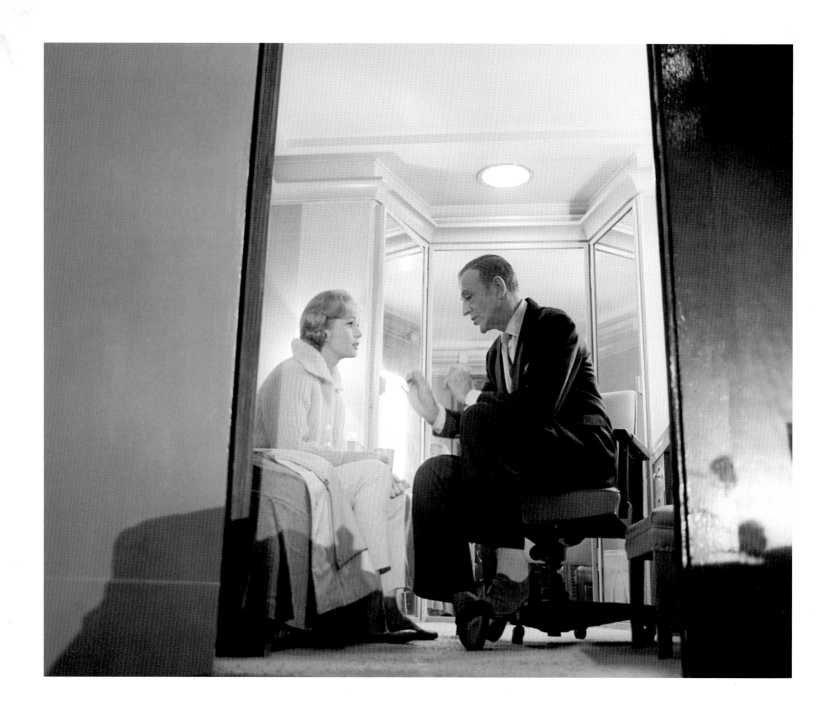

DEBBIE REYNOLDS

She was such a doll. This assignment was just a few months after Elizabeth Taylor 'palled up'
with Eddie Fisher. And yet Debbie was nice enough to work with me – she was very cooperative.
I spent a lot of time with her and her children – she was up all the time (I went to a lot of different
places with her – and shot quite a bit). Incidentally, during this period, the studios were fighting with
television, trying to stop their audience from staying home instead of going to the movies. So studios
were turning to gimmicks like super wide screens, 3-dimension, smell-a-thonics, and God knows
what else. This was a tough period for the studios.

Debbie Reynolds photographed on the set of **The Pleasure of His Company** *with Fred Astaire; with a Lincoln
Continental Mark II at Paramount Studios; and at home with her children, Carrie and Todd Fisher. For the*
Saturday Evening Post *article, 'I Call on Debbie Reynolds', 26 March 1960.*

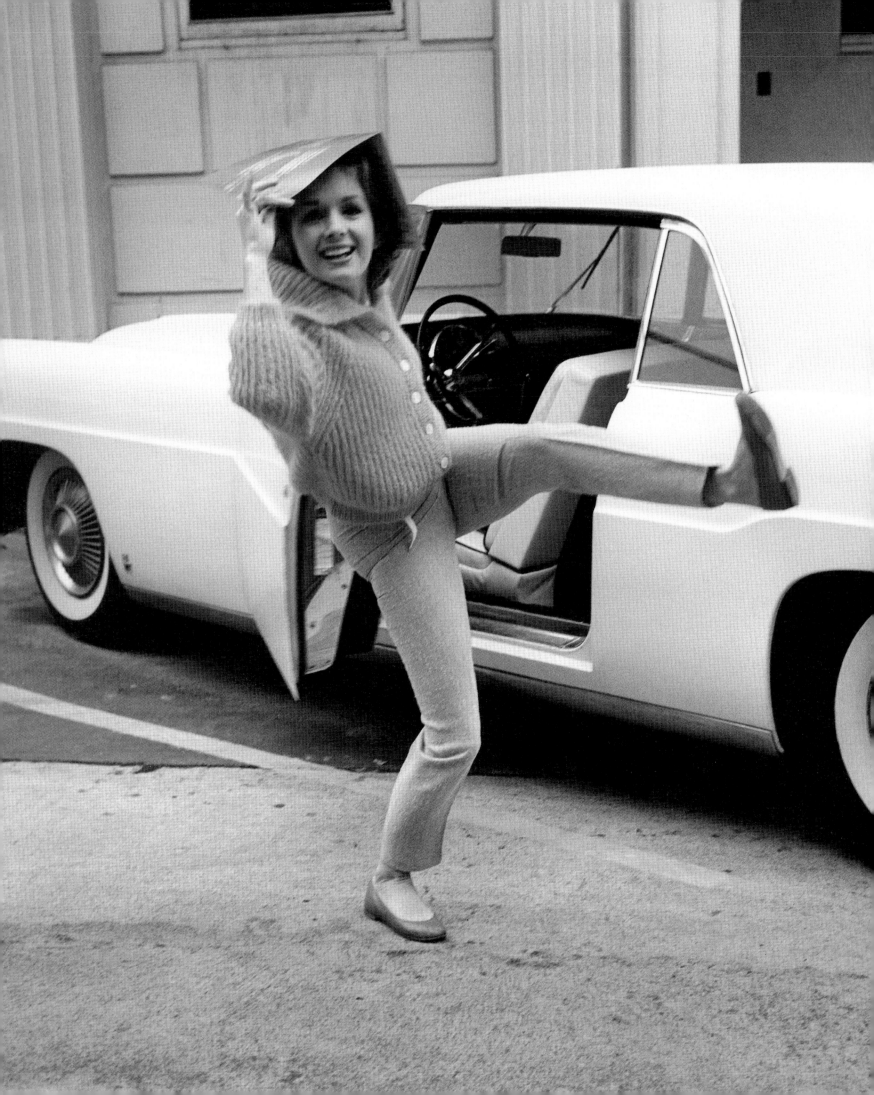

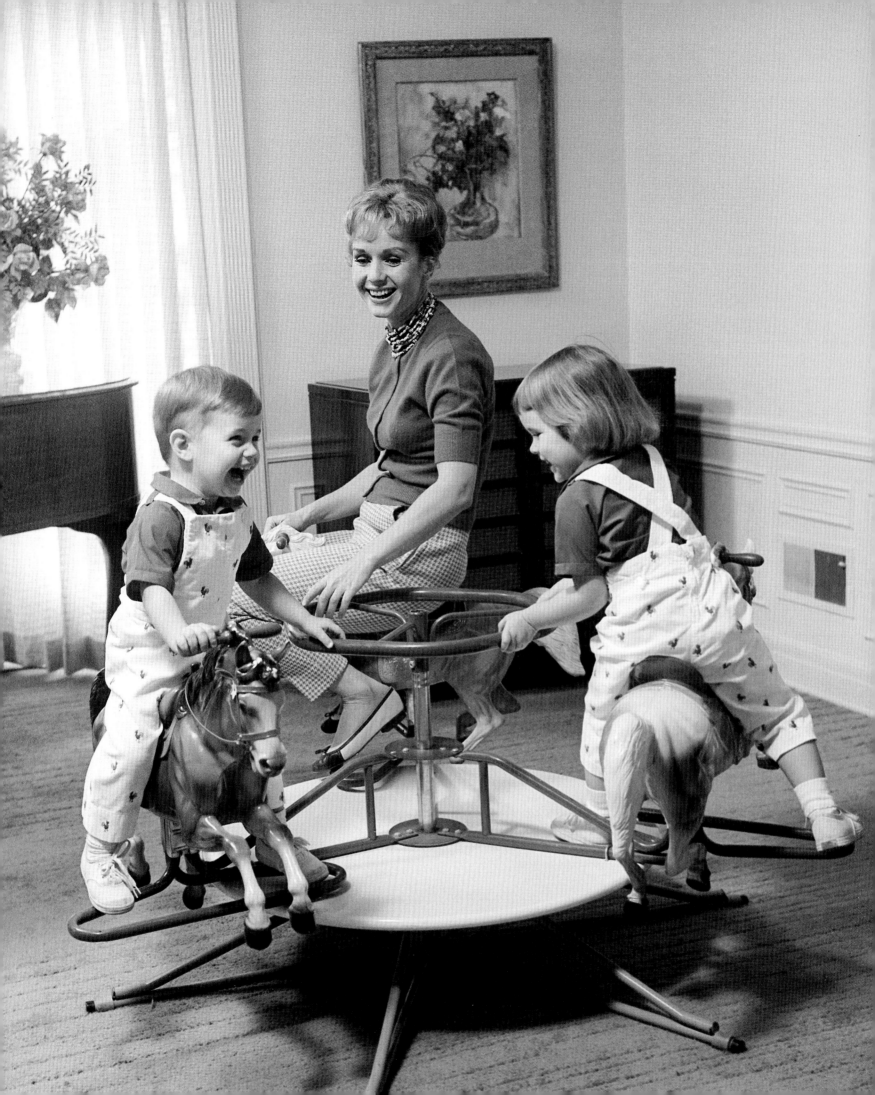

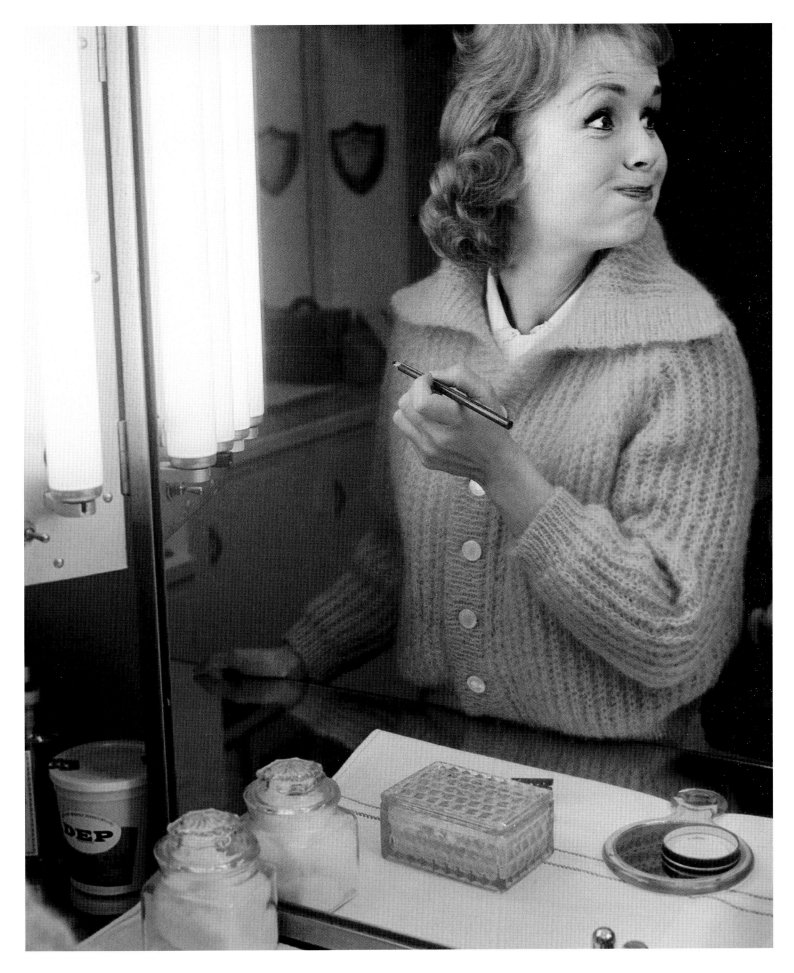

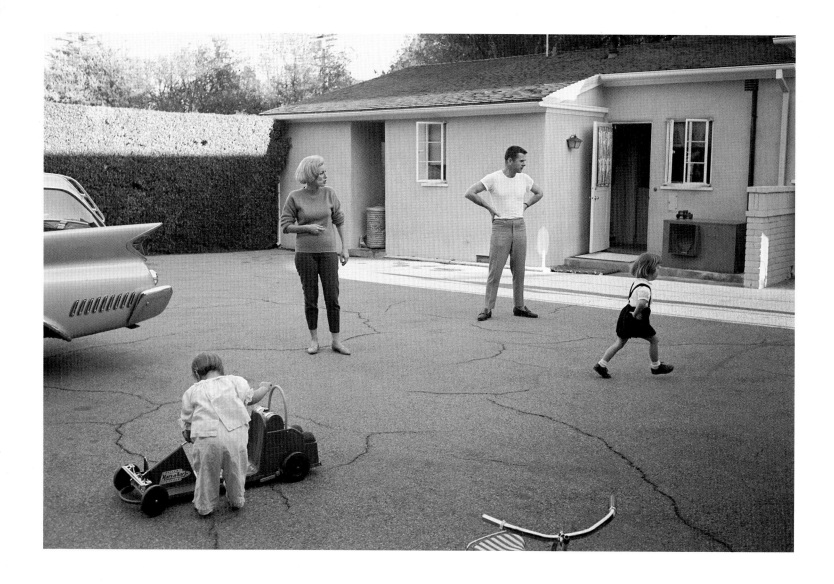

JACKIE COOPER

He and I met a few times earlier than this because he came to our camp to entertain the troops before we went overseas in World War II. We double-dated when he came into town and we've been friends ever since.

*Jackie Cooper photographed at his Brentwood, California, home with his wife Barbara, daughters Julie and Christina, and son Russell. For the **Saturday Evening Post** article, 'Unfortunately I Was Rich', 25 March 1961.*

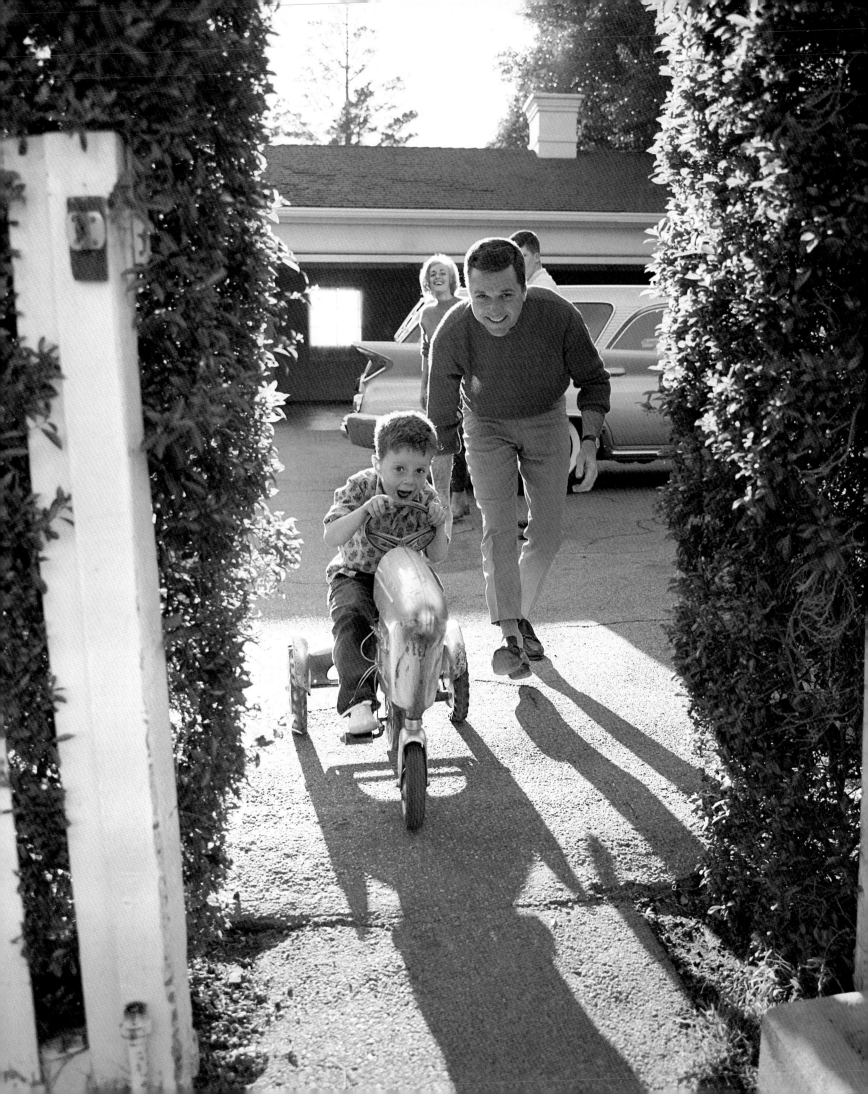

PAUL NEWMAN AND JOANNE WOODWARD

The most relaxed couple I have ever worked with. When I went to knock on the door to get in to do the shooting, it was like being invited into some old friend's home. They were so warm and so relaxed and so easy going – here have some popcorn, get yourself a beer, open up the refrigerator. We spent a little bit of time shooting together and it was one of the most fun assignments that I had. Absolutely no star ego at all, real people.

I love this picture because he's there cracking eggs and making breakfast while she's standing there with her favorite dog – the cupboards are open and the drawers are pulled. In the background, there's a washing machine and there's a lot of clothes thrown on top.

I thought it was kind of funny – there's a sign posted there and he's standing in his shorts [see p.243] – they had been working on a scene but took a brief moment to get coffee.

At this particular time, she had already won an Oscar for *The Three Faces of Eve*. And he never had an Oscar so she went out and had one made for him called 'Noscar' [No Oscar] and presented it to him. He looks a bit downhearted but that's the breaks.

Paul Newman and Joanne Woodward photographed at home in Beverly Hills and on the set of
Rally 'Round the Flag, Boys!*, 1958.*

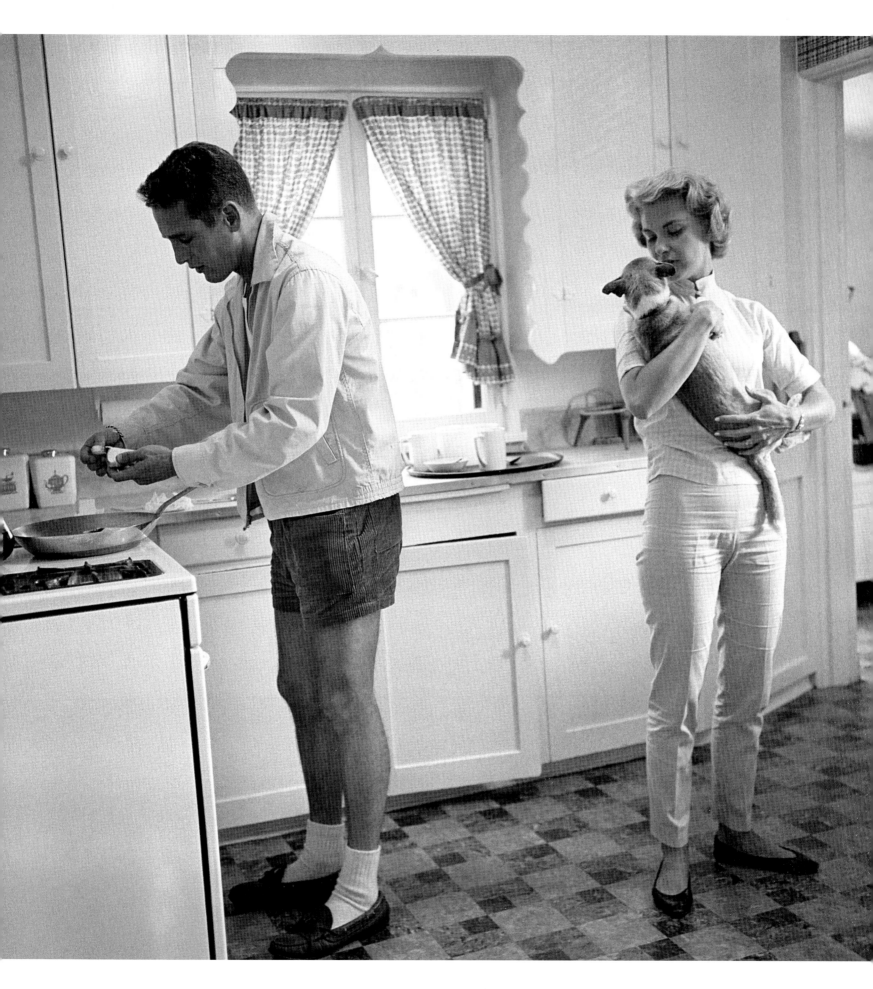

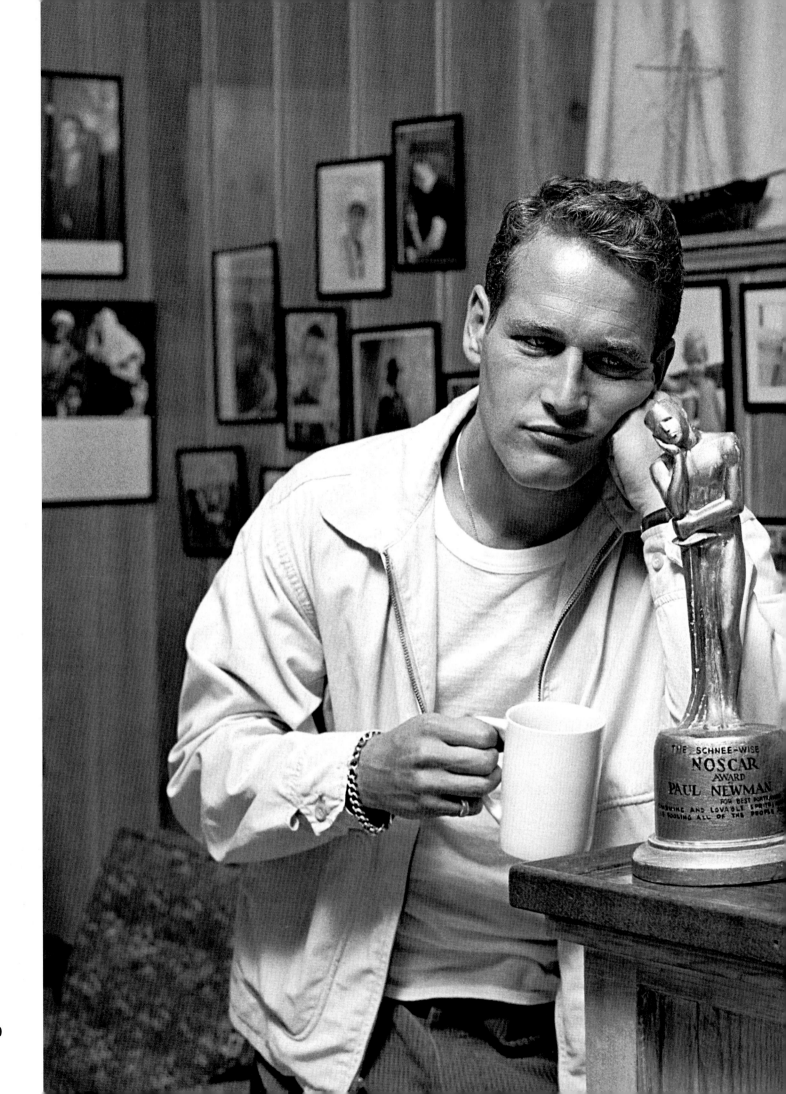

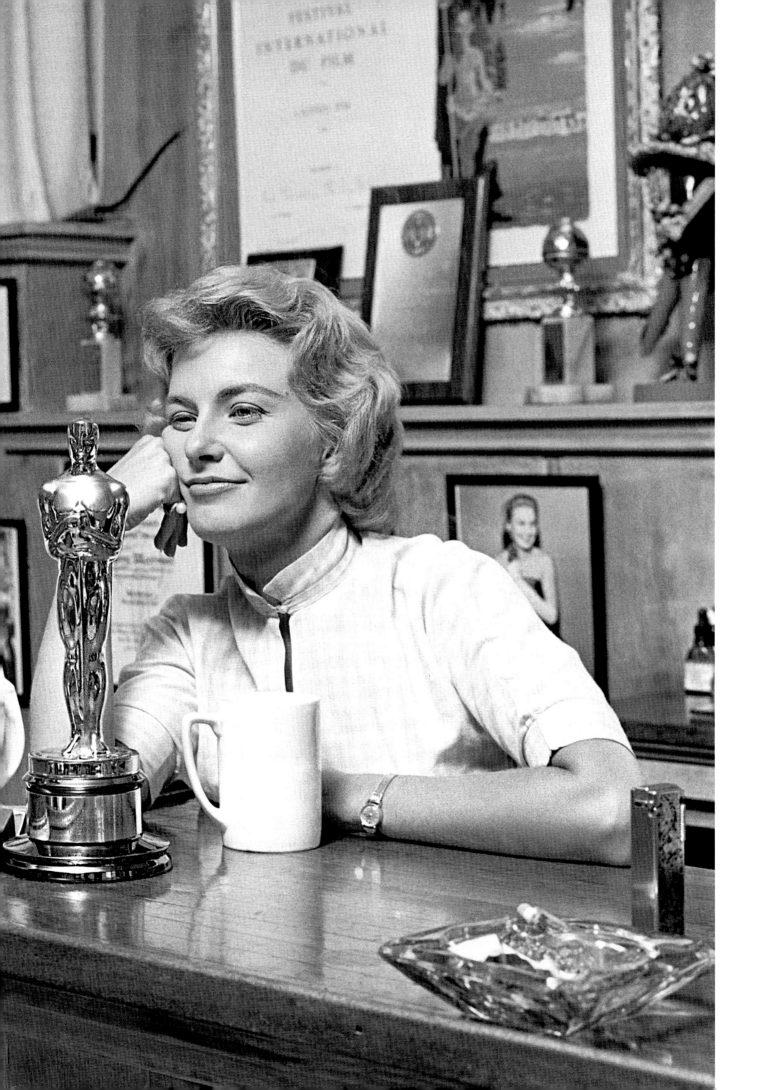

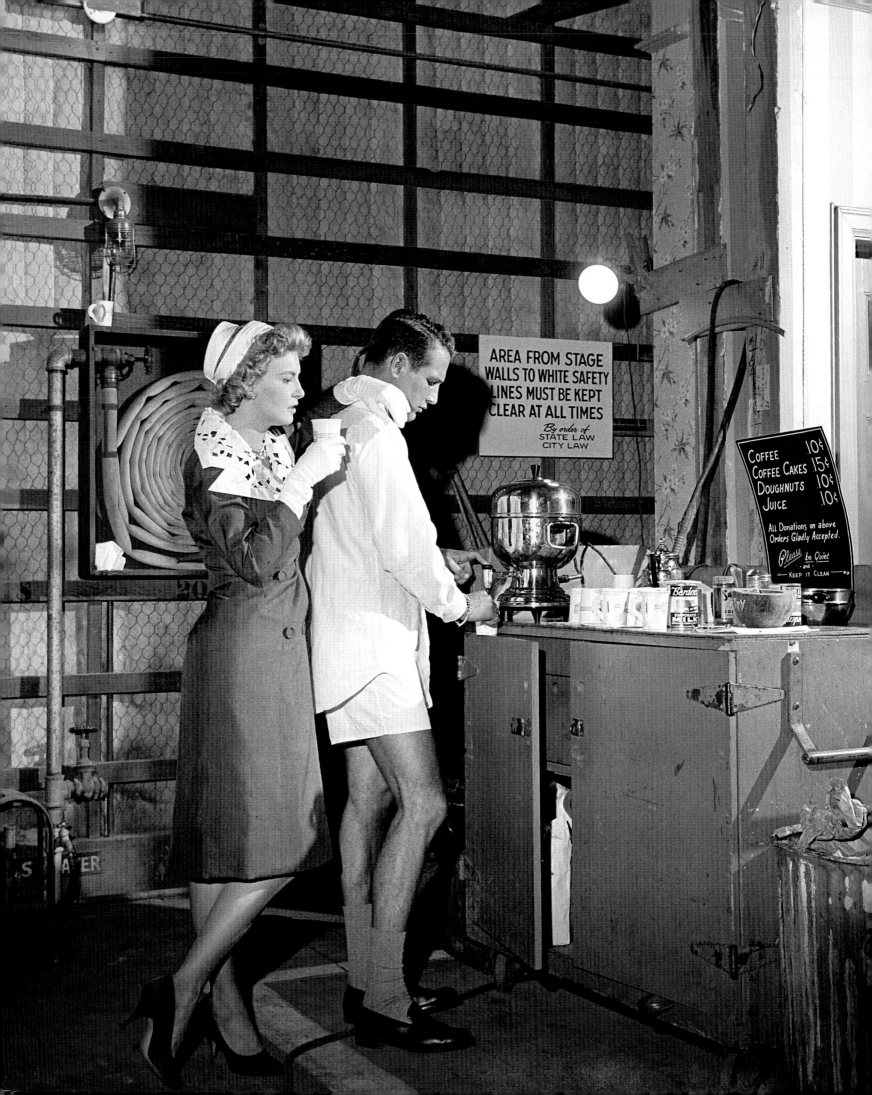

AREA FROM STAGE
WALLS TO WHITE SAFETY
LINES MUST BE KEPT
CLEAR AT ALL TIMES

By order of
STATE LAW
CITY LAW

COFFEE .10¢
COFFEE CAKES .15¢
DOUGHNUTS .10¢
JUICE .10¢

All Donations on above
Orders Gladly Accepted.

Please be Quiet
and
KEEP IT CLEAN

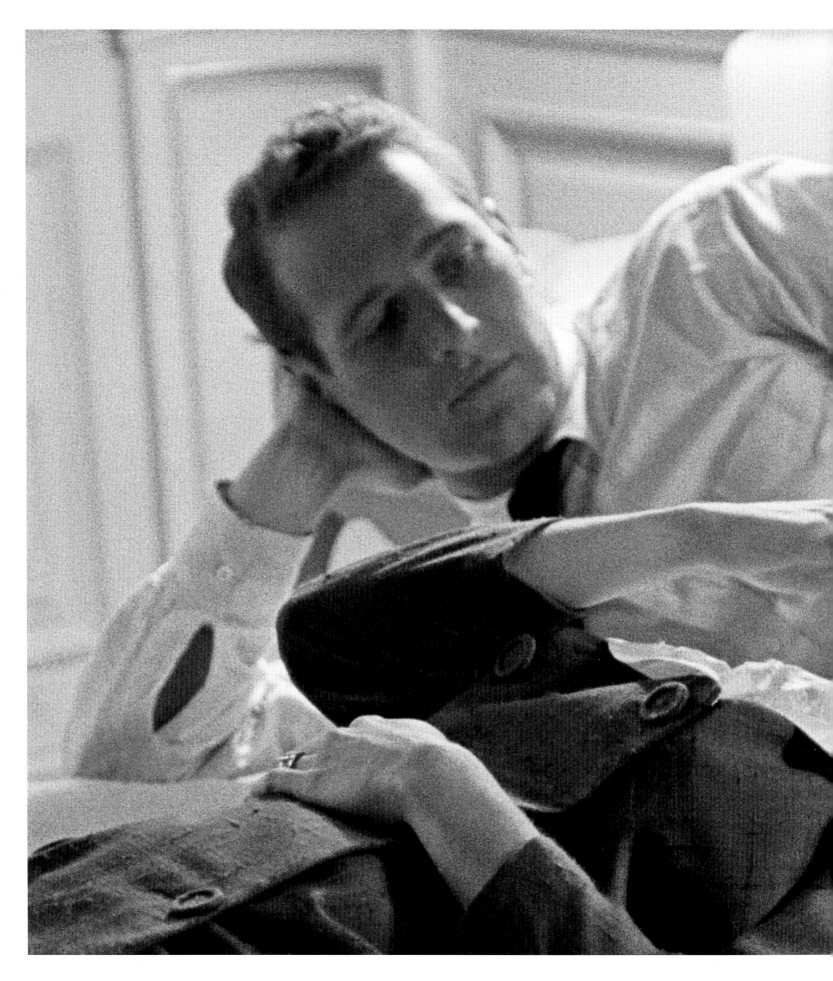

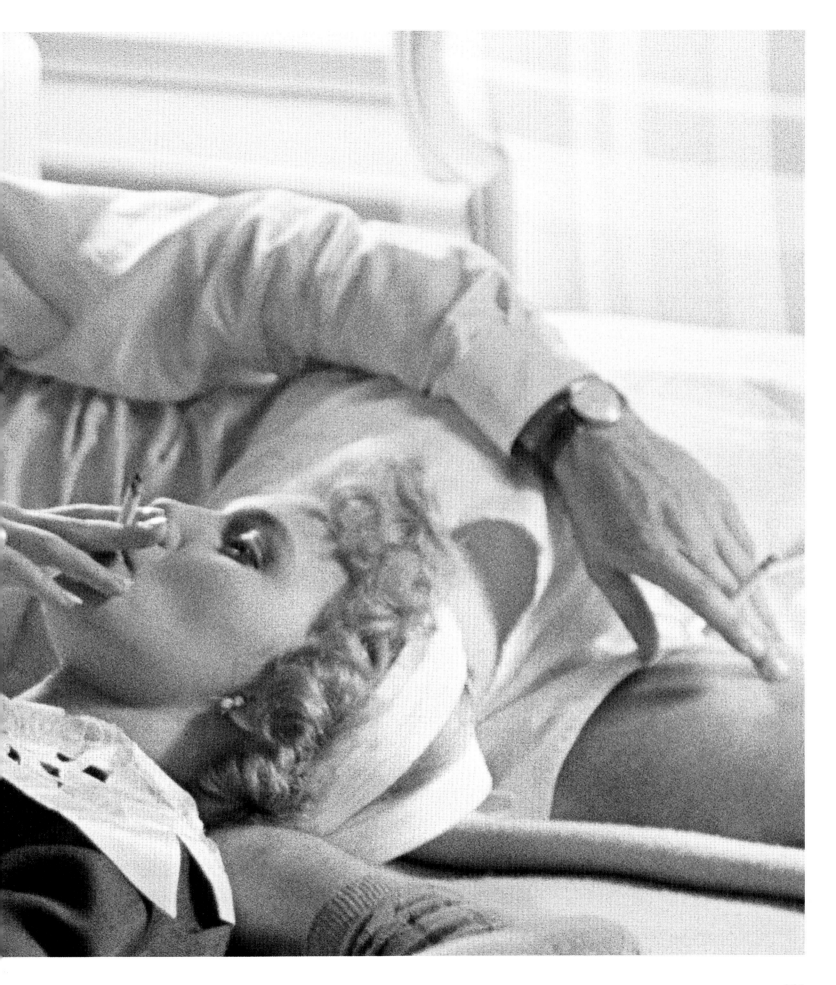

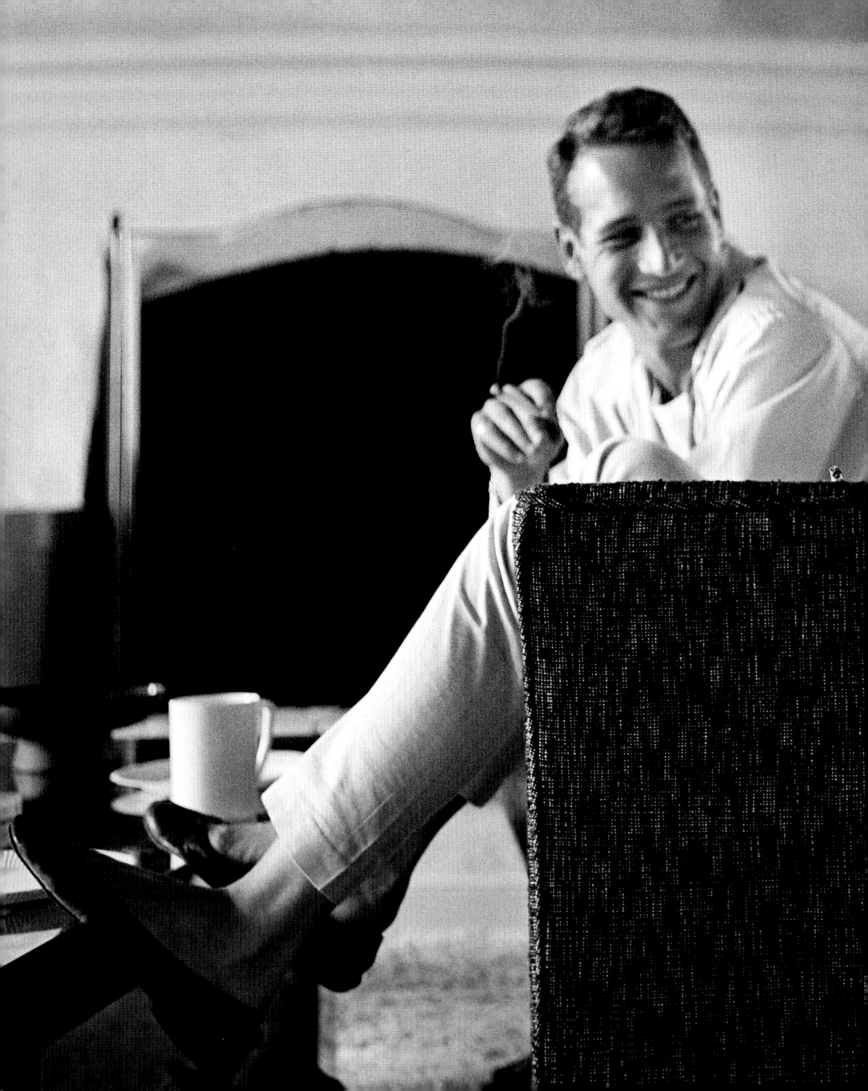

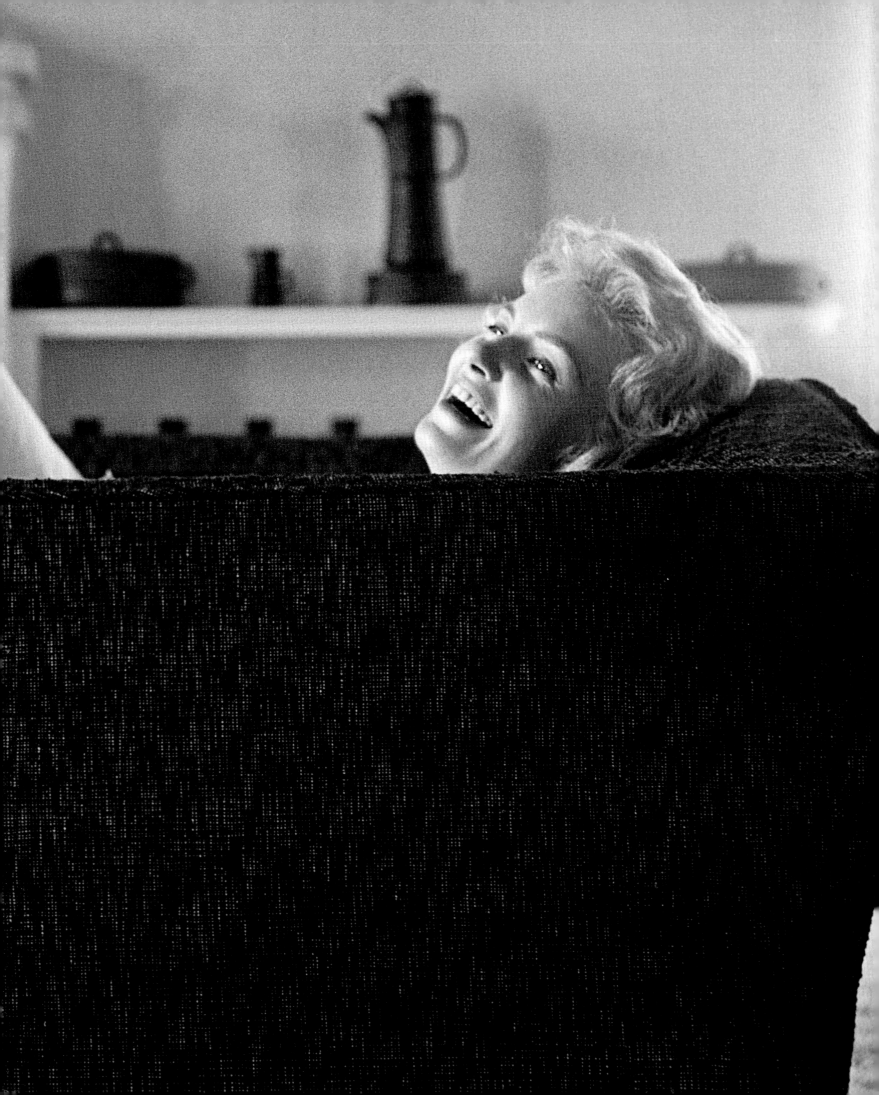

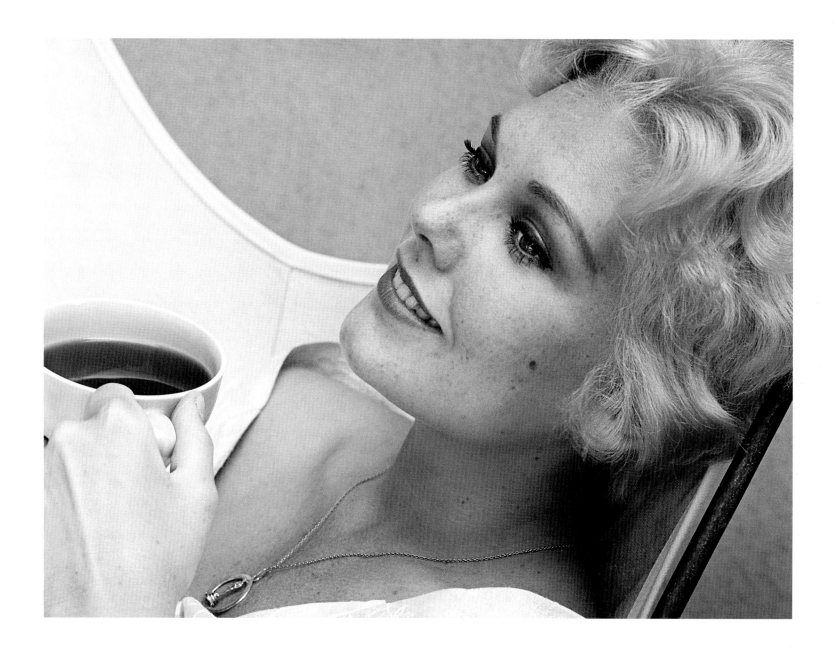

KIM NOVAK

Beautiful woman – easy to photograph – never looked bad from any angle or in any situation. She was obsessed with the color purple, everything in her house and clothes seemed to be purple. It was a very fun shoot.

*Kim Novak photographed at home in Los Angeles and with her new Corvette. For the **Saturday Evening Post** article, 'Hollywood's Melancholy Blonde', 6 Oct 1954. One of the original captions from the article reads, 'Kim, an emotional, cloud-borne girl, says she is probably the loneliest star in Hollywood. From a box-office standpoint, she is also one of the most valuable properties in filmdom.'*

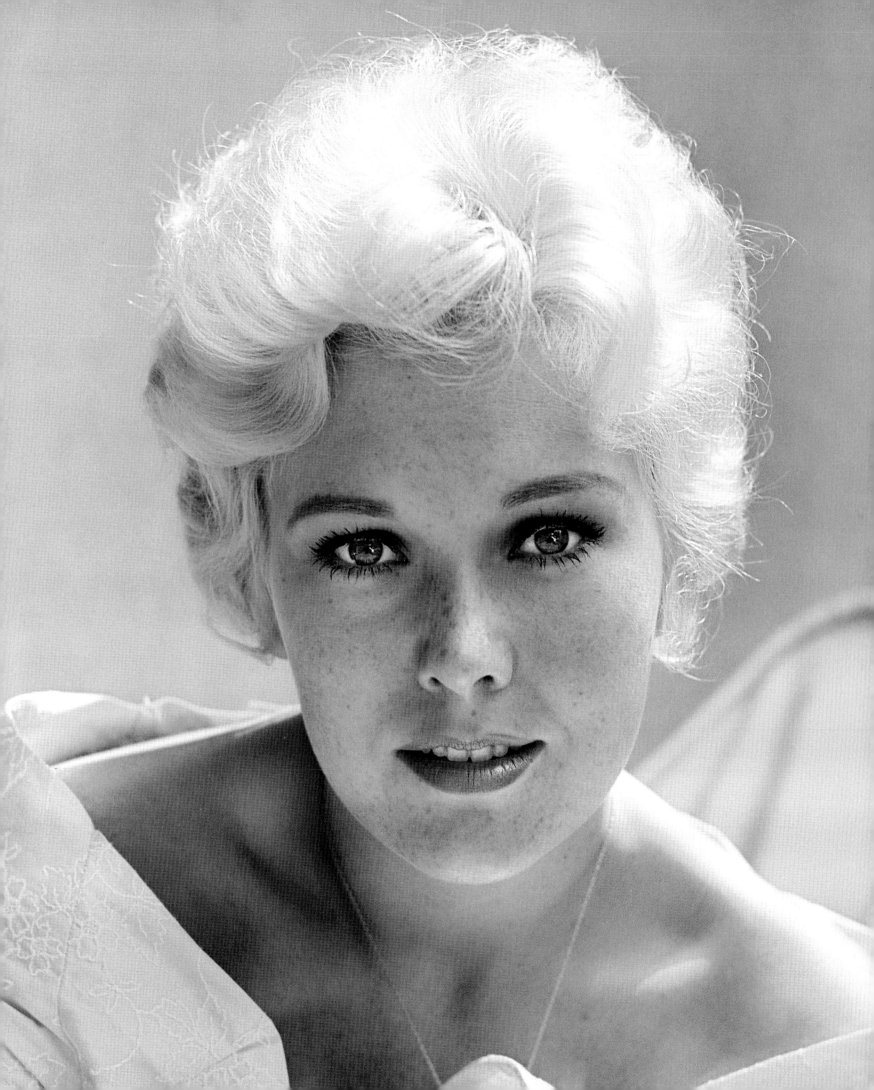

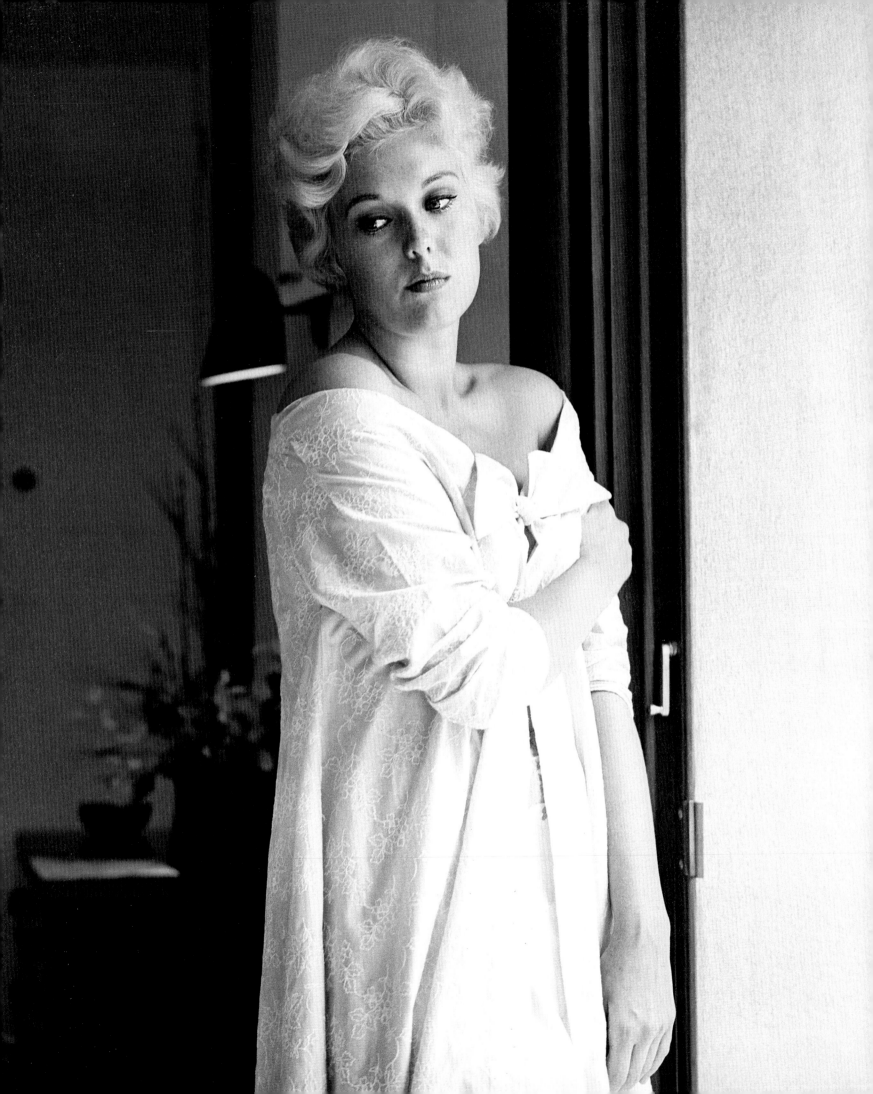

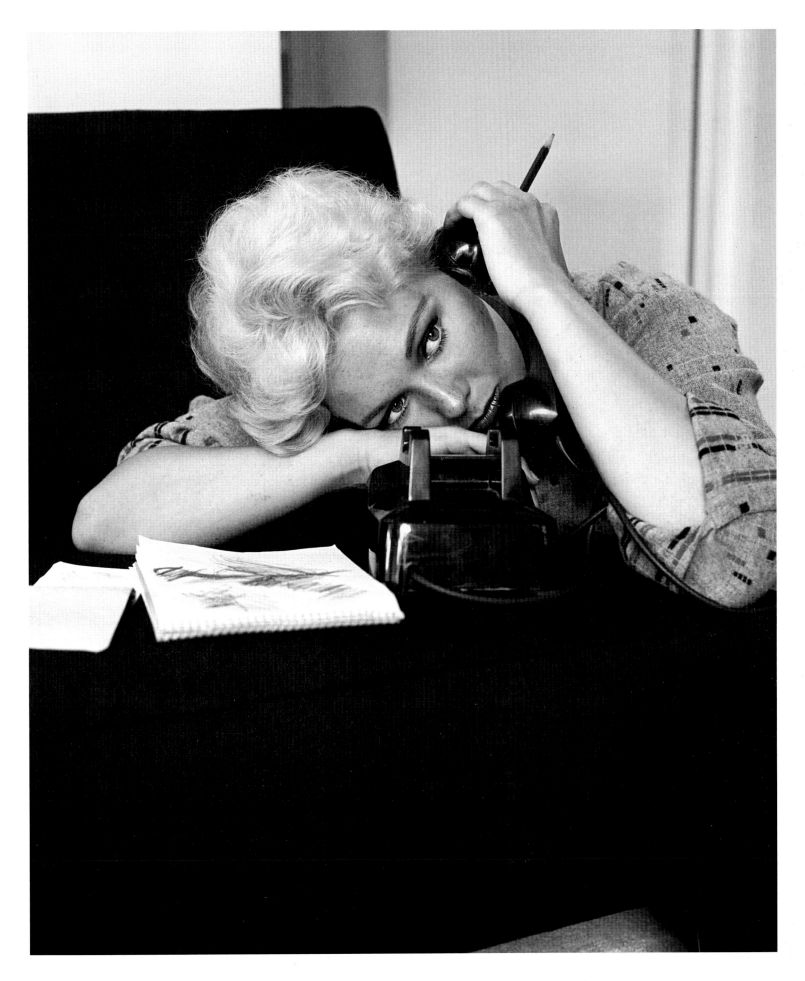

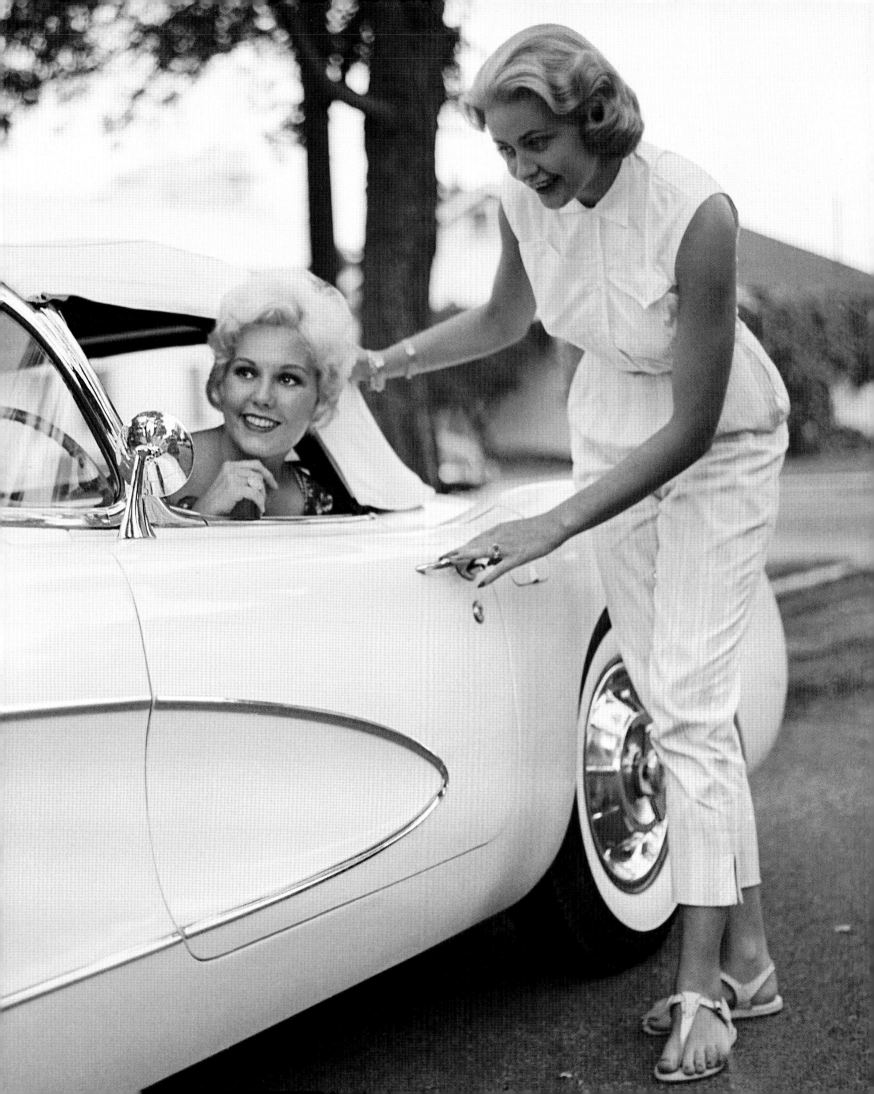

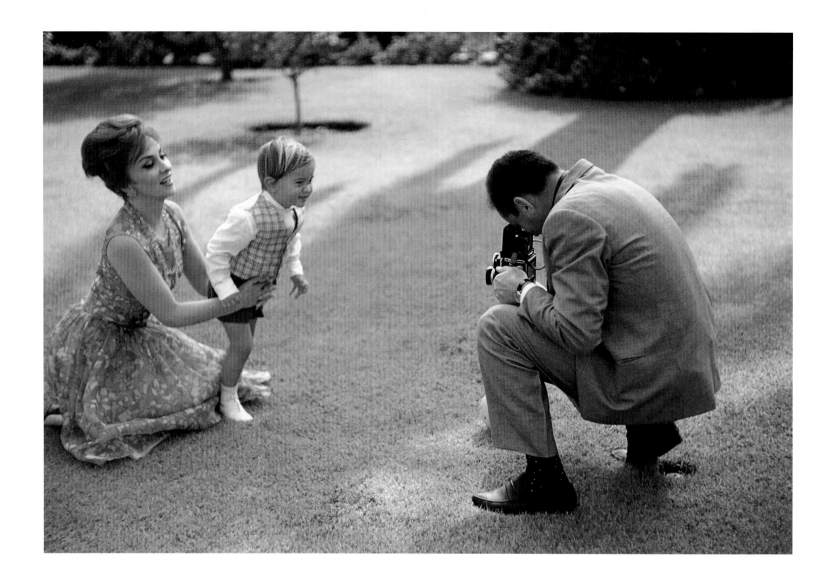

GINA LOLLOBRIGIDA

She was one of the only women I photographed that knew what was the best lighting direction for her to be photographed in. She said she, 'Could just feel it.'

Gina Lollobrigida photographed with husband Dr. Milko Skofic and three-year-old son Milko Jr. at the Beverly Hills Hotel in Beverly Hills, California. For the **Saturday Evening Post** *article, 'Saga of a Siren', 13 August 1960. Avery also photographed Lollobrigida in Acapulco, Mexico during filming of* **Go Naked in the World** *in 1959.*

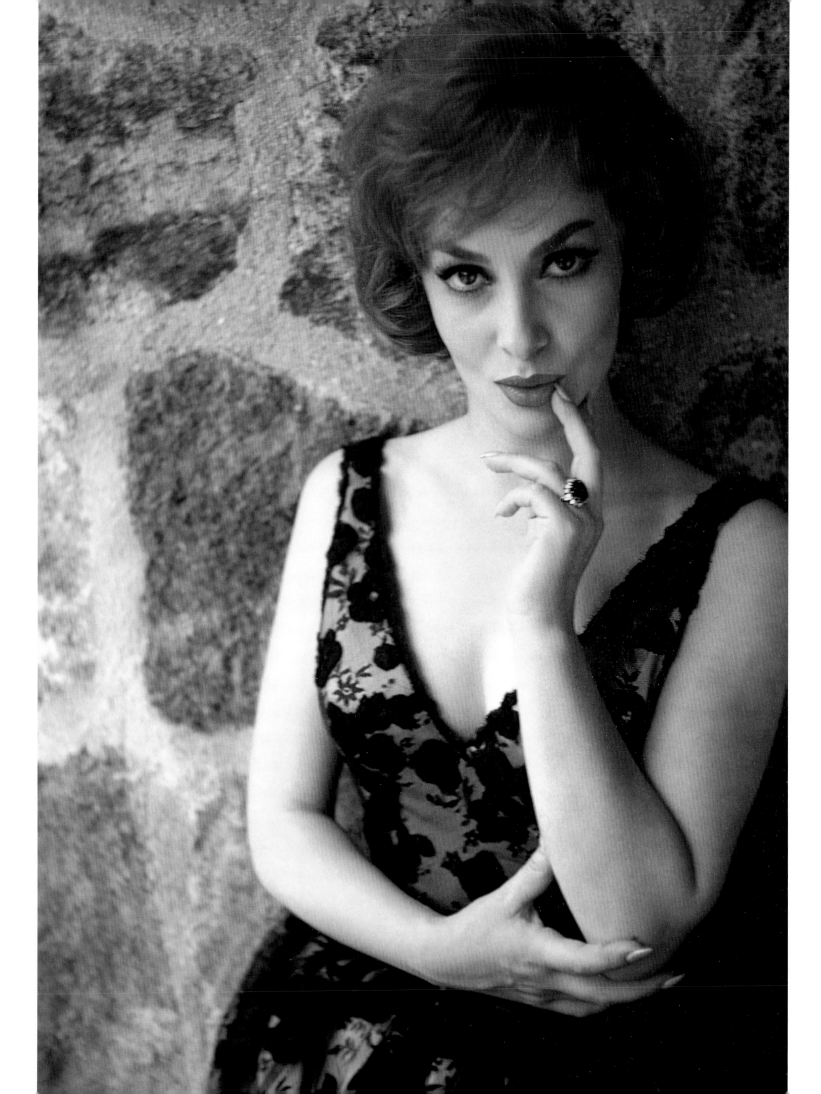

MARLON BRANDO

I was assigned by the *Saturday Evening Post* to do a few pictures of Brando on his first visit to Los Angeles for a film. He was living in a little shack up in Beverly Glen. I had called to get permission to shoot and he said, 'I can't give you any time – I'm leaving for New York. If you want to come in for a quick shot, I'll do it.' When I arrived, I asked him what he was doing. He told me he was playing chess. I told him to keep playing – so I shot him playing. He asked if I wanted anything else. I said, 'Well, maybe we can do something of you packing for your trip to New York.' We tried to figure out how to untangle his hangers so that he could pack.

I've always thought this photo to most depict the 1950s – with the bongos and African art.

After I made a few shots of him in the house, I spotted the kitchen and told him, 'I would love to get a shot of you cooking. But your trash is all way up to the sink. Can you and your buddy take it out?' So he and his friend took the trash out – took it to the incinerator and burned it (those were the days when you could do that). After his kitchen was clean, I was able to shoot him eating some toast.

He was extremely relaxed, innovative and was thoroughly enjoyable. Plus, I must say, he was a very rewarding photographic subject even though he had an aversion to publicity and very little time for our shoot because he had to leave for New York. However, he gave me one of my best home layouts.

Marlon Brando photographed in his Beverly Glen home for the **Saturday Evening Post** *article, 'The Star Who Sneers at Hollywood', 6 June 1953.*

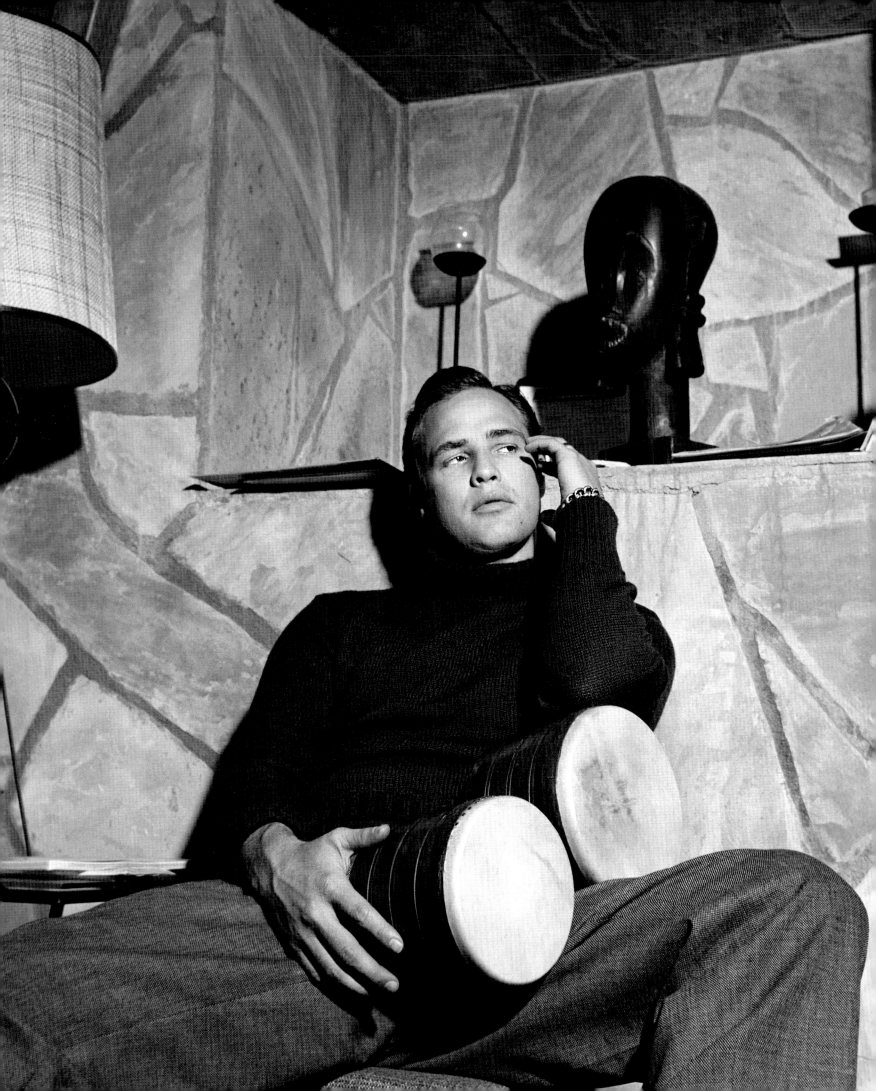

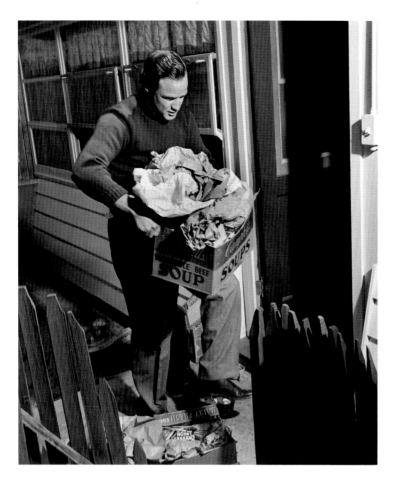

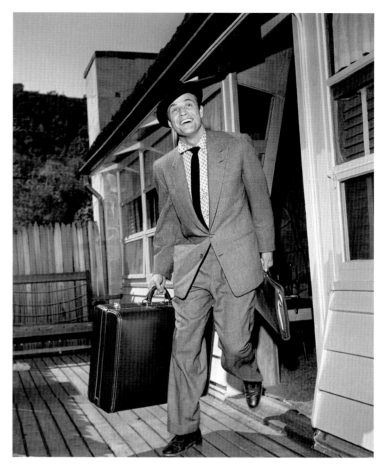

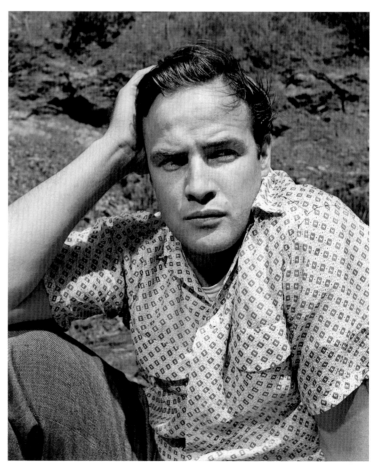

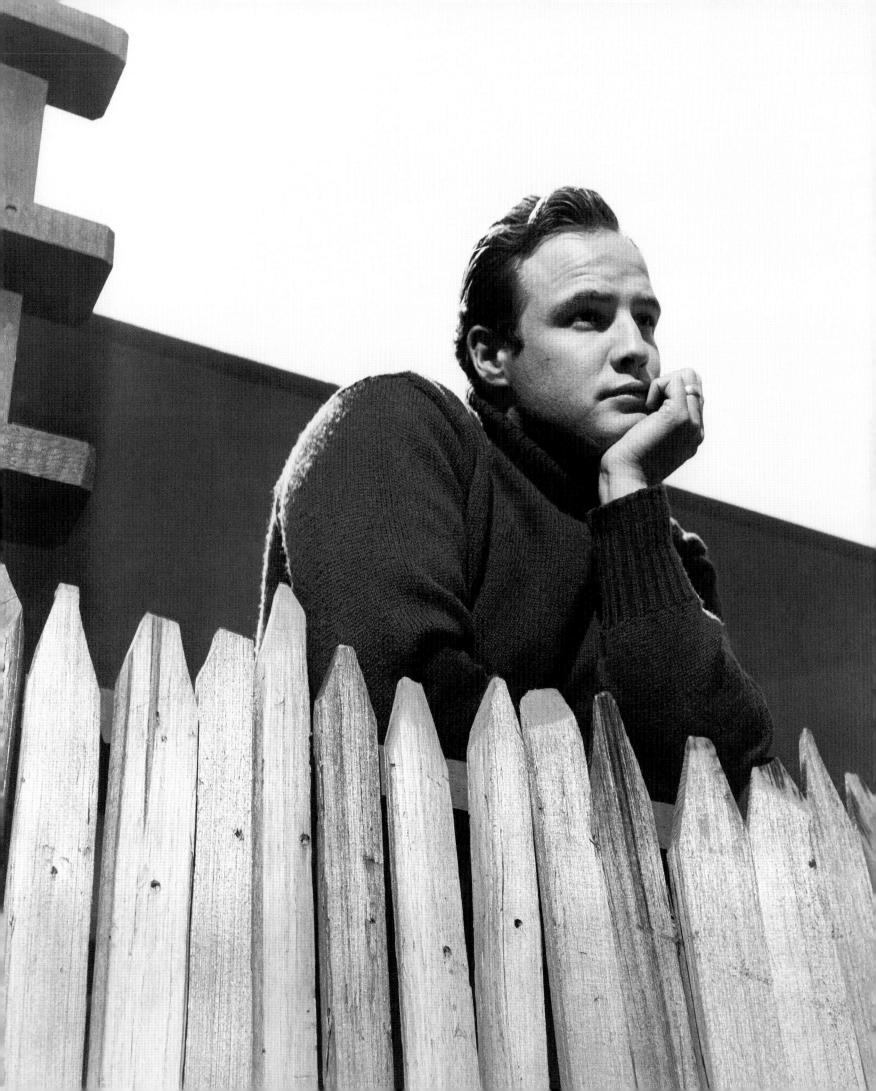

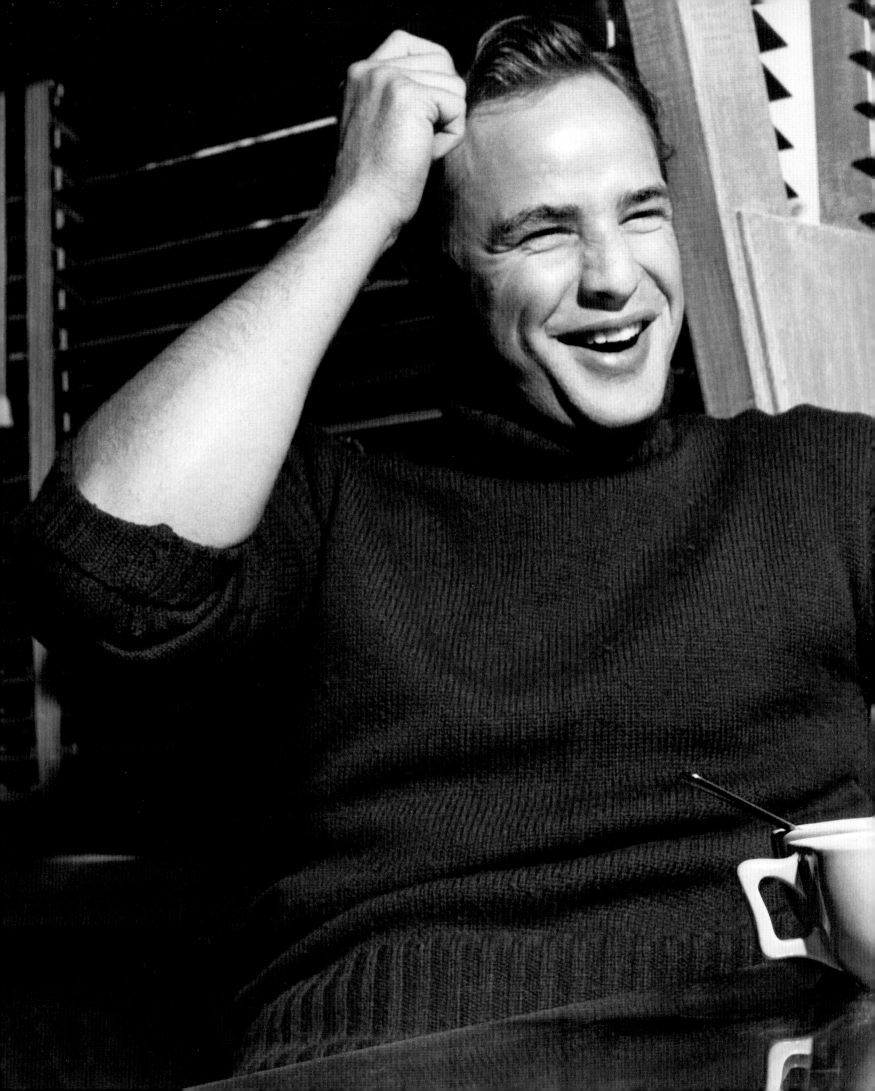

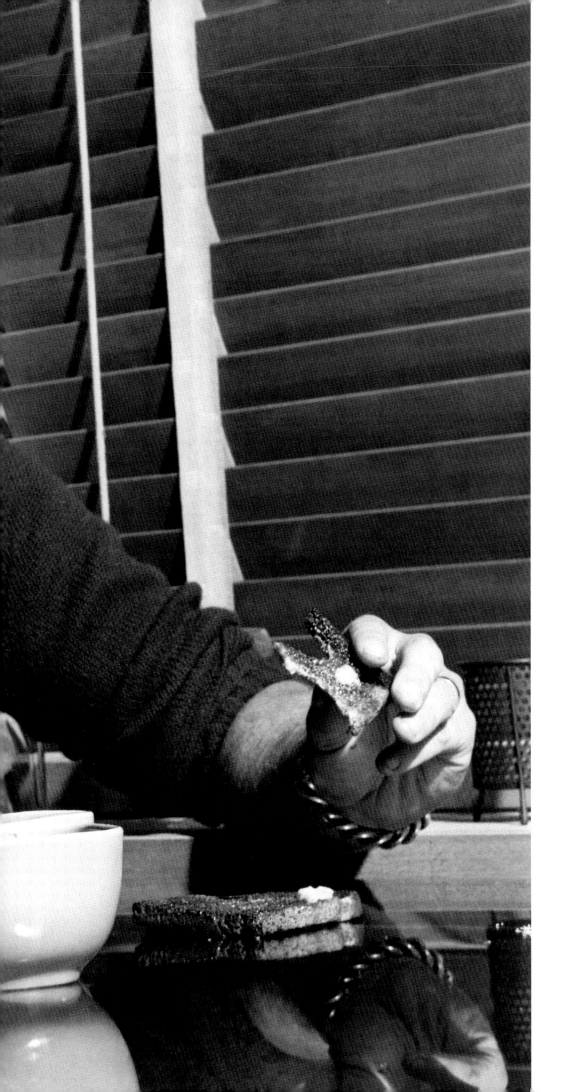

sid avery & associates

MOTION PICTURES & STILL PHOTOGRAPHY

6432 SELMA AVE. · HOLLYWOOD 28, CALIF. · GLADSTONE 7193

sid avery
earl cooke
john s. nash
marvin newton

May 1st, 1952

Mr. Douglas Borgstedt
Saturday Evening Post
Independence Square
Philadelphia, 5, Pa.

Re: CONVERSATION WITH SHELLEY WINTERS

Dear Doug-

Shelley Winters gave all of us an awfully bad
time during the picture-taking sessions so I hope the
coverage was adequate.

Don't know whether it was her impending marriage
which caused the temperamental outbursts, but she got
practically hysterical at every photographic situation
suggested. Never saw such an ornery dame, and all for no
apparent reason.

The last line of Pete's story reads: "But, as for
me, she is not habit-forming". I'll go along with that.

Sincerely yours,

Sid Avery

SA:kj

PS- Negatives enclosed herewith.

SHELLEY WINTERS

This was the only time in all the years I worked for any magazine where I had to write a note
to the editor and get off the job. I told them that I just can't continue – this woman has the
foulest mouth and is the least dependable person I have ever worked with. I just couldn't handle it. I
finally sent in what I did take and I guess they had enough pictures to use. But she was really tough.

Shelley Winters photographed at home in Hollywood with her husband-to-be, Vittorio Gassman. For the
Saturday Evening Post *article, 'Hollywood's Blonde Pop-Off', 29 June 1952.*

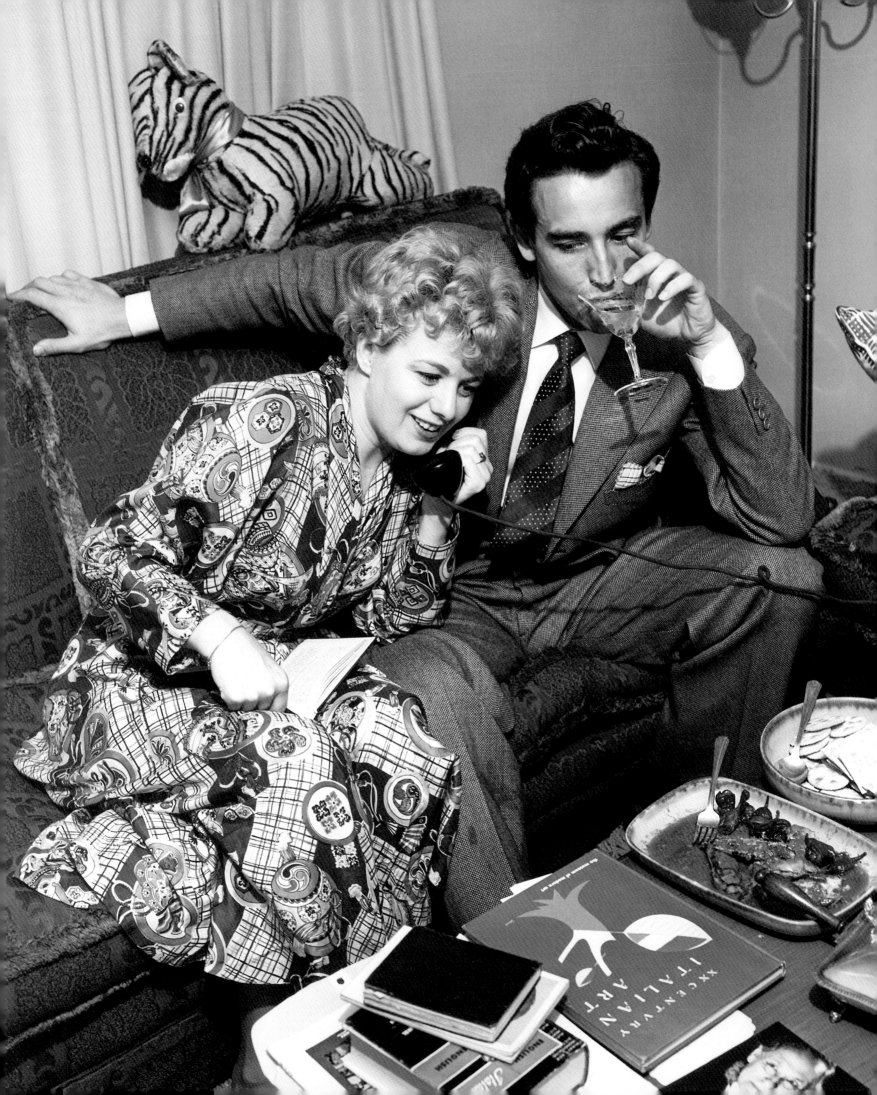

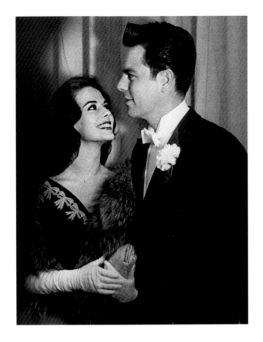
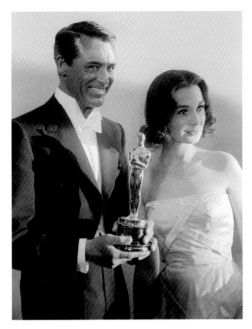
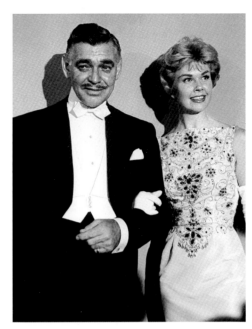
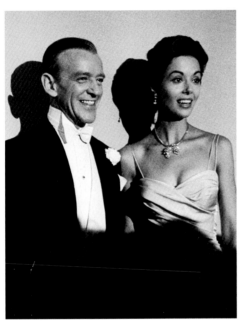
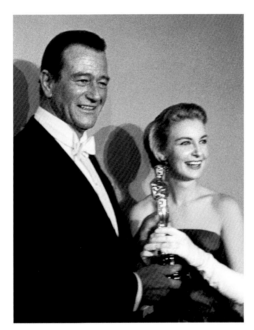
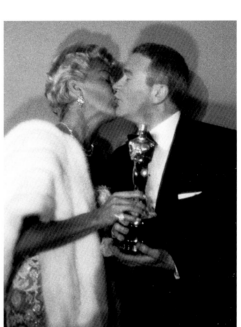

THE ACADEMY AWARDS

Avery photographed several of the guests and winners at the 30th Annual Academy Awards, held on 26 March 1958.

Clockwise from top left: Natalie Wood and Robert Wagner; Cary Grant and Jean Simmons; Clark Gable and Doris Day; Lana Turner and Red Buttons; John Wayne and Joanne Woodward; Fred Astaire and Dana Winter. Main picture: Sophia Loren.

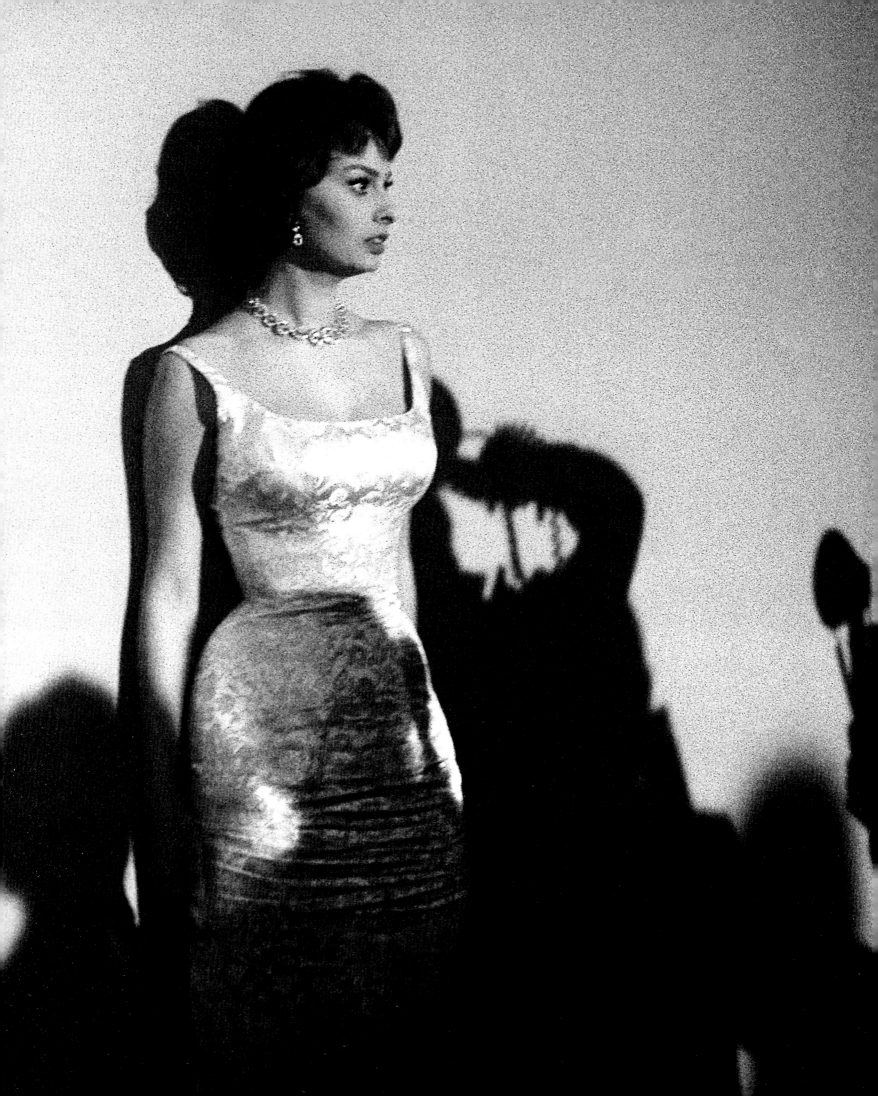

ERNEST BORGNINE

We first met around 1952, before he got the Academy Award for *Marty*. Down to earth and one of the warmest subjects I've ever photographed. We became true friends from the first moment I photographed him. A great actor and human being. He and I, my wife Diana and his wife went out together, visiting each others homes – he put in all the cement work around the swimming pool at my home and had some of his other actor friends come over and help. Ernie is one of the most genuine people I've ever known.

Rhoda was his first wife – I was friends with him when he married all of his ladies – the next one was Katy Jurado and after her, Ethel Merman (my wife and I were the only two outsiders invited to the wedding, everybody else was just family). After he divorced Ethel (in about three-four weeks), he married Donna and had two children with her. Eventually, he married Tova and they have been married for a long time.

Ernest Borgnine photographed in the studio and at home with wife Rhoda and daughter Nancy. For the **Saturday Evening Post** *article, 'He Gets $150,000 a Year for Being Mean', 27 August 1955.*

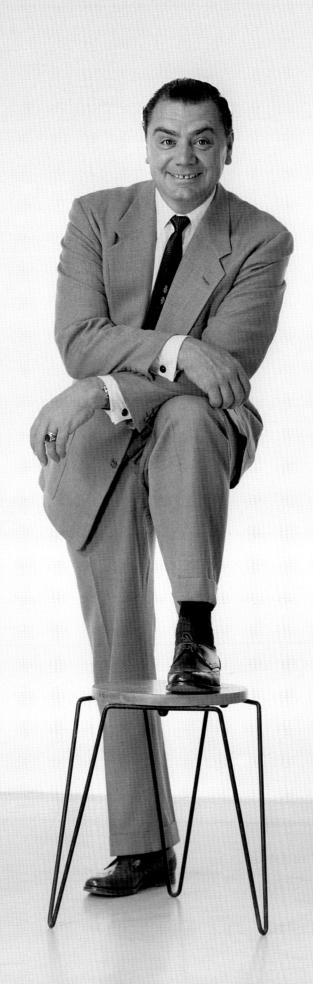

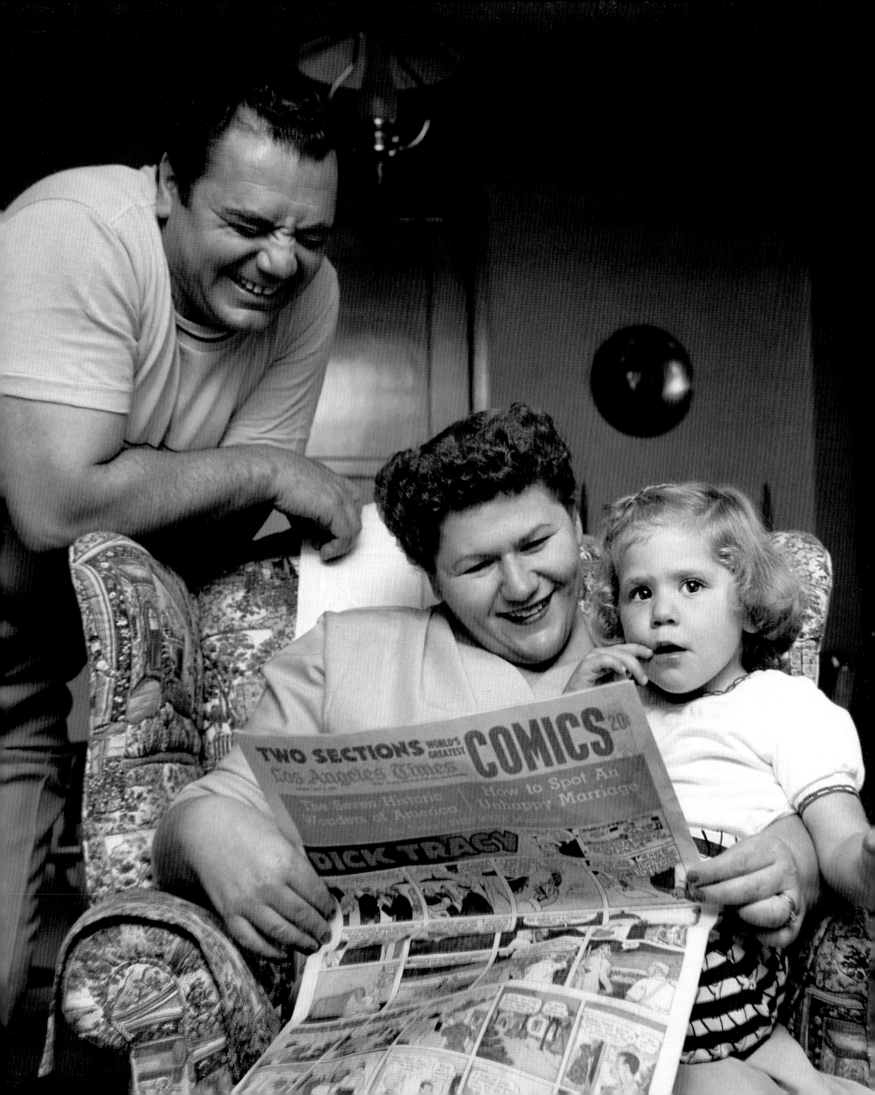

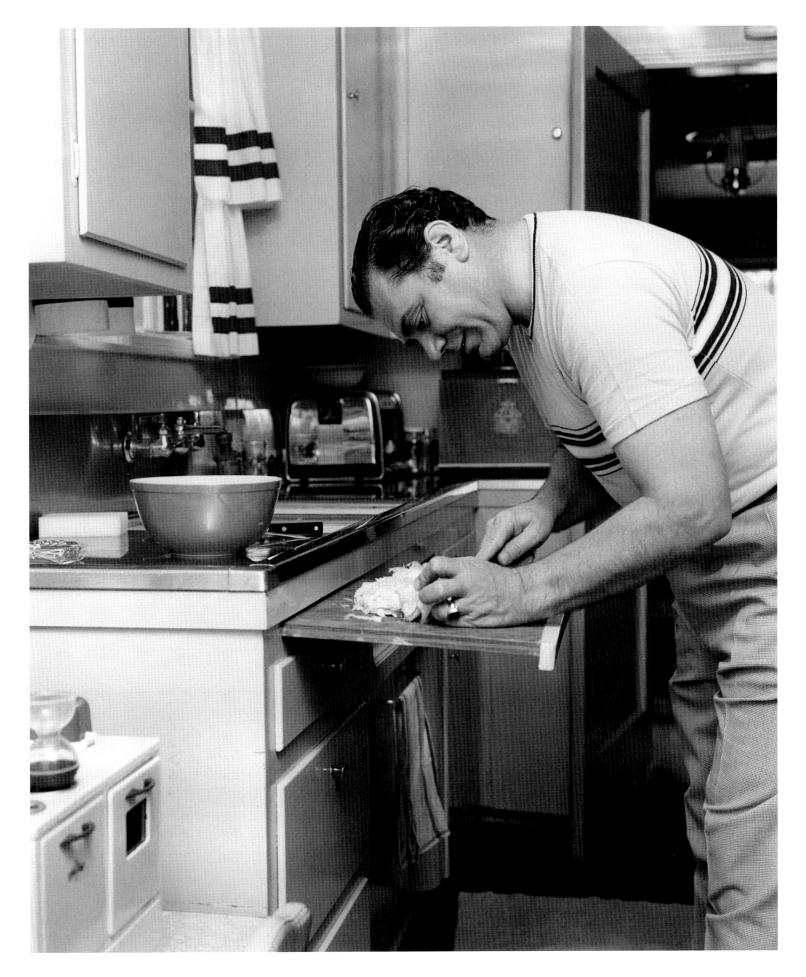

OCEAN'S ELEVEN

This was a film that I worked on where I was shooting Sammy Davis Jr. I came in and shot a lot of pictures of these guys horsing around the way they did on the set – throwing cherry bombs [firecrackers] in each other's dressing rooms, fast draw games, etc. They would stage these fight scenes for me and I shot a lot of those. This particular photo [the cast shot around pool table] has become more of an icon than anything else that I've shot. I asked the director Lewis Milestone if I could take this photo after they were shooting a scene of the gang planning the robbery. The director said, 'I'll give you a couple minutes.' So, I got set up and put my camera on the tripod and made two exposures, and then the director says, 'That's it!' Both exposures were pretty good – this one was a little bit better and it's the one I've always used.

In 2001 I got a call from Warner Bros and they asked me if I would like to shoot the new cast and I said, 'No, I've been directing film for 35 years and I don't think I should. Besides, I don't have any camera equipment.' Upon hearing this, my son, Ron, told me to put them on hold and he said, 'Look, this is a wonderful opportunity for you to have a lot of fun. I'll be the production manager and we'll get some of the photographers who have worked for you and who are now top photographers in the business – and they'll be your assistants. They'll bring their gear so we would be able to do it.' So I finally accepted the offer and I had a wonderful time.

The producer, Jerry Weintraub, was very warm and friendly – he hugged me all the time. Everybody in the cast, especially the old-timers that I worked with before – even Brad Pitt, George Clooney, Matt Damon, etc., all of whom I've never worked with before – all of them came over and said what an honor for us to have you shoot the picture. I kept thinking to myself, what an honor it is for me, at this age to come back and have an opportunity like this.

Bruce McBroom also vividly remembers that day: 'It was just like the old days, where we got everyone together again. I had so much fun helping Sid do that, it was such an honor for him and he was really the star that day. Everyone wanted to talk to Sid, find out how he took the first picture, what was Sinatra like, what was Dean Martin like etc. ... It was really neat, after all those years, to see Sid basking in the spotlight again. This was really the frosting on the cake for Sid's career.'

Ocean's Eleven original cast photographed on set by Sid Avery, 1960. Full cast, from left to right: Richard Conte, Buddy Lester, Joey Bishop, Sammy Davis Jr., Frank Sinatra, Dean Martin, Peter Lawford, Akim Tamiroff, Richard Benedict, Henry Silva, Norman Fell, and Clem Harvey.

Ocean's Eleven remake cast photographed on set by Sid Avery, 2001. Full cast, from left to right: Bernie Mac, Casey Affleck, Li Dian Feng, Scott Caan, George Clooney, Brad Pitt, Matt Damon, Elliott Gould, Don Cheadle, Edward Jemison, and Carl Reiner.

Photographs of Sid behind-the-scenes with the Ocean's Eleven remake cast shot by Bob Marshak, 2001.

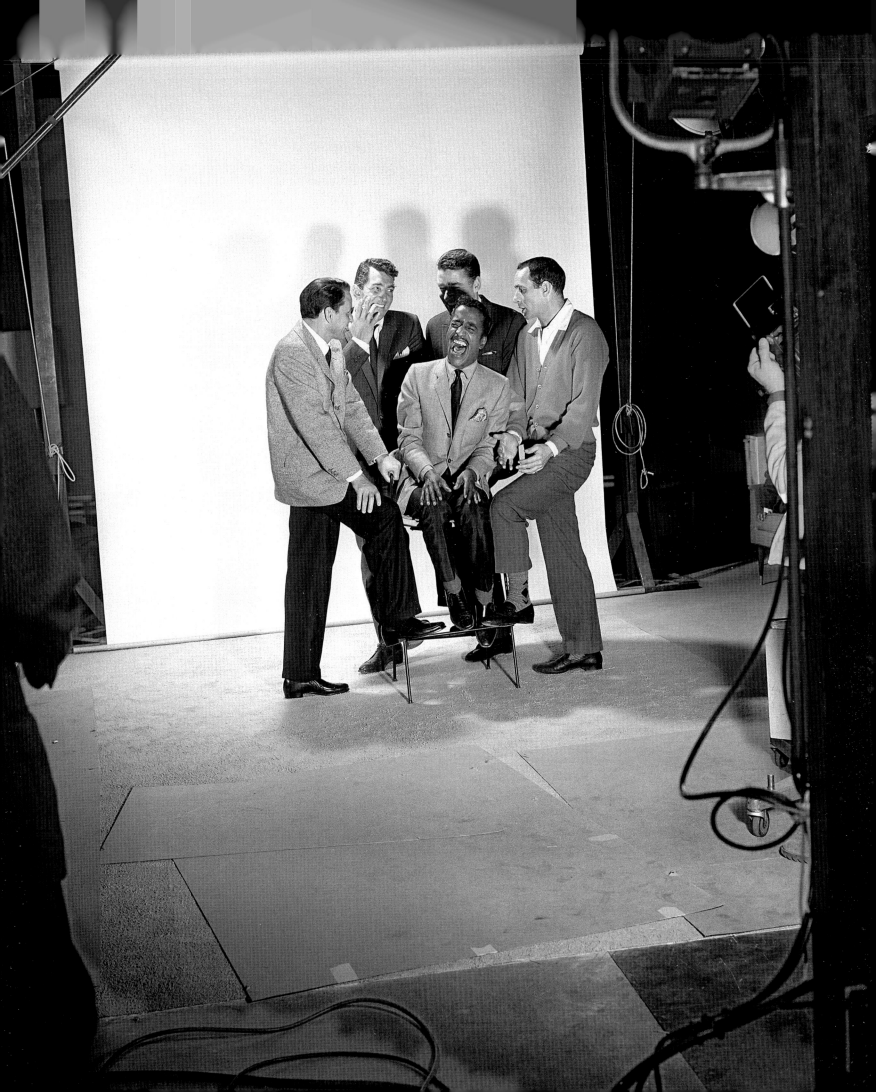

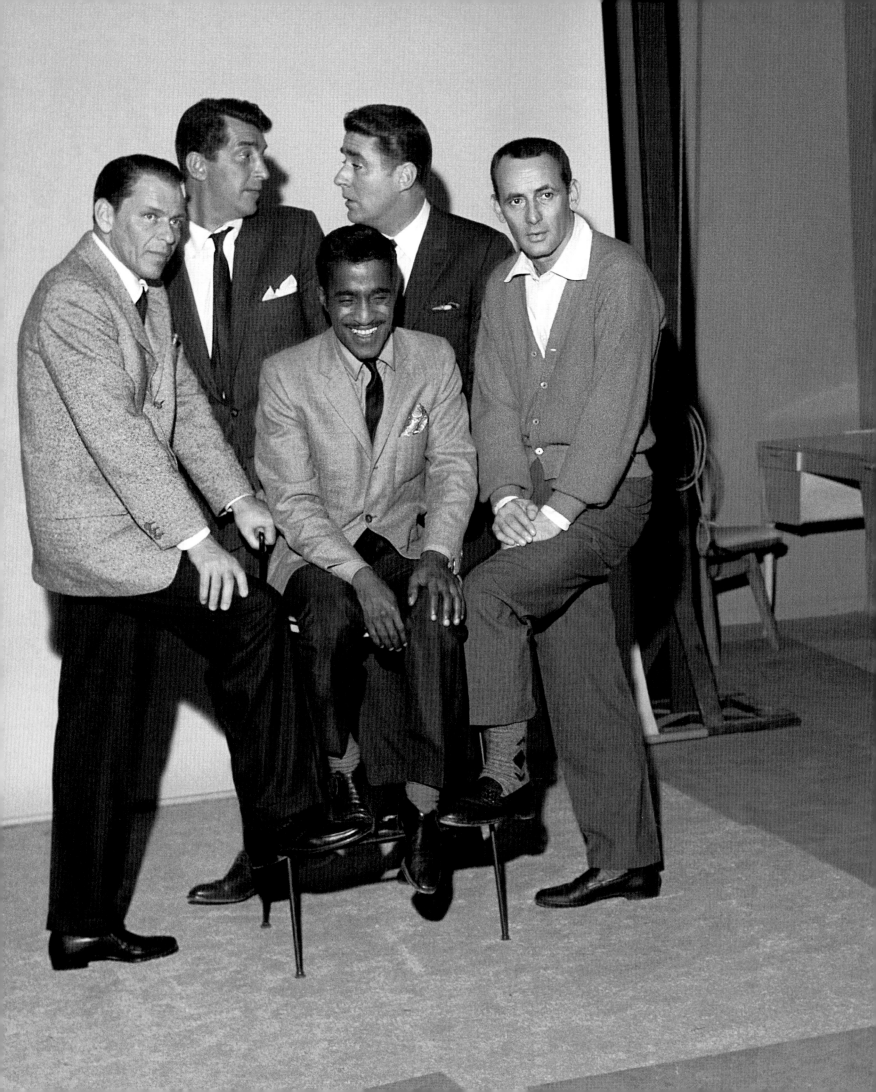

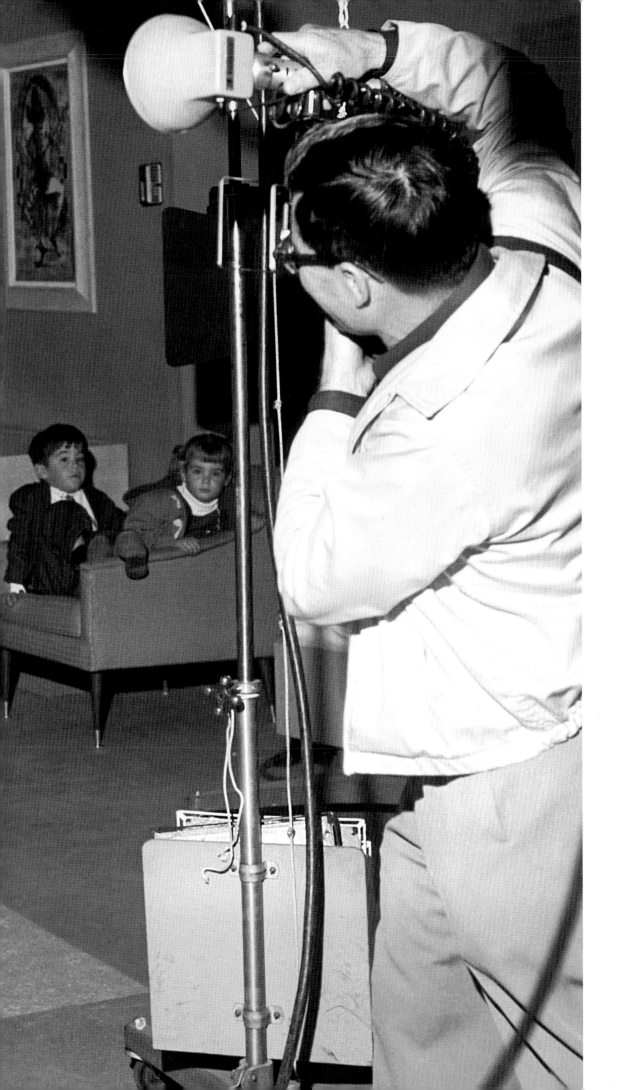

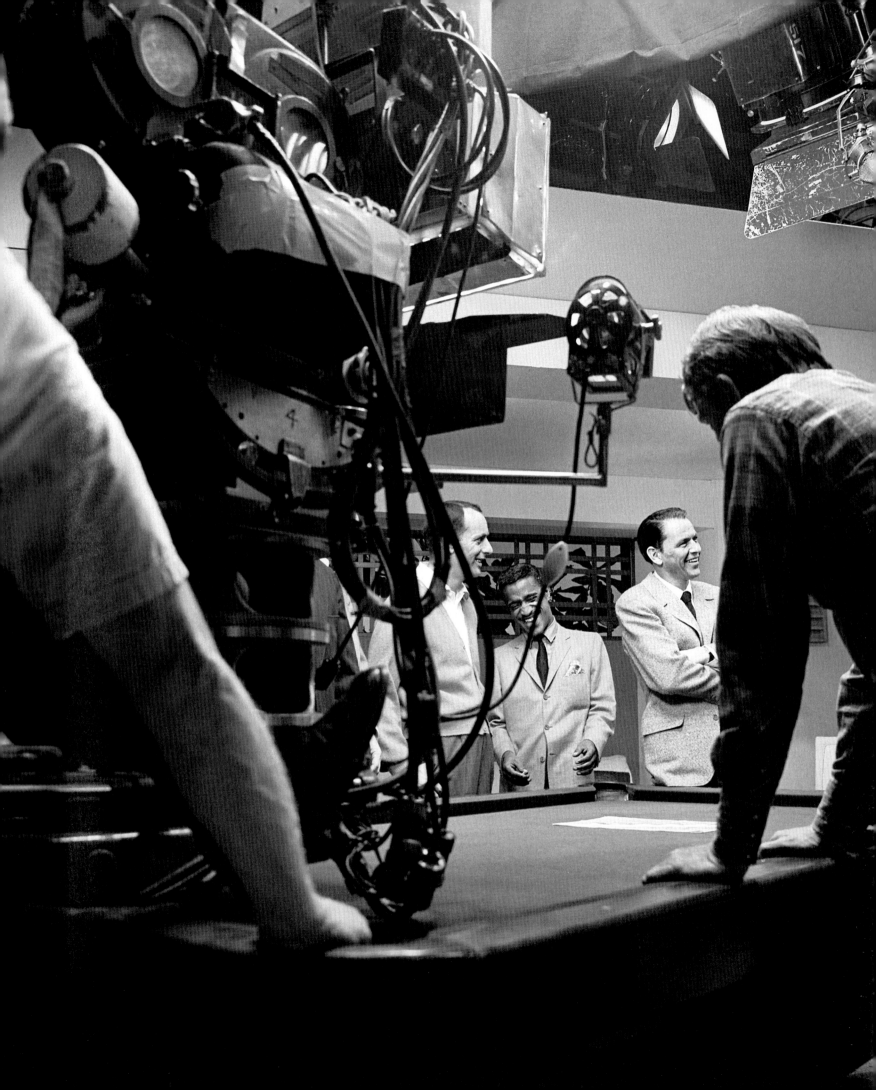

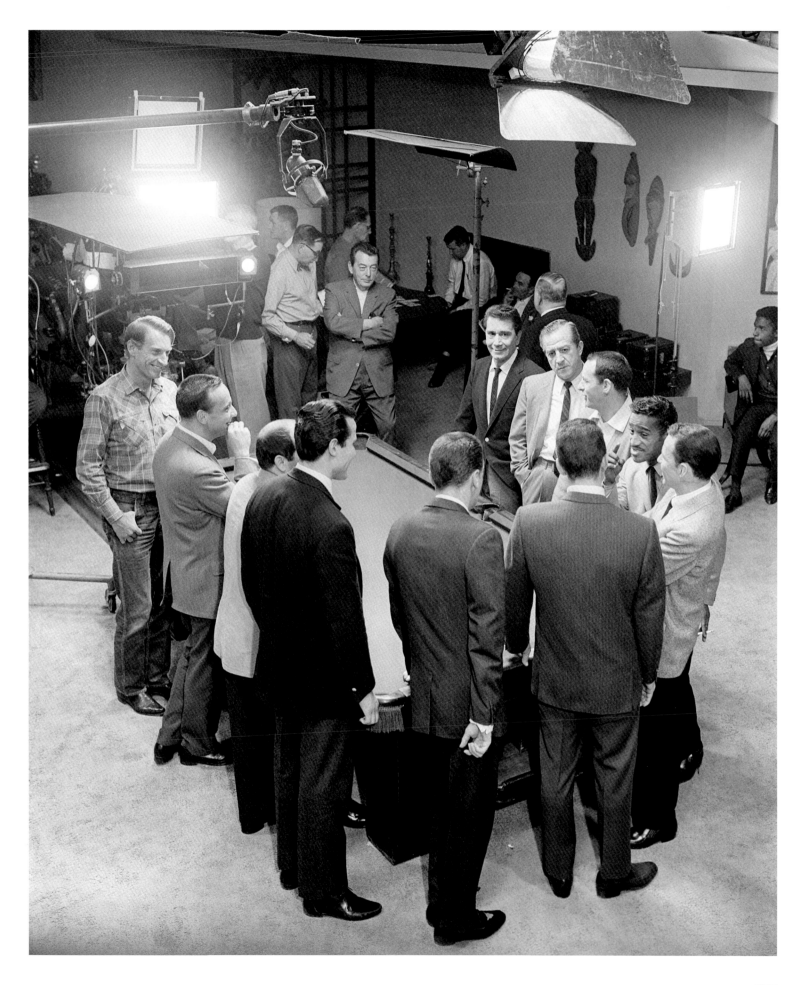

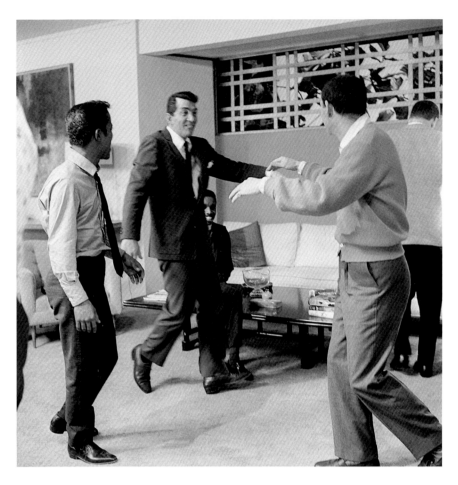

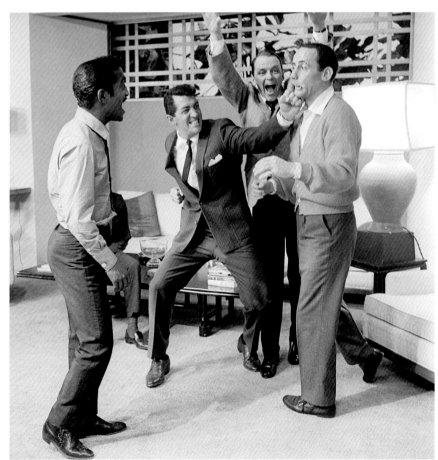

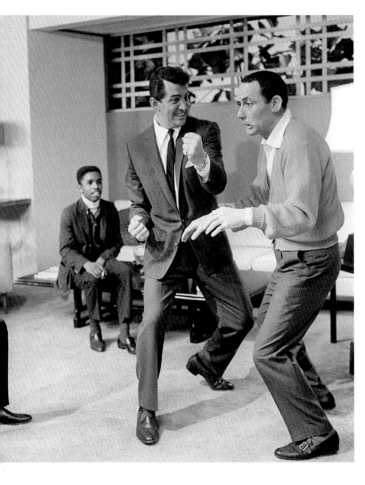

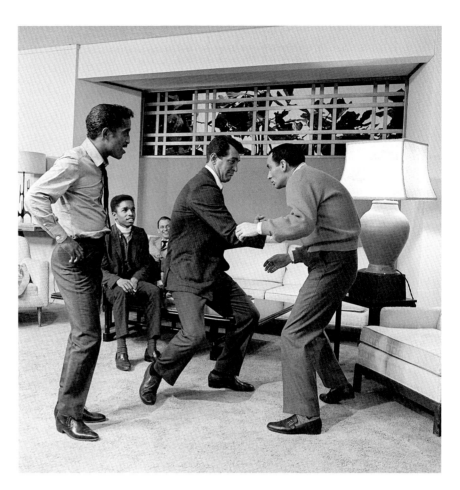

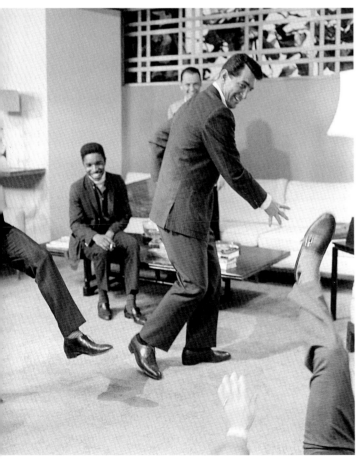

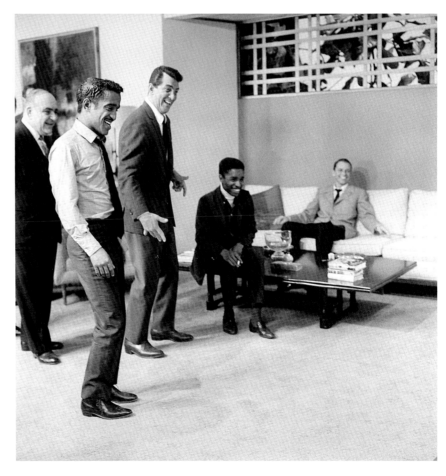

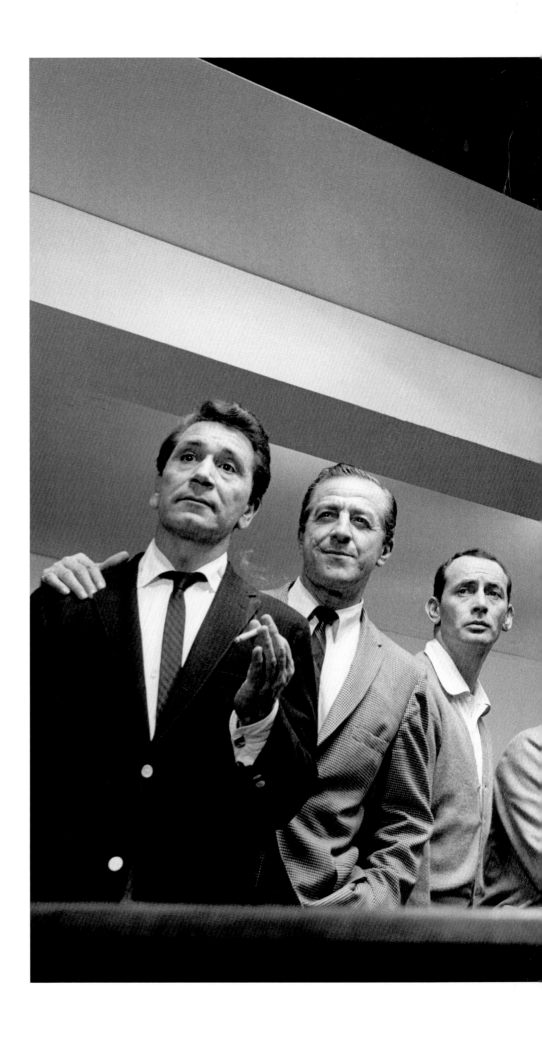

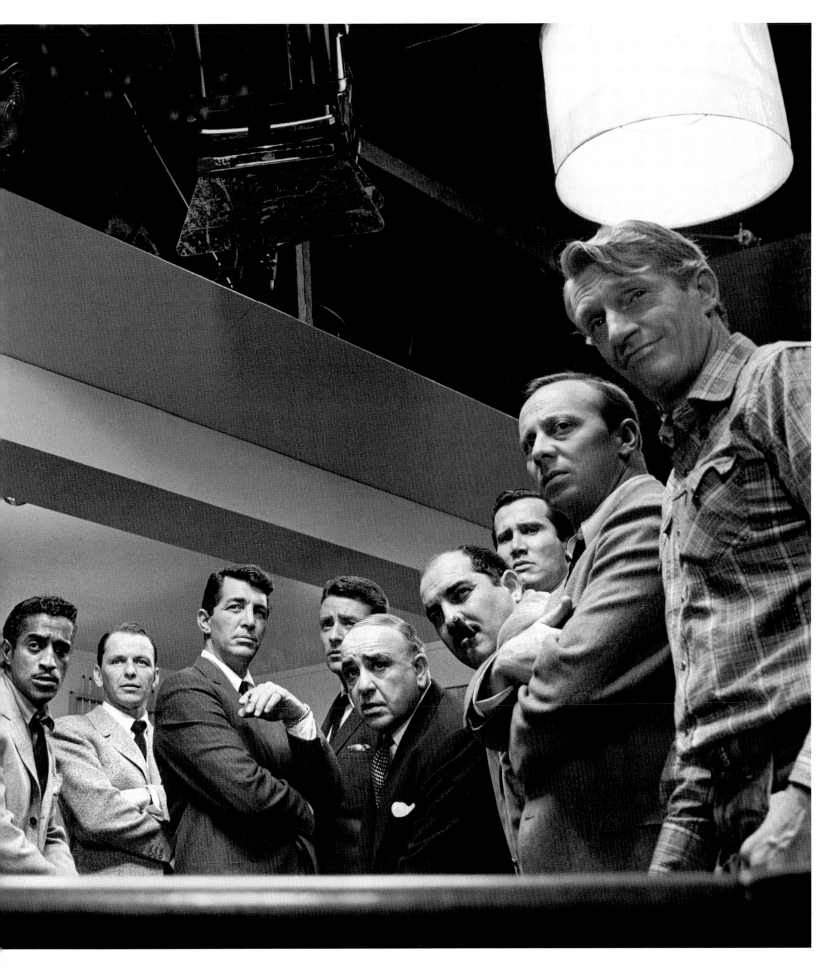

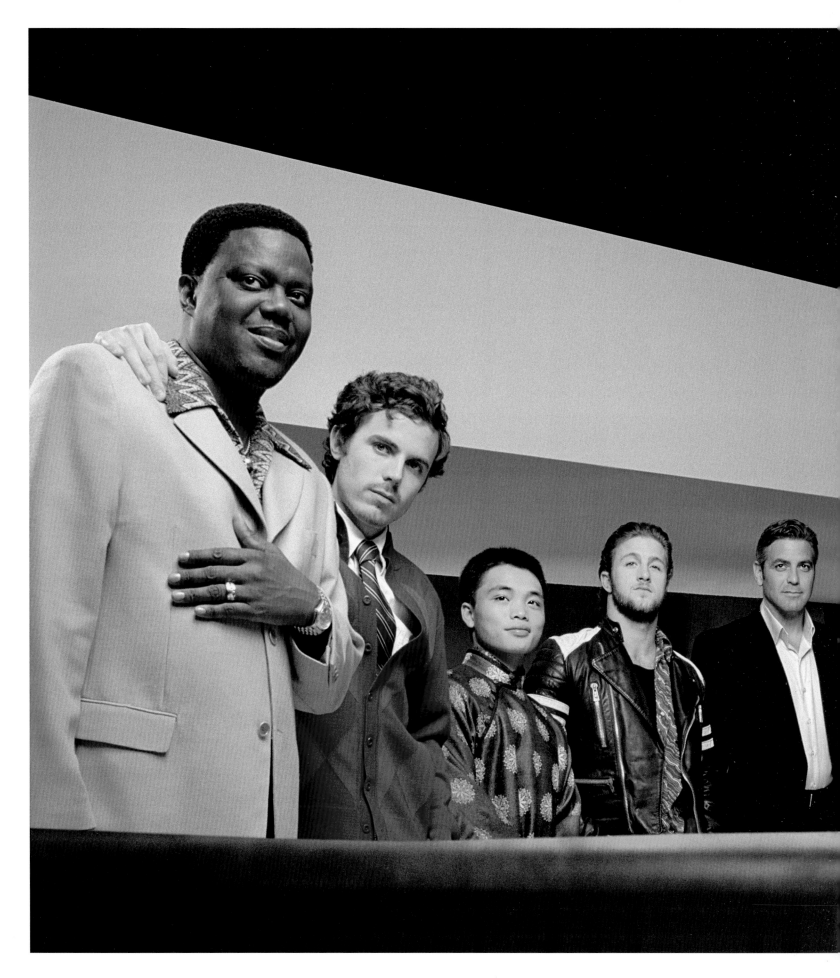

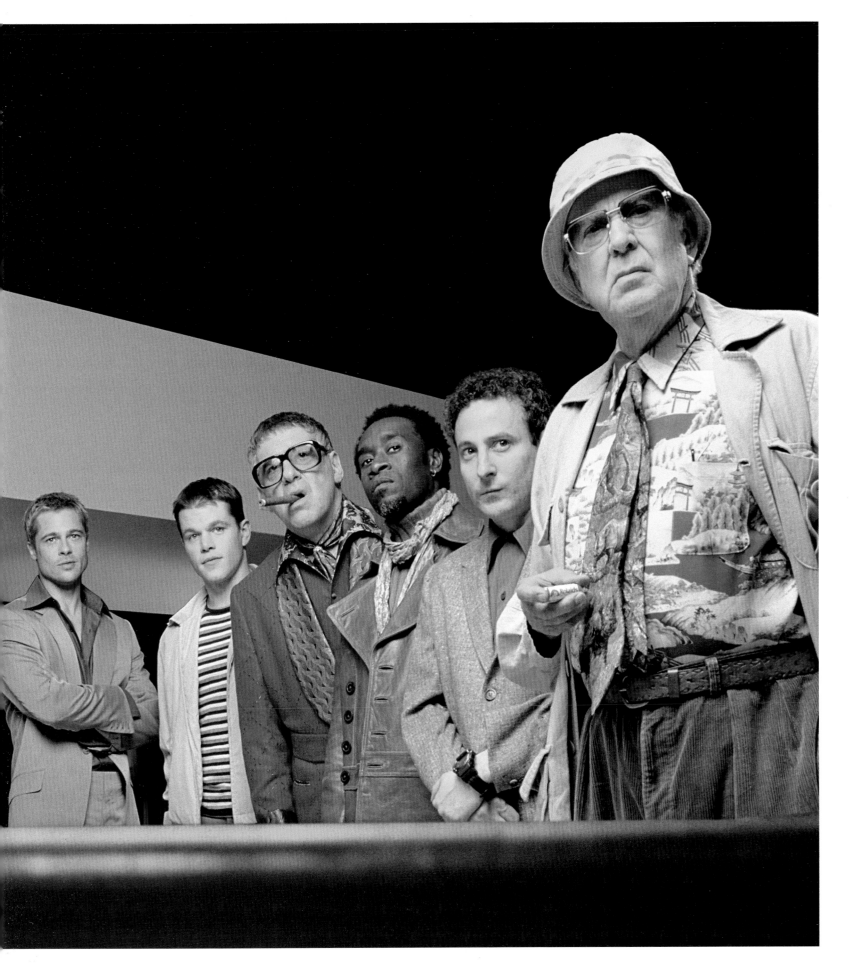

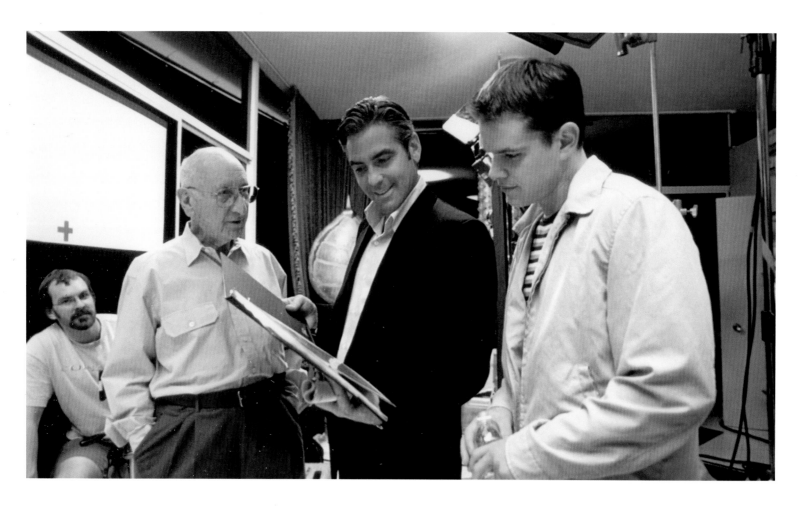

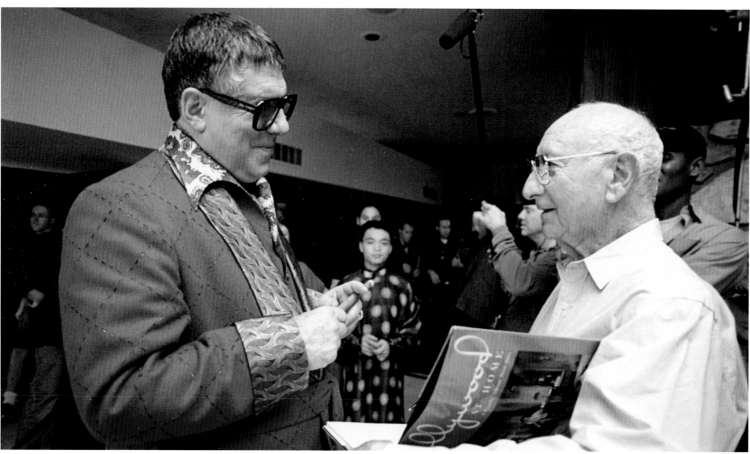

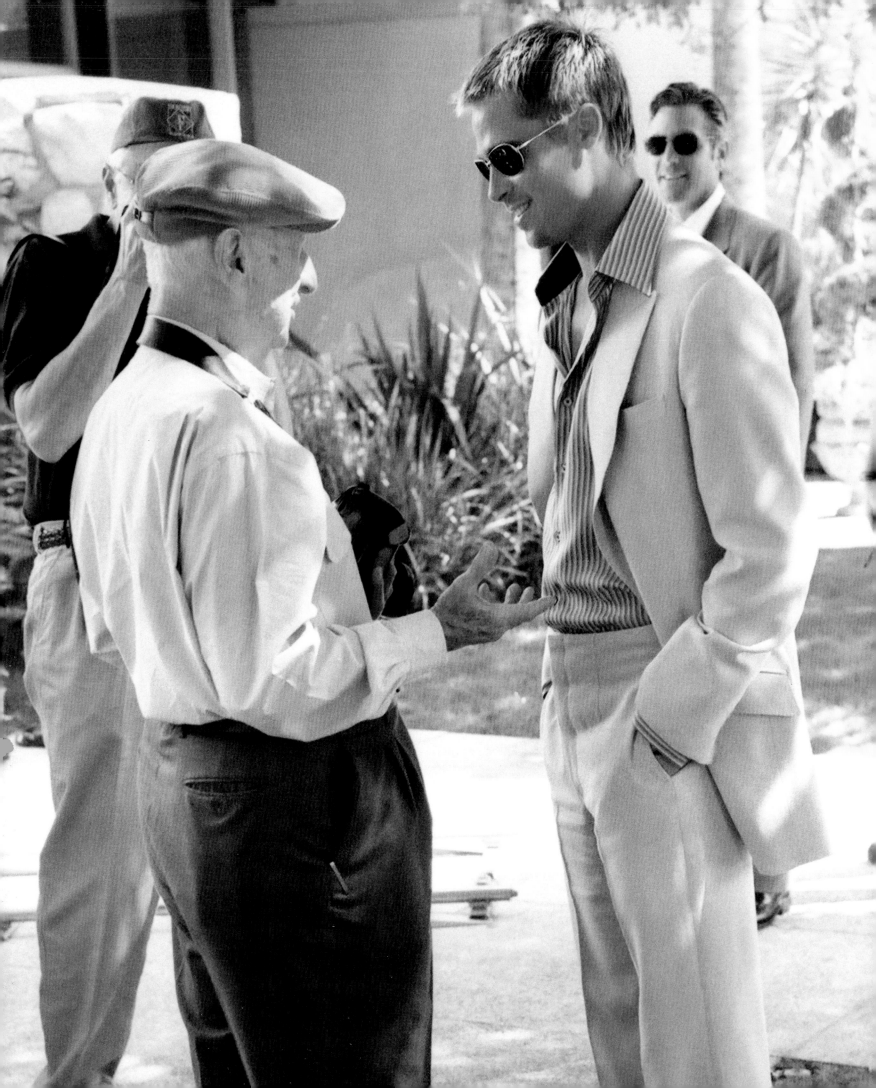

ACKNOWLEDGEMENTS

I would like to thank the following individuals for their invaluable help and support with this project:

To my wife Donna Avery.

To my mom Diana Avery.

To my daughter Toni Avery, especially for her role in interviewing my dad's former assistant, Bruce McBroom.

To my staff Andy Howick, Nazanin McAfee and Beth Jacques.

To Benjamin Peterson for his immaculate restoration of my dad's photos.

To Bruce McBroom for sharing his wonderful recollections of my dad.

To Deana Martin for writing such kind words.

Reel Art Press would like to thank the following friends and colleagues for their continual help and support: Lisa Baker, Joseph Baldassare, Daniel Bouteiller, Luisa Brassi, Joe Burtis, The Crew from the Island, Priya Elan, Christopher Frayling, Leslie Gardner, Beth Jacques, Andy and Maria Johnson, Dave Kent, John and Billie Kisch, Sara Lindström, June Marsh, Bill Ndini, Samira Kafala Noakes, Jake Noakes, Bruno Nouril, Hamid and Doris Nourmand, Joakim Olsson, Sammy and Sheida Nourmand, Steve Rose, Philip Shalam, Jonathan Stone, Claudia Teachman, Caroline Theakstone and Ski Williams.

PHOTO CREDITS

ADDITIONAL CAPTIONS

p.2 Sid Avery, self portrait, 1942; p.5 Sergeant Sid Avery with Barbara Stanwyck and Claudette Colbert at Ciro's Nightclub in Hollywood, California, 1941; p.6 Sid Avery, circa 1960; p.8 Sid Avery on assignment with Audrey Hepburn and Mel Ferrer, 1957; p.10-11 Sid Avery and wife Diana, circa 1944; p.13 Sid Avery in his first studio at 6263 Hollywood Blvd. in Hollywood, California, 1940; p.14 Sid Avery at Pacific Ocean Park in Santa Monica, California, 1940; p.26-27 Sid Avery's studio in Los Angeles, California (on Selma and Wilcox), 1946; p.288 A gag gift given to Sid Avery by an art director, 1962.

SOURCE MATERIAL

Avery, Sid, *Palm Springs Desert Museum Lecture*, January 1996 (transcript); Avery, Sid and Schickel, Richard, *Hollywood at Home: A Family Album 1950 – 1965* (New York: Crown, 1990); Brierly, Dean, 'Sid Avery: Transforming the Hollywood Icon' [transcript of an original interview in *Camera and Darkroom* magazine, 1994]; *Photographers Speak*, 24 May 2012. <http://photographyinterviews.blogspot.co.uk/2012/05/sid-avery-transforming-hollywood-icon.html> accessed 30 September 2012; Goldman, Ari L., 'Sid Avery, 83, Candid Photographer of Film Stars', *The New York Times*, 16 July 2002; McBroom, Bruce, *A telephone conversation with Toni Avery, Sid's daughter*, September 2012 (transcript); Rasmussen, Henry 'Spotlight: Sid Avery', *B&W*, Issue 3, Fall 1999.

Sid Avery while stationed in London, England (wife Diana applying lipstick in mirror), 1943.

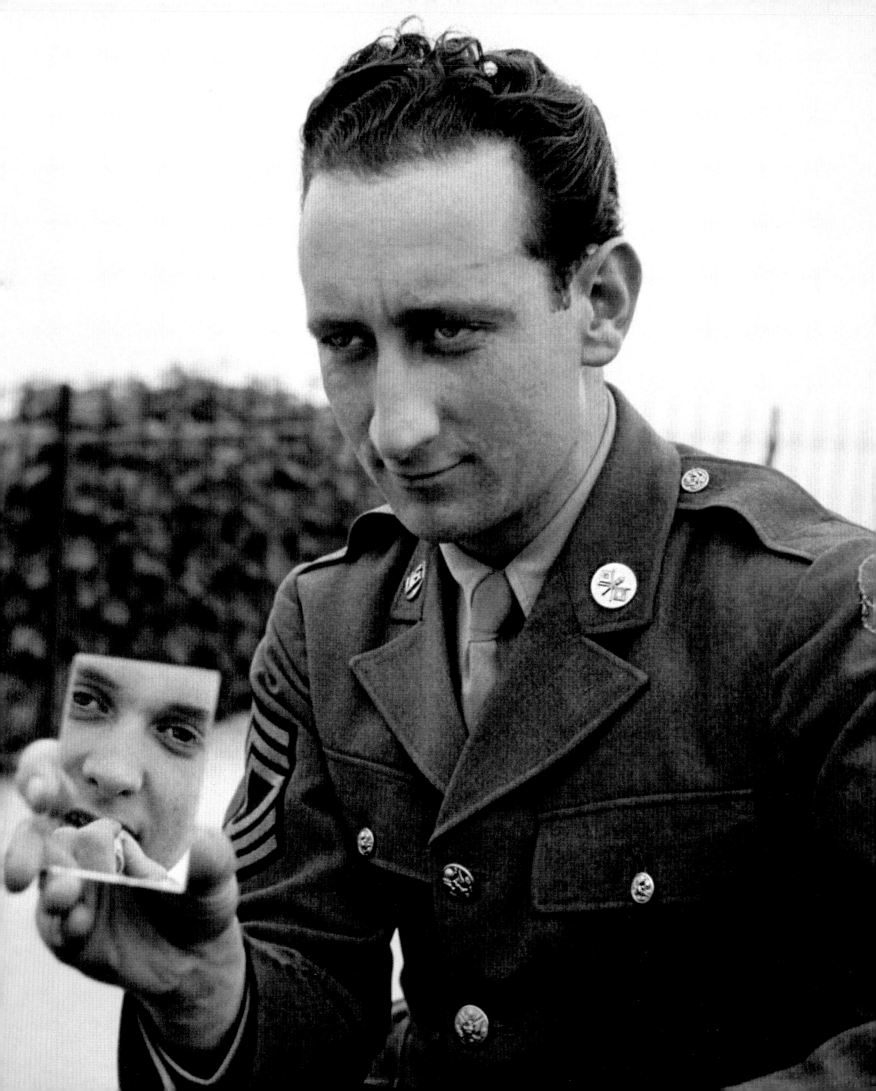

INDEX

Elaine Stewart photographed for the Saturday Evening Post article, 'Her Favorite Star is Herself', 5 September 1953.

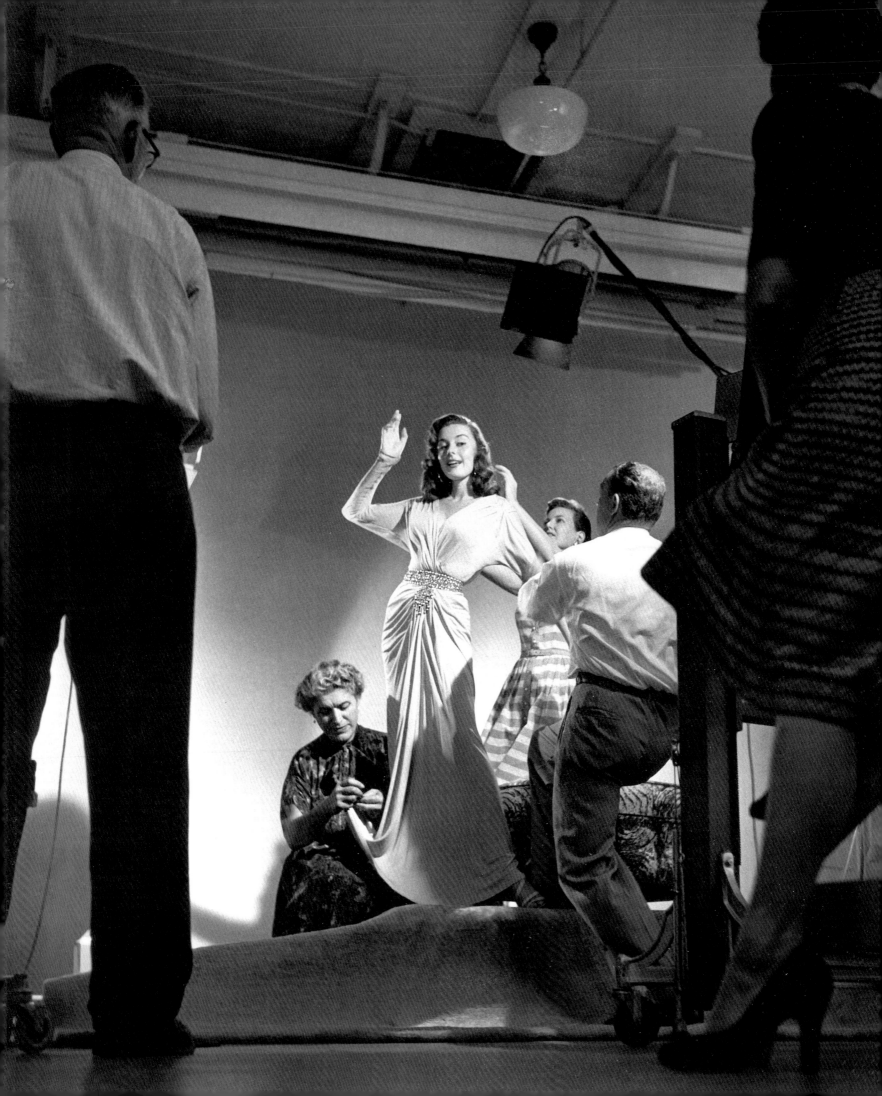